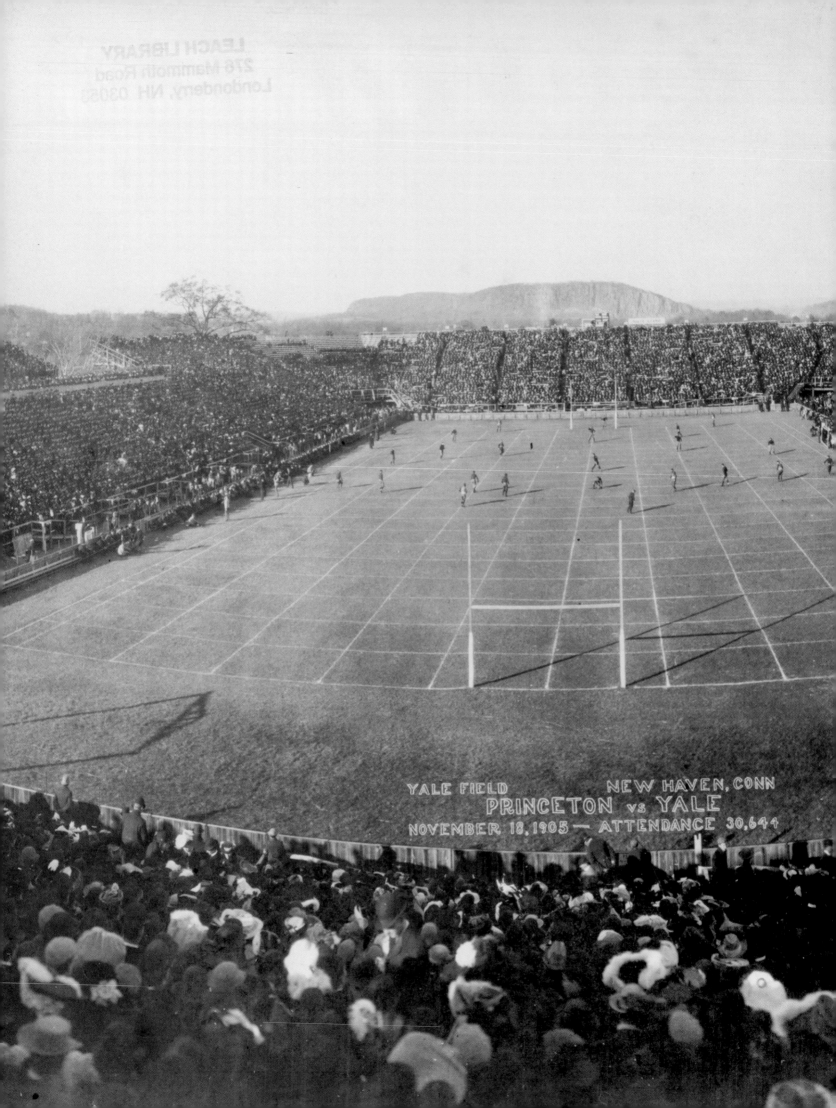

YALE FIELD NEW HAVEN, CONN
PRINCETON vs YALE
NOVEMBER 18, 1905 — ATTENDANCE 30,644

FOOTBALL NATION

★★★★★★★★★★

FOUR HUNDRED YEARS OF AMERICA'S GAME

FROM THE LIBRARY OF CONGRESS

SUSAN REYBURN

ATHENA ANGELOS, IMAGE RESEARCHER/EDITOR

JONATHAN HOROWITZ, CONTRIBUTOR

ABRAMS, NEW YORK

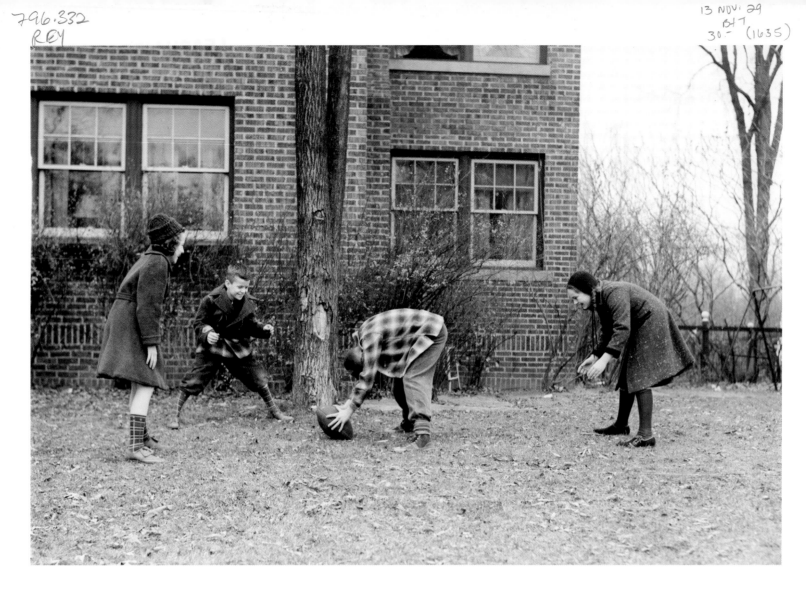

Editor: Laura Dozier
Designers: John Gall and Danielle Young
Production Manager: True Sims

Library of Congress Control Number: 2013935763

ISBN: 978-0-8109-9762-2

Printed and bound in China
10 9 8 7 6 5 4 3 2 1

Abrams books are available at special discounts when purchased in quantity for premiums and promotions as well as fundraising or educational use. Special editions can also be created to specification. For details, contact specialsales@abramsbooks.com or the address below.

THE ART OF BOOKS SINCE 1949
115 West 18th Street
New York, NY 10011
www.abramsbooks.com

(Page 1) Detail from *All-American Football Magazine*, by George Gross, 1943.

(Above) Backyard football in Royal Oak, Michigan, by Arthur Siegel, 1939.

(Opposite) Texas A&M at practice, College Station, by Marvin E. Newman, 1954.

(Following pages) UCLA locker room at the Rose Bowl, Pasadena, by Positive Image Photographic Services, 1996.

(Pages 8–9) BenJarvus Green-Ellis (42) of New England dashes past Chicago Bears linebacker Brian Urlacher (45) in a Patriots victory, Soldier Field, Chicago, by Ross Detman, December 12, 2010. The difficulty of rescheduling games, which are separated by a week, unlike in baseball and basketball, means that football is played in even the most challenging weather, contributing to its reputation as a tough, demanding sport for both athletes and fans in the stadium.

CONTENTS

Gentlemen, you are about
to play a game against
Harvard. Nothing you do
in life will ever again be
so important as what
you do on the field today.

—Tad Jones, Yale coach
(1916–17; 1920–27)

If each of you goes out there and plays the
best game you'll ever play, if each of you
plays over your head, and if each of them
plays the worst game they'll ever play, the
worst game of their lives, we still don't
have a chance. —Tommy Prothro, San Diego
Chargers coach (1974–78), before his team lost to the
Pittsburgh Steelers, 37-0, on September 21, 1975

Don't worry about the horse being
blind, just load the wagon.

—John Madden, Oakland Raiders coach
(1969–78), just before his team defeated
the Minnesota Vikings 32-14 in Super
Bowl XI, on January 9, 1977. Years later,
when asked about this comment, Madden
admitted, "I never knew what it meant."

Better to have died
as a small boy than any
of you fumble it.

—John W. Heisman, Georgia
Tech coach (1904–19)

We're not just going out there to win, we're going out
there for glory. We're going to yank them, tear them,
and rip them. We're going to roll them around and rip
them up! Then we're going to slaughter them. After the
slaughter is over, we'll come back here and ring that
victory bell—like we always wanted to. —Coach Calhoun (Sid

We—are—Penn—State! And by God if they don't win, I'm gonna kill 'em. —Joe Paterno, Penn State coach (1966–2011), at a student pep rally, Friday, November 21, 2008, before defeating Michigan State, 49-18

You are going against Yankees, some of whose grandfathers killed your grandfathers in the Civil War. —Dan McGugin, Vanderbilt coach (1904–17; 1919–34), riling up his team before taking on Michigan, October 14, 1922. The game ended in a 0-0 tie. McGugin was himself a Northerner, a Michigan law school graduate, and the brother-in-law of Michigan's coach, Fielding Yost. McGugin did not mention that he was also the son of a Union Army officer.

Those guys put their jocks on just like you do. Those guys like the same girls that you guys like. Everything's the same, okay? It gets back down to who wants to win it the most. —Phillip Fulmer, Tennessee coach (1992–2008), prior to the Volunteers' victory over second-ranked Florida, 34-32, on December 1, 2001

Let's win one for the Gipper. —Knute Rockne, Notre Dame coach (1918–30)

Now go through that door and bring back a victory! —Vince Lombardi, Green Bay Packers coach (1959–67)

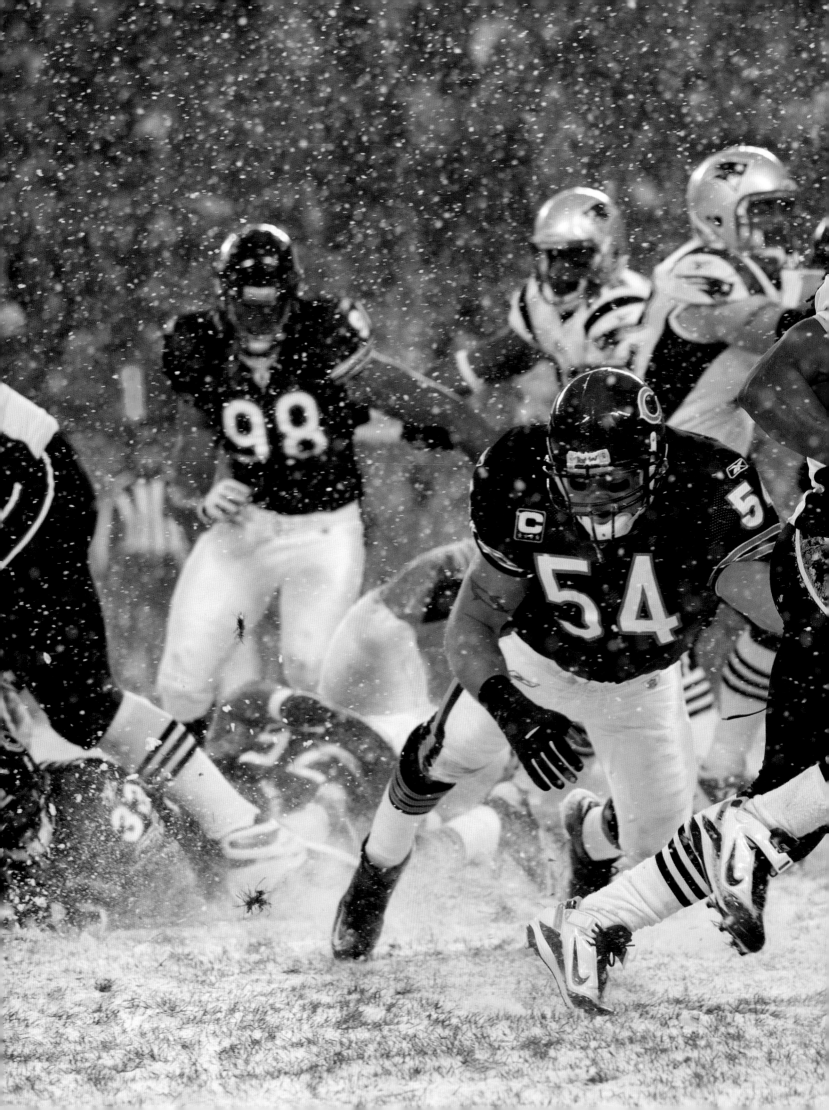

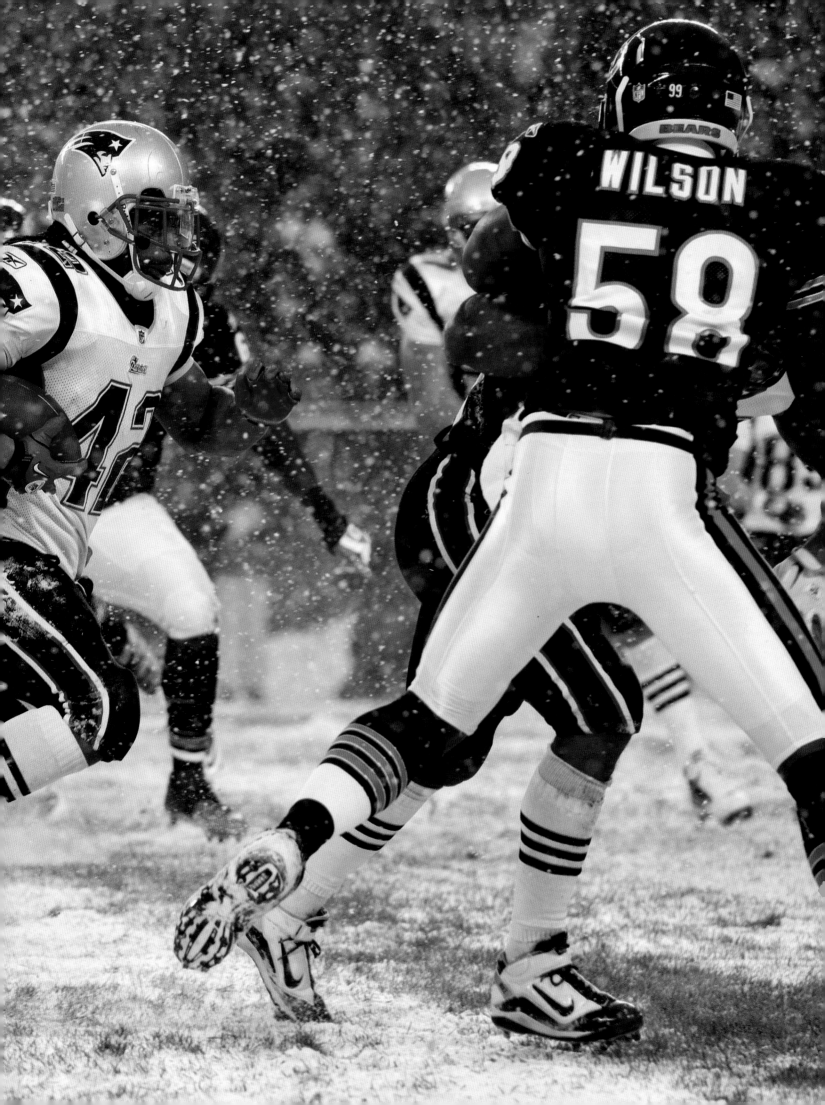

PREFACE

Conventional wisdom notwithstanding, there is no reason either
in football or in poetry why the two should not meet in a man's life
if he has the weight and cares about the words. —Archibald MacLeish
(1892–1982), Pulitzer Prize–winning poet and playwright, and the ninth
Librarian of Congress (1939–44)

Archibald MacLeish, one of my predecessors, was a man of letters, including
the one he earned at Yale in football. A soldier, author, diplomat, and professor, our man
experienced football and warfare, the former so often associated with the latter, more
intimately than those who usually make the comparisons. He spent two seasons on the college
gridiron and was already a published poet when he entered combat as an artillery captain in
World War I. For a man of MacLeish's expansive interests and skills, it is not surprising that he
should embody both sport and verse on his way to serving as Librarian of Congress.

Today, the Library of Congress offers an ideal vantage point from which to consider the
game that has occupied Americans for more than four centuries. With Thomas Jefferson's
extensive personal library at its core, the Library of Congress collects material that documents
the creative expression and the advance of knowledge in every subject. To paraphrase

MacLeish, there is no reason why the Library, the nation's oldest federal cultural institution and the largest library in the world, should not have in its collections the story of football if one cares about American culture.

Here one finds the earliest film footage of the college game, dating back to the 1890s; the earliest surviving football radio broadcasts; and the first televised game (the Philadelphia Eagles vs. the Brooklyn Dodgers), which aired in 1939. Former college stars and NFL players who went on to become Supreme Court justices, congressmen, and top military officials have left their papers in the Library's manuscript division. Our photographic collections show us a game played on raw nineteenth-century gridirons and in sparkling, high-tech, twenty-first-century stadiums. Our map collections illustrate the country as a matrix of sports conferences and even indicate how to orient stadiums for the best use of light. Our performing arts collections are proof that football has long been a topic for musicians, actors, composers, and comedians. Then there are the books: rows and rows and rows of works on football, from the earliest rule books to novels, memoirs, and the latest video game instructions.

The Library of Congress does far more than preserve and maintain exciting and transforming evidence of the human experience. It is our mission to make these holdings available to all, and the public is welcome to visit the Library and explore the collections. Some of the images in this book can also be found on the Library's website at www.loc.gov, which offers a virtual doorway to the more than 150 million items we hold. With the publication of *Football Nation*, the Library of Congress is pleased to tell the story of the country's most popular sport and to share its collected riches with the American people, who are, in fact, its owners.

—James H. Billington
Library of Congress

(Above) Football, ceiling painting, in the Jefferson Building of the Library of Congress, 1897, photo by Carol M. Highsmith.

(Below) Archibald MacLeish, second row, left, trots onto the field with the rest of the Yale varsity, ca. 1913.

INTRODUCTION

Baseball is what we used to be. Football is what we have become. —Mary McGrory, Pulitzer Prize–winning newspaper columnist, 1975

No one knows precisely when it happened—and there were those who did not want to believe that it had happened at all. But sometime in 1965, between the moments when world heavyweight boxing champion Muhammad Ali defended his title with a "phantom punch" that crumpled Sonny Liston, and Los Angeles Dodger Sandy Koufax hurled a shutout against the Minnesota Twins in Game Seven of the World Series, the tectonic plates underlying the American sporting landscape shifted. Any number of things could have tipped the seismic balance by early autumn: Vikings quarterback Fran Tarkenton's heart-stopping, unorthodox scrambling that unnerved his coach, stymied opposing defenses, and entertained everyone else; the Bears' slippery rookie running back, Gale Sayers, off to a record-setting season; the Rams' "Fearsome Foursome" defensive line launching furious, bone-crushing assaults; the Chargers' aerial circus, showcasing flanker Lance Alworth's acrobatic catches; or the Jets' wealthy, pioneering "glamourback," Joe Namath, making passes at wide receivers and smitten women.

For decades, a groundswell of enthusiasm had gathered in energetic fury each autumn, as colorful and vivid as the accompanying leaves, before receding into the depths of a long and silent off-season. By October 1965, however, nearly a century after the first intercollegiate football game, the groundswell was perceived not only in the folding seats and bleachers at the stadium, but most acutely on the couch in front of the television. That's when the results of a semiannual national Harris Poll revealed an inevitable new truth: Professional football had become the nation's favorite spectator sport, surpassing major league baseball in popularity. Factor in the college game's large, loyal following, and football was clearly America's top sport. This notable fact was confirmed in subsequent surveys, then in the Nielsen television ratings, and later in the sales of logoed apparel.

For a fellow named Bowie Kuhn, this was difficult to accept. As late as 1972, he was still struggling with the uncomfortable fact that a change *had* occurred: "I haven't wanted to dignify those findings," he said. His reluctance to concede the obvious was certainly understandable. Bowie Kuhn was, after all, the commissioner of major league baseball. Yet well into the twenty-first century, the aftershocks of 1965 continue to reverberate throughout American life, far stronger than when they so upset Mr. Kuhn.

Both modern baseball and football are related to games played in colonial America, and those games have medieval and ancient ancestors. Organized baseball achieved regional prominence early on in the Northeast, and the New York *Mercury* declared it the national pastime in 1856. Settlers took the game west, Union soldiers introduced it to Southerners during the Civil War, and in 1869 the Cincinnati Red Stockings became baseball's first professional team. For generations of immigrants, mastering baseball as a player or following

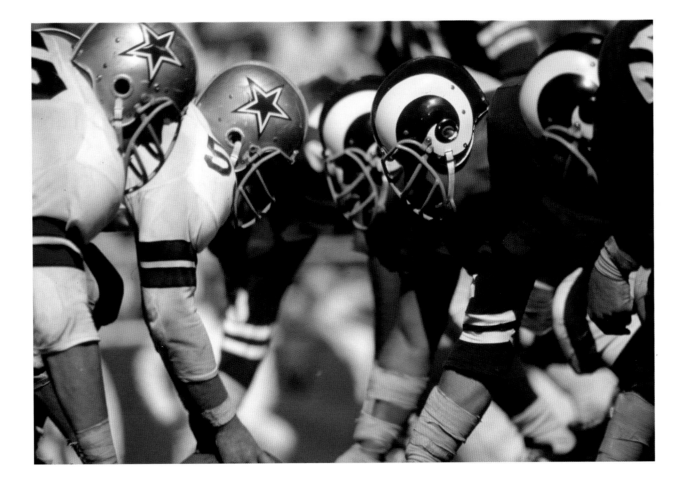

a team as a fan was an essential part of becoming an American. It was also proof that you *were* an American. Among its charms, baseball coincides neatly with the natural calendar, from spring training's rhythms of rebirth to fall's abundant championship harvest. That baseball—historically rooted in urban grittiness but heralded for its pastoral, Arcadian associations, its intellectual and literary bent, its democratic nature (*everyone* on the field has a turn at bat and a chance to score), and, perhaps most of all, its well-tended mythology and pantheon of heroic figures—had been eclipsed as the country's favorite professional sport was no small thing.

Organized football in the United States developed more slowly, and its newfound predominance in the 1960s represented a major cultural stirring, though it clearly snuck up on some people. Perhaps that was because the change had come gradually, its rumblings muffled in an era of escalating warfare in Vietnam and the increasingly radical beat of popular culture. That American football, both brute force and crisply choreographed movement packaged together as organized violence, should eventually come to dominate the national sports conscience is well worth considering. Examples of the game's elevated position in American life abound: It accounts for the most costly public expenditures in many a municipality; it has prompted congressional interest in playoff schemes; Super Bowl Sunday represents a nationwide, day long consumption of food second only to Thanksgiving, to which the game is also closely allied; and, in more than a few cases, football contributes to the health or dysfunction of one's family life.

How did it happen? What did this process look like, moving from universal, organic forms of play with a ball to a distinct and complex American game that is thoroughly embedded in the national culture? How did the United States become "Football Nation," and how did the game reflect and respond to the vicissitudes of American life? As with so many things, a good place to start is at the beach. . . .

Dallas Cowboys and the Los Angeles Rams, Cotton Bowl, by Neil Leifer, October 1, 1967.

December 969

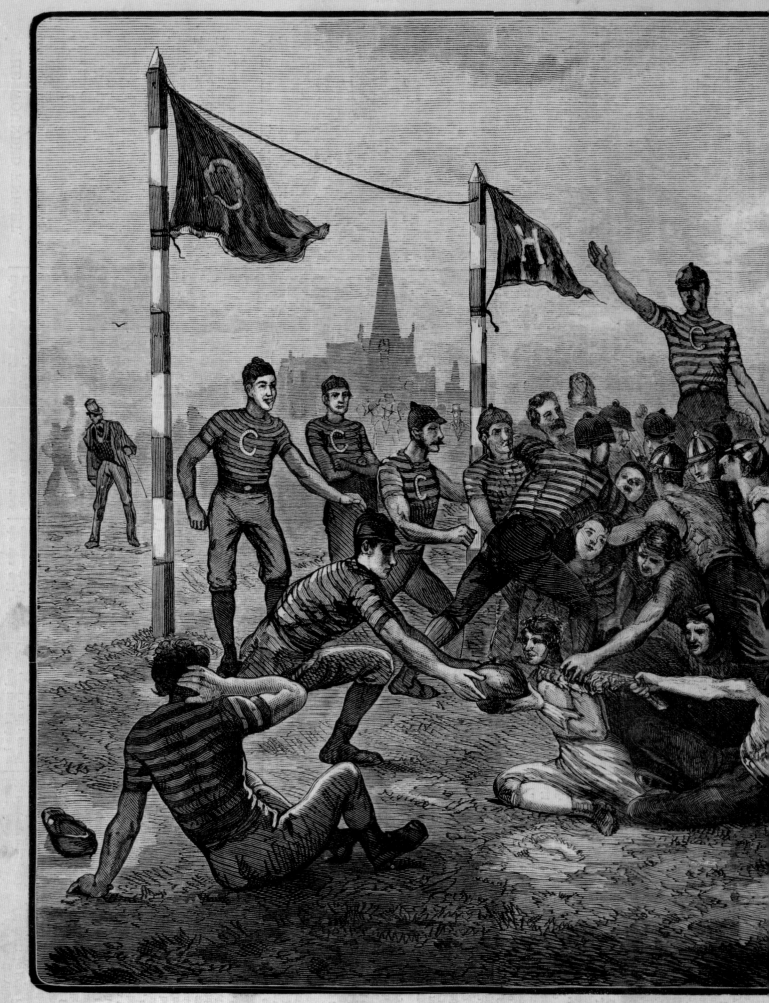

A GAME OF FOOT-BALL.—DRAWN BY J.

EARLY DAYS AND IVY

Origins to 1899

"A Game of Football," by J. Davidson, *Harper's Weekly*, December 7, 1878. A ball carrier loses his shirt attempting to hand off the ball in an early college game. *Harper's* informed readers that "The game requires speed, wind, and judgment, and if properly played, according to the revised rules, it is not dangerous."

Two to one is odds at Foot-Ball. —*The American Almanack* by Titan Leeds, week of February 14, 1736. This proverb suggests that one is enough, two is too many, but that two to one is probability.

Anything an English settler in nascent colonial America could tell his countrymen in the Old World about the new one was riveting: the flora, the fauna, the football. Admittedly, the archival record on seventeenth-century football is comparatively—and disappointingly—scanty; this is no doubt in part because persons promoting the infinite possibilities of the New World viewed the flora, fauna, minerals, and such as commodities, investments, and perhaps the eventual makings of an empire. They did not foresee recreational football as the tremendous business and entertainment opportunity it would become several centuries on, when it outperformed the spice trade. (Had they done so, the New England Patriots might well have been established much earlier and perhaps been known as the Boston Tories prior to the 1776 season.) As it was, mere survival and handcrafting a European civilization out of the coastal wilderness left little time for settlers to engage in recreation. Hence, early English references to beachside football and other games in America were typically brief, often made in passing, but, like everything else about the established native communities and the fledgling colonies, fascinating to those who read them on the far side of the Atlantic.

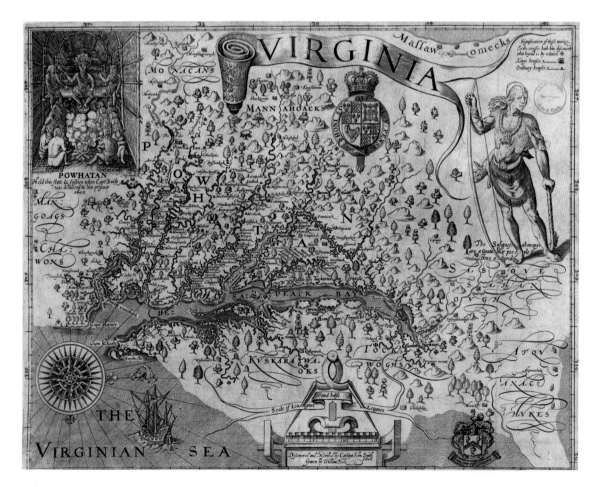

Captain John Smith's map of Virginia, engraving, by William Hole, *The Generall Historie of Virginia*, London, 1624. Smith explored the Virginia Company's colonial claims and the surrounding area in 1607–9, first publishing his map in 1612. To the west, near "James towne," located on the river identified as the "Powhatan Flu," English colonists watched Powhatan Indians engaged in football.

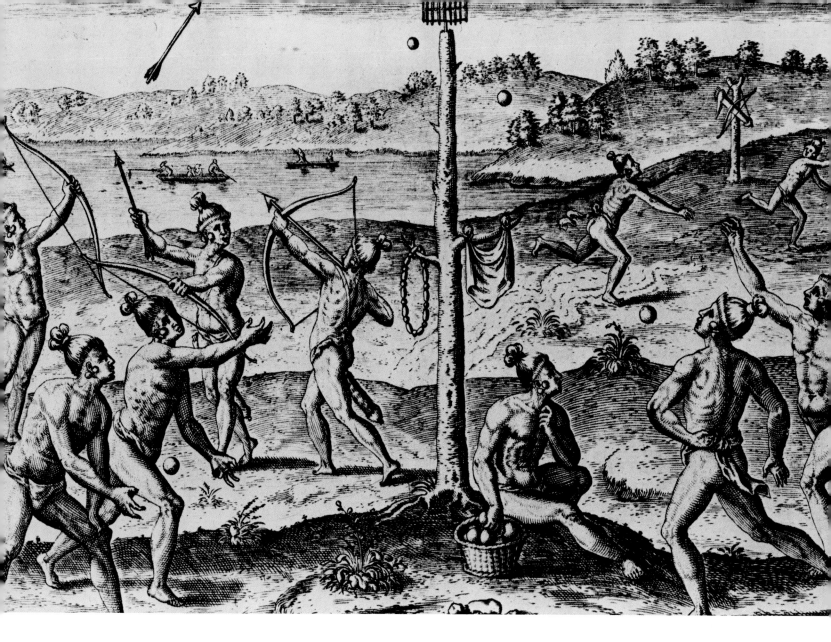

Two early residents of Jamestown, the first permanent English settlement in America, described Indian football in manuscripts that lay unpublished for more than 200 years. Henry Spelman, an adventurous fourteen-year-old who arrived in 1609, was almost immediately traded to the Powhatan Indians in exchange for land, but also for the purpose of learning their language. He spent two years with them, and in *Relation of Virginia* Spelman wrote that "They use beside football play, which women and young boys do much play at. The men never. They make their Goals as ours only they never fight nor pull one another down." William Strachey, who showed up in 1610 following a shipwreck off Bermuda, wrote a substantial and invaluable history of his time in Jamestown. "Likewise," he observed of the Powhatans, "they have the exercise of football, in which they only forcibly encounter with the foot to carry the ball the one from the other, and spurned it to the goal with a kind of dexterity and swift footmanship, which is the honour of it; but they never strike up one another's heels, as we do, not accompting that praiseworthy to purchase a goal by such an advantage." The English were obviously struck by the Indians' sporting civility, which contrasted with its apparent absence in their own game. They did not, however, seem surprised that Indians engaged in a game so similar to their own despite all the other glaring differences between their cultures. It is as if the colonists innately understood that driving a ball across a line was a universal practice and a natural thing to do.

"Exercises of Youth," engraving, by Theodor de Bry, *Brevis Narratio eorum quae in Florida Americae. . .* , **1591.** De Bry created this imagined rendering of Florida Indians at play based on the art of Jacques le Moyne de Morgues, who accompanied a French colonial expedition to America in 1564.

The earliest known published reports about colonial North America that use the English term "football" date back to within a generation of the *Mayflower*'s arrival. In his book *Key Into the Language of America* (1643), Roger Williams, who founded Providence Plantation (in what is now Rhode Island) and befriended the Narragansett, described Indians who "have great meetings of foot-ball playing, only in summer, town against town, upon some broad sandy shore . . ." At about the same time, less than fifty miles east, on Martha's Vineyard, the Aquinnah Wampanoag were also coping with the recent arrival of uninvited English settlers. They, too, traditionally played football on the beach, and at times the games served to resolve tribal conflicts, even to the point of preventing war between communities. As many as a hundred men participated, covered in face and body paint. The playing area extended a mile or more, and on the goal lines—which measured the width of the beach—players and spectators literally placed their bets, setting down personal belongings and valuables. Players advanced the small deerskin ball by kicking, throwing, or carrying it. The first side to move the ball beyond their opponents' goal line won.

Those who find the modern, three-hour-plus professional or college football game an endurance test would be utterly exhausted by the version the Massachusett played. Colonist William Wood, in his classic marketing text, *New England's Prospect* (1634), observed that "Their goals be a mile long . . . sometimes also it is two days before they get a goal; then they mark the ground they win and begin there the next day." What would also be familiar to a modern-day spectator were the game's other essential accoutrements: the band, the cheerleaders, and tailgating. Wood noted that, "While the men play, the boys pipe, and the women dance and sing trophies of their husbands' conquests; all being done, a feast summons their departure." With an attitude that summed up European regard toward New World inhabitants, Wood admired the men's "swift footmanship" yet concluded that one Englishman could "beat ten Indians at football."

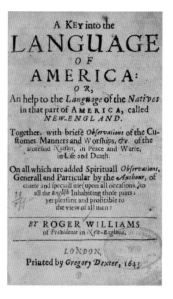

(Above) *A Key Into the Language of America*, by Roger Williams, 1643. Williams provided one of the first published accounts in English of football in America.

(Right) "Unus Americanus ex Virginia," engraving, by Wenceslaus Hollar, 1645. Thought to be the earliest engraved portrait of an American Indian done from life, this image of a twenty-three-year-old Algonquian from Virginia was probably done when the young man was part of a delegation visiting London.

(Far right) Footballs used by the Achomawi of California, left (buckskin, four inches in diameter); the Zuni of New Mexico, center (wool, six inches in diameter); and the Chukchansi of California (stone, four inches in diameter), *Games of the North American Indians*, by Stewart Culin, the U.S. Bureau of American Ethnology, 1907.

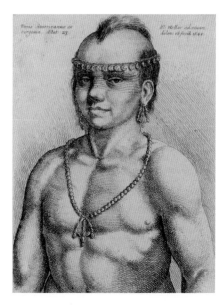

Meanwhile, for the English newcomers to America, the football they were accustomed to playing usually lived up to its other name, "mob ball," as participants clamored for control of the bounding object. Since the Middle Ages, the game was associated with fairs and festivals, when large numbers of men turned out to compete on an epic scale. The playing area was often in the streets, or it could extend across the fields from one village to another. Whatever its dangers (and there were many), football was simple, requiring minimal equipment—a

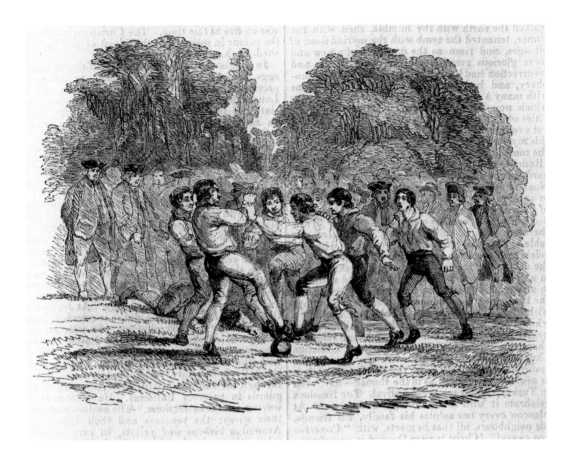

ball, typically made from an inflated animal bladder, often encased in leather, was all that was needed. Game particulars naturally varied from place to place, though generally there were few rules. Much of football's appeal was in its tremendous versatility—it was played any way one wanted, using any number of players, on almost any terrain. Play could consist of simply kicking a ball around among several participants, or, like soccer, would involve kicking the ball to a designated object or across a makeshift goal line. Many neighborhood versions allowed the ball to be thrown, caught, or carried as well. Thus, "football" was a general term used for a variety of games until much later in the nineteenth century, when specific styles of play (e.g., soccer, rugby, American football) began adopting formal rules.

But as far as social critic Phillip Stubbes was concerned, any form of football was repugnant. In his best-selling survey of England entitled *The Anatomie of Abuses* (1583), he found "football playing . . . a bloody and murdering practice . . . sometimes their necks are broken . . . sometimes their noses gush out with blood . . . And hereof groweth . . . malice, rancor . . . hatred, displeasure, enmity, and what not else?" Colonial Puritans in America— more zealous in their piety than their brethren in the mother country—disapproved of fellow settlers playing ball for other reasons as well. Besides being loud, a social nuisance, and a complete waste of time, football encouraged gambling; even worse, games were usually played on Sunday, in blatant disregard of Scripture.

Upper-class colonial elites of any religious persuasion tended to dismiss football as coarse and rowdy. The game belonged primarily to ordinary citizens, soldiers, and children. Boston's *Weekly Rehearsal* remarked in 1735 that "The Common People will endure long and hard Labours insomuch that after twelve Hours hard Work, they will go in the Evening to Foot-ball, Stool-ball, Cricket . . . or some such like vehement Exercise for the Recreation."

Holidays for the People—Easter Monday, by William Howitt, 1754. In his description of eighteenth-century football, Edward Duncan, writing in 1846, noted that after Easter services in England, priests "threw up a ball in the church, and there was a regular game . . . the very archbishops or bishops, if present . . . engaged in the sport with their clergy. This, no doubt, originated in the egg, which used to be tossed about, and played with as a ball." In Europe and parts of America, Easter Monday was devoted to sports and entertainment, including various forms of football.

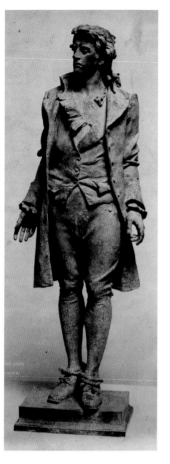

In time, steadily growing towns instituted measures to maintain public order, which football was particularly well suited to threaten. As early as 1655, Boston banned football-playing in the streets. His Majesty's Court of General Sessions of the Peace, in Salem, Massachusetts, took action in 1762 when it banned several games in public areas, including the "playing or kicking of Foot-Ball . . . under a Penalty of One Shilling and Six Pence." Among the youngsters playing football in the colonial era were John Adams and others who would later rebel against that same Majesty—George III—over more serious matters. Thomas Jefferson, however, was not among them. In a letter to a nephew, he wrote: "Games played with the ball, and others of that nature, are too violent for the body, and stamp no character on the mind." Meanwhile, if British imposition of the Sugar Act, Stamp Act, and Townsend Acts in the 1760s was not enraging enough to Bostonians, interfering with children's play did nothing to ease political tensions. In 1769, the King's attorney prosecuted several boys who, in playing football near the royal governor's residence, had knocked over a sentry box. The *Boston Evening Post* feared that the supposed "heinousness of the offense" would be used "as another proof of the necessity of regular troops, to keep the inhabitants in order."

When war broke out between Britain and American patriots in 1775, some in the colonies, which had long complained that they were the "political football" of European powers, found relaxation with actual footballs. Elihu Clark Jr., of the 2nd Connecticut Regiment, encamped at Roxbury, near Boston, noted in his journal playing football on several occasions in the weeks leading up to the Battle of Bunker Hill, even surrendering "2 punchboles" to his victorious opponents. Nathan Hale, serving with the 7th Connecticut Regiment, recorded in his diary the day's events for November 8, 1775: "Cleaned my gun—played some football and some checkers." After the British executed Hale for espionage in September 1776, Lt. Elisha Bostwick warmly recalled the twenty-one-year-old martyred patriot: ". . . his bodily agility was remarkable . . . I have seen him follow a football & kick it over the tops of the trees in the Bowery at New York . . ." Elsewhere, on the home front, Abigail Adams, busy managing the family farm, was not entirely satisfied with the American war effort in August 1777. In a letter to her husband, John, away with the Continental Congress, she wrote: "Our Militia are chiefly raised, and will I hope be marched immediately. There has been a most shamefull neglect some where. This continent has paid thousands to officers and Men who have been loitering about playing foot-Ball and nine pins, and doing their own private business whilst they ought to have been defending our forts and we are now suffering for the neglect."

Winning independence from the British, however, did not deter local tyrants who would interfere with football. The war officially ended with the Treaty of Paris in September 1783, and in November, the Charleston, South Carolina, city council outlawed "sports or pastimes"—including bear-baiting and football—on Sundays, punishable by a five-pound fine. Football participation also remained a sign of one's social status. William Bentley, Harvard class of 1777, a renowned scholar and popular minister, wrote in his diary in 1791:

"Before winter comes on the Foot Ball, which is differently pursued in different places. In Marblehead, even heads of families engage in it, & all the fishermen while at home in this season. The bruising of shins has rendered it rather disgraceful to those of better education." He also pointed out that football "is unfriendly to clothes, as well as safety." In the coming century, though, students at his alma mater would see to it that football became a game for gentlemen.

Child's Play

I beg leave to call the attention of our Police to the very unpleasant and improper custom, which our boys have, of kicking a football in the streets. Upon what social contract these "Rights of Boys" are founded, I never could understand. I see none such recognized in the Palladium of our liberties, the Declaration of Independence. —A. B., letter to the editor, *The Repertory*, December 4, 1804

As a variety of early nineteenth-century children's books attest, football had its place in young America's sporting canon. Many of these early texts were first published in London, such as *The Book of Games, or, A History on Juvenile Sports Practised at the Kingston Academy* (1805), which was reprinted in Philadelphia in 1821 and in New York the following year. From the 1830s on, many books were in agreement that football should be played on a one-hundred-yard field flanked by goal lines or goals, whose design was not always specified. The rules of the game were also rarely spelled out. Whereas trap-ball, cricket, and other games had more specific formats, football was still very much a free-for-all, suit-yourself endeavor.

In addition to fashioning their own rules, youngsters also had to construct their own footballs. According to Robin Carver's *Book of Sports* (1834), country boys would "sometimes use a blown bladder, without the covering of leather, for a foot-ball; and they often put peas and horse-beans inside, which occasion a rattling as it is kicked about." Another form of ball acquisition, practiced in England and some American locales, involved a quaint but curious postnuptial custom. As the *Philadelphia Repository and Weekly Register* reported in 1805, "At present, a party always attends here at the church gates, after a wedding, to demand of the bridegroom money for a football: this claim admits of no refusal."

The ongoing debate on football's merits is reflected in *Remarks on Children's Play* (1818), which cautioned youngsters to take care when kicking the ball and suggested that "there are many kinds of play more suitable than foot-ball." Perhaps, but, historically, this argument has never won over its intended audience. For many children, no other game was as fun or as exciting as football, and that would always be the challenge, not just in the nineteenth century, for those wishing to steer youth toward other recreational and athletic pursuits.

"Foot Ball" from *The Book of Games, or, A History of Juvenile Sports Practised at the Kingston Academy*, printed and published by George Long, New York, 1822. In this American edition of an earlier British work, the narrative follows academy student George Benson, who comes to possess a football after friends "contrived to send it through the dining-room window, so their mother thinks it not a proper toy for them." Children's game books in this period often described both the game itself (sometimes in text that rhymed) and the moral lessons one should derive from recreation.

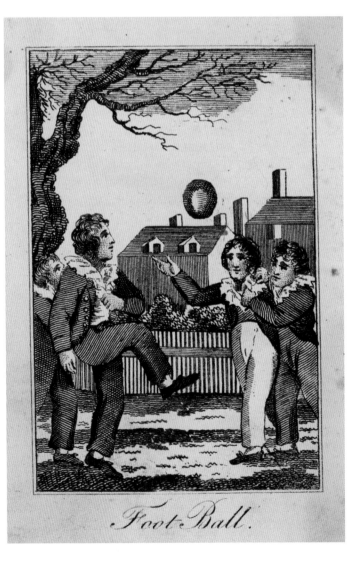

Foot-Ball.

Ancestors and Cousins—Early Football

Some men wolde saye, that in medios crites, whyche I haue too muche prayred in moo tyng, why shoulde not boulynge, clap the pynnes, and koyeyng, be as muche commen ded: Uerily as for two the laste be to be v: teely abiected of al noble men in lyke wyse foote balle, wherin is nothyng but beastelye Eurp, and extreme violence, wherof proceedeth hurte, and consequentlp rancoue and malice Doe remayne with them that be wounded, wherfoze it is to be put in perpetual silence.

For a millennium, football has been played in various forms, and in the twenty-first century some member of the football family is the most popular sport in almost every country in the world. The earliest known record of "football" (Latinized as "*lusum pilae*") appears in William Fitzstephen's twelfth-century history of London. Towns throughout Europe developed distinctive versions of the game for intra-village competition. In 1314 the Lord Mayor of London issued a decree on behalf of King Edward II banning the disruptive game of football, but play continued. For the next 300 years, at least thirty local and royal edicts forbade the sport in Great Britain, citing adverse effects on society and interference with military training.

In the early nineteenth century, when these village mob ball games became an accepted part of the physical curriculum in British public schools, each school established its own rules for intramural contests. Competition between schools led to some standardization of rules. Thus, football was exported in different forms to other countries. However, countries that were still loyal to the British crown had less impetus

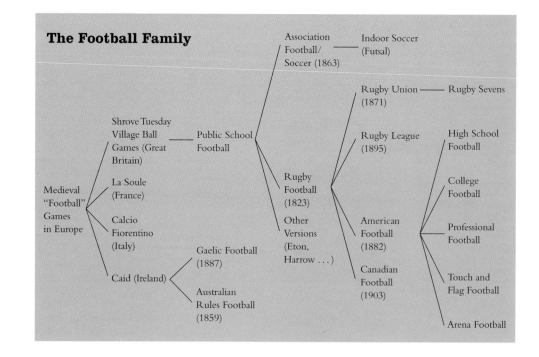

The Football Family

Major Football Leagues

	National Football League	Canadian Football League	Association Football/ Soccer
Year Formed	1920	1958	1863
Object of Game	Score touchdowns by carrying ball into opponent's end zone or kick field goals through posts	Score touchdowns by carrying ball into opponent's end zone or kick field goals through posts	Score goals by kicking ball into opponent's net
Major Skills Required	Passing, catching, running, blocking, tackling, kicking	Passing, catching, running, blocking, tackling, kicking	Kicking, dribbling, striking (no hands)
Predominant Countries	United States	Canada	Worldwide
Major Championship	Super Bowl (annual)	Grey Cup (annual)	FIFA World Cup (every quadrennial)
Players per Team	11	12	11
Field	100 yards long by 53.3 yards wide	110 yards long by 65 yards wide	100–130 yards long by 50–100 yards wide
Ball	Prolate spheroid with pointed ends, brown, 11 inches long	Prolate spheroid with pointed ends, brown, 11 inches long	Sphere, white, 8.5–9 inches in diameter
Time of Match	15-minute quarters	15-minute quarters	45-minute halves

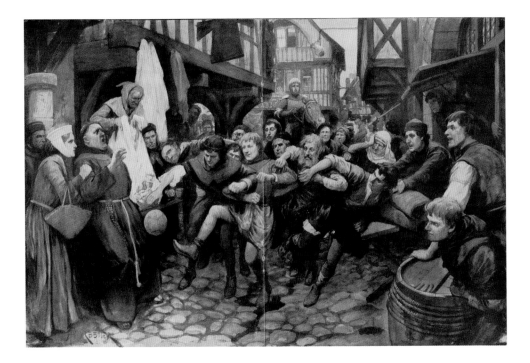

to create a uniquely native version. As a result, football in Canada remained more faithful to its rugby roots. Yet Canada would ultimately borrow from the United States to establish its own football identity; in particular, the "snapback" used in American football replaced the rugby "scrum" in 1882, and in 1931, the Canadian Rugby Union adopted the forward pass that had been instituted in American football twenty-five years earlier. Notably, American and Canadian football are the only two versions that allow players to throw the ball forward.

At the 1932 Summer Olympics in Los Angeles, the United States shared its brand of football with the world as a demonstration sport. One German athlete declared, "Nobody in Germany would go out to see this. Not enough action." He would have been surprised to learn that in 2011, nearly one million people in Germany watched the Super Bowl live in the middle of the night.

—Jonathan Horowitz

Rugby Football Union	Australian Football League	Gaelic Football
1871	1858	1887
Score tries by touching ball down in opponent's goal area or kick ball through posts	Score goals by kicking ball between goalposts	Score goals by kicking ball into net or points by kicking or fisting ball over crossbar
Running, passing (only backward), kicking, tackling	Kicking, running, dribbling (with hands), tackling	Running, dribbling (with hands), kicking
Great Britain, New Zealand, South Africa	Australia	Ireland
Rugby World Cup (every quadrennial)	AFL Grand Final (annual)	All-Ireland Senior Championship (annual)
15	18	15
110 yards long by 77 yards wide	Ellipse 148–202 yards long by 120–170 yards wide	142–159 yards long by 87–98 yards wide
Prolate sheroid with rounded ends, white, 11–12 inches long	Prolate sheroid with rounded ends, red (day) or yellow (night), 10.5–11 inches long	Sphere, white, 10 inches in diameter
40-minute halves	20-minute quarters	35-minute halves

(Opposite, inset) Detail of text from *The Boke Named the Governour*, by Sir Thomas Elyot, London, 1557 edition. Originally published in 1531 and dedicated to King Henry VIII, Sir Elyot's educational treatise regards "foote balle" as a beastly, violent activity that "produceth hurte" and ought to be discontinued, left in "perpetual silence."

(Above) "The Early Days of Football: The Game a London Street Nuisance Under Edward II," by A. Forestier, *Illustrated London News*, 1905. This depiction of a lively game in the early fourteenth century shows a style of play that remained little changed over the next 500 years in England and colonial America, and suggests why Edward II saw fit to ban the sport in 1314.

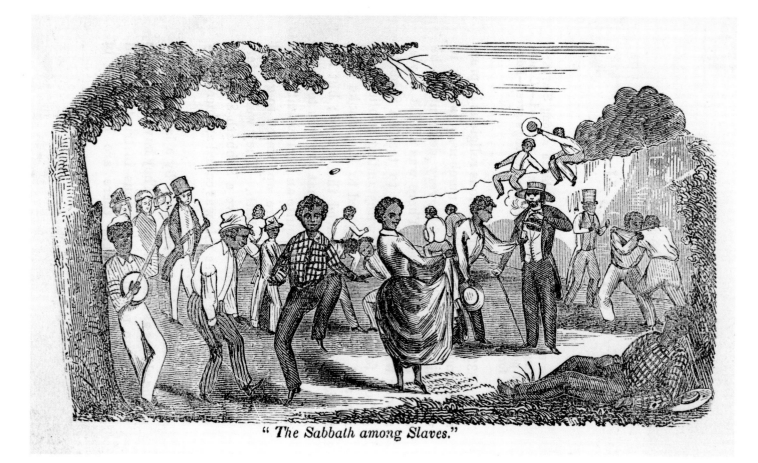

"*The Sabbath among Slaves.*"

"The Sabbath Among Slaves,"
from *Narrative of the Life and*
Adventures of Henry Bibb, an
American Slave, **New York, 1849.**
Most slaves were given time
off on Sundays, and recreation
might include a game of football,
especially among youngsters.
For some, though, that was not
an option. "As a boy I played
marbles, but not ball," said John
Gilstrap, enslaved on a plantation
outside Fulton, Mississippi. To him,
reminiscing in the 1930s, "Ball
playing is a new game."

But what was suitable for participants was one thing, quite another when it came to property and involuntary spectators. The *New-Hampshire Statesman and State Journal* covered an especially spectacular incident in 1836 when youngsters retaliated against a crockery-store owner who habitually confiscated their stray footballs and tossed them into his stove: "A horrible explosion took place—the stove was blown 'sky high,' the store shattered by the shock—and about $40 worth of crockery was dashed in pieces. It is unnecessary to add, that the urchins . . . had charged their football with gunpowder, by way of a *practical* hint to the old fellow to let them alone in future." Even out west, with its wide-open spaces and sparsely settled territories, footballs found their unsuspecting targets. The *Owyhee Avalanche*, in Silver City, Idaho, reported in 1874 that "Football has been the sensation of the town this week. We contributed 50 cents towards buying a ball for the boys and had the satisfaction of seeing it smash one of the windows in our office last Wednesday evening—thus getting our money back sooner than we expected."

Among the enslaved population, the opportunities to play ball and other games varied and generally depended on the disposition of slave owners. In his autobiography, Frederick Douglass described the "Holiday Times" between Christmas and New Year's Day, when slaves were given time off, noting that "the majority spent the holidays in sports, ball-playing, wrestling, boxing, running, footraces . . ." Former slaves interviewed late in life for the Federal Writers' Project recalled the little recreation available to them in their youth. Mingo White, a slave in Alabama and South Carolina, had a typical childhood in bondage: "The only games that I played when I was young was marbles and ball." Booker T. Washington, raised in slavery on a Virginia plantation before working in coal mines to pay for his schooling, mentioned in *Up from Slavery* (1901) that "I have never seen a game of football . . . I suppose I would care for games now if I had had any time in youth to give them, but that was not possible."

On the College Green

Were it spring or autumn you should see a brave set-to at football on the green, or a brisk game of wicket. —Ezekiel P. Belden, *Sketches of Yale College*, 1843

Football's route from its humble, disparate existence to uniformity and organized competition followed the increasingly trafficked path from village field and town common to the academy quadrangle. As the game evolved throughout the nineteenth century, gentlemen, rather than common folk, first participated in *organized* football. The well-to-do or adequately provisioned young men enrolled in the growing number of colleges and preparatory schools in the northeastern United States—where the distinctive brand of American football would first emerge and flourish—filled their autumn and springtime afternoons with football and baseball. It was these students, collegially and collegiately bound, with free time on their hands and campus turf beneath their feet, who would eventually transform football from a neighborhood recreation to a national obsession. As of 1818, West Point cadets are known to have played "at football" in an area safely removed from their barracks. As early as 1820, Princeton students were playing a game called "ballown" (teams had 25 players each, the rules permitted catching a kicked ball but not carrying it, and the first team to score six goals won). Oliver Wendell Holmes Sr., after an illustrious career as a physician and author, recalled that in 1824, during his year at Phillips Academy, in Andover, Massachusetts, "a rudimentary form of base-ball and the heroic sport of foot-ball were followed with some spirit."

Harvard's "Bloody Monday" tradition, dating back to at least 1827, suggests the sanguinary nature of the annual football game between the freshman and sophomore classes. Henry Winthrop Sargent, a student in the 1830s, vouched for its apt appellation, recalling that

"A View of the Building of Yale College at New Haven," lithograph, by A. B. Doolittle, 1807. A student game of football on the New Haven Green, across from the Old Brick Row, draws a pair of spectators to a fence on the sidelines.

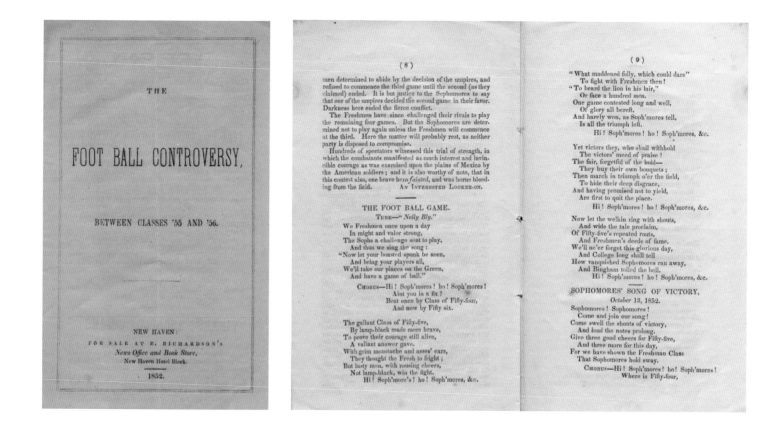

THE

FOOT BALL CONTROVERSY,

BETWEEN CLASSES '55 AND '56.

NEW HAVEN:
FOR SALE AT E. RICHARDSON'S
News Office and Book Store,
New Haven Hotel Block.
1852.

(8)

men determined to abide by the decision of the umpires, and refused to commence the third game until the second (as they claimed) ended. It is but justice to the Sophomores to say that one of the umpires decided the second game in their favor. Darkness here ended the fierce conflict.

The Freshmen have since challenged their rivals to play the remaining four games. But the Sophomores are determined not to play again unless the Freshmen will commence at the third. Here the matter will probably rest, as neither party is disposed to compromise.

Hundreds of spectators witnessed this trial of strength, in which the combatants manifested as much interest and invincible courage as was exercised upon the plains of Mexico by the American soldiers; and it is also worthy of note, that in this contest also, one brave hero *fainted*, and was borne bleeding from the field. AN INTERESTED LOOKER-ON.

THE FOOT BALL GAME.
TUNE—" *Nelly Bly.*"

We Freshmen once upon a day
 In might and valor strong,
The Sophs a challenge sent to play,
 And thus we sing the song :
"Now let your boasted spunk be seen,
 And bring your players all,
We'll take our places on the Green,
 And have a game of ball."

CHORUS—Hi ! Soph'mores ! ho ! Soph'mores !
 Aint you in a fix ?
Beat once by Class of Fifty-four,
 And now by Fifty six.

The gallant Class of Fifty-five,
 By lamp-black made more brave,
To prove their courage still alive,
 A valiant answer gave.
With grim moustache and asses' ears,
 They thought the Fresh to fright ;
But lusty men, with rousing cheers,
 Not lamp-black, win the fight.
Hi! Soph'more's ! ho ! Soph'mores, &c.

(9)

"What maddened folly, which could dare"
 To fight with Freshmen then !
" To beard the lion in his lair,"
 Or face a hundred *men*.
One game contested long and well,
 Of glory all bereft,
And barely won, as Soph'mores tell,
 Is all the triumph left.
 Hi ! Soph'mores ! ho ! Soph'mores, &c.

Yet victors they, who shall withhold
 The victors' meed of praise ?
The fair, forgetful of the bold—
 They buy their own bouquets ;
Then march in triumph o'er the field,
 To hide their deep disgrace,
And having promised not to yield,
 Are first to quit the place.
 Hi ! Soph'mores ! ho ! Soph'mores, &c.

Now let the welkin ring with shouts,
 And wide the tale proclaim,
Of Fifty-five's repeated routs,
 And Freshmen's deeds of fame.
We'll ne'er forget this glorious day,
 And College long shall tell
How vanquished Sophomores ran away,
 And Bingham tolled the bell.
 Hi ! Soph'mores ! ho ! Soph'mores, &c.

SOPHOMORES' SONG OF VICTORY,
October 13, 1852.

Sophomores ! Sophomores !
 Come and join our song !
Come swell the shouts of victory,
 And loud the notes prolong.
Give three good cheers for Fifty-five,
 And three more for this day,
For we have shown the Freshman Class
 That Sophomores hold sway.
CHORUS—Hi ! Soph'mores ! ho ! Soph'mores !
 Where is Fifty-four,

The Foot Ball Controversy, Between Classes '55 and '56, booklet, 1852. The 1852 Yale freshman-sophomore football game turned bitter as recounted in this student booklet, which features the lyrics to "The Foot Ball Game," by the freshmen, and the second-year students' "Sophomores' Song of Victory," an exceptionally detailed thirteen-verse ode to themselves.

several days were spent "recovering from the severe ordeal of the football contest." A Bloody Monday veteran, Joseph R. Williams may have been the first American politician whose collegiate football career was cited as an asset for elected office. When running for Congress from the western district of Michigan in 1843, his local newspaper, the *Troy Whig*, praised his speed and kicking ability, prompting the *Albany Argus* to comment that "This is certainly a new point of distinction in the character of a public man, and a qualification so singular." Sadly, if only for the game's credibility as an indicator of political competence, Mr. Williams was defeated.

As at Harvard, Yale also held an annual freshman-sophomore football game (dubbed "the Annual Rush") shortly after the fall term began. Coverage of the 1852 match describes a game in which any player who received or gained control of the ball "has the right to one kick." The *New York Daily Times* correspondent was impressed with a sophomore, "a powerful fellow, who ran several rods with it when he was overtaken by a more athletic Freshman, but succeeded in throwing the ball nearly over the goal." The five-game match ended abruptly in acrimony when the referees initially awarded the second game to the sophomores, then revoked their decision. The ensuing controversy resulted in the publication of a twelve-page booklet documenting the event and its fallout, including reprints of letters in local newspapers and class-song lyrics about the contest. Referees, however, were not the only ones to hold authoritative powers over game results. The following year, according to Parke H. Davis, a Princeton player, coach, and one of football's early historians, the game between Yale freshmen and sophomores "was declared a tie by the officials, but ladies of New Haven who had watched the conflict from the balconies of the New Haven House, and the steps of the old State House, reversed the verdict by presenting their flowers to the Freshmen."

At midcentury, as the rift widened between North and South over slavery, states' rights, and westward expansion, American colleges—several of them much older than the United

States itself—were forging bonds in their first forays into intercollegiate competition. Sports clubs and intramural athletics had existed for some time, but the first intercollegiate athletic event was not held until 1852, when Yale challenged Harvard to a boat race on Lake Winnipesaukee. Amherst and Williams played the first organized intercollegiate baseball game in 1859 (a contest that was uniquely double-billed with a chess match between the schools). As for college football, it remained an intramural endeavor, but no less a robust one, as described by the London-born, Boston-bred Henry Ropes. The popular Harvard sophomore,

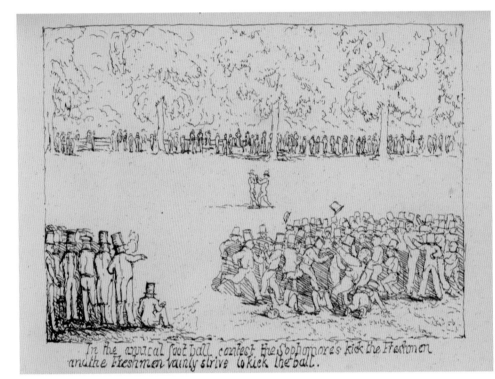

In the annual foot ball contest the Sophomores kick the Freshmen and the Freshmen vainly strive to kick the ball.

an excellent all-around athlete, reported on Bloody Monday in a letter to his brother dated October 1, 1859: "We made the first charge, with Sophomoric confidence, the Freshmen fought well, there was a desperate jam[,] the Freshmen were forced back, we were all in one body, when the ball by some accident was thrown out of the fight unknown to most of us and kicked over our bound by some Freshman assisted by outsiders. You cannot imagine the desperate fury of our men when we learned that we had been defeated."

Fortunately for Ropes, the sophomores rebounded and won two out of three games. The following year, the Harvard faculty upset students when it voted, on July 2, to prohibit the annual Bloody Monday game following reports of hazing and "intolerable abuse" of first-year students. Players responded by holding a torchlit funeral for their sport on September 3, 1860. Yale faculty also banned the game, as did a New Haven city ordinance. A dozen years passed before football returned to Cambridge and New Haven, a period encompassing the Civil War, national reconciliation, and the first intercollegiate football match.

Amid the national turmoil, however, a group of young civilians playing on Boston Common beginning in 1862 proved to be an unwittingly influential teenage outfit, recognized years later as the first organized football team in the United States. Drawn from several private high schools, they called their team the Oneida Football Club, with a nod to a New York lake favored by team founder and captain Gerrit "Gat" Smith Miller and perhaps associating themselves with Indian warrior prowess. According to original team member Winthrop Saltonstall Scudder, their "only distinctive uniform" consisted of a "red silk handkerchief—tied around the head, pirate fashion." In combining their preferred elements of kicking games and rugby to customize their own game (known as the "Boston Game"), the Oneidas employed both field goal kicking and limited ball carrying. The team went undefeated against temporarily assembled opponents and drew a bit of bemused news coverage. Years after the Oneidas left Boston Common far behind, their rules were still in use at many New England schools. The Oneidas' significance would later emerge when several of its former players matriculated to Harvard, where they promoted their hybrid game over Association-style football (soccer).

"In the Annual Foot Ball Contest . . . ," from *College Scenes*, by Nathan Hayward, 1850. Hayward's book, containing thirty-two of his sketches illustrating life at Harvard, includes a depiction of the annual "Bloody Monday" game.

"MANLY EXERCISES": FOOTBALL IN THE CIVIL WAR

They are all well and seem to delight in camp life. Colonel Kennedy preserves strict discipline but is nevertheless pleased that the soldiers should enjoy themselves as much as possible with football and other manly and harmless games. —Report on the Tammany Regiment encamped at Great Neck, New York, *New York Herald*, June 6, 1861

(Below) "Holiday in the Camp of the 23rd Pennsylvania Volunteers, Near Bladensburg," pencil and Chinese white drawing, by Alfred Waud, 1861. Waud's detailed rendering of the Christmas holidays includes scenes of a football game and soldiers chasing after a greased pig.

(Opposite, top left) "Holiday in Camp, Soldiers Playing Football" wood engraving after Winslow Homer, *Harper's Weekly*, July 15, 1865. Officers welcomed recreational games during downtime, and many were partial to football themselves. Among them was Confederate Lt. Gen. James Longstreet, who later recalled that at West Point, he had more interest in "the outside game of football than in the academic courses." (Indeed. He graduated third from the bottom of his class in 1842.) At the Battle of Gettysburg, the former footballer commanded the assault known as Pickett's Charge.

Before the Civil War left more than 600,000 servicemen dead and much of the South in ruins, and before it was determined whether the unique American experiment in representative democracy would survive, the first months of the conflict between the Union and Confederacy were spent training and mobilizing newly formed military forces. Beyond the small existing cadre of American military professionals, North and South were in need of ordinary citizens to form their armies. Most were young white men, with an average age of twenty-five upon enlistment; most were farmers or laborers; and about a quarter of them were foreign born. Most also brought with them a craving, if not the equipment, for competition, and military officials attempted to accommodate them.

Soon after the war began, a Union soldier wrote to the *Boston Investigator* begging the kindhearted folks donating books to the troops to please stop sending Bibles and religious tracts—they had received plenty of those and wanted something more entertaining. As it was, he explained, "The pipe, cards and football are our amusements for the present, each good in their places." As if in response, that fall fifty U.S. Navy vessels left Fort Monroe, the Union bastion of the Virginia coast, packed with supplies, including several hundred footballs. Confederate troops were equally in need of "manly exercises," as the *Charleston Mercury* pointed out in an April 1862 editorial: "Every volunteer who has been in service has realized the tedium of camp life . . . Cricket and base ball bats are also wanted, and a few dozen substantial foot balls would, we are sure, find ready sale."

In a letter to the *Daily True Delta* in October 1861, a Southern correspondent at Camp Jackson, Arkansas, already upset that *Harper's Weekly* illustrated Confederate troops as Bowie-knife-wielding backwoodsmen, gleefully recounted "the most animated game of foot-ball I ever beheld . . . Really it was a magnificent sight. The Louisianans playing football! Let Mr. Harper

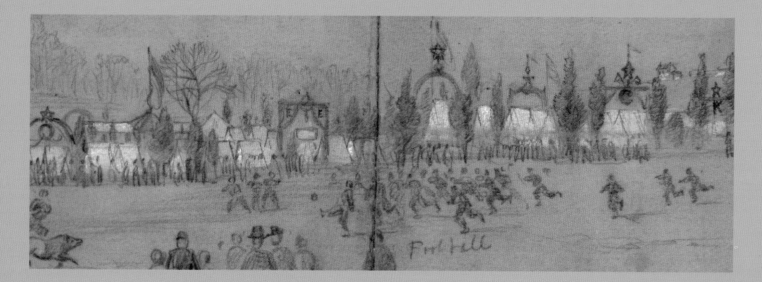

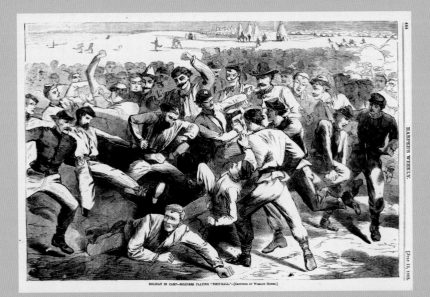

HOLIDAY IN CAMP—SOLDIERS PLAYING "FOOT-BALL."—[SKETCHED BY WINSLOW HOMER.]

A bad **HEAD** but a good **FOOT** ball.
"Keep the ball a-rolling."

send down his artist and we will give him a scene to paint he never dreamed of . . . 'Dusky eve' had closed 'round the excited gamesters and a hard 'fought' game had ended. Says a lieutenant, 'Captain, shall we have another game?' 'Yes, yes,' says Gilmore, 'they outnumber us but we can beat them.' The game was played, and Gilmore won. The opposite side said, 'We will close for the night, boys, but continue the game to-morrow. Mr. Harper, smoke that.' For the present, adieu. P.S. . . . We move to-morrow or next day. Clothing was distributed yesterday. The sick and wounded are going home to-day. The game of foot-ball still goes on. More anon."

As the war progressed, fewer men escaped battle fatigue, gruesome wounds, or disease, but those who were healthy, particularly troops on occupation duty or awaiting their next orders, still participated in games. Football was also a pastime in prisoner-of-war camps. From Fort Warren, near Boston Harbor, came a report that "while the [Confederate] prisoners were engaged in kick foot-ball, one of them ran across the guard after the ball. He was ordered to halt, but took no notice of the order and kept on. The guard charged on him, pricking him slightly, and the prisoner exclaimed: 'You [damned] Yankee, I'll put a ball through your heart.' He was reported to the officer of the day and immediately placed under arrest." The conditions in the notorious Libby Prison in Richmond, Virginia, were so appalling by early 1864 that even the *Richmond Enquirer*, a strong supporter of Confederate president Jefferson Davis, was driven to sympathy for the Union soldiers crowded within: "The passerby may hear now and then of a morning the most demoniacal shouts proceeding from the gloomy interior of [the kitchen], and might readily be led to believe that a serious set-to at fisticuffs was in progress. He would soon discover, however, that it was only a desperate effort at a game of football."

The fratricidal nature of the Civil War unfolded repeatedly on battlefields not far removed, in time or geography, from the playing fields of its combatants. During the Battle of Kenesaw Mountain, in Georgia, in the summer of 1864, the 21st Kentucky Infantry, fighting for the North, tangled with the 7th Kentucky Infantry, which fought for the South. As recorded in their unit history, members of the 96th Regiment Illinois Volunteer Infantry witnessed what happened next, when their Kentucky allies captured Kentuckians serving with the Confederacy. The guards and their prisoners engaged in animated conversation, discussing mutual acquaintances, prompting an Illinois man to remark, "'You seem to know some of these fellows.' 'Know them?' was the reply. 'Yes, every one of them. I used to play foot-ball with them in Lexington. Got my own brother here.' 'You didn't get me until I gave you 200 rounds of cartridges today, anyhow!' was the reply of the captured brother. Thus they talked as they passed to the rear. And this was civil war—neighbor fighting against neighbor, brother against brother."

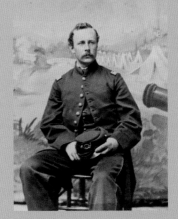

(Top right) Portion of an illustrated envelope depicting the head of Confederate President Jefferson Davis in use as a football, ca. 1862.

(Above) First Lieutenant Henry Ropes, Union Army, carte de visite, 1863. Ropes, Harvard class of 1862, was a leading player the last year football was permitted on campus. On July 2, 1863, exactly three years to the day that football was abolished at Harvard, Lt. Ropes and the 20th Massachusetts Infantry staked out a position in the line of battle at Gettysburg where a memorial to the unit now stands. The next day Ropes was killed by friendly fire as Union artillery responded to Pickett's Charge.

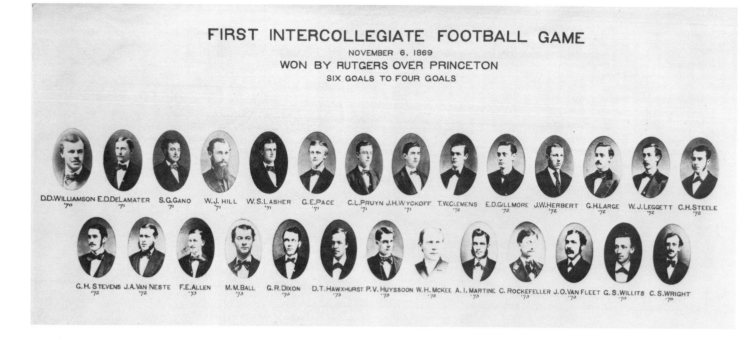

FIRST INTERCOLLEGIATE FOOTBALL GAME

NOVEMBER 6, 1869

WON BY RUTGERS OVER PRINCETON

SIX GOALS TO FOUR GOALS

D.D.WILLIAMSON '70 E.D.DeLAMATER '71 S.G.GANO '71 W.J. HILL '71 W.S.LASHER '71 G.E.PACE '71 C.L.PRUYN '71 J.H.WYCKOFF '71 T.W.CLEMENS '72 E.D.GILLMORE '72 J.W.HERBERT '72 G.H.LARGE '72 W.J.LEGGETT '72 C.H.STEELE '72

G.H. STEVENS '72 J.A.VAN NESTE '72 F.E.ALLEN '73 M.M.BALL '73 G.R.DIXON '73 D.T.HAWXHURST '73 P.V. HUYSSOON '73 W.H.MCKEE '73 A. I. MARTINE '73 C. ROCKEFELLER '73 J.O.VAN FLEET '73 G.S.WILLITS '73 C.S.WRIGHT '73

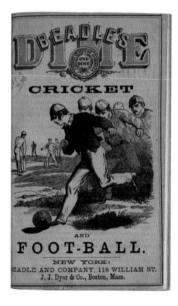

Formation of the Oneida Football Team on the field

○

○ ○ = *Rushers in*

○ ○ ○ ○ = *Infielders*

○ ○ ○ ○ ○ ○ ○ ○ = *Outfielders*

○ = *Tender Out (Full Back)*

(Top) "First Intercollegiate Football Game, November 6, 1869." A series of Rutgers player portraits commemorates the winning team that participated in the landmark game against Princeton.

(Above) *Beadle's Dime Book on Cricket and Foot Ball* **(1866).** Edited by Henry Chadwick (1824–1908), a transplanted Englishman and America's first sportswriter, this dime book contains the first set of football rules published in the United States. The game described here is essentially Association football (soccer); many schools modified the rules to suit their own preferences and circumstances.

While the Oneidas cobbled together a game from loose parts, British sportsmen were unsatisfactorily beta testing a standardized game that combined the best features of rugby and other football games. The effort ultimately failed, and in 1863, Association football rules were codified; eight years later, standard rules for rugby union football were approved. Thus, soccer and rugby continued to develop separately, becoming Britain's two most successful football games and, along with the English language, among its most widely and frequently practiced exports. In the United States, however, no particular form of football was especially dominant. Among American schools, some preferred a kicking game, others a running game, and many customized rules that took into account the architectural and topographical peculiarities of a particular playing area.

There was, then, no standard brand of college football when Princeton met Rutgers at College Field in New Brunswick, New Jersey, on November 6, 1869, in what is considered the country's first intercollegiate football match. With 25 men to a side, the game was played

primarily under Rutgers's rules. According to the *Rutgers Targum*, "The style of playing differs materially in the two colleges . . . We bat with hands, feet, head, sideways, backwards, any way to get the ball along. We must say that we think our style much more exciting and more as football should be." Spectators, some of whom had traveled with the Princeton squad, perched atop fences, nestled on the ground, or stood on the sidelines, an inconvenience made up for by the lack of an admission charge. The Princetonians were hailed as "tall and muscular," while the home team was described as "small and light." The latter must also have been scrappy and skilled, as Rutgers prevailed, 6-4. But when the two teams met the following week at Princeton using the host's rules, which emphasized a long-ball game, free catches, and free kicks, the Princetonians claimed victory, 8-0.

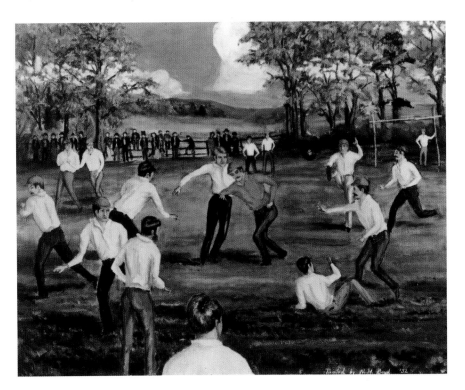

Organizers and Egg-Shaped Balls

This has been without exception the happiest Fourth I ever spent in my life and I wish myself many more of such . . . We wanted Pa and Ed to come and learn how to play croquet, but they began to play football with the balls and cut up so that we couldn't do a thing with them. —Annie L. Youmans, age twenty, Yonkers, New York, describing July 4, 1869

Although football generated interest among college men and schoolboys, the absence of widely accepted rules hampered the possibility of any meaningful competition. The English author Thomas Hughes (*Tom Brown's School Days*) experienced the situation firsthand in 1871. A member of Parliament and a graduate of Rugby, where its namesake sport developed, Hughes visited Ithaca, New York, and joined Cornell students in a football game. In an account written with a colleague, Hughes noted the popularity of baseball on campus and the haphazard state of football:

All who cared to play collected into two irregular crowds, unorganized and leaderless, and stood facing one another . . . Then a big, oddly-shaped ball arrived, somebody started it with a kick-off, and away went both sides in chase, wildly jostling one another, kicking, catching, throwing, or hitting the ball, according to fancy, all thoughts more bent, seemingly, upon the pure delight of the struggle than upon any particular goal. 'Are there any goals, and, if so, where?' we asked, toiling after the ball, which appeared to be visiting all sides of the field with strict impartiality and equal satisfaction to the players. 'O yes, anywhere between those trees,'—two great elms, standing perhaps thirty feet apart . . .

A helpful step forward in football's march to sporting legitimacy occurred on April 21, 1872, when Harvard students resurrected football using the Boston Game rules. Robert Grant, who played that day, later remarked that "One of the salient features of the game was the rule that a player could run with the ball only when chased, and he must stop as soon as pursuit ceased. Dribbling was forbidden. The ball was kicked a great deal, and there was much running and dodging." Yale students soon revived football as well, playing Association-style

(Opposite, bottom right) "Formation of the Oneida Football Team on the Field," by Gerrit Smith Miller. Miller's diagram of a Christmas-tree-like formation indicates player positions "where they would be most likely to catch or meet the ball when kicked off by our opponents, in order that we might return it without delay toward their goal." The illustration appears in *An Historical Sketch of the Oneida Football Club of Boston, 1862–1865* (1926), a manuscript produced by Miller's teammate Winthrop Saltonstall Scudder in support of the team's claim to being the country's first organized football club.

(Above) Rutgers-Princeton football game, 1869. In a painting created shortly after the contest, Rutgers men, in caps, surround a Princeton player. The small size of the ball, which worked in Rutgers's favor, was a matter of pre-game contention.

with twenty players to a side. Even at Vassar College, then a women's school, students briefly took up football among themselves. In 1874, a wiseacre commented that "many a young man thereabouts wishes he were a football, especially as the girls sometimes miss the ball and land on their heads in the grass. It must be an inspiring sight, too, to see the girls engaged in this important area of study, and if they were to charge fifty cents admission, the gate money would be more than enough to pay for their education."

With the advent of occasional intercollegiate play and recent codification of rules for other sports, it was clearly the right time for American football to reach a new level of maturity—the acceptance of standard rules. Just what those rules should be, however, was problematic. In October 1873, delegates from Princeton, Rutgers, and Yale emerged from the Fifth Avenue Hotel in New York City with a set of agreed-upon rules; among them, the football could not be carried or thrown. Harvard had graciously declined to attend the meeting, explaining that its brand of football, the Boston Game, was completely incompatible with other styles of play. That spring, with no one in the area to compete against, Harvard entertained Montreal's McGill University in Cambridge for a two-match contest: The Crimson easily won the first, played under the Boston rules; the second, using McGill's rugby rules, ended in a scoreless tie. Despite its dominance, Harvard was immediately impressed with McGill's brand of play and their "egg-shaped" ball, which was much easier to carry than a round one. McGill also introduced their hosts to the "try" (which would eventually be known as a touchdown), in which players crossing their opponents' goal line touched the ball down on the ground and were then eligible to try kicking a goal. In time, the value of the touchdown was increased, and fewer points were awarded for the kicked goal, known in American football as the "point after touchdown" (PAT), extra point, or conversion.

Harvard happily touted McGill's version of the game, which other schools soon welcomed in part because no one—except routinely victorious Princeton—was entirely pleased with the 1873 rules, and the rugby-style game possessed greater appeal. In the first Harvard-Yale football game (1875), held in Hamilton Park, New Haven, the teams used what came to be called the Concessionary Rules; i.e., rugby rules with certain changes that Yale requested. Princeton, strongly divided over which game format to pursue, eventually accepted that the Concessionary Rules were the best route toward uniting other colleges under one uniform code of play. Thus, at Princeton's invitation, delegates from Columbia, Harvard, and Yale met at Massasoit House in Springfield, Massachusetts, on November 23, 1876, and produced a new football code, based on rugby rules but containing various agreed-upon modifications. For the next two decades, the teams operated as part of the Intercollegiate Football Association, something of a loose forerunner to the Ivy League. (Ivy League schools, which had actual ivy on their walls by the late nineteenth century, were not referred to as such until the 1930s, when the name, coined by a sportswriter, arose in connection with football competition.)

As the United States celebrated its Centennial (in New Orleans, the elaborate Fourth of July festivities included "a unique football match" and "three barrels of lager beer" for the winning team), 1876 also marked two events that would indelibly shape American sports and culture. Baseball team owners created the National League, which would become the country's oldest continuously operating sports league. Its immediate and long-term effects can hardly be overestimated. The National League sharpened city and team rivalries, enhanced local identity and pride, and introduced Americans to what were then revolutionary concepts: undisguised team sport professionalism, regularly scheduled team competition, and important games as *events*, the sort of thing one slipped out of work to

attend. Just as important, the National League meant that for the first time Americans could follow a team sport on a national scale.

It was also in 1876 that seventeen-year-old freshman Walter Camp (see page 34) joined the Yale football team. His impact as a player and coach was such that his legacy as an architect of the modern game endures. A presence at every major football meeting from 1878 to 1925, Camp authored fundamental and critical innovations in the game's rule book, devised groundbreaking player training regimens, wrote authoritative commentary unmatched in its effect on first-generation coaches and their heirs, and successfully promoted the game through his numerous publications and All-American player designations. Although Camp acquired the title "Father of American Football" early in his career, the game was not without its doting uncles, including his protégé, Amos Alonzo Stagg, as well as John Heisman, Glenn "Pop" Warner, and Fielding Yost, whose innovations and longevity further shaped the sport.

Throughout the late 1870s, intercollegiate football remained a modified form of rugby, but in the early 1880s, several critical breaks from the game gave American football its unique appearance and its own strategic possibilities. Camp's "line of scrimmage" and reduction of players to eleven on a side were the most visible changes. In rugby, the "scrummage" was a method for putting the ball in play: Teams gathered in a circular scrum formation, arms interlocked, and battled for possession of the ball. When one side obtained the ball, it could then initiate an offensive charge. Unless a team repeatedly won the ball to launch its next play, its offense operated in fits and starts. To create a more fluid game, Camp proposed that

McGill vs. Harvard, Jarvis Field, Cambridge, Massachusetts, May 15, 1874. McGill lost to Harvard on the field but won over the Crimson with its rugby version of football and its ergonomic, egg-shaped ball.

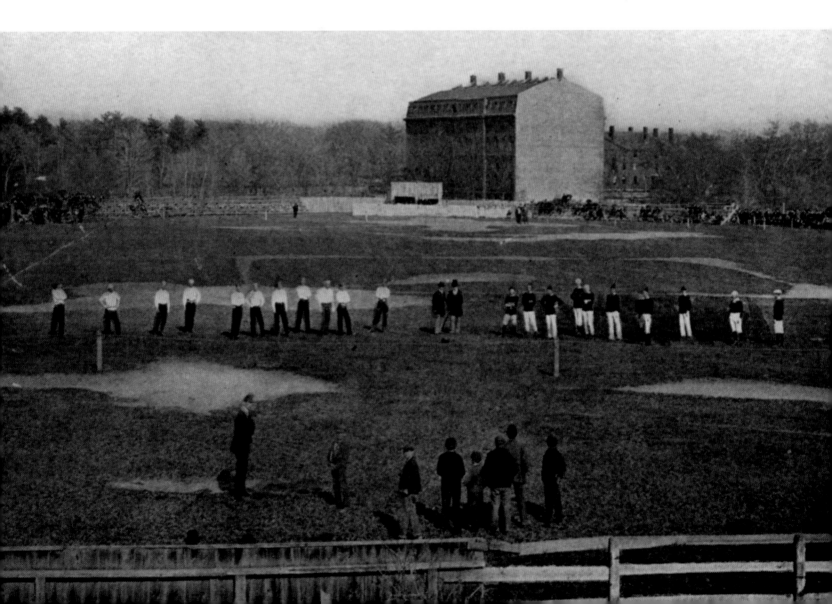

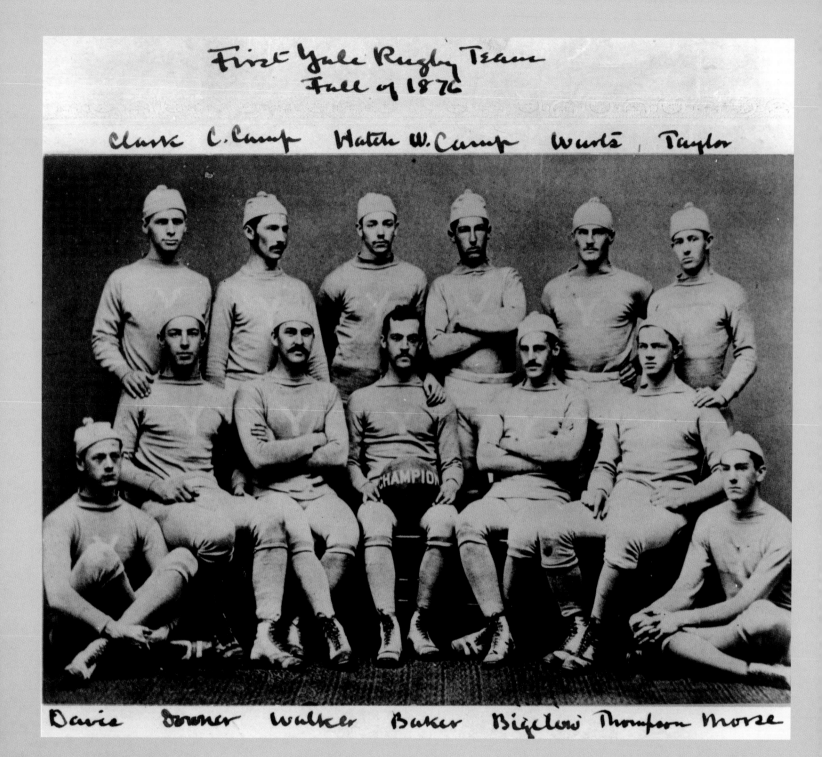

First Yale Rugby Team Fall of 1876

Clark C. Camp Hatch W. Camp Wurts Taylor

Davie Downer Walker Baker Bigelow Thompson Morse

GAME CHANGER: *Walter Camp (1859–1925)*

When Walter Camp entered Yale in 1876, "football in America was an outlaw game, a sort of town game, old and disreputable," wrote Harford Powel Jr., Camp's first biographer, in 1926. As a player, coach, and head of many football rules committees, Camp, who had nearly completed a medical degree, took a Frankensteinian game of styles bolted together and gradually fashioned a new, unified creature that looked and functioned better than before. Whereas teams had struggled over which version of football to play, Camp devised and engineered rules for a codified, uniquely American sport with its own appearance and its own strategy.

AMERICAN
FOOTBALL
BY
WALTER CAMP

FOOTBALL

WALTER CAMP AND LORIN F DELAND

(Opposite) Yale football team, 1876. Walter Camp, second from left, back row, and his teammates pose in their new elflike uniforms.

(Above) *American Football* (1891) and *Football* (1896). Camp's first book, with a cover featuring a pair of screaming eagles clutching footballs, focused on position descriptions, signals, and training. The 1896 book, with co-author Lorin F. Deland, was a detailed and definitive work, the football bible of coaches and players alike.

Camp's Innovations:

Eleven players to a side

The line of scrimmage and the direct snap from center

Modern offensive formation: seven linemen, one quarterback, two halfbacks, one fullback

Planned plays (as opposed to the more spontaneous continual play of English rugby)

Use of a quarterback, who also called play signals

Measured yards to gain to retain ball possession and the concept of downs

Defensive score for a safety

Tackling below the waist

(Below) "Play II, Ordinary Formation: Outlet No. 2," *Football*, by Walter Camp and Lorin F. Deland, 1896. In the play, "the ball is passed to the right half-back, who turns half round after receiving it, and blocking himself backward against his own line and interferers, passes the ball to the quarter-back, who circles the left end." Early football books used human figures in diagrams, a convention that soon changed to black-and-white circles, then *X*s and *O*s.

(Opposite, top) Practice scrimmage at Yale, ca. 1913. Camp, far right, remained associated with Yale football long after ending his tenure as coach in 1892.

(Opposite, bottom) "A Yale Thanksgiving Jubilee," printed card with illustration by Walter Camp, 1883. In his second season coaching Yale and in a burst of whimsy, Camp drew himself with a playbook above the laces on a ball and depicted his football-bodied players, including two holding crutches.

Under Camp's guidance, and with input from his wife, Alice, Yale posted a 67–2 record in five seasons from 1888 to 1892, including three undefeated seasons when no opponent scored a point. He also served as an administrator for Yale athletics and was the first to create a financial structure that enabled football profits to support other sports, a model adopted by hundreds of colleges. Profits also funded the construction of the Yale Bowl, a mega football stadium whose bowl shape became the prototype for future football stadiums and inspired the term "bowl game" for post-season play. After the 1892 season at Yale, Camp carried his football philosophy to the West Coast, coaching for three seasons at Stanford University.

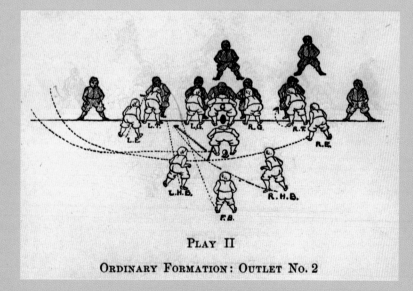

PLAY II
ORDINARY FORMATION: OUTLET NO. 2

Not only did Camp invent much of American football, but also he relentlessly and methodically championed the sport. He instructed his team managers to rent large stadiums (such as the Polo Grounds in New York) for major rivalry games to generate the feeling of an important spectacle taking place. In a brilliant publicity ploy, Camp garnered popular interest in individual players through the All-American teams he and sportswriter Caspar Whitney selected from 1889 until his death. Camp's influential All-American format would be replicated by every other college sport, and the term, which he popularized, became synonymous with the best examples of physical achievement and the nation's most prized character traits. In that regard, Camp

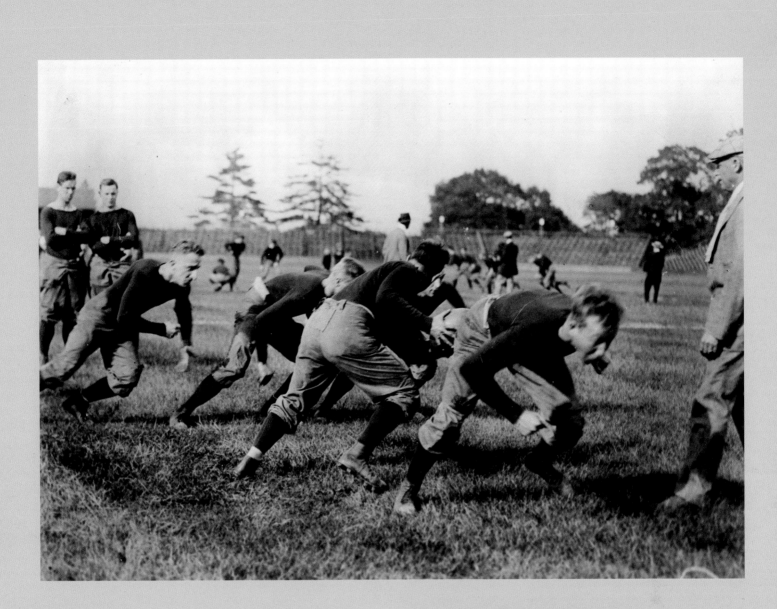

himself was the ultimate all-American: a gifted athlete, a resourceful promoter, a successful businessman.

He was also a prolific writer. His best-known work, *American Football*, was published in 1891 to an eager and welcoming audience, going through several updates. "[It] is easily the first treatise on that now popular game," said *The Nation* in its original book review. "It is not only eminently readable, even to the tyro, but it contains suggestions based upon such profound experience in the science of football that no captain or coach of any first-rate team can afford to miss the consideration of them." He cranked out hundreds of articles as well and attached his name in bold to numerous other publications in a never-ending marketing blitz. Camp was not just promoting a product; he was also offering an irrevocable lifetime membership in a heroic enterprise to anyone who would pick a team and cheer. Walter Camp was the rare inventor who lived to see his creation widely embraced, culturally embedded, inseparable from its season, and as capable of dictating the lives of its adherents as any other endeavor yet conceived.

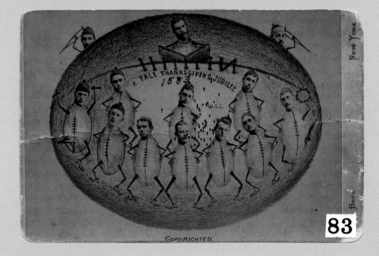

once a team had the ball, it retained possession; ideally, the team would then put together a sustained drive forward over a series of plays. Since there was no longer a need for a scrum formation from which to fight for the ball, Camp came up with a new starting formation: Teams opposed each other in parallel lines, between which ran the line of scrimmage, on which the ball was placed. The offensive center then snapped the ball back (originally with his foot, later by hand) directly to the newly devised position of quarterback. As Princeton's Richard Morse Hodge explained in 1888, the quarterback position "is a distinct product of the American game. In his place at the back of his center rusher, the quarter back receives the ball as it rolls from the snap and in his turn 'passes' [it] on to a third player that it may be kicked or run with." (Passes then were tossed backward, as in rugby; the forward pass was not permitted until 1906.) The quicker initiation of plays and fewer players on the field sped up the game, making it even more exciting for spectators. To further inspire offensive progress, an 1882 rule required teams to advance the ball at least 5 yards on three attempts (downs), or else give up possession (a further improvement in 1912 gave the offense four downs to gain 10 yards).

Such refreshing changes lessened the chance of games ending in stalemates and prompted more creative, lively play as new play options were introduced. (One play used on wet fields involved the ball carrier running up and over the hunched back of his quarterback, nimbly stepping onto an adjacent lineman, and launching himself over the defensive line. In an equally practical designed play, a small quarterback outfitted with large belt straps on his trousers was picked up "by a couple of burly teammates and flung over the line of scrimmage for the necessary yardage.") With a variety of plays coming into use, captains began issuing verbal signals to their teammates on what to run next, and blockers were given specific assignments to assist the runner they now knew for certain was behind them. By 1891, Camp

and company's modern, American-style football had replaced hybrid- and rugby-style play among college and high school varsity teams. In the United States, "football" now usually referred to the distinct American game, and soccer and rugby continued traveling down their own separate paths.

It was no coincidence, really, that the most pivotal stages of American football's evolving configuration and initial fan base development occurred during the Gilded Age and Wild West era, from the 1870s to the 1890s. Those years marked a flourishing, enterprising period in business, the arts, science, and westward expansion that pointedly contrasted with a dull stretch of undistinguished and indistinguishable presidential administrations. No longer taking their marching orders from wartime Washington or Richmond, Americans turned their attention from making do to making much more. Wrote one dazzled optimist in 1874: "This is not alone or simply the practical age—the age of steam and the telegraph, of railroads and machinery, of invention and the application of man's ingenuity and skill to the discovery and perfection of whatever can contribute to the satisfaction or gratification of the wants and necessities of the race. In this particular it is indeed a marvelous age, surpassing all others in effort and achievement." The pigskin now came from the factory, not the farm, and so did some of football's guiding principles. Walter Camp, after all, was employed in the New Haven Clock Company, and he knew a thing or two about business and moving parts. With his student, Stagg, he taught the game as a science, and his teams were efficient, well-oiled machines that ran like—well, like clockwork. Camp and others meeting regularly to refine football rules applied the same principles to the game that helped fuel the Industrial Revolution. Standardization (of game rules) and specialization (of coaches and player positions) made intercollegiate play both possible and artful.

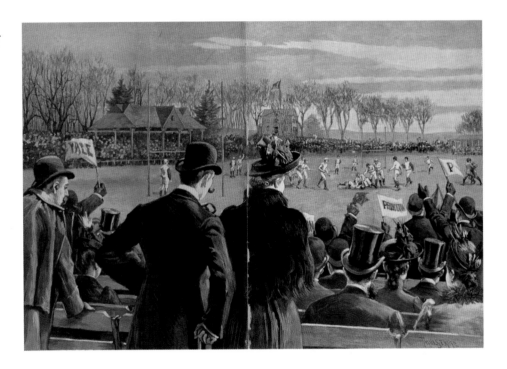

The accelerated growth of postwar urban America, with its densely populated cities, rapid-transit hubs, infrastructure, and amenities made organized sports feasible and successful. Industry fed the late nineteenth-century sports boom through mass production of footballs, baseballs, croquet sets, tennis rackets, golf clubs, and bicycles, which ranked among the best-selling sporting goods. But the most important thing to come out of industrial and corporate America was the very thing that punched in each morning: the ordinary employee, who was not only primed and ready to use that recreational equipment but to become a dedicated spectator—a *sports fan*—without whom sports enterprises could not function. Postwar availability of resources, advances in industrialization, and a greater emphasis on public education mobilized the national labor force, a large chunk of which moved from farms to factories, offices, and other commercial concerns. Standard work schedules and set business hours, in turn, promoted the notion of regular leisure time, best exemplified in a new concept—the *weekend*. Regular hours further translated into reliable

The Barnum & Bailey Greatest Show on Earth, poster, Strobridge Lithography Co., 1898. Water carnivals drew large crowds in the 1890s, and one of the attractions was "water football," shown in the lower left corner. An advertisement for an 1895 water carnival in Chicago declared its "Football in the Water" to be "The Most Exciting and Novel Match Ever Witnessed. Something New and Worth Coming 100 Miles to See."

salaries, and more workers could count on having funds available year-round (rather than on a seasonal, agricultural timetable), leading to greater discretionary spending on entertainment, whether one purchased game tickets, athletic equipment, or the hometown newspaper for game scores.

In rural America, much of life was lived outdoors and in motion. That was changing for citizens in urban America. With so many workers (more than 50 percent by 1870) no longer engaged in farm labor, a commensurate need arose for exercise. Businesses, like schools, realized that sponsoring company athletic teams benefitted employee morale and fitness while also boosting corporate visibility. Municipal and club team membership soared as consistent work schedules made it possible to plan regular practices and games (many club and athletic union "football teams" played Association football or rugby, while others adopted the American game). The American Athletic Union, established in 1888, was formed to regulate, standardize, and sponsor competition in a variety of sports, just as Camp and others were doing with football. Since organized and equipped amateur sports were no longer limited to wealthy gentlemen, a larger slice of the population representing a wider range of demographics opened the way to a broad, potentially deep fan base that was becoming more knowledgeable about sports, better able to participate in them, and more likely to pay for the privilege of watching them.

An American Game

Now that the cool breezes of autumn are beginning to blow, and the trees are beginning to change from emerald to old gold, and the schools and colleges are beginning to open, the students' fancy seriously turns to thoughts of football. —*Bangor Daily Whig & Courier*, September 11, 1899

"*The* game of American football, as time goes on, is coming to represent more of science, of skill, of careful forethought, and theoretic and practical study, than any other American game," wrote J. H. Sears, former captain of the Harvard team, in 1893. That was a bold claim to make in a country where baseball was especially admired for its strategic planning

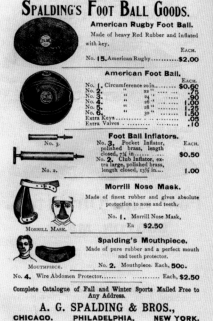

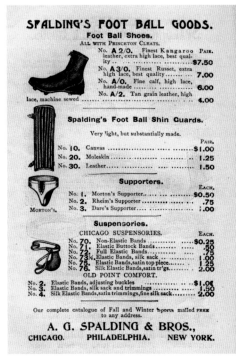

and tactical craftsmanship, and where in many cases football could easily be mistaken for a barroom brawl without the broken chairs. That same year, A. A. Stagg published *A Scientific and Practical Treatise on American Football,* observing that "The game of football is fast becoming the national fall sport of the American youth. Among the larger eastern colleges . . . football has now been raised to a definite science . . ." He recommended players follow an uncollegiate-like sleep schedule from 10:00 PM to 7:00 AM and suggested a diet with generous helpings of meat, potatoes, and fruit. Under Stagg, salads, then much richer and more fattening, were off-limits, as were pipes, cigars, and cigarettes during the season.

Coaches initiated several customs that fell into place in the 1890s, including spring practice, specialized-position coaching, and the trend toward former players returning seasonally to their alma maters as assistant coaches. Sears and his colleagues agreed that football was "settling in," as the experienced player-turned-coach gradually replaced the captain as the team's ultimate authority. Although many regarded paid coaches as a major threat to the sanctity of amateur sports, the fierce competition to field good teams was such that by the 1890s, some coaches were not only paid, but college presidents actively recruited them. When Stagg signed on to coach at the University of Chicago in 1892, he was made an associate professor of physical culture. By including Stagg on the faculty, the university

Pages from *Spalding's Foot Ball Goods* catalog, 1894. In the 1890s, modest attempts at safety gear, including rubber nose and teeth guards, leather shin guards, and padded pants, became additional accessories for the well-equipped player.

A

Scientific and Practical Treatise

ON

AMERICAN FOOTBALL

FOR

Schools and Colleges

BY

A. ALONZO STAGG

AND

HENRY L. WILLIAMS

HARTFORD, CONN.
Press of The Case, Lockwood & Brainard Company
1893

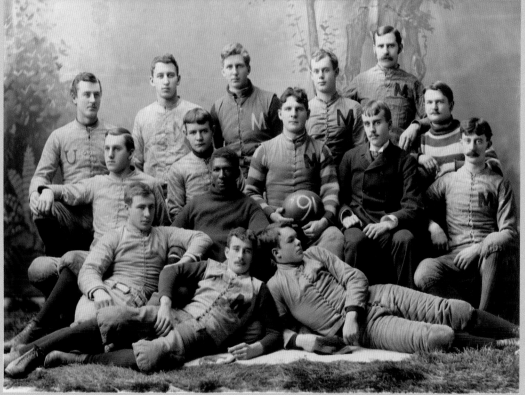

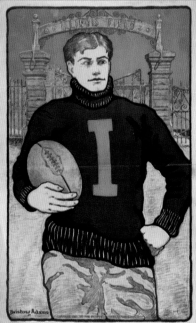

recognized both the importance of physical education as a legitimate new academic field and the advantages—both financial and reputational—associated with intercollegiate athletic success. Other schools also sought out former Yale players in particular, as well as those from Harvard and Princeton, to develop their football programs; by the end of the century, at least one hundred players had found employment around the country as college coaches, passing on knowledge and traditions directly from the sport's original powerhouses.

Although American football developed and first prospered in long-standing private northeastern colleges, it spread south and west by way of recently established public schools. For this, fans of "State U" can thank Justin Morrill, the thickly sideburned congressman from Vermont. The 1862 Morrill Act, a brilliant legacy of Civil War–era legislation, allowed states to use or sell federal land within their borders for establishing institutions of higher learning. It underscored strong and unprecedented support for public education that would help produce millions of American success stories, thousands of football careers, and several dozen bloodthirsty rivalries. Soon, these land-grant colleges—"state schools"—appeared from coast to coast, with a revenue-generating, school-spirit-fostering football program almost sure to follow. Among the land-grant schools that would develop significant big-time football traditions were Auburn, California (Berkeley), Florida, Georgia, Illinois, Louisiana State, Missouri, Nebraska, Ohio State, Penn State, Tennessee, and Wisconsin. These large land-grant and other public schools would later serve as "football factories"—essentially, a nationwide minor league for manufacturing professional players—paid for by the public. Unlike major league baseball, which relied upon, and later funded, a system of minor leagues for cultivating talent, professional football would depend on colleges to develop players, sparing itself considerable effort and expense.

The University of Michigan operated as football's westernmost outpost when it fielded its first team in 1879; the next season, in Lexington, Centre College and Kentucky University waged the first intercollegiate game in the South. By 1886, football was being played at the University of California. The Golden State's first intercollegiate game, between Cal and Stanford in 1892 at the Haight Street Ball Grounds, was played before an "immense crowd" of jubilant spectators who had spent the day racing about San Francisco in decorated coaches, shouting cheers, and blowing horns. However, the organizing committee dropped the ball when it failed to bring one to the game. (A courier on horseback was dispatched downtown and returned with a football an hour after the scheduled start time.) "The most striking feature of the season in Western football was the marvelous spread of the game, there being, without exaggeration, twice as many teams as in 1894," observed Caspar Whitney of *Harper's* in early 1896. "Improvement in play, however, has not been so rapid . . . The tackling was atrocious, and it seems impossible to get a Western line to work together while their opponents have the ball. This accounts for the few games in the West in which both teams have not scored."

Not only was football flourishing geographically, but institutions with winning teams enjoyed a surge in applicants for admission, a phenomenon also documented in the twenty-first century. In the 1890s, the University of Virginia, the Virginia Polytechnic Institute, and the Virginia Military Institute all experienced increased enrollment in years that followed a successful football season. The University of Kansas student newspaper boasted that the football team's success did more to publicize the school than paid advertisements. Where football was already well established, game attendance continued to rise, from 4,000 spectators at the 1878 Princeton-Yale contest to 50,000 fans fifteen years later. Ticket requests for the sold-out 1898 Harvard-Yale game so overwhelmed Percy Rockefeller,

(Opposite, top) *A Scientific and Practical Treatise on American Football*, by A. A. Stagg and Henry L. Williams, 1893. Sporting a gold-embossed cover, Stagg's book moved football literature forward with its extensive discussion of designed plays and field tactics.

(Opposite, bottom left) Michigan Wolverines, 1890. Team captain William Malley holds a ball marked for 1891, the year he graduated from Michigan's law school. His teammate George Jewett, Michigan's first black player, was a prolific scorer and scholar, fluent in four languages, and later earned a medical degree from Northwestern.

(Opposite, bottom right) University of Illinois player in letterman's sweater, in front of Illinois Field, lithograph, by Bristow Adams, 1902.

(Above) Groton School team portrait, Groton, Massachusetts, 1899. Franklin Delano Roosevelt, seated second from left, was not much of an athlete, but his letters to his mother were full of football news. On one occasion Sara Roosevelt responded: "It would be absolutely dangerous for you to play too hard or too long at football. I shall be glad when you begin golf instead."

(Right) University of Nebraska team portrait, 1894. Before they were called the Cornhuskers, the team was known as the Nebraska Bugeaters. George Flippin, second row, third from left, the team's first black player, served as captain that season.

Primer of College Foot Ball, by **W. H. Lewis, 1896.** Born to former slaves in Berkeley, Virginia, in 1868, William Henry Lewis became the first of three black college football players to play for a white team in 1889 as a center at Amherst. While he was a law student at Harvard in 1892 and 1893, Lewis was named the first black football All-American and was described by *Harper's Weekly* at the end of his career as "not only the best centre of this year, but the best all-round centre that has ever put on a college jacket." He went on to coach at Harvard, becoming "the recognized authority on defense in football the country over," according to the *Philadelphia Inquirer* in 1904, and to author *Primer of College Foot Ball*, an early book on rules and strategy. He is credited with introducing the neutral zone before snaps—one of the major rules that distinguishes American football from its British predecessors—so that linemen could not attack vulnerable opposing players before the ball was put into play. When Cornell University tried to lure Lewis to coach at Ithaca in 1903, President Theodore Roosevelt, a Harvard alum, stepped in and arranged for Lewis to be appointed assistant district attorney in Boston, keeping him close to the Cambridge campus. President Taft appointed Lewis in 1910 as an assistant attorney general at the Department of Justice—the highest-ranking federal position ever held by a black man up to that time. Lewis later appeared before the U.S. Supreme Court on behalf of clients others would not represent, such as Charles Ponzi, master of the Ponzi financial scheme.

the Elis' assistant manager who handled ticket applications, that the exhausted student was "obliged to go to his home in New York to rest" before the game even started.

Meanwhile, organized high school football shadowed the spread of college ball, and principals, like college presidents, hoped having a team would further instill school pride, develop boys into men, and provide an alternative activity to after-school mischief. Elite private preparatory schools had a long history of supporting athletic competition, but in the 1890s, with standard American football rules now firmly in place, more public high schools fielded teams. Two Pennsylvania squads, Mansfield State Normal School and Wyoming Seminary, hold the distinction of participating in football's first night game. Played as a demonstration of both football and electric-light technology at the 1892 Great Mansfield Fair, the game was called at the end of a scoreless first half because of poor visibility and injuries caused from run-ins with the light pole in the middle of the field. Ironically, night football would eventually become most common among high school teams.

Along with changes in the game came changes in the players. As more public high schools and colleges formed teams, their rosters encompassed a wider variety of the population, including working-class students. Some high schools had racially integrated teams, and while that was not the norm, it occurred often enough in the North and Midwest that newspapers referred to "mixed" teams from time to time. During the late 1880s and throughout the 1890s, black students at Amherst, Beloit College, Harvard, the Massachusetts Institute of Technology, and the University of Michigan played varsity football, prompting the *New York Mail and Express* to conclude that "When Southern Colleges shall have so far advanced as to accord the Negro the same degree of equality as he secures in the great colleges at the North, the 'race problem' will cease to be a problem."

Northern attitudes, however, could not be counted on to uphold progress, as some teams refused to take the field unless their opponents' black players were benched. Out west,

The Flying Wedge

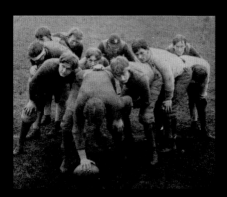

It lasted little more than a season, but the Flying Wedge was early modern football's most spectacular and memorable designed play. Lorin F. Deland, an inventor and military-history buff, came up with the V-shaped formation after seeing his first game in 1890 and then consulting his library on tactical warfare. He considered the Flying Wedge "nothing more or less than the application to football of one of Napoleon's favorite methods for turning the enemy's flank," working out the details on a five-foot-long, built-to-scale model field. He offered the play to Harvard's eleven, which introduced it in its 1892 game against Yale. Used to put the ball in play, the Flying Wedge involved two angled lines of offensive players racing toward each other to form a point, behind which another teammate carried the ball within the moving protective barrier. The wedge's point then aimed directly at a single defender on the opposing team, plowing him over and opening the way for the ball carrier. "Think of it," said the *New York Times*, "half a ton of bone and muscle coming into collision with a man weighing

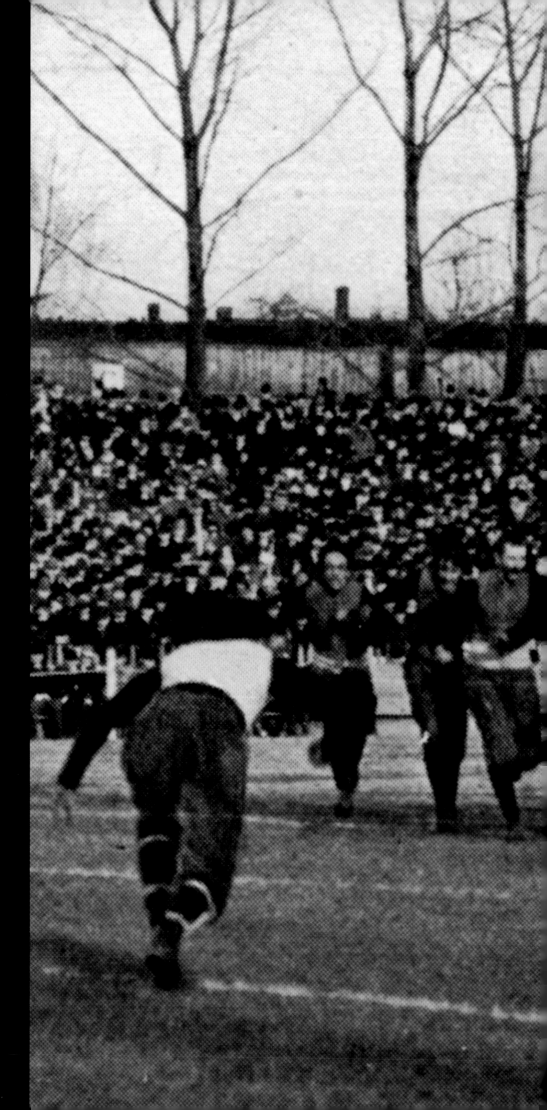

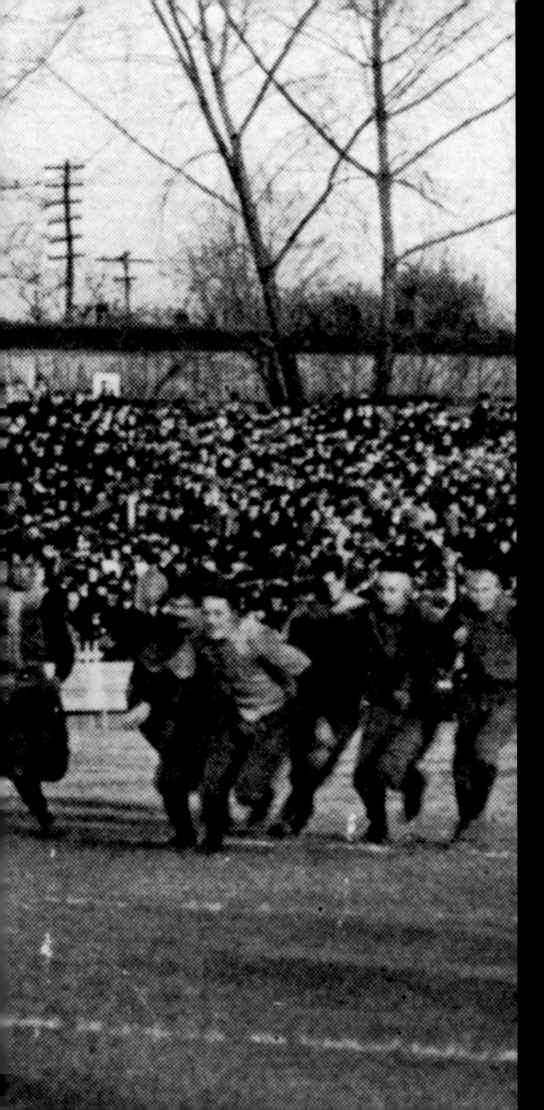

160 or 170 pounds. What is the result? The victim is generally sent sprawling with his nose broken or his chest crushed, and if the man with the ball gets through the line for ten or twenty yards the critics all exclaim: 'What a grand play!'"

Things got even wilder when both offense and defense simultaneously ran wedge plays against each other, a practice Harvard—apparently under an invincibility spell—initiated in 1893. That season, many teams employed the Flying Wedge and new variations Deland and others developed. Although wedge formations had been used before, the high-speed Flying Wedge was a revelation, a thrilling offensive response to an 1888 rule change that allowed tackling below the waist, but one that gave ammunition to football's adversaries and threatened to upend the game. A couple of player fatalities and a slew of horrendous injuries—some requiring minor sideline surgery, such as ear reattachment—were attributed to the wedge and similar mass-momentum plays. Fearful that the sport he had done so much to nurture might be banned altogether, Walter Camp and his football rules committee outlawed the Flying Wedge before the 1894 season.

(Opposite, inset) Yale demonstrating its flying wedge formation, 1893.

(Left) Harvard's flying wedge, November 19, 1892. The Crimson unveils its new offensive weapon against Yale, as players form a point and head for a lone defender.

1896

Missouri warned its competitors in Iowa not to suit up their black players, and it forfeited an 1892 game to Nebraska, whose roster included George Flippin. Two years later, the Lawrence *Journal* reported that the University of Nebraska "was all torn up . . . because the boys have elected Flippin, the colored halfback who has a head like adamant and a nerve like steel, the captain of the team. If he were white, the university and the whole west would be so proud of him that he would

A JOB FOR THE CHAMPION.
Wife—"You were the champion football player at college, weren't you?"
Husband—"Yes, m'dear. Why?"
Wife—"Oh, nothing, nothing. Only that ten-a-week clerk is in the parlor with our daughter.
—Selected.

be dressed in purple and carried on a floral wreath." In time, underfunded black schools developed their own teams. In 1892, in Salisbury, North Carolina, Biddle University defeated Livingstone College on a snowy pasture in the earliest known intercollegiate football game between black schools. At least a dozen black colleges had teams by 1900, including Howard University and the Tuskegee Institute.

Elsewhere, descendants of the earliest practitioners of football in America were engaged not on the gridiron but on real battlefields, herded into ever-shrinking areas. In the 1880s, as the federal government continued its war on the remaining Indian tribes that had not accepted assimilation or the reservation system, scientists and scholars at the recently established American Museum of Natural History in New York City were fearful that Indian material culture was on the verge of vanishing. Research expeditions headed west to collect information before it was too late, and in several ethnographic reports published in the following years, they documented football as played by the Crow, Shoshone, Gros Ventre, and others. Meanwhile, at the Indian Training School in Carlisle, Pennsylvania (see page 82), a tumultuous, intensive experiment in white cultural assimilation was under way, one that, as its

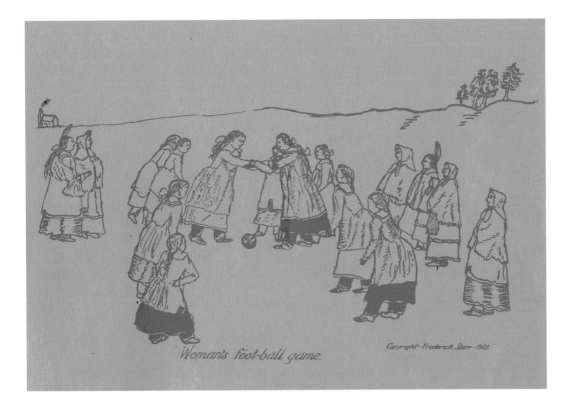

Woman's foot-ball game.

Copyright-Frederick Starr-1903.

founder Lt. Richard Pratt bluntly put it, was intended to "kill the Indian and save the man."
It was directly through its football success that Carlisle became the best-known Indian school
of its time and one that would produce one of the greatest athletes of the twentieth century
in Jim Thorpe. Football not only gave Pratt greater recognition for his controversial methods,
but he believed team travel and association with white players furthered immersion efforts.
For Pratt, that cause and the team's prowess neatly meshed with student recruiting, and he
had Indian Bureau agents notify him of athletic talent wherever they found it.

"IT SOUNDS APPALLING; IT LOOKS BEWITCHING": GIRLS ON THE GRIDIRON

Every now and then an extremist advocates football for women. He is the same man who declared that baseball was not tabooed as a feminine sport . . . He would demand that the college girl punt and tackle as well as con isms and ologies. —*San Francisco Call*, 1895

One thing the new woman does is to play football. —*Deseret Evening News*, 1895

They were regular spectators in stylish, view-blocking hats. They were loyal fans. In some instances, they were players. And, in a few cases, they assisted coaching men's teams. Women in the late nineteenth century were participating in organized football long before they had either the vote or pom-poms. As the *Chicago Herald* reported in 1892, "There are numerous football teams and baseball nines managed and equipped by the women students in different parts of the country." Notably, one of the best football minds in the nation belonged to Alice Sumner Camp, whose husband coached at Yale.

Women regularly went to games in this era, and commentators remarked on how insistent men were that women be in attendance. Their presence lent a civilizing aspect to the whole affair, bestowed a sought-after stamp of approval, and provided an audience whose applause and favor was valued above all. After a game in Memphis, Tennessee, in 1895, when the local athletic club crushed St. Thomas Hall Academy 30-0, much of the post-game coverage was devoted to the "pretty women who spent the day here, attracted by the contest . . . At any rate, the players always want them present, and use many persuasions to bring them to the fields of struggle."

(Right) Yale vs. Harvard game program, 1898. Players are relegated to the background behind the program's cover girl.

(Opposite) "Football Kicking Maidens: A Lively Scrimmage Occurs Between Two Rival Teams on the West Troy, N.Y., Ground," *National Police Gazette*, June 22, 1895.

PEOPLE WHO WORSHIP WITHOUT CLOTHES.

THE NATIONAL POLICE GAZETTE

THE LEADING ILLUSTRATED SPORTING JOURNAL IN AMERICA.

Copyrighted for 1895 by the Proprietor, RICHARD K. FOX, The Fox Building, Franklin Square Publishing, Printing and Engraving House, New York City.

RICHARD K. FOX,
Editor and Proprietor.

NEW YORK, SATURDAY, JUNE 22, 1895.

VOLUME LXVI.—No. 929
Price 10 Cents.

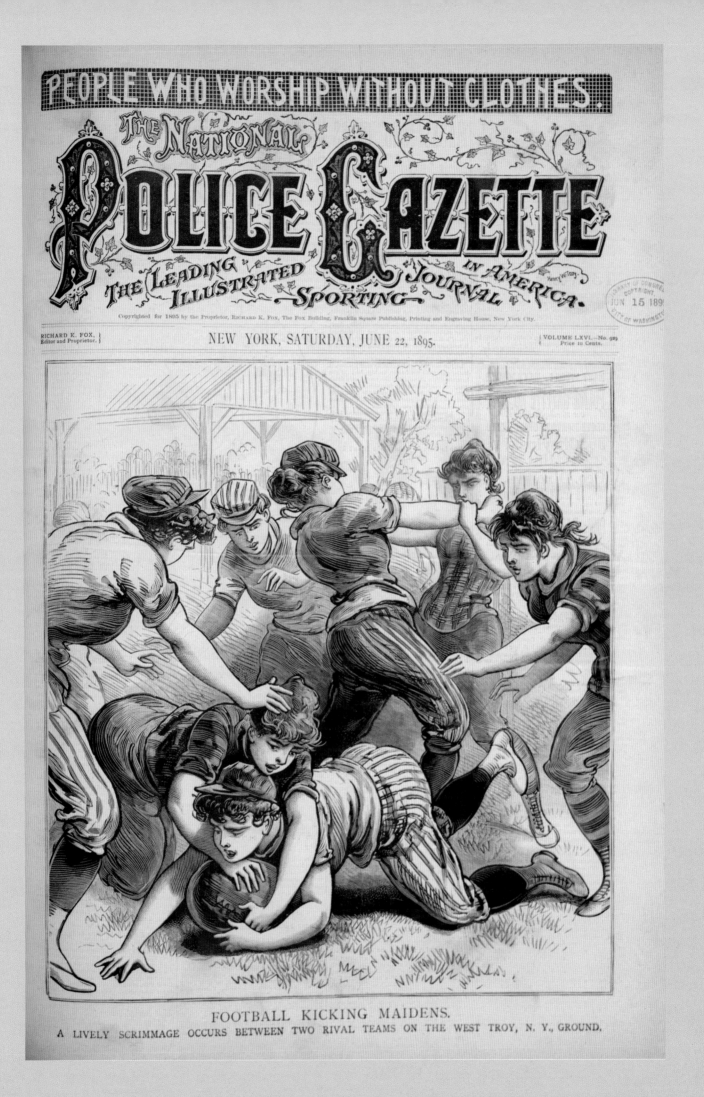

FOOTBALL KICKING MAIDENS.

A LIVELY SCRIMMAGE OCCURS BETWEEN TWO RIVAL TEAMS ON THE WEST TROY, N. Y., GROUND.

MR. AND MRS. WALTER CAMP

THE HEAD COACHES

OF THE

YALE FOOT BALL TEAM

OF

1888

(Above) *Dinner to the Yale Football Team of 1888 on Its Twenty-Fifth Anniversary,* program, November 12, 1913. A celebratory dinner and reunion at the Hotel Taft in New Haven commemorated the greatest team of its era, which went undefeated and unscored upon. The opening program page, in referring to the Camps as "Head Coaches," acknowledged the contributions and key role Alice Sumner Camp played in the team's success.

(Opposite, top) "Progress," by Frank Nankivell, *Puck* magazine, January 9, 1901. The original caption read: "I should say the girls *are* enthusiastic about foot-ball! You know Miss Jones, whose sole ambition was to be *svelte*?" "Yes?" "Well, she's breaking her heart because she isn't heavy enough for a full-back!"

(Opposite, bottom) "The Play Is Swift While It Lasts," 1895. This illustration appeared in newspapers nationwide accompanying stories of women taking up the game of football.

If the pretty women of Memphis were not themselves playing ball, other ladies certainly were elsewhere. In 1892, the Philadelphia School of Design for Women (later Moore College) fielded *two* football teams. The following season, three thousand miles away, the Colleen Bawns defeated the Bonnie Lassies, 2–0, in a soccer-style match in San Francisco's Central Park before a crowd of several thousand spectators. It was reported that in this "the play was rough at times" but "no one was painfully injured." Clad in "abbreviated skirts and knee trousers," each player was paid $2, an early milestone in women's professional sports. In 1897 the city hosted another women's professional match, at the Velodrome, and players— recruited from the ranks of ballet, theater, and the circus—were paid $5 to compete in rugby-style football after ten days of practice. (The Frisco Grays defeated the Oakland Browns, 20–8.) According to the game promoter, each player had been given a clean bill of health, and, to reassure the public, each carried a signed certificate attesting to her good morals. A spectator and Stanford football team member conceded that the play was "all right. But girls never can play a boy's game, and vice versa." Then he added, "Now, some of those girls can really be made to play a good game of ball. That Miss Hart is a corker. She can run like a deer, and how she clings to the pigskin!"

"Girls on the gridiron," as the author Madge Robertson put it, "has a sufficiently startling sound," yet there she was in 1895 observing a handful of college games in San Francisco and Boston. The women played Association football but with American variations. Robertson was taken aback by the field chatter: "One is dumbfounded at the politeness. 'Really, I beg your pardon!' 'I'm sorry.' 'Are you sure I didn't hurt you?'" The players assured Robertson "that next to ice-hockey the foot ball game, as girls play it, has within it the elements of more pure fun than any game as yet invented—even the battle ball and basket ball."

The same year that Madge Robertson was witnessing a combination of sportsmanship and inept trash-talking, Diana Crossways reported on women at Wellesley College, in Massachusetts, and in Pontiac, Michigan, engaged in American tackle football as played by men. "The modern maiden is well versed in every athletic art," Crossways declared. "The latest one added to her repertoire is football . . . It sounds appalling; it looks bewitching, but is altogether beyond description on paper." The Wellesley women received coaching from a professional player, while the Pontiac team practiced in the yard of its left tackle. In explaining how football's object, rules, and techniques could be taught to others, Crossways suggested using seven teacups and four teaspoons to represent player positions on the field, as "this method of illustration can be recommended from experience."

Not everyone—actually, not that many at all—was enthusiastic about women taking up football. Parents of players at the Philadelphia School of Design soon put a stop to the game. An item in the *St. Paul Daily Globe* opinion page in 1895 remarked that "There is much speculation as to whether the young women who are yearning to play football at Wellesley will make good wives. Their expertness at kicking may not be a strong card in their favor a little later." A few years after this, amid rumors that women's football teams were forming

back East, an alarmed Walter Magee, associate professor of physical culture at the University of California, Berkeley, expressed concern that while women could "intellectually" understand and physically play the game, emotionally they were not suited for it.

Though usually models of decorum at games, women occasionally defied social custom in support of their teams. One excited "gentle lady" rooting for Auburn at the 1892 game against Georgia "broke her parasol over the head and shoulders of a gentleman in front her." At an 1895 game between Greensburg and Latrobe in Pennsylvania, when "noisy delegations of Greensburgers" arrived, "loyal female Latrobists glanced disdainfully at the shouting marchers, and some even grew livid with rage. This was the case among old and young. An old lady turned her back after spitting at a Greensburg crowd and then defiantly waved a yard or more of red and blue ribbon."

Meanwhile, at that bastion of football, Yale University, a schoolteacher and principal, Alice Sumner Camp (1861–1934) was a natural coach, and her husband considered her a "most valuable" aide. She attended team practice daily, which Walter missed due to his job as a clock company executive. Each evening, Alice provided him with detailed notes on the team's performance, which Walter reviewed before meeting with players in the Camps' parlor. She had a "very superior knowledge" of the game, "her advice proved very valuable to us, and she was always very cordial," said William Corbin, captain of the 1888 team, whose members regarded her as "the mother of American football."

According to referee Mike Thompson, Alice "knew as much football as her husband." He recalled a Wesleyan-Yale matchup in the early days of the forward pass, when it was seldom used, and that she "had a hunch that Wesleyan might try the innovation in this game, and was anxious that I should not miss the play. It came down on Mrs. Camp's side of the field, and she was so excited that she danced up and down, just as delighted as if Yale had been the beneficiary." In her obituary, the *Hartford Courant* noted that she was credited with making "various changes in football tactics brought about by her personal observations."

Women's View of Football . . . in 1897:

"What do you think of football?" Mrs. Henry Wood surveyed women in Denver, Colorado, and compiled their answers for the *Rocky Mountain News.* Among the responses:

Mrs. E. M. Ashley: "I am ashamed to say it, but I love to go to a game with my husband and son, and I love to hurrah with them, too!"

Mrs. T. B. Stearns: "I'm afraid I am very cold-blooded, for I enjoy the game immensely; though brutal in some respects, I think it is a manly game, and I like to have my boy play."

Mrs. Charles H. Toll: "My sons shall never play as long as I can prevent it."

Mrs. Nettie Allen: "Splendid! I love to see it played—as I have no boys to get their necks broken."

Mrs. William Maguire: "A perfectly horrid game."

Miss Margaret Packard: "The finest thing out. Bully for football!"

Mrs. A. M. Welles: "Awful! I hope the law will forbid it."

Mrs. Laura P. Coleman: "Football is life, and life is uncertain; we must take our chances."

(Bottom left) "Not So Bad," by Frank Nankivell, *Puck* magazine, December 20, 1899. This cover illustration and exchange between two spectators captures the different attitudes toward football brutality: "Mrs. Newcome (her first game)—Oh! Isn't it awful? Horrible! Why, they will kill that man underneath! Her Daughter (an enthusiast)—Oh! He doesn't mind it, Mother. He's unconscious by this time!"

(Bottom right) Advertisement for *Harper's* magazine, lithograph, by Edward Penfield, 1894.

"None but the Brave Will Play It"

Vigor, health, bravery, appeal to us as no mental attainment can. No amount of culture nor of refinement nor of intellectual force can atone for lack of those virile virtues essential to the perpetuation and the well-being of mankind. Sport, the greatest developer of these virile virtues, has always stirred men to utmost enthusiasm, and it always will. —Caspar Whitney, "Amateur Sport," *Harper's Magazine*, 1899

Just as sports would reap huge benefits from television broadcasts in the 1950s and the proliferation of twenty-four-hour sports-talk cable television and radio stations in the 1990s, so it was that newspapers spread and sustained interest in athletic competition in the late nineteenth century. The newly nationwide telegraph network prompted a rapid growth of newspaper titles in the 1870s, especially in smaller cities and towns, as local publications supplemented their own reporting with readily available stories from other papers. It also meant that game scores quickly appeared throughout the country, allowing fans to follow their teams from a distance. As was the case with baseball, football's accelerating popularity led to greater news coverage that reinforced further interest in the sport and its players.

Tracing the upward trajectory of fan interest in the Harvard-Yale game through the nation's newspaper of record over a fifteen-year period is illuminating. The *New York Times* did not even bother to mention the first game, held in 1875; the following year, the contest earned three sentences. It received three paragraphs in 1881, nine in 1886, and by 1891, when the matchup drew 25,000 spectators, the *Times* had printed several pre-game articles and then featured a lengthy post-game story on its front page. With his purchase of the *New York World*, news pioneer Joseph Pulitzer created the industry's first sports department in 1883, and a

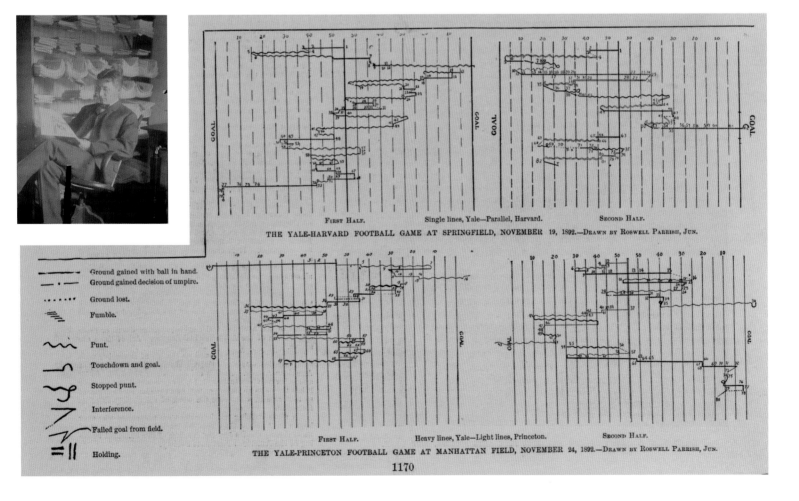

Ground gained with ball in hand.
Ground gained decision of umpire.
Ground lost.
Fumble.
Punt.
Touchdown and goal.
Stopped punt.
Interference.
Failed goal from field.
Holding.

FIRST HALF. Single lines, Yale—Parallel, Harvard. SECOND HALF.
THE YALE-HARVARD FOOTBALL GAME AT SPRINGFIELD, NOVEMBER 19, 1892.—DRAWN BY ROSWELL PARRISH, JUN.

FIRST HALF. Heavy lines, Yale—Light lines, Princeton. SECOND HALF.
THE YALE-PRINCETON FOOTBALL GAME AT MANHATTAN FIELD, NOVEMBER 24, 1892.—DRAWN BY ROSWELL PARRISH, JUN.

1170

55

(Top) "The Great Football Match Between Yale and Princeton," *Once a Week*, December 15, 1891. An artist's views of the Thanksgiving Day game played at Manhattan Field include game plays, cheering fans, and, at top right, a player tended to with "sticking plaster," i.e., a bandage.

(Middle left) Princeton and Yale fans parade up Fifth Avenue to Manhattan Field for the game, November 30, 1893.

(Middle right) "Frank Merriwell's High Jump," *Tip Top Weekly*, 1900. Scholar, athlete, gentleman—Frank Merriwell was the ideal American boy and a popular fictional character. A creation of writer Burt Standish, pen name of Gilbert Patten, Merriwell was featured in numerous dime novels and short stories for boys that promoted wholesomeness, integrity, and hard work. The iconic character also served as inspiration for similar works aimed at young readers of later generations.

(Bottom) "An Episode of the Football Season," *New York Evening World*, November 24, 1894. A cartoon captioned "What Lovely Chrysanthemums!" makes a play on the term "Chrysanthemum Hair," used to describe shaggy-headed football players who grew their tresses long for whatever minimal protection it might provide. "Chrysanthemums and football players are flowers that fade at the same time" went a seasonal saying. In the 1890s, mums were in great demand among college football fans, who wore the versatile-hued flowers on game days (crimson for Harvard and blue for Yale). The practice spread west, and in 1895, demand for crimson chrysanthemums was so great among Kansas Jayhawkers that one local florist grew the flower only in red.

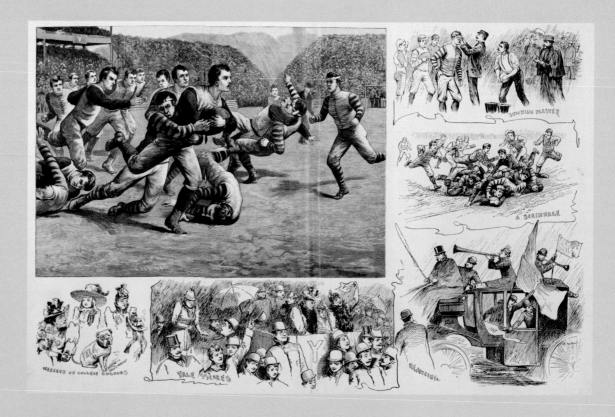

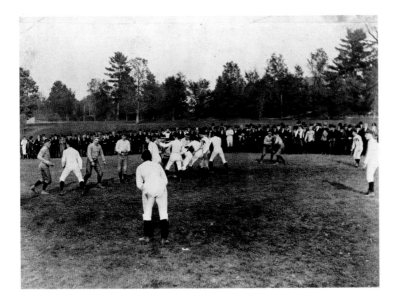

dozen years later the mold for every decent American newspaper was cast when William Randolph Hearst inaugurated a dedicated sports section in his *New York Journal.* While sensational scandalmongering was essential to increase circulation among the lowly regarded but highly readable tabloids, more respectable publications increased their readership with expanded sports coverage, which at the time typically accounted for 9 percent of a paper's news content and nearly a third of its sales.

Football's growing stature combined the popularity of the game itself with positive interpretations of what this young, organized sport meant and represented. The *Christian Union* cited benefits of college sports as early as 1870, declaring that "if you frown on football, and pass rules against boat racing, you may look out for drinking parties, smashing of tutors' windows, and tearing up of the college fence, as a natural consequence." More than twenty years later, Caspar Whitney, whose incessant defense and justification of football were perfectly suited for a publication called *Harper's,* harped continuously on this point. In 1893, he argued that football "elevated the general morale of the undergraduate body by absorbing the animal spirits that formerly were wasted in dissipation"; thus, "American and English universities have none of the dueling and sanguinary scandals common in European colleges." Given that the Bavarian Minister of War had recently pronounced it impossible to outlaw dueling in Germany, Whitney suggested that "if football were introduced, there would be no need for legislation on dueling."

With the closing of the American frontier in 1890, as declared by the U.S. Bureau of the Census, some viewed football as a replacement for the rugged heroics and challenges that once drove men to explore and conquer (rather than merely "settle") the West. More than any other team sport, football was heralded for its manliness and inculcation of values, including courage, discipline, and teamwork, and it carried both militaristic and religious overtones. Commentators and participants alike repeatedly compared football to warfare, the player to a soldier, team spirit to a warrior ethos. The U.S. Army deemed football practical exercise for both recreation and combat readiness, and by the early 1890s, the sport was played on military bases across the country. In rounding up "Rough Riders" for his 1898 Cuban adventure during the Spanish-American War, Teddy Roosevelt specifically sought out cowboys, Indians, and college football players to serve in his cavalry.

As to that old-time religion, a country as God-fearing as it was enthusiastic about athletics was bound to combine those two passions in a workable philosophy. The Young Men's Christian Association (YMCA), a European import to the United States, flourished in the postwar years, strengthening the spiritual and physical natures of its members through Bible study, discipleship, and structured athletics. Chapters nationwide fielded football squads,

(Left) Rochester vs. Cornell, Ithaca, New York, 1890. Like many teams at the time, Rochester (in white) wore caps but no protective gear. Cornell's Big Red opened the season by steamrolling over their guests, 98-0, which must have hurt Rochester more than any padding could have prevented.

(Below) Captain Edward Beecher, Yale, Old Judge and Gypsy Queen Cigarettes (1888), and Knox Taylor, Princeton, Mayo Cut Plug (1894) tobacco football cards. Tobacco companies produced the first sets of sports cards, which were packaged with cigarettes and other tobacco products, to encourage repeat purchases from consumers wanting to collect complete sets of featured athletes.

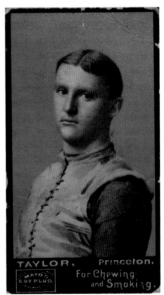

OUR FOOT BALL ELEVEN.

O, Football's very funny,
 Football's very gay,
Watch the fellow's running,
 See who wins the play.

The names of all the places
 And the start and rush and rout,
And just how they will do it,
 The boys know all about.

It's all like Greek to me,
 But they stand up in a row,
Seven manly fellows,
 When, Ha ! away they go.

One, two and *three* boys,
 Four boys and more,
Mingle in the clamor,
 Hear the shout and roar !

They fly down the gridiron,
 One, two, three, and all.
When they make a touchdown,
 And kick for the goal.

Oh, count them, if you can, now,
 The blue and the black,
All in a jumble,
 Seven in a pack.

Oh, who has won the game, dear ?
 I think it is the blue.
But perhaps the black and orange,
 I can't tell, can you ?

M.

(Above) *Child's Block 1, 2, 3 Picture Book,* **published by W.B. Perkins & Co., Buffalo, New York, 1895.** Children in college-style football uniforms grace the pages of this hands-on book that came with tabbed and numbered paper blocks to be inserted in the corresponding numbered slots.

(Right) *"Football & Love": A Story of the Yale-Princeton Game of '94,* **by Burr W. McIntosh, Transatlantic Publishing Co., 1895.** A reviewer of this early entry in the football romance genre said little about the story but noted that it came "With a novel cover, pretty illustrations, and the clearest of print on the freshest of paper."

offering those who did not play on school teams an opportunity to compete in an organized environment. The YMCA approach was similar to the sweeping Muscular Christianity movement, which viewed physical fitness as adhering to the biblical edict to treat one's body as a temple, and believed that through athletics the Christian gentleman was honed and toned as God's servant. Strong, fit, gallant—and, especially if he were handsome—the football player came to embody the all-American man; even the term "All-American" entered the national vocabulary to describe those selected as the college game's best players. Regularly published photos of well-built players posing on campus or on the gridiron in their striped and quilted armor solidified a heroic, gladiator image that held widespread appeal. As a result, football, wrote one enthusiast in 1898, was a sport "nearer the heart of a college boy than any other. He may not play it himself, but he would rather see his team win the Thanksgiving match than a dozen contests at any other sport. It is still in its virgin purity . . . None but the resolute *can* play it, and none but the brave *will* play it."

Fin de Siècle Football

Well, say, this beats croquet! There's more go about it. —Mark Twain, at his first college football game, while watching Yale defeat Princeton, November 17, 1900

Even with its laudable assets, fin de siècle football already carried the trappings that would characterize the sport and sow controversy well into the twenty-first century. Quite apart from the litany of player and team achievements in sports history, the more consequential story of American football from this point forward concerns the game's place and purpose in the national culture, its beneficial and harmful effects, and the subsequent responses to these issues. In early 1894, a pair of astute University of Pennsylvania medical professors felt it was

time to take stock, laying out the state of the collegiate game. "Football has acquired such a hold upon the American people that the question of its merits or demerits as a game must force itself upon everyone's attention," wrote J. William White and Horatio C. Wood. Although they regarded football as "the best and manliest of all intercollegiate sports," they also recognized that it was the only one to generate revenue; thus, a school's entire athletic department was dependent on the football team's success. Reliance on football income elevated the team's already prominent status, enhanced the increasing influence of its coach, and fostered a must-win environment. As a result, young men were "bought or bribed to come to certain colleges for the purpose primarily of playing football," a little-known fact outside sporting circles.

(Above) "The Modern Maid— as Changeable as the Seasons," *Puck* **magazine, November 23, 1898.** In this cover illustration run during the Spanish-American War, a lady forsakes the sailor, civilian, and soldier in favor of the battered, "chrysanthemum-haired" football player.

(Left) James O. Rodgers, Yale team captain, 1897. The golden-haired Rodgers epitomized the handsome football hero celebrated in the press and popular culture. In a joke circulating at the time, a young man asked, "Do you think that women are much influenced by a man's personal appearance?" His friend replied, "I should say so. Apollo was all right in his day, but he'd have to put on quilted trousers and wear a football mask to make an impression now."

The Professional Element

In the age of amateur athletics, professional play was often considered low and disreputable, with the not-unfounded perception that it was tied to gambling and game fixing. The greatest objection to professionalism, though, was when it crept into amateur competition. As Ira N. Hollis, president of the Worcester Polytechnic Institute and a sincere sports fan put it, competition between professionals and amateurs was "unequal if the facts are known; unfair if the facts are concealed." And in many college football and baseball programs, keeping the facts concealed was part of the game.

Among colleges, each school determined its own students' eligibility to participate in intercollegiate sports, and the rules were often vague or inconsistent. Thus, "tramp athletes" easily bounced from school to school under assumed names, operating as mercenaries, and it was not unheard of for a player to compete for multiple schools in a single season. College boosters and alumni paid some athletes, while others were surreptitiously provided room and board. It was also not unusual for ringers—nonstudents who may or may not have been paid—to appear on a roster. The University of Michigan's 1894 team featured seven starters who did not even attend the school, and the University of North Carolina reportedly had a faculty member on its team. In 1898, delegates from prominent Northeastern colleges met at Brown University and produced a code meant to standardize athletic eligibility. Despite the spelled-out measures, teams and their schools found ways to creatively interpret them—or violate them outright— and the issue remained unsettled.

According to many contemporary sources, semi-professionalism was also "rampant" in amateur club football. In the 1890s, one

of football's earliest professional teams hailed from Butte, Montana. The Butte Beauts recruited former college players for the team who were then given high-paying jobs with remarkably flexible hours that allowed for practice and extensive travel. The Beauts' competitors included YMCA teams, athletic clubs, and college squads. By 1896, opponents were accusing the self-proclaimed "world champions" of fielding professional players. "The team is backed by a man in Montana with a great deal more money than sportsmanship, and whose chief interest in the venture may be discovered in the gate receipts and self-advertisement," fumed *Harper's* Caspar Whitney, who meticulously documented cases of

professionalism. After admitting to having one paid player, the Beauts had difficulty scheduling games against amateur teams and eventually disbanded.

"The indifference with which the Amateur Athletic Union views transgressions of its rules is simply a disgraceful reflection on the athletics of the United States," moaned Whitney. One solution under discussion: create a separate professional football league. In California, plans were under way in 1897 to do just that, starting with a traveling four-team pro-football circuit. The *San Francisco Chronicle* reported that league organizers "say that the manner in which contests are conducted between various

universities savors very much of professionalism, and would be declared so but for fear of offending the delicate public." The effort proved unsuccessful, and a sustainable professional league remained years away.

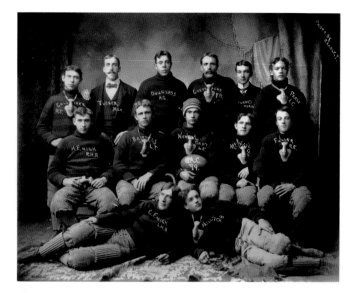

As the 1894 season got under way without the recently banned Flying Wedge formation, football's critics and defenders grappled as ferociously with one another in ink as the players they were discussing did in actual games. In November, police in Chicago stopped a game between Englewood and Hyde Park high schools "because the youngsters were slugging so viciously," and the mayor of Altoona, Pennsylvania, "announced that he will allow no more football playing within the city limits . . . If an attempt is made to play the game scheduled for next Saturday, the mayor will order the arrest of the participants." The secretaries of the U.S. Army and Navy canceled the service academy football rivalry for five seasons "because of a conviction that inter-academic football matches are detrimental to discipline and to the studies of the cadets."

Several colleges temporarily sidelined football out of concern that all students, not just the players, were more immersed in the game than in their studies, and beginning in 1892, Columbia dropped the sport entirely for seven seasons. Harvard and Yale called off their rivalry game in 1895 and 1896 to allow tempers to cool after the especially bloody '94 contest in which several players suffered broken bones and others left the game concussed and barely conscious. The reformer William Lloyd Garrison, once the country's best-known slavery abolitionist, maintained that high school players, bullied into playing and allowed to sail through their classes, were victims of the sport, "the product of a brutal public sentiment, marking a distinct social degeneracy."

In defending the game, the usual suspects—players, coaches, sportswriters, and fans—were joined by some unexpected eyewitnesses. The author Mark Twain, who took pride in exercising as little as possible, saw his first college football game at age sixty-four, finding it to be "the grandest game ever invented for boys—one which showed all their best qualities to advantage and a game that must necessarily build up the mind as well as the body." Unlike in years past, Yale's faculty backed the game.

A father of two New York City high school players suggested that "A football player commits his atrocities, if any, on his own kind . . . He may come out with a twisted nose or broken collar bone, but he takes about as many chances ten years later every time he crosses Broadway with two cable-cars going fifteen miles an hour in opposite directions." Poignant testimony in support of football came in 1897 from Rosalind Gammon, whose son, Richard, a University of Georgia player, died of injuries suffered in a game against Virginia. Amid calls to abolish the game, Georgia Tech and Mercer joined Georgia in shutting down their football programs, and state lawmakers quickly passed a bill banning the sport at state schools. With Governor William Atkinson poised to sign the legislation, Mrs. Gammon, citing her son's

(Above) Colorado Agricultural College team in padded uniforms with rubber face masks, Denver, 1899. The 1890s not only saw more teams adopt protective gear, as these players have, but football's popularity continued to grow with new teams forming in the West.

(Right) Dr. Charles Eliot (1834–1926). In 1895, Dr. Eliot, president of Harvard for forty years and a leading critic of football for at least half that time, asserted that the sport was "unfit for college use." An educational innovator and reformer, Eliot led the university to national and international prominence, moving from a classical curriculum to one that emphasized research and business. As a respected, high-profile figure, he received considerable publicity for and deference to his views. He argued that team activities not only interrupted players' studies, but also that coaches and crowds drove the players to greater levels of violence. "They are swayed by a tyrannical public opinion—partly ignorant and partly barbarous," wrote Eliot, who likened the game atmosphere to what was found at a "prize fight, cock fight or bull fight, or which in other centuries delighted in the sports of the Roman arena."

love of the game, requested "that the boy's death should not be used to defeat the most cherished object of his life." The governor acquiesced, and football returned the next season.

★ ★ ★ ★ ★

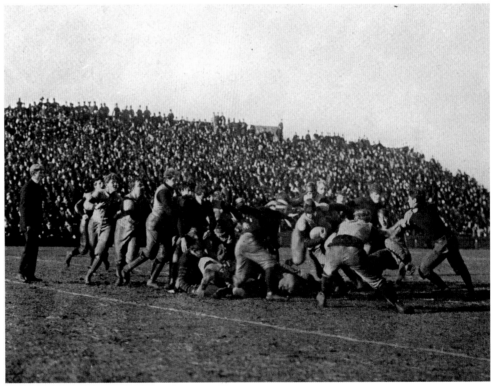

After centuries of casual play, in just under two decades American football had established itself as a distinct and major organized sport that had spread 3,000 miles, from Boston to Berkeley. What had not existed in the 1870s was extensive in the 1890s: football leagues and full schedules, specialized player regimens and rudimentary equipment, professional coaching and grandstands around the gridiron. By 1899, some 120,000 players were participating on 5,000 college, high school, and club teams; hundreds of thousands of fans watched games in person; and millions more followed the season in their newspapers. Yet even as football exited the nineteenth century as a widely popular and growing enterprise, it also entered the new century with its very existence in doubt.

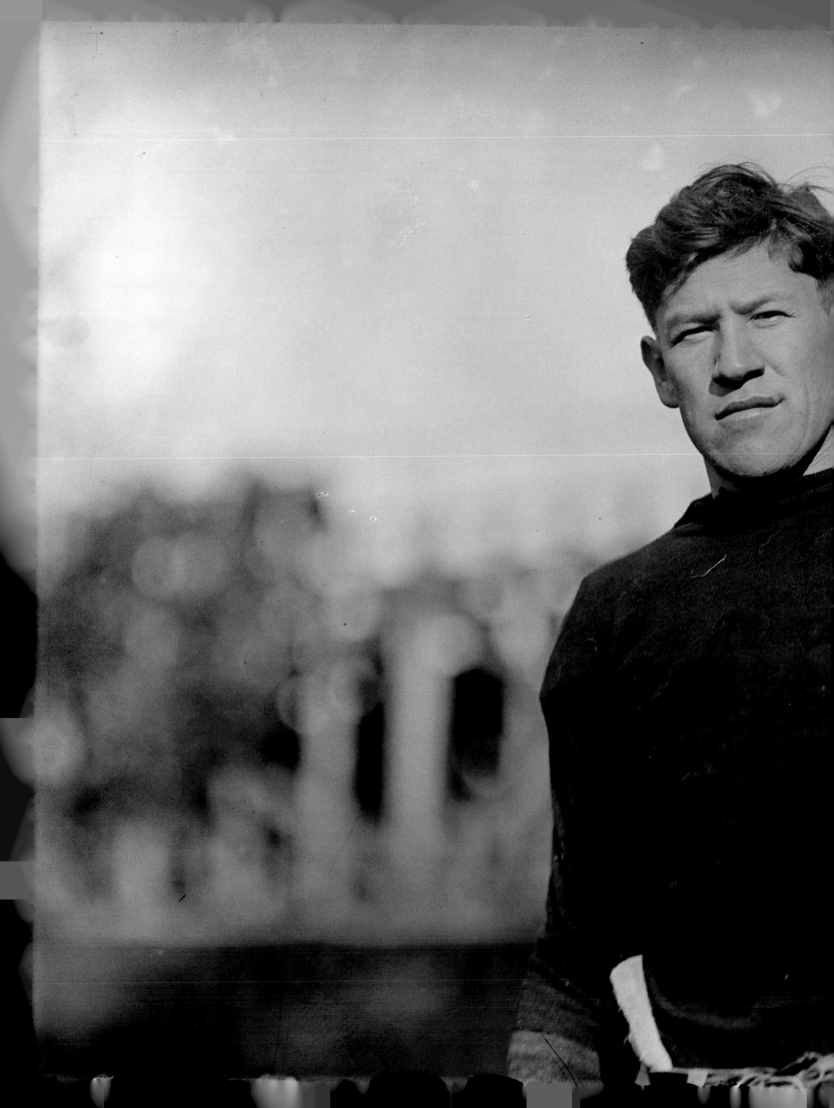

COLLEGIANS AND SPORTSMEN

1900 – 1929

Jim Thorpe, ca. 1915. Early pro football's best known player, Thorpe starred for the Canton Bulldogs beginning in 1915. The *Detroit Free Press* hailed him as "that sterling all-around Sac and Fox Indian athlete, who has gained more athletic fame than any other man who ever trod the cinder path or donned the moleskins."

Having ended the war in the Far East, grappled with the railroad rate question and . . . prepared for his tour of the South . . . President Roosevelt today took up another question of vital interest to the American people. He started a campaign for reform in football. —*New York Times* front page, October 10, 1905

The worst day American football had ever known fell on Saturday, November 25, as the 1905 season hobbled toward its conclusion. By early evening, a White House–brokered pledge was broken, two players were dead, and a third was barely alive. Within a few hours, the president had in his possession a long, grim tally of the year's football fatalities. Two days later, so did the rest of the country, and the list of the dead was accompanied by serious calls to abolish the game. Fans and foes alike agreed on one thing: Football, long accused and now condemned, appeared bound for the gallows. Only major reforms to the game might grant it a reprieve.

Even before the disconcerting season of 1905 began, the college game had some explaining to do. That summer, American football was splattered by the newly flourishing muckraking profession, which had set up shop on the moral high ground. The sport had withstood objections to its violence from the pulpit and criticism of its commitment to amateurism from the respected Caspar Whitney and many others, but the increased number of shovel-wielding, fire-hose-brandishing Progressive Era journalists presented a new challenge. Appalled by the Gilded Age excess that left a filthy residue on both the urban landscape and the national character, muckrakers exposed corrupt and debauched practices in the oil,

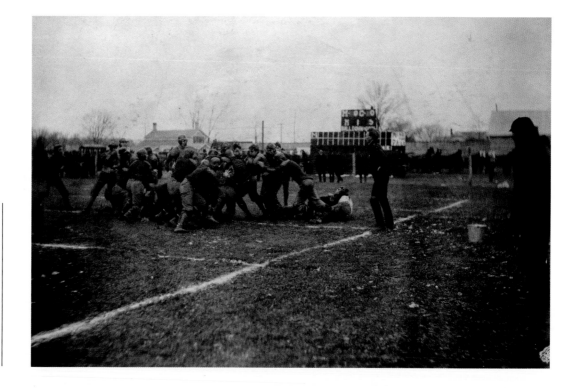

Michigan defeats Chicago, 22-0, Regents Field, Ann Arbor, November 16, 1901. Fans behind the end zone, horses to the right of the scoreboard, and Chicago Coach Alonzo Stagg, far right, watch as Michigan foils the Maroons' famous "whoa back" play. In the play, the quarterback spun around, handing off to an end who ran behind him rather than to a halfback.

mining, banking, and meatpacking industries, in the medical and health-care professions, and among prominent politicians and workaday government officials. College athletics fell under their inquisitive gaze as well. For the pure amateur sportsman, learning the extent to which corruption had tainted college athletics was almost as nauseating as learning what was really in the nation's meat supply.

A pair of articles that appeared in the June and July issues of *McClure's* magazine and a four-part series in *Collier's* that fall were especially influential in directing public attention to unseemly aspects of collegiate sports, particularly football and baseball. The reports detailed the unfair scourge of professionalism, a loss of academic integrity, and unscrupulous "proselytizing," as athletic recruiting was then called, a practice most readers were not likely familiar with. *Collier's* accused the University of Chicago of running a professional ball club. *McClure's* described overzealous recruiting methods that included offers of unauthorized scholarships and a guaranteed pass on the college entrance exam. Among the most disturbing discoveries was that Princeton players were specifically instructed to injure the best player on opposing teams within the first five minutes of play.

Somewhere, surely, Caspar Whitney's head exploded.

Whitney, not surprisingly, recommended the articles to his readers. Colleges, also not surprisingly, claimed that if their teams could not win honestly, they wanted no part in competitive athletics. Yet, as *McClure's* Henry Beach Needham and others pointed out, most school administrations and alumni wanted—demanded, even—a strong football program, one that brought further glory and attention to their institution. Even the brightest minds on campus would have had trouble figuring out how to win and be profitable while

"Down!" by Udo J. Keppler, *Puck* magazine, September 27, 1905. Players symbolizing corporate interests, including steel, tobacco, and oil, tackle a small, helpless consumer whose football represents tariff revision. President Theodore Roosevelt "busted" these industry monopolies, known as trusts, with the same enthusiasm he had for football.

relying only on the talent that was naturally found there. Thus, recruited players and experienced tramp athletes could serve as a useful insurance policy against a humiliating season.

In the meantime, the game had gotten bloodier. Boxing champion Jim Jeffries—later known as "the Great White Hope"—claimed that "Football is far more brutal than prizefighting. Every healthy man and woman likes to see a fight, and football is the hardest kind of fighting I have ever looked at. Call it strenuous sport or any other fancy name you like, it is just a big, red-hot fight." Defensive strategies had caught up with offensive maneuvers, cutting off end runs and resulting in close interior play. "No quarterback was willing, when he felt sure of his five yards through the line,

BACK AGAIN TO HARD STUDY

to take a gamble on ten or twenty around the end," said Yale coach William Knox. Offensive play, then, especially between evenly matched teams, consisted of repetitive plunges through the line, as if the entire game was one goal-line stand after another. The mass of clashing bodies frequently produced intense slugging, which, in the overall tumult, officials too often missed and spectators seldom noticed but that resulted in serious injuries. This type of play over two hours, however, could be less than spellbinding, as fans waited anxiously for the aberrant breakaway run. Such was the state of play in the controversial season of 1905.

(Right) "Back Again to Hard Study," by W. A. Rogers, *Harper's Weekly*, September 27, 1902.

(Below) Harvard-Yale game, Harvard Stadium, Pictorial News Co., November 25, 1905. There were no fatalities connected with this infamously violent meeting, save for the Yale alum who suffered a fatal heart attack later that day while reading accounts of the Elis' win on a Boston newspaper bulletin board.

November 25, 1905

I'm going to play in that game if I have to jump through that window. —Harvard captain Dan Hurley, from his hospital bed, referring to the upcoming Harvard–Yale game while recovering from a head injury suffered against Dartmouth

If the revelations in *McClure's* and *Collier's* were not disappointing enough, a season troubled by extensive violence had also drawn the attention of President Theodore Roosevelt, a keen sportsman, the country's foremost cheerleader for all things athletic, and a champion of the

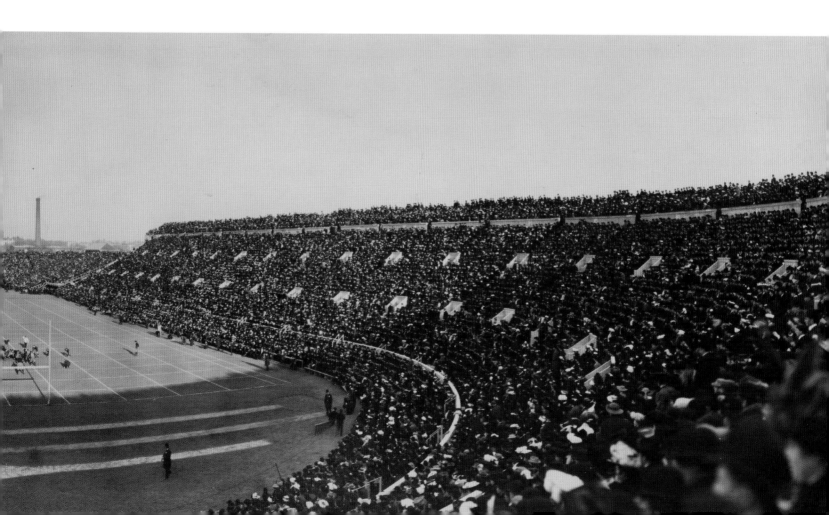

(Left) *Football Game*, Edward Penfield, ca. 1900, and the Harvard-Army game, 1904. Artistic and photographic renderings capture similar action on the field. Most player injuries resulted from close interior play, as seen here shortly before the advent of the forward pass, when offenses relied on plunges through the line for yardage.

Progressive movement. TR was long on record in support of football, and General Douglas MacArthur would later recall attending a Harvard-Yale game with the president who told him, "I would rather be in that Harvard backfield today than be in the White House." At the urging of others, Roosevelt convened a White House meeting on October 9 to discuss with coaches and representatives from Harvard, Princeton, and Yale—the Big Three—what could be done to eliminate football's brutality while maintaining a "manly game." The conference marked the first time that an American president involved himself in a sports issue; even Secretary of State Elihu Root sat in on the meeting.

Over the course of the afternoon, Roosevelt, characteristically, did most of the talking. For the president, the issue was not so much football's inherent dangers as it was that players exhibit good sportsmanship and play fair and that referees enforce existing rules. Afterward, the game's three leading powers issued a statement promising to follow "in letter and spirit the rules of the game." That football needed the intervention of the president of the United States to pledge that it would follow its own rules was rather absurd. Yet the well-received conference underscored just how much interest there was in producing a game that was

neither too deadly nor too tame. As for the Big Three's pledge, it did not amount to much, as Francis Burr could have told anyone on November 25, after he regained consciousness.

Burr, a nineteen-year-old freshman and rising star for the Crimson, put on a spectacular kicking performance that day in the Harvard-Yale contest, the most anticipated game of the season. (Captain Hurley, who could barely sit up, much less stagger to the nearest window, received game updates in his hospital room from a specially installed telegraph wire.) Harvard, with one loss on the year, hosted undefeated Yale, but the Elis' 6-0 victory was soon overshadowed by two incidents less triumphant than the final score. In one instance, a Yale player was ejected for punching a Harvard man in the ribs. The more controversial case centered on Burr. After he signaled for a fair catch, Yale's captain, Tom Shevlin, charged into him anyway, and Jack Quill struck Burr squarely in the face, breaking his nose. Harvard's outraged coach, Bill Reid, was urged to take his team off the field by none other than the philanthropist who had donated the very turf that Burr was bleeding over. Quill, apparently rabid, was still upset that he had been bitten earlier by a Harvard man. Worse yet, the officials declined to call a penalty on the play. Reid kept his men in the game but saw to it that the umpire—Paul Dashiell, the head football coach at Navy—never again had the honor to officiate a Harvard game. Reid also personally described the incident to President Roosevelt, who, in his rare moments of inactivity, sat on Dashiell's promotion at Annapolis for months. Clearly, the Big Three's pledge would not suffice.

T. ROOSEVELT, JR., THE STAR.

Saves Harvard Freshmen from Defeat Worse than 5 to 0.

(Special to The World.)

WORCESTER, Mass., Oct. 28.—Harvard's freshmen were defeated in a football game this afternoon by the Worcester Academy. The score was 5 to 0 and it would have been bigger had it not been for Theodore Roosevelt, jr. Jones had got through the entire Harvard eleven and was headed for a touchdown, but young Roosevelt caught him after a hard run and brought him down with a neat tackle.

This was young Roosevelt's first game for Harvard and he was one of the star performers. He showed he was game all through and played left end for all there was in it. He made several pretty tackles.

THE WORLD: SUNDAY, OCTOBER 29, 1905.

At Harvard T played football on the Freshman team & on the 2nd Eleven, although he weighed less than 130 pounds, until he broke his ankle (v. picture being helped off the field.)

FOOTBALL YEAR'S DEATH HARVEST.

Record Shows That Nineteen Players Have Been Killed; One Hundred Thirty-seven Hurt.

TWO ARE SLAIN SATURDAY.

FOOTBALL KILLS 21

Forty More Are Crippled in Short Season of Two Months on the Gridiron—Girl Numbered Among the Slain—Sport More Deadly Than Automobiling.

REFORM PLAY OR ABOLISH FOOTBALL

Chancellor MacCracken Calls On Pres Eliot to Help.

Harold P. Moore of Union College Killed on Ohio Field.

In the Bronx that day, Union College of Schenectady, New York, faced off against New York University. Among the visiting Dutchmen was nineteen-year-old Harold Moore, whose father had made the 400-mile trip from Ogdensburg to watch him play. In the tussle, a teammate inadvertently knocked Moore out. Fearing there was no time to wait for an ambulance, doctors and coaches loaded him into a fan's automobile for the short trip to the hospital. There, Moore died a few hours later from a cerebral hemorrhage brought on by a concussion. Shortly after Moore's accident, at a high school game in Rockville, Indiana, Bellmore's Carl Osborne, age eighteen, son of the school principal, was killed almost instantly making a tackle when he broke a rib that punctured his heart. Finally that day, at a game in Sedalia, Missouri, between Southeastern and Summit high schools, another teenager, Robert Brown, landing awkwardly on the ground, was left paralyzed from the neck down.

That evening the *Chicago Daily Tribune* telegraphed the White House a detailed account of the season's casualties: "Today's fatalities bring the total of slain to nineteen . . . This year's record of deaths is more than double that of the yearly average for the last five years, the total for that period being forty-five . . . Of those slaughtered, eleven were high school players and ten of the killed were immature boys of 17 and under. Three hardened, seasoned and presumably physically fit college men were slain. The others were amateurs." One fatality was an eighteen-year-old Maryland woman, playing on a girls' team, and another was a fourteen-year-old Wisconsin boy, killed in a freak accident when he "fell in a scrimmage and a weed entered his nostril, penetrating the brain." Among the injuries players sustained that season, the *Tribune* listed internal and spinal damage, concussions, blood poisoning, and broken collarbones, arms, legs, and skulls. Other newspapers supplemented the *Tribune*'s account with their own catalog of carnage, including injured players not expected to survive.

So distraught was Henry MacCracken, the chancellor of NYU, by what had occurred on his home field that he telegraphed his counterpart at Harvard that evening, asking him to organize a meeting of college leaders to discuss football reform. This, Charles Eliot refused to do. MacCracken had hoped that if the nation's oldest college and a sporting powerhouse demanded changes or threatened to abolish the game, everyone else would fall in line. But as far as Eliot was concerned, any reform movement was at the mercy of Walter Camp. "He has always controlled the existing irresponsible committee on rules," wrote Eliot in a letter to Nicholas Butler, president of Columbia. "I should never have had any faith in his superintendence of football reform, inasmuch as he is directly responsible for the degradation and ruin of the game. The trouble with him seems to me to be that he is deficient in moral sensibility—a trouble not likely to be cured at his age." Furthermore, Eliot believed that making a few adjustments to rules would solve nothing. In his view, "Deaths and injuries are not the strongest argument against football." The far greater "evils" that infected the sport were the "immoderate desire to win," the advantages that came with cheating, the excessive praise of players, and the "misleading" consideration of football as war.

Although Eliot opted to stay on the sidelines, NYU's MacCracken and the *Tribune* were not the only ones responding to the events of that fateful Saturday. On Sunday, the University of Pennsylvania stated it would redouble its ongoing efforts to promote reform, which put special emphasis on player eligibility. On Monday, William Moore accompanied his son's body back to Ogdensburg. On Tuesday, the White House announced that the president would be at the following Saturday's Army-Navy game, reassuring football advocates that

Roosevelt's support remained firm. In New York City, NYU scheduled a conference, in which attendees would consider game changes and alternative sports to football. In Sedalia, paralyzed Robert Brown died from his injuries.

The biggest news on Tuesday, however, was Columbia University's decision to abolish football. The Committee on Students' Organization—which had no student members—not only disbanded the varsity team but also decreed that students who played on their own were subject to expulsion. "The reasons for this action need no explanation," explained one committee member. "Only by such radical action can the university and college life be rid of an obsession, which, it is believed, has become as hindersome to the great mass of students as it has proved itself harmful to academic standing, and dangerous to human life." The Lions' coach, Bill Morley, now out of a job, did not exactly help his sport's case, suggesting that "When you consider that during the football season probably 100,000 players are engaged in the game, the death rate is wonderfully small." Columbia students rallied in protest on Wednesday, but the committee was unmoved. For the next ten years, the Lions remained in their den, absent from intercollegiate football.

"I think that is going entirely too far," said Cyrus Northrop, president of the University of Minnesota—whose team had, it is worth noting, just gone 10–1—on learning of Columbia's decision. And most players shared the opinion of Yale captain Tom Shevlin, who asked, "Didn't 48,000 people go out to see the Yale-Harvard game? If there was anything wrong with the game, would a crowd like that attend?. . .The game is okay as it is. Why change the rules? The talk about injuries and brutality is all rot." But others, especially those who had witnessed fatalities or serious injuries, appeared to reconsider the game as it was currently played. One of the biggest names to disown the game belonged to Harvard's Karl Brill. "I believe that the human body was not made to withstand the enormous strain that football demands," he told the press in early December, announcing his decision to stop

(Opposite) Newspaper headlines, in autumn 1905, call attention to the growing crisis in football.

(Above) *Columbia*, poster, by John E. Sheridan, 1902. A poster within a poster depicts a football player, surrounded by other accoutrements of campus life, and an idealized view of the American college man.

(Left) *Harvard Scores*, poster, by John Jepson, 1905.

playing. "Moreover, I do not believe the game is right. I dislike it on moral grounds. It is mere gladiatorial combat." He knew whereof he spoke; Brill was the player who had been punched in the ribs during the Harvard-Yale game.

Meanwhile, after a couple of days of silence, Walter Camp agreed that changes to the game were necessary. As he had so many times before, he quickly identified improvements, partly by revisiting his own ideas that the rules committee had previously rejected, such as increasing from 5 yards to 10 the distance needed for a first down. This, Camp argued, would open up the field of play and relieve congestion at the line of scrimmage, where so many injuries occurred. It would also allow smaller, speedier players to participate, since brute strength alone would matter less. The challenge for Camp was to save as much as possible a game that was still relatively new and did not have generations of tradition behind it. "Some of the proposed changes are so radical that they would practically make a new game," he cautioned. "What we want to do is to preserve the game and eliminate the objectionable features."

In the remaining days of 1905, a general consensus of "mend it or end it" emerged, with the widespread realization that the only way to save the game was to change it. Although football would never rid itself of all the ills its critics diagnosed, even supporters acknowledged that there was room for improvement. Most interested parties, led by President Roosevelt, opposed federal or state legislation that would regulate school football. Others, however, such as the presidents of Harvard and Columbia, did not trust Camp's rules committee to make significant reforms. Yale's president, Arthur Hadley, believed it was up to students and alumni to fix the game, not college presidents. And the fact was, students still ran football—they managed the teams, scheduled games, handled finances, recruited players, and often hired the coach. Young alumni and former players were also closely involved, and the authority and attentiveness of any given faculty athletic committee varied greatly from school to school; some committees were more of the overlook than the oversight variety. Simply put, "Faculty control is a myth," said Stanford University president David Starr Jordan.

Rugby and Reform

Teams advertise for players and buy them like chattels. Players sustain permanent physical and moral injuries. The spectators, under the excitement of a great game, become hoodlums, exhibiting violent partisanship and gross profanity, bestowing idiotic adulation upon the victors and heaping abuse upon the referee. —Professor G. T. W. Patrick, University of Iowa, on the perception critics had of the game in 1903

Popular journalist Ralph D. Paine concluded that the 1905 season "was chiefly notable for the fact that the game was played all over the country in the face of a general revolt against the rules in force." Under palpable pressure, the football rules committee (primarily consisting of Easterners) hunkered down for the winter. A rival committee (which had greater western representation) formed as well, made up of members selected at the conference MacCracken and NYU sponsored in early December. At year's end, the two groups merged, each realizing they needed the other: The old committee required an infusion of reformers' blood to keep the game alive, and the new committee counted on the expertise of traditionalists to maintain football's essence. Their alliance marked the founding of the Inter Collegiate Athletic Association (later renamed the National Collegiate Athletic Association, or NCAA), which was responsible for implementing and overseeing the new regulations.

Image from the *Spokane Press*, November 30, 1905. A newspaper graphic illustrates an accounting of the season's injuries. The accompanying article described "lives sacrificed to mass play" and listed players who had become "cripples for life."

CHAPTER 2 · COLLEGIANS AND SPORTSMEN

SEASON'S FOOTBALL FATALITIES TOTAL AN APPALLING NUMBER

DEATH AND BROKEN BONES IN GRIDIRON SCRIMMAGES — TWELVE LIVES SACRIFICED TO THE MASS PLAY — THE SIGHT OF TWO PLAYERS DESTROYED — YOUTHS MADE CRIPPLES FOR LIFE—ACCIDENTS NOT RESTRICTED TO MINOR SCHOOLS—NEED OF MODIFIED RULES—RECORD OF THE YEAR'S VICTIMS.

Gridiron Victims.

Deaths	12
Partially paralyzed	1
Eyes gouged out	1
Intestines ruptured	2
Backs broken	1
Skulls fractured	2
Arms broken	4
Legs broken	7
Hands broken	3
Shoulders dislocated	7
Noses broken	4
Ribs broken	11
Collarbones broken	7
Jaws broken	1
Fingers broken	4
Sholders broken	2
Hips dislocated	4
Thigh bone broken	1
Concussion of brain	3

Seventy-one recorded deaths is the list of football fatalities in the past five years. Twelve deaths is this season's record, but it will probably be increased, as there are half a dozen players in hospitals so badly injured that death may ensue at any time.

Seventy-eight accidents of a serious nature happened on the gridiron this season, according to newspaper reports, exclusive of minor injuries, such as wrenched knees, torn ligaments, dislocated arms and turned ankles. The deaths by years for the 20th century are as follows:

1901	7
1902	15
1903	14
1904	13
1905	12

The deaths for 1905 were almost exclusively confined to members of high school or small college teams. The list is as follows:

Bryant, Jas. Edward, member of Canon City, Col., high school team; killed in game with Florence, Col., high school, Oct. 19.

Decker, Miss Bernadotte, aged 18, killed in game at Willimantic, Oct. 22.

Dondero, John C., Jewett City, Conn.; killed in game at Willimantic, Oct. 22.

Ficken, G. C., member of junior team Southern Athletic club, New Orleans; injured in game with the Queen and Crescent eleven, Nov.

Wise, Vernon, Oak Park, Ill., aged 17 years, member high school; hurt in game with Hyde Park high school; died Nov. 3.

In nearly every instance the deaths have led to the abandonment of football by the high schools and smaller colleges to which the victims belonged. Among the other gridiron victims who may forfeit their lives as the result of injuries inflicted during games are Scott dero received injuries that cost him his life, his brother, Fred Dondero, was kicked in the face and his left eyeball burst, causing the loss of the eye. Leo De Tray of the Chicago university may lose the sigt of one eye as the result of being kicked in the face in the game with Northwestern, Nov. 18.

In a game played at Bridgeport, Conn., Oct. 23, James Burns, 16 years old, received a broken arm; Ed Sirretta had four ribs broken and John O'Brien's hip was dislocated.

The claim is often made that injuries are sustained by boys and young men not in physical condition to play football; that the members of the college elevens, under careful training, are less liable to injury. As a general proposition

Draper, Notre Dame, foot crushed; Silver, Notre Dame, shoulder dislocated; Koster, Oberlin, O., college, hand broken; McCarthy, Indiana university, shoulder broken; Snyder, Ursinus college, shoulder dislocated; Abel, Ursinus, collarbone broken; Gordon, Bethany, Pa., shoulder dislocated; Captain Conn, Lorain, O., Athletic association, two ribs broken; Captain Roudebush, Denison, O., collarbone broken.

Edward Mynders, who played with the Elyria, O., team, received injuries in a game Nov. 13 that made him a cripple for life. C. H. Montgomery is partially paralyzed from injuries received in a game at Richmond, Va., Oct. 6. In a game at Marshalltown, Ia., on Nov. 11, Randall McLeod's intestines

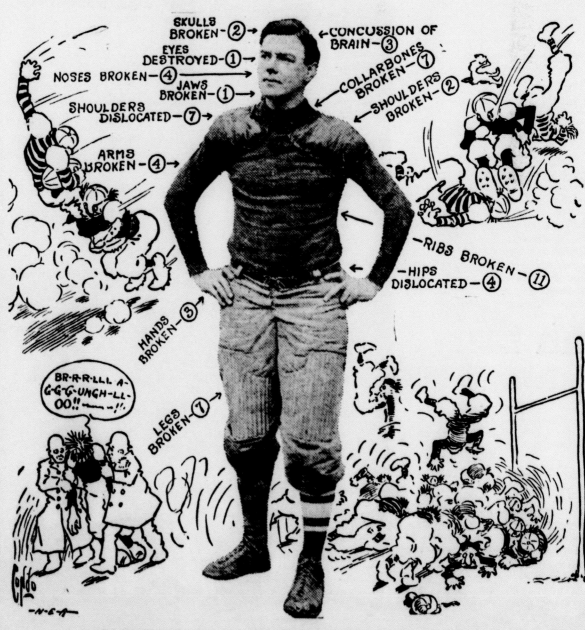

TWELVE DEATHS THE 1905 TOLL GRIDIRON GAME EXACTS.

Foot Ball Heroes WIN IN Life's Game

Success Written Large on Life's Page by Erstwhile Warriors of the Gridiron. Statistical Reports From the Great Centres of Learning and Foot=Ball

DOES foot-ball help or hurt a man in the after battles of life?

Does the instinct of overbearing physical force—the breath of power in the nostrils of the brute—contract the finer and, off the field, the more useful attributes of the man?

Is it not true that the adulation and applause of a public gone sport-mad inflicts upon its object a false idea of his importance in the world, so that he may come to despise the details and suffer resentfully the hardships that are a part of every success and of every successful business man?

In fine, may not the limelight have deranged the vision of the man who one day must face the minutiae of doing work-a-day things?

This newspaper has sought to secure a consensus of opinion on the point. The result appears upon this page. There may be no mistaking the temper of foot-ball players, coaches and promoters of the game regarding the help and the hurt of it.

They agree either that foot-ball does not hurt or that it helps.

While it is true that the contributors to the symposium point to no failures, the exhibit of successes is imposing and not to be despised.

All the professions, notably that of the law, have been graced and strengthened by the accession of sturdy talent from the gridiron.

Men who have made their colleges more famous by reason of their brilliant work with the pigskin have executed a mental hurdle landing them in professors' chairs that they fit to a nicety.

These men of punt and tackle have been heard of in war and on the seas; their keen, true scalpel has gone to the infinitesimal vital point that marked the line between life and death, between surgical failure and achievement.

They have braved the dangers of the Klondike and have walked home over the graves of weaker men, bearing golden burdens.

Their big voices, once raised in college yells, are mellowed to accord with the incense that floats about the altars over which they preside.

They are running newspapers, managing railways or treading the devious paths of the sciences, their brains clear, their hands firm, their limbs sturdy.

It may be argued that these were men too good and too strong to have been brutalized or weakened by the life of the foot-ball player. But that, perhaps, proves the point of our contributors that while the game may not help it does not hurt.

To appreciate fully the effect of foot-ball upon the enthusiastic and habitual player, one must know foot-ball. And to know foot-ball one must have played it.

To the onlooker, even granting that he be familiar with the rules and the ethics of the game, the cardinal essence of the play may not be seen or imagined.

"Often the players themselves do not grasp the subtle shadings of the play in which they are engaged," said a student-writer of the game. "In my capacity as sporting editor of a newspaper I have been called upon repeatedly to produce photographs that my man had taken of certain points in the play, this to determine disputes between the coacher and those whose work he directed."

If in the rush of victory and the struggle for advantage, the men of the gridiron, trained as they are to think and act as one great machine, are unable to keep pace with the points of a play in which they are the life and the centre, how is the spectator in the grandstand to understand or judge?

A. Conan Doyle, viewing the famous Penn-Princeton game at Trenton in 1894, rubbed his big hands gleefully at a high-pitch point and exclaimed:

"That's warfare!"

He was right, but he might have gone further. War teaches a man the value of generalship, strategy, daring and caution; foot-ball teaches all of these—is all of them—but it teaches and is, besides, alertness, self-control, concentration.

Many a magnificent specimen of manhood, who, in a way, was invincible on the foot-ball field, has been cast out of the lists because he lacked one or more of these essentials.

Honorable rivalry is one of the things that foot-ball demands of a man. The giant who has just mown down a line of opposition, leaving sorry marks of his prowess, must stride out of the carnage with a smile on his face. And the man whose one arm he has put in a sling is expected to extend the other at next meeting.

This is all good training for the "life rush," our correspondents agree. The evidence that they produce in support of their point is worthy of a passing look.

F. EARL CHRISTY

FOOTBALL IN 1906.

During the winter and spring of 1906, the rules committee focused on producing a safer, open game, and, in doing so, it also managed to come up with a more captivating one. The most intriguing and exciting modification was the introduction of the forward pass. This maneuver, it was rightly assumed, spread the playing area out over more of the field, reducing the number of bodies bunched together at the line of scrimmage. Although the pass was infrequently used at first (initially, throws were limited to 20 yards, and incompletions were penalized), for spectators, watching a successful pass suddenly result in a large gain or an instant touchdown was more than thrilling—it was magical. Other improvements included lengthening the distance from 5 yards to 10 for a first down; establishing the neutral zone at the line of scrimmage; expanding the description of, and increasing the penalties for, personal fouls, unnecessary roughness, holding, and unsportsmanlike conduct; shortening the game time to two thirty-minute halves; and designating the positions of four game officials (referee, two umpires, linesman).

The overwhelming majority of schools—including, notably, NYU—gratefully accepted the new rules and eagerly scheduled their 1906 seasons. The Western Conference also went forward with the season but reduced its number of games by half. Most high schools retained the sport as well. A few college programs, however, temporarily disappeared: Baylor, California, Northwestern, South Carolina, Stanford, and Union College joined Columbia in dropping the sport. The California schools further thumbed their noses at the Eastern sports establishment when they introduced rugby as a substitute game.

For the rest of the country, the success of the 1906 changes, following some initial chaotic play, was most apparent at the end of 1907: Fans and players found the new American game superior to the old. For a sport clinging to life only two years earlier, football's turnaround raises the

(Opposite, top) "Foot Ball Heroes Win in Life's Game," *St. Paul's Globe*, October 18, 1903. The handsome hero and his adoring followers accompanied an article in which the author found that "All the professions, notably that of the law, have been graced and strengthened by the accession of sturdy talent from the gridiron."

(Opposite, bottom) University of Pennsylvania silk pillowcase, by F. Earl Christy, 1907. Early twentieth-century team merchandise included pennants, sweaters, and mugs, as well as pillowcases for the parlor settee. Note the woman's multicolored chrysanthemum, bred specifically to represent Penn's colors.

(Above) "Football in 1906," by John S. Pughe, *Puck* magazine, January 3, 1906. Many fans worried that new rules to make football safer would result in a less manly game played by sissies, fops, and dandies.

Meanwhile, out in California . . .

Long after its debut and decline
on the East Coast, rugby was
again in vogue, this time on the
West Coast. In February 1906,
California and Stanford hosted
teams from Canada and New
Zealand for a series of exhibition
games. The next month, the two
universities, whose distance from
the heart of big-time college
football facilitated an apparent act
of treason, replaced the American
game with one from England.
Cal referred to its own study of
football's brutality, and Stanford
pointed to the rules committee's
past ineffectiveness as reasons
for making the change, though
both believed the greater problem
was that football interfered with
their academic missions. Pomona
College and the University of
Nevada soon followed suit. The
Eastern press was dismissive,
but for ten years in the Far West,
football was rugby. By 1910, most
California high schools had made
the switch, and Walter Camp
arrived to study the situation. The
Los Angeles Herald even predicted
that "Rugby style of football will
be [the] ultimate successor to
American."

International opinion on
California rugby would prove
to be equally optimistic and off
base. In 1910, the All-American
rugby team, comprising players
from various California colleges,
made such an impression during
their tour of Australia that
sportsmen there suggested they

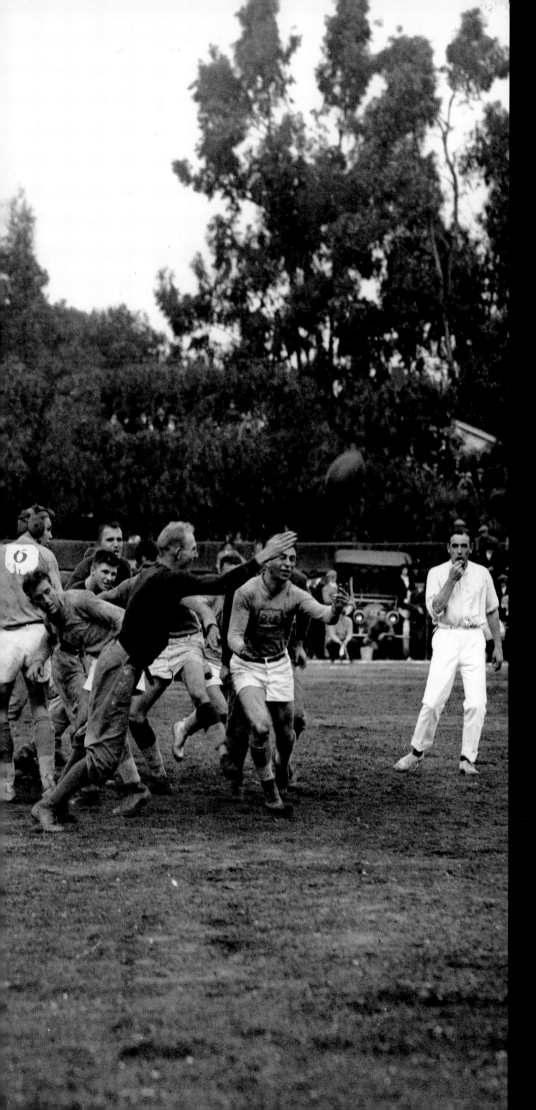

might soon take the rugby world title. Perhaps they would have, had the tide on the West Coast not turned back toward the American game. The University of Southern California, which went to rugby from 1911 to 1913, found the game "grievously wanting," according to team manager Warren Bovard. Among the complaints, Bovard cited more injuries in rugby because more men were on the field at once. Another problem, which American football had rectified as it evolved from rugby, was an arbitrary scoring system that bore little relation to the value of plays (rugby would rectify this issue as well). In the meantime, the death rate among college players in the American game had fallen from a high in 1909. USC and Cal both returned to the American-football fold in 1915; Nevada changed back that season so as to play Cal and rekindle its rivalry with Utah. Stanford held out a little longer. Its president, Ray Lyman Wilbur, vowed in 1916 that Stanford would never abandon rugby. "Never" lasted two and a half years; then it was back to American football.

Rugby football match between California and USC that ended in a 3-3 tie, Los Angeles, November 27, 1913. *Los Angeles Times* sportswriter Owen Bird—who a year earlier had given USC teams their nickname, the Trojans, reported that "As the dawn that comes up like thunder, out of China 'cross the bay, the Trojan Rugby warriors . . . smashed, crushed and rushed the Bears off their feet, tying the score . . . thereby snatching victory from that gaunt specter defeat, which had been looming up grimly . . ."

question of whether the game had really been on the brink of execution, as so many believed at the time. The record suggests that many players were resigned to losing their sport. The greatest indication, though, that football was seriously threatened is seen in the conciliatory actions of two antagonistic rules committees. Those sportsmen would not have forged an alliance and hammered out an improved product if they did not believe it was necessary to save the game.

On the other hand, despite American football's adolescence, by 1905, the game had amassed tremendous assets in its favor and would not have been easily brought down. Claiming autumn as its own, the sport had found a welcome, comfortable niche on the nation's recreational calendar. "Accepting the game as institutional," rhapsodized journalist Clarence Deming in 1902, ". . . what is more moving than the 'big' American football game! . . . With time, moreover, the game has begun to acquire a classic flavor, indexed by the growing stock of traditions . . ." Adding to football's attraction and sense of spectacle, especially in rivalry games, was its relative infrequency. Professional baseball teams played 154 regular-season games, while college football teams typically had no more than ten games, making every contest significant and worth getting excited about.

Schools had also come to rely on football revenue to support their athletic associations and finance other sports. Potential monetary losses, perhaps not appreciated at the height of the "Ban Football" fury, were more apparent later, specifically during budget meetings, making football a more difficult line item to remove. As to the complaint about the high rate of injuries, one resourceful student compiled university statistics that showed there were more

Broadway production of ***Strongheart***, **Hudson Theater, New York City, 1905.** Robert Edeson, center, under a coat of vermilion makeup, starred in the title role in William C. DeMille's comedy-drama set at Columbia University. Strongheart, a popular Sioux football star, is denounced by a prejudiced teammate, left, when he becomes engaged to the player's sister. In the fourth act, Strongheart feels compelled to give up his fiancée and return to his tribe as their new chief. Edeson enjoyed good reviews and toured with the show nationwide.

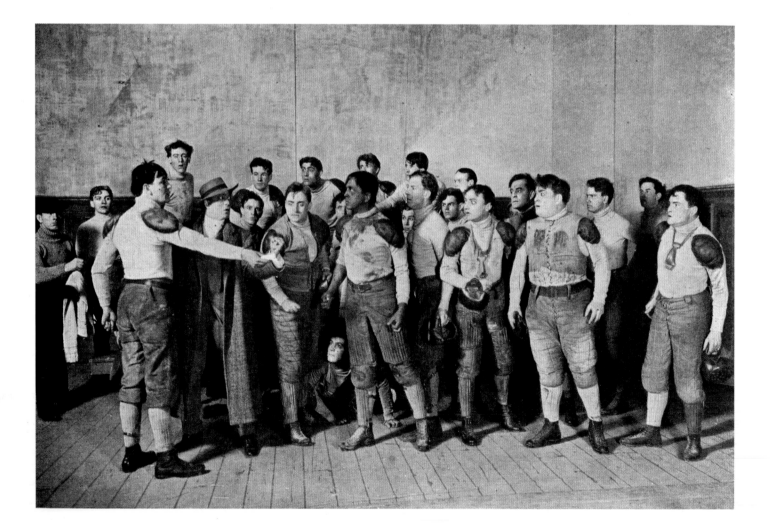

CHAPTER 2 · COLLEGIANS AND SPORTSMEN

accidents in winter on Harvard's slippery walkways than there were on its football field. Further, the economics of football had become a significant consideration for others who profited from the game and had an interest in its preservation and advance, including sportswriters and newspapers, the sporting-goods industry, stadium owners, local businesses, and advertisers.

Aside from financial rewards, football controlled important, intangible assets not easily shed. In football's short history as an organized sport, no other campus activity could match its ability to rally the student body, foster school spirit, please alumni and donors, and spread institutional name recognition. Not even recipients of the recently established and highly prestigious Nobel Prize and Rhodes Scholarship came anywhere near attracting the positive attention for an institution that the school's varsity eleven garnered. As Charles Seymour noted in the *Yale Literary Magazine* in 1908, "There could not be fifty men in Yale College who could not tell you who was captain of the football team in 1906, and there are hardly fifty who could tell you who was president of Phi Beta Kappa." Around the same time, Dr. Daniel Steele, a Boston Methodist minister, in a magazine column headlined "Football Preferred to Christ," complained that the game had become "a matter of so great importance" at Harvard "that a lecture on the 'Relation of Christ' to some element of civilization, by Professor Francis G. Peabody, was recently postponed for a mass meeting on football." Such were the formidable factors— both the practical and the sublime—that weighed against abolishing football.

"The College World," *Puck* **magazine, November 14, 1906.** In the world of reformed football, a helmeted sun shines on North America, depicted as a stadium.

Although the drive to save the game was successful, the efforts to make it safer were less so. Football remained a violent sport. Surprisingly, the college fatality statistics for 1906 were identical to those for 1905, but there was a modest decrease in serious injuries, and fewer deaths occurred among high school players. Despite the fatality numbers, in the spirit of the times, a feeling prevailed that at least something was being done about the danger, that progress was being made, and that a responsive organization was now in place to monitor the rules as needed. The reforms reflected the effect muckrakers and the Progressive movement had on American society at large, pointing out, in shout-sized seventy-two-point type, various ills people had previously put up with or never worried about but now had to resolve.

Let's Make a Deal

The only positive way to prevent accidents would be to cut out the game and substitute association football, and then the ingenious American college man would find some way to make the game dangerous. —L. deP. Vail, University of Pennsylvania varsity player (1889–90; 1892–93), in 1909

Perhaps the most important outcome of the 1905 controversy was the deal fans and the country at large struck with football, a deal that has remained in force ever since: They chose the excitement, the opportunities, and the benefits that the game offered in exchange for tolerating serious casualties and ethical lapses. As part of this symbiotic arrangement, when

THE CARLISLE INDIANS: AN UNLIKELY POWERHOUSE

Like Camelot, to which it bears no further resemblance, Carlisle enjoyed a brief, shining era of miraculous feats that passed into legend, as intriguing now as it was fascinating to the public then. The Carlisle Industrial Indian School in Pennsylvania played football from 1893 until World War I, when the War Department reclaimed the school for use as a hospital following Congressional investigations into mismanagement and student mistreatment. During its glory years (1902–13), Carlisle was a household name among sports fans, and its team comprised quick, lithe young men plucked from the prairies and the plains. Most had never seen modern American football before, and some did not speak any English.

When Carlisle and West Point finally scheduled a game in 1905, the U.S. 7th Cavalry massacre of Lakota Sioux at Wounded Knee Creek fifteen years earlier was still fresh in the minds of the army and Indian communities. The Carlisle players, through their own family histories and as students at a federal school run under military discipline, had very different experiences with the U.S. Army than other Americans. "The coming contest with the army is stirring the hopes of all the Carlisle students," the *New York Times* reported, "this being the first time that the War Department officials have consented to trials of athletics and skill between their protégés and the redman." Carlisle beat Army 6-5 on the soldiers' home field.

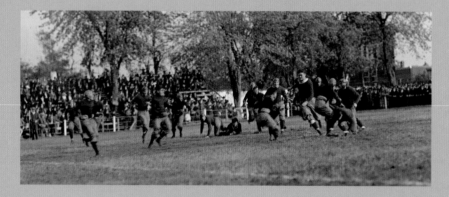

The team did not return to West Point again until 1912, when that one-man track-and-field team, Olympic pentathlon and decathlon champion Jim Thorpe, was on the roster, and innovative coach Glenn "Pop" Warner was on the sidelines. "The Injuns scalped Captain Devore and his soldier team by a score of 27 to 6," said the *Philadelphia Inquirer*. "The Army was completely baffled by the bewildering double pass that Carlisle used for great gains." This game earned much of its lasting fame long after the fact, once players other than Thorpe had gained national reputations, such as Army halfback Dwight D. Eisenhower and a slew of future World War II generals.

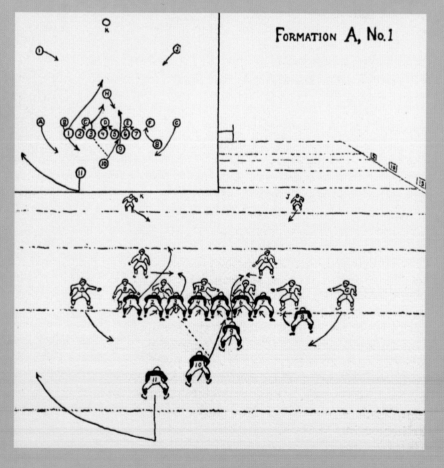

FORMATION A, No. 1

Carlisle was unique for a football powerhouse. It was not a college—it was a coeducational trade school, and most students came from poor or modest financial circumstances. Nearly all of Carlisle's games were on the road, as the school lacked facilities to accommodate large crowds, and it preferred to reap a healthy share of the gate receipts its opponents promised. The Indians also played an unusually fast-

paced, exciting brand of football marked by Warner's fondness for sleight of hand—hidden ball tricks, feints, flea-flickers, unbalanced line formations (later known as the single wing, which he developed in response to the 1906 rule changes), body blocking (to accommodate their smaller size against large opponents), and all manner of unconventional plays, often communicated only by hand gestures. As early practitioners of the seldom-used forward pass, Carlisle did not hesitate to go long, and, unlike other teams, they would pass on any and all downs.

During Carlisle's brief run, fans packed the stands when they came to town. The Indians' skill, colorful names, and "exotic" nature prompted curiosity and often empathy. Carlisle was the first nonwhite team to regularly play the sport's reigning powers, acquainting players with the upper echelons of U.S. society. One result was that most found it difficult to live in their home communities again, as they straddled Indian and white America. Many went on to play football professionally or became coaches. In those cases, Carlisle accomplished what it had set out to do—propel students into the wider culture. Less publicized were the instances in which attempts at assimilation proved psychologically damaging. After Carlisle closed, the Haskell Institute in Lawrence, Kansas, became the nation's premier Indian school and, like its predecessor, earned much recognition through its successful football team.

(Opposite, bottom) Carlisle formation, *Football for Coaches and Players*, by Glenn Warner, 1927. As Carlisle's coach, Warner used this asymmetrical formation with great success; it later became known as the single wing, for its shape, and was the most common formation in use until the 1940s. Note that the center (3), with the ball, is not actually positioned in the center.

(Above) "The American Indian, Past and Present," by Albert Levering, *Puck* magazine, November 28, 1906. Carlisle players are depicted as having moved from their traditional activities to American football. On the right, a Carlisle banner waves over the field as the Indians engage in one of Coach Glenn Warner's signature trick plays.

(Right) *2-98-49-C.-O.-D.—Charge!* by Albert Levering, *Puck* magazine, November 8, 1905. The game makes its presence felt in everyday life as eager shoppers in football stances await the opening of a department store.

(Opposite, top left) "Gee, but You Look Funny," by Will Crawford, *Puck* magazine, November 13, 1912. A "chrysanthemum-haired" player and one sporting the latest protective gear illustrate the increased use of safety equipment over a twenty-year span.

(Opposite, top right and bottom) *Yale-Harvard 1911* game program. The hand-stitched, ball-shaped leather program sold at the 1911 game included a photograph of Harvard's left halfback, Hamilton Corbett, on a 25-yard run in the 1909 game. (Note the well-dressed official.) The Crimson lost that contest, 8-0, and the game between the two undefeated teams concluded the deadliest year in the sport's history; the next day the *New York Times* reported twenty-six players killed during the season.

football visibly crosses a perceived threshold into danger or scandal, the public registers its disapproval, but it does not abandon the sport. Various authorities and participants respond, assurances are made, order is restored, the game continues, and much satisfaction is derived by all, secure in the knowledge that a deal is a deal.

The public's pact with football was soon put to the test. In 1909, there were more than two dozen football fatalities, and, unlike in 1905, most occurred in the college game. That revelation belied the claim that football was most dangerous for less experienced or poorly trained players. Members of the ICAA football rules committee believed that the high death toll was "largely traceable to the diving tackle, to persistent massed attack upon a given point, and in certain cases, to the exhausted condition of the players." The response was to ban diving tackles, require seven men on the line of scrimmage, and to divide the game into four fifteen-minute quarters, to allow for player substitutions. (Unless they left a game because of injury, players had usually stayed in the whole time, playing both offense and defense.) Notably, at season's end, there was no concerted effort to ban the game as there had been four years earlier, and ICAA school presidents voted overwhelmingly to keep football. They held that the best way forward was to continue tweaking the rules, improve player training and officiating, and develop better equipment.

By the 1910s, most fatalities were at the high school level, and Coach A. A. Stagg recommended universal physical examinations for all schoolboy athletes. Although some college players had begun using simple leather padding, rubber nose guards, and light headgear in the 1890s, padded, aviator-style helmets were just coming into general use in 1909. Heavy leather shoulder pads stuffed with wool or foam padding became more prevalent, and there was greater faith that the ongoing application of technology would improve equipment and reduce serious injuries. The unwritten football-and-fan deal made it possible for the game to continue growing, experimenting, and improving without fear that missteps would lead to banishment.

NOV 13 1912 PUCK BUILDING, New York, November 13th, 1912.
VOL. LXXII. No. 1863. Copyright, 1912, by Keppler & Schwarzmann. Entered at N. Y. P. O. as Second-class Mail Matter. PRICE TEN CENTS.

YALE-HARVARD
1911

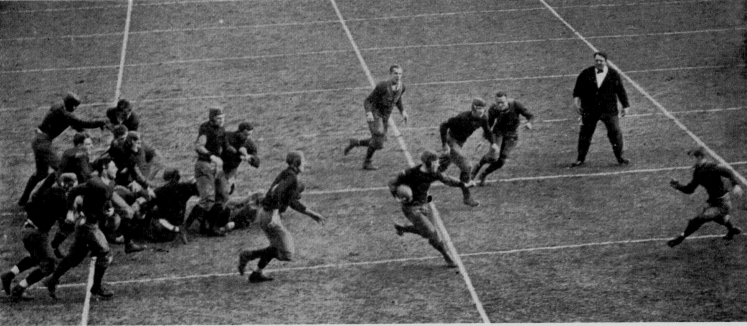

FIGHT! FIGHT! FIGHT! THEN, FIGHT SOME MORE

There is perhaps no other musical genre more aptly named than the "fight song," given that in some instances the word "fight" accounts for most of the lyrics. With a lineage steeped in English music halls, drinking ditties, vibrant folk culture, and a malleable concept of public domain, the American fight song first appeared at football games in the late nineteenth century, joining a catalog of somber, reverential college hymns. Fight songs differed in that they were short, snappy, intended for use at sporting events, and often directly referenced football or rivals by name. Newly formed school bands, modeled after military bands, clearly welcomed the opportunity to turn traditional march music or familiar melodies into an uplifting rite of fan participation.

In writing "The Victors" (1898), Michigan sophomore Louis Elbel, ecstatic over his team's come-from-behind win against Chicago, produced an enormously influential early fight song, imitated not only for its sound but also for its purpose. "The Victors," joined by the "Notre Dame Victory March" (1908) and "On, Wisconsin!" (1909), were written at the height of the Tin Pan Alley era in popular music, and they still routinely land at the top of Best Fight Song lists. Each features stirring, anthemic rhythms that sweep the song forward—or "down the field" (as Yale would say) or "across the field" (in the words of Ohio State).

In 1907, with the football crisis over and fight-song production in full swing, the *Boston Daily Globe* remarked, "There is hardly a popular air that is not immediately twisted about for local college use with words which are, if possible, even worse than those of the original." By 1920, few schools and football teams were without a fight song, as students nationwide urged victory, pledged loyalty, and exhorted everyone to fight, fight, fight. Amid the borrowing and pilfering, songsmiths modified everything from gospel ("When the Saints Go Marching In") to folk ("I've Been Working on the Railroad"), to popular spirituals ("The Battle Hymn of the Republic"), to military and patriotic march music ("The Caisson Song"/"The Army Goes Rolling Along") in fashioning the college fight song.

Mighty Oregon, 1916.

Georgia Tech's instantly catchy "Ramblin' Wreck" is derived from an old Scottish drinking tune, "Son of a Gambolier." The University of Oklahoma's bouncy "Boomer Sooner" is a sped-up version of Yale's "Boola Boola," itself a faster form of an 1898 song by Cole and Johnson. Yale, as an early football power, was an obvious source of plunder for band directors who came along later; the Elis' "Down the Field" also turns up in the form of the Volunteers' "Here's to Old Tennessee" and the University of Nevada's "Hail, Sturdy Men!" These and other college numbers, in turn, were then adopted with revised lyrics by high schools, which is why the music to "On, Wisconsin!," for example, is heard in so many football stadiums nowhere near the state.

Hurrah for Dear Old Dartmouth, 1903.

Notable loyal sons and daughters who produced original works include American icon Cole Porter, who wrote several at Yale, and Tom Lehrer, the comedic singer-songwriter and math professor. As a student, Lehrer filled an apparent need for a dignified fight song with "Fight Fiercely, Harvard" (1945), which exhorted, "Let's try not to injure them, But fight, fight, fight!" Milo Sweet, from the University of Southern California, was especially prolific, contributing the galvanizing and relentless "Fight On" (1922) and other Trojan numbers. A dentist and song-slinger for hire, he wrote, among others, "Fight Vols Fight" for Tennessee and "Go You Spartans" for Michigan State. Sweet must have received some special dispensation, however, to author songs commissioned by crosstown rival UCLA. The Bruins also recycled songs. In 1936, the school asked the recently relocated Gershwin brothers for a new fight song. Ira reworked the lyrics from their 1927 Broadway number "Strike Up the Band," and,

California Give It to Him, 1937.

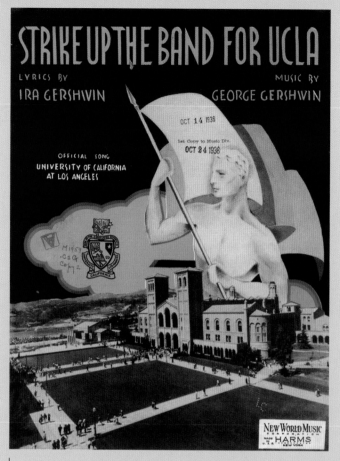

Strike Up the Band for UCLA, 1936.

Fight On Ohio, 1941.

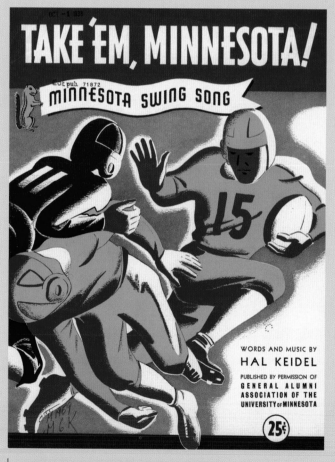

Take 'Em, Minnesota, 1938.

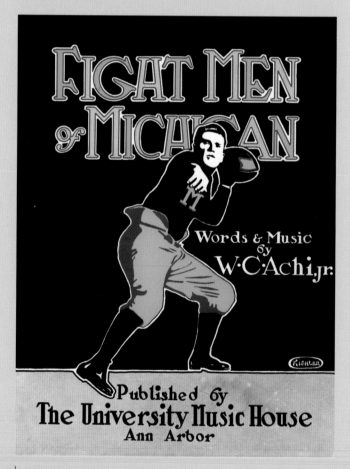

Fight Men of Michigan, 1915.

voilà, there was "Strike Up the Band for UCLA." When the school discovered that rival UC Berkeley's adrenaline-releasing "Big C" was not under copyright, the Bruins appropriated the tune (as did other UC schools), rearranged it, added some swirling horn work, and converted it into "Sons of Westwood."

Some NFL teams have dabbled in creating a fight song tradition, but the professionals, which historically were less likely to have bands, cheerleaders, or youthful spectators on hand, have been less successful overall. Green Bay's "Go! You Packers Go!" (1931) is the league's oldest fight song, and Washington's "Hail to the Redskins" (1938) its most notable, albeit with slight changes to the lyrics, which originally referenced scalping and Dixie. Philadelphia's "Fly Eagles Fly," used in the 1960s, eventually fell out of favor but took off when revived in 1994. Disco rhythms set "San Diego Super Chargers" (1979) apart from the rest of the field. Marv Levy, when he coached Kansas City, wrote a fight song in 1979 (borrowing the tune from a Chicago high school) "to fully capture fan and city spirit," then, as the Bills' coach, penned "Let's Go Buffalo" in 1994. Levy's Buffalo effort was inspired by a loss during which he endured "that doggone 'Bear Down, Chicago Bears' fight song" throughout the game.

A functional fight song must be neither too slow, so as to lose its urgency, nor too fast for fifty thousand people to sing at once. Even with its generally limited lexicon and subject matter, a typical fight song mentions the school colors and contains at least several of the following elements:

Lyrics seemingly written in secret code:

"Oskee wow wow" (Illinois)

"Hullabaloo, Caneck! Caneck! . . . Chig-gar-roo-gar-rem! Chig-gar-roo-gar-rem!" (Texas A&M)

"Ay Ziggy Zoomba Zoomba Zoomba" (Bowling Green)

"Um ya ya, um ya ya" (St. Olaf)

"Sock their kabinas, you Javelinas" (Texas A&M, Kingsville)

Profound confidence:

"Run the ball clear down the field, a touchdown sure this time" (Wisconsin)

"Foes shall bend their knee before us, and pay their homage to pow'r so great" (Colgate)

"No doubt about it,
 We're gonna shout it—Bobcats will win this game!" (Southwest Texas)

"Hail to the team whose conquering might
 Brings fears to all foes they play" (West Virginia State)

"It's harder to push them over the line
 Than pass the Dardenelles" (Washington)

Rousing calls to action:

"Shake down the thunder from the sky!" (Notre Dame)

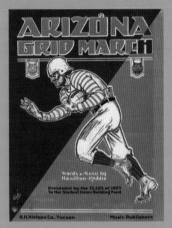

Arizona Grid March, 1925.

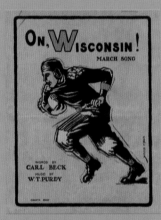

On, Wisconsin!, 1909.

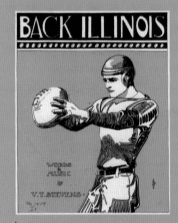

Back Illinois, 1914.

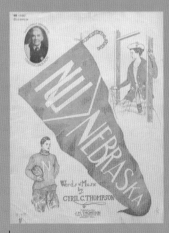

Nebraska, 1917.

Notre Dame Victory March, reissue, 1948.

"On your toes dig in and hit that line" (Fresno State)

"Circle the ends and crash through the center" (Arizona)

"Here they come zooming to meet our thunder,
 At 'em boys, give 'er the gun!" (Air Force)

Local sentiment:

"Where the girls are the fairest and the boys are the squarest" (Nebraska)

"We'll buy a keg of booze, and we'll drink to the Aggies, 'til we wobble in our shoes"
 (New Mexico State)

"I'm a Sooner born, and a Sooner bred, and when I die, I'll be Sooner dead" (Oklahoma)

"And the squeal of the pig will float on the air,
 From the tummy of the Grizzly Bear" (Montana)

"You're Dixie's football pride, Crimson Tide!" (Alabama)

Victory song of William and Mary College, 1931.

Violent, warlike imagery:

"You got to scalp 'em, Seminoles!" (Florida State)

"We'll drop our battle axe on Georgia's head, CHOP!" (Georgia Tech)

"Adieu, adieu, Lehigh, adieu, adieu, adieu,
 There will be nothing left of you, left of you" (Lafayette)

"Golden Panthers, see the paw,
 We will fight, you'll feel the claw!" (Florida International University)

"We'll stomp 'em in the mud,
 Their green will turn to blood
 In our hour of victory, Blood! Drip drip drip" (UC Davis)

The Battle Song of Princeton, 1905.

A sense of unity:

"Ten thousand men of Harvard want victory today" (Harvard)

"For it's hail, hail, the gang's all here, and it's onward to victory!" (Arizona State)

"Hail, hail, the gang's all here, so let's win that old conference now" (Ohio State)

"Hail, hail, the gang's all here, and it's good-bye to all the rest!" (Texas)

"That is why we jollify, and that is why we sing" (Grinnell)

Animal sounds:

"Bulldog, bulldog, bow-wow-wow, Eli Yale!" (Yale)

"From his lair he fiercely growls, Grr-ah! Grr-ah! Grrrrr—ah!" (California)

"Grrruff! Hail to the Bulldogs, ripping, roaring, tenacious Bulldogs" (Truman State)

On Iowa, 1919.

Harvard players practice tackling on a weighted dummy, Bain News Service, 1912.

Although the sport's popularity and its violence dominated football conversations in the early twentieth century, something else was especially noticeable by 1901, when Caspar Whitney published the first season-ending list of the top twenty teams in the country: Seven squads hailed from the Midwest, one was in the South. Until then, the nebulous "college championship" had been credited to a Northeastern powerhouse by general acclamation, if there was a worthy candidate for the title. There were no playoffs, no official championship game, and no coaches' or sportswriters' polls for determining the best teams. Statistical analysis consisted of looking at what teams had a zero in the loss column. Scholars and historians have since retroactively named nineteenth-century football champions, and, in doing so, one of the Big Three either owned or shared the title nearly every year from the 1870s to 1900, with Penn or Lafayette occasionally snagging a share of the belated honors.

In the early twentieth century, however, the growing parity among teams and the improved quality of play nationwide signaled that the days of Northeastern dominance were clearly waning: Between 1913 and 1920, various authorities awarded the national title to such far-flung teams as Georgia Tech, Auburn, Michigan, Oklahoma, Texas, and California. The year 1919 brought a watershed season, as West Virginia crushed Princeton, 25-0, and Boston College upset Yale, 5-3. The Big Three made their last claims for the top ranking in the 1920s, and, with that, the founders of American football gradually receded into the realm of local play, rulers of a small regional fiefdom. Both happenstance and deliberate decisions contributed to their reduced status. Widespread high-quality competition prompted teams to travel greater distances for games, a time-consuming and expensive endeavor. As it was, the Big Three played nearly all their games at home (they alternated sites for their games against each other), and their regional opponents dutifully visited them, happy to play in an excellent facility before large crowds and share in the gate receipts. In choosing not to travel nationwide, the Ivies inevitably appeared in fewer important games. Eventually, in 1945, long after the Big Three's heyday, the Ivy Group Agreement bound the associated schools to a higher standard of academic eligibility and eliminated football scholarships, thereby ensuring the league's disappearance from big-time football.

THOSE EVER CHANGING FOOTBALL
RULES

"NOW LET ME SEE. WHAT DO I DO
NEXT?"

Several more critical adjustments to American football rules followed in 1912, and the changes continued along the path toward livelier play charted six years earlier. Among the major changes, most passing restrictions were eliminated, and the size of the ball was reduced, allowing for a more sophisticated aerial game and the advent of long bombs. Teams also now had four downs to gain 10 yards; the value of a touchdown was increased from five points to six; and the length of the field between goal lines was shortened from 110 yards to 100. These positive changes, painstakingly debated since 1906, produced a vibrant game on the field that was mirrored by the antics in the stands.

Energized by the faster, more thrilling sport, fans found new and more involving ways to participate, as pep rallies, cheerleaders, and mascots gained greater currency. The ubiquitous college band played fight songs and patriotic fare between quarters. Male students who were especially engrossed in organized exuberance had women barred from designated cheering areas—or given their own—lest their presence be a distraction. (Yale's game advertisements advised that "Only one ticket will be sold to each individual for the cheering section, and women are positively not admitted to this section.") A foreign visitor witnessing his first American football game described himself as "astonished and fascinated" by the Dartmouth cheering section, under the direction of two young men whose purpose was to keep the rooters "in a constant state of mental and tracheal inflammation."

(Above) "Those Ever Changing Football Rules," by Paul Goold, *Life* magazine, November 14, 1912. Players had to master a new set of rules for the season, the most important of which opened up the passing game.

(Right) Captain Benjamin Hoge, left, and five West Point teammates, Bain News Service, 1913.

CHAPTER 2 · COLLEGIANS AND SPORTSMEN

Huts Versus Tents

My own idea is that it would be a great mistake for this country to depart from its normal, healthy ways of life, including healthy amusements, because of the situation in Europe. —Secretary of War Lindley Miller Garrison, September 17, 1914, opposing a suggestion to suspend college football during World War I

What works in the game of football will work in the game of war. —*Stars and Stripes*, weekly newspaper of the American Expeditionary Force, May 3, 1918

In the uneasy summer of 1914, a complex web of entangling alliances drew the major European powers and their colonies into a disastrous war, one defined on the Western Front by trenches and devastation in No Man's Land, the battlefield that lay between those earthen gashes and feculent burrows. For nearly three years, the United States managed to stay out of the conflict—President Woodrow Wilson's 1916 reelection campaign was centered on this particular accomplishment—but when Germany reinstituted unrestricted submarine warfare

in the Atlantic, the country marched into the fray. On April 2, 1917, the day Wilson asked Congress for a declaration of war, Secretary of War Newton Baker wrote to the president on the benefits of incorporating college football training methods into military training. If the United States, with its tiny regular army of just over 100,000 men, was to quickly train and mobilize some two million enlistees and conscripts, "the experience of our colleges in recreation will go a long way by analogy to aid us," said Baker. The president, formerly the head of Princeton University and, as a student, co-director of the Princeton College Football Association, agreed.

Football had been played recreationally on some military bases for years, but the effort to equip and organize service teams took on greater emphasis in 1916. The War Department determined that servicemen fending off Pancho Villa's incursions along the border with Mexico spent too much time in bars and brothels, and what the men *really* needed was a first-rate, time-consuming athletic program. Although the primary purpose of service team football was to raise morale rather than another glass, its usefulness in hand-to-hand combat training was readily apparent. At Camp Upton in New York, the "over the top" drill was essentially a goal-line stand exercise between platoons. (Going "over the top," in the parlance of the war, referred to leaping out of a trench and charging toward the enemy.) The Commission on Training Camp Activities (CTCA) even appointed the biggest name in football—Walter Camp—as the U.S. Navy athletic director,

(Above) *Athletic Annual, 1914–1915,* **University of Michigan.** Michigan's sports guide gave preference to the football team, as did the university itself, in that the stated dimensions required for the block letter *M* used on varsity football sweaters and jerseys was noticeably larger than those permitted for baseball, track, and tennis.

(Left) *El Paso Herald,* **November 25, 1915.** Front-page photographs contrast Thanksgiving Day in devastated Europe with the traditional football games in the United States, which had not yet entered the Great War. Even the Cornell-Penn game results made the front page of this Texas newspaper.

Femmes Fans Fatales

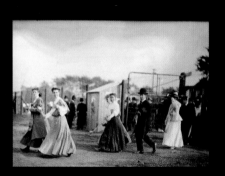

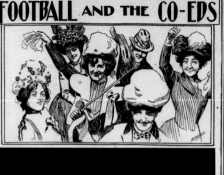

Women's increasing presence in football was a source of inspiration for both Madison Avenue in its portrayal of fresh, natural American beauty occupying the stands and for bemused male commentary. Some women, however, needed coaxing that this football thing was actually worth seeing. To make the game-day experience more inviting, young Franklin Delano Roosevelt suggested in a 1903 *Harvard Crimson* editorial that "It is undoubtedly disagreeable for ladies under the present seating system to be surrounded with smoke and flying ashes from tobacco which is not always of the best quality . . . it is not unreasonable to ask that a separate section be provided which ladies may enter without fear of being asphyxiated."

One newsman commented in 1912 that "the feminine interest in the game . . . is very real, very vital. Your football girl of the younger generation, whose name is legion, follows the various phases of the game with interest as keen, with intelligence as wide, and knowledge as profound as her brother, or other male escort." Coach Carrie Burckhardt, age twenty-seven, took that "very real,

very vital" interest even further, serving as coach of the Price Hill High School football team in Covington, Kentucky, beginning with the 1913 season. A graduate of Vassar, the coach, described in the press as "about the most attractive, most feminine little woman ever," led "her boys" to a 6-0 record. It can only be hoped that she would have received similar acclaim had she sported a more ordinary appearance.

In 1911, a British commentator observed that "The excitement and enthusiasm of the women, indeed, struck me as most extraordinary. In England if a woman goes to a football match, she spends half the time in criticizing the colors of the jerseys and the other in lamenting the fact that her feet are so cold. There is nothing of that sort about the American woman . . . She appears ready to swoon with excitement at any given point in the game . . . If a player runs ten yards with the ball, which is a considerable run in American football, she beats her clenched fists on the shoulders of the person in front of her, ejaculating: 'Oh! Oh, my land! There he goes! Oh, my land!'"

At Northwestern, however, Dean Thomas Holgate pointed his finger at young women for the team's losing skid in 1914, when it finished 1-6. The dean's appeal: "Let the football players alone. Don't keep the football stars up late, girls. Don't feed them rarebits and candy that puts them out of condition. Make that 200-pound boy who comes to call feel cheap if he hasn't tried out for the eleven—and one last word, don't set the football men to dreaming about you when they ought to be rehearsing signals." The women of Evanston must have eased up on the men just a tad, as Northwestern improved to 2-5 the next year.

(Top left) Fans of Northwestern University pass through the entrance gate at Marshall Field, Chicago, 1905.

(Top right) A Stanford fan, left, and a California supporter, right, demonstrate their cheering techniques and paraphernalia before the Big Game, 1900.

(Opposite) Cover illustration, by J. E. Sheridan, *Sunday Magazine*, November 28, 1909. Ladies enjoy a view of the team bench, where a player holding his rubber nose guard awaits the call to enter the game.

SUNDAY MAGAZINE
Of the NEW-YORK TRIBUNE

COPYRIGHT, 1909, BY ASSOCIATED SUNDAY MAGAZINES, INCORPORATED.

NEW YORK
NOVEMBER 28, 1909
PART III.
20 PAGES

JESHERIDAN

and the coach popularized a set of exercises known as the "Daily Dozen," designed to keep both servicemen and the home front in shape.

Beginning in 1917, from "Somewhere in France," as American soldiers overseas usually referred to their location at any given time, came a flurry of game reports in between battle news. "Though we are far from home, the boys did not lose the old spirit that always reigned supreme on Thanksgiving Day in the States," wrote Ralph F. Seifert, a private in the U.S. Railway Engineers. "So we arranged to play a football game between the boys who live in the huts and those who live in the tents. While practicing for the game, we had to place guards around the field so that no spies could creep into any of the shell-holes and get a line on our signals . . . Betting was even, and some 1,500 francs, or about $265, was placed on the two teams . . . Just as Lieutenant Ruggles of our company blew the whistle to call play, a flock of airplanes, 17 in all, patrolled the sky overhead, and Fritzy started shelling the ridge which sheltered the field where the gridiron was located. There were some British officers, and many British soldiers on the sidelines witnessed the game . . . remarks were passed by the British soldiers to the effect they would much rather 'go over the top' than take part in such a game as that." The contest ended in a scoreless tie, but "We are all feeling fine," concluded Siefert, who played left end for the Huts, "a little bit sore in a few places, but happy."

In response to a request for 500 footballs, "Big Bill" Edwards, a guard on Princeton's 1896–99 teams, spearheaded a drive to collect funds and equipment for the troops in Europe. The well-connected Edwards put Walter Camp, A. A. Stagg, Paul Dashiell, and many other prominent football men on his scavenger committee. In writing to potential donors, Edwards pointed out, "You may not be able to get to France, but think of the wonderful privilege you have of sending your football clothes across seas." At the same time, the army's resourceful 38th Division, unable to procure "football suits" for its team—known as the Hunhuskers—created uniforms out of aviator caps, Red Cross sweaters, and denim fatigue breeches

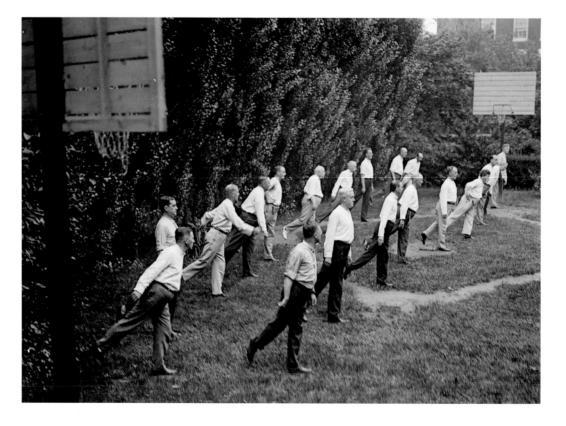

U.S. cabinet officials participate in the Walter Camp Exercise School, Washington, D.C., Harris & Ewing, 1917. During World War I, the "Father of American Football" devised a series of simple exercises for the Navy that later became known as the "Daily Dozen," a program soon promoted to all Americans as a way to rapidly condition the body. Franklin D. Roosevelt, assistant secretary of the navy, is in the back row, third from the right.

CHAPTER 2 · COLLEGIANS AND SPORTSMEN

reconfigured with extra padding. The army, working with the YMCA and other charitable organizations, understood that a competitive athletic program would help maintain soldiers' morale, and it oversaw highly organized leagues and tournaments in more than a dozen sports, of which football was the most popular. (A failed attempt to stage a speed skating championship was a rare setback.) All of this activity was duly reported and avidly read in the sports pages of *Stars and Stripes*.

For servicemen still "Over There" after the Armistice in November 1918, the highlight for many was the AEF championship football series held in early 1919. As *Stars and Stripes* later observed, it "was probably the best conducted sport on the Army list. The games attracted thousands, and every man in the various units was seen pulling for his team." Top players from various company and regimental teams represented their divisions, and seven division teams headed to the French capital for a three-round playoff. On the recommendation of a Belgian colonel who had seen American football, the king and queen of Belgium attended a playoff game between the 7th and 36th Divisions. "Upon conclusion of the game," reported *Stars and Stripes*, "General Pershing called the two teams together in front of the grandstand, where the queen snapped their pictures with a pocket Kodak."

A crowd of 15,000 off-duty troops, American civilians, and hospitable locals turned out for the March 29 championship game—an excellent display of Rose Bowl–style hoopla and precise military pageantry—at the Velodrome, Parc des Princes. General Pershing and other top officials were present to watch the 89th Division come from behind to claim a 14-6 victory over the 36th. A year later, when the 89th Division's official wartime history was published, it contained a detailed account of the team's battle accomplishments and its triumphant football season. Of the celebration that followed the AEF title game, the author said only, "Paris was not dull that night."

At home, graphic reports on the horrors of actual warfare tempered views on football violence. General objections to the game's inherent roughness did not entirely subside, but compared to armed charges, poison-gas attacks, and artillery fire, football no longer seemed quite so dangerous. It was also more popular than ever. Some 1.3 million servicemen participated in football from 1917 to 1919, and those who had never played or followed a team before the war returned home eager to see more of the game. Within three years of the war's end, more than a dozen colleges started varsity teams, fourteen new stadiums popped up (including a 60,000-seat behemoth at Stanford University), and efforts to launch a national professional football league were under way. "America's college record is passing that of the Roman Empire in the number and size of amphitheatres built for games and athletic contests," reported the *New York Times* in 1922. "Many of the American structures are far larger than anything in the ancient world, marking a new golden age of sport and outdoor amusement." By the end of the decade, seating capacity in American grandstands and stadiums had increased 148 percent since 1920.

(Above) Cartoons in the *New York Evening World*, October 20, 1917. Bolstered by a cheering media, Americans were confident that their football-players-turned-soldiers would triumph over Germany and its allies. The press predicted that U.S. troops would be especially effective using hand grenades "because of their skill in throwing a baseball or a football . . . as the Germans will learn."

(Following pages) Army defeats Navy 15-7 at the Polo Grounds, New York City, Bain News Service, 1916.

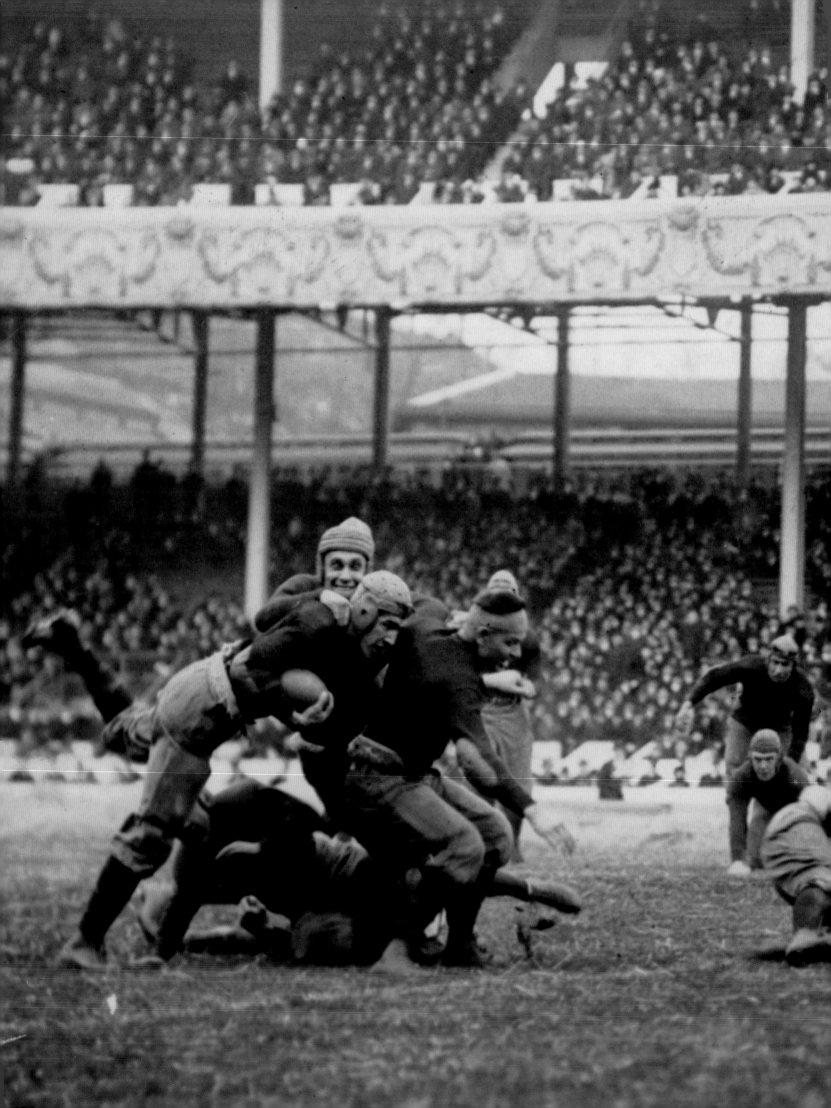

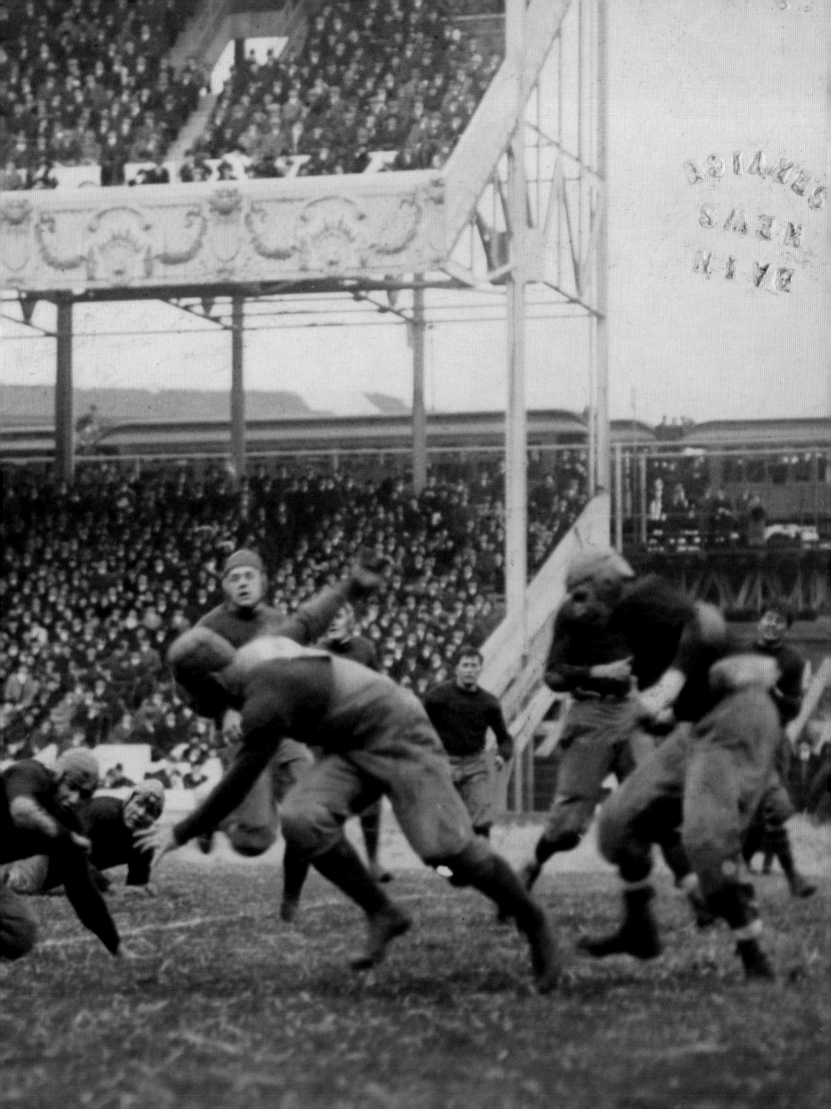

(Right) The 33rd Division football team, Diekirch, Luxembourg, by Sgt. C. H. Jackson, February 28, 1919.

(Below) Scenes from the AEF championship game between the 36th and 89th Divisions, Paris, France, March 29, 1919. "It wasn't necessary to add the 'perhaps.' It WAS the greatest game of American football in history," wrote Lucian Swift Kirtland, *Leslie's* war correspondent, of the title match. He noted that the participants were among the greatest football heroes of the previous half dozen years, and "the parade of victory reminded all of college days."

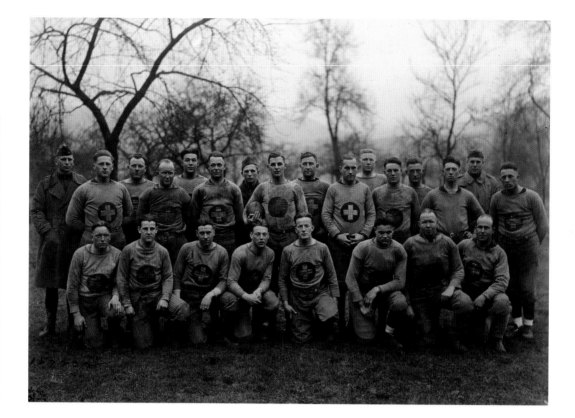

Associations between football and the war's legacy were archived in stone with the construction of large "memorial" stadiums that honored a university's students or state residents killed in the conflict. With so many willing contributors to these projects, building funds were quickly established. Replicating traces of Roman architecture, as at the Los Angeles Coliseum (1923) and at Champaign, Illinois (1924), these monuments to sacrifice and to sport strengthened connections to the ancient idea of warrior as athlete and the American notion of football player as soldier. Likewise, university memorial stadiums at Kansas (1921); California, Nebraska, and Oklahoma (1923); Minnesota and Texas (1924); Indiana (1925); and Missouri (1926) met a need to both commemorate the country's losses and accommodate the game's growth. In Chicago, the colonnaded Grant Park Stadium (1924) was renamed Soldier Field on Armistice Day the next year.

The United States exited the war with its territory and infrastructure unscathed and, unlike most of Europe, unburdened by war debt and the need for reconstruction. With its new status as a major world power secured, the country pivoted inward, disinclined to participate in another foreign-manufactured catastrophe but destined to produce one of its own in the pursuit of good times and an eternally sunny future. Until the Great Depression silenced the Roaring

Twenties, the United States indulged, to a degree not previously possible, in two of its favorite activities: producing wealth and mass entertainment. These two endeavors joined forces as never before, and football was among their gilded, gleaming offspring in the forthcoming Golden Age of Sport.

What Made the Golden Age So Golden

This is the golden age of sport, the age of the multitudes shelling out golden shekels beyond all past records. —Sportswriter Grantland Rice, October 10, 1923

Both archival and anecdotal evidence supports the perception that the 1920s was a jazz-loving, machine-gun-toting, bathtub-gin-producing, Prohibition-defying, stunt-flying, flagpole-sitting, Communist-hunting, immigrant-shunning, Jim-Crowing, religion-reviving, Charleston-crazed, flivver-driving, flapper-happy, hair-bobbing, sports-mad, Great-Gatsbying, trials-of-the-century-sensationalizing, laissez-fairing, stock-buying, skyscrapering, über-urbanizing-America-on-a-bender era.

Naturally, college football, with its energetic crowds, exciting action, and revenue-generating capabilities, fit right in with the times. The game also benefited from a doubling in college enrollment from 1918 to 1930, increasing football's fan base as industry demanded better-educated employees. Industry, in turn, flourished in a pro-business environment, fostered by the Harding and Coolidge administrations, that encouraged entrepreneurial business innovations as well as dangerous financial risks.

The Golden Age of Sport, as both astute journalists in their own time and latter-day historians have referred to it, boasted an unprecedented alchemy of athletics, entertainment, and media interest. As the nation recovered from the war and from losing more than a half million lives to the 1918–19 influenza epidemic, it focused on expanding its postwar prosperity, and a staggering leap in mass-media technology shared that focus with millions. "The grip which sport now has on the masses, the classes, the high-brow and the low-brow, man, woman and child, is beyond all measuring," wrote Grantland Rice, a prominent sportswriter throughout most of the early twentieth century.

College football charged right into the widening pantheon of the country's favorite sports, where it joined baseball, boxing, and horse racing. Football would soon find its first great national star in an Illinois ice deliveryman (see page 120), while U.S. athletes dominated international sporting news in boxing (Jack Dempsey), golf (Bobby Jones), tennis ("Big Bill"

Army-Navy game, Soldier Field, Chicago, November 27, 1926. The rival service academies settled for a 21-21 draw before a crowd of 110,000 at the first Army-Navy game played in the Midwest. The stadium, a memorial to the city's war dead, was officially dedicated that day, becoming a landmark venue and gleaming example of the era's grandiose sports palaces.

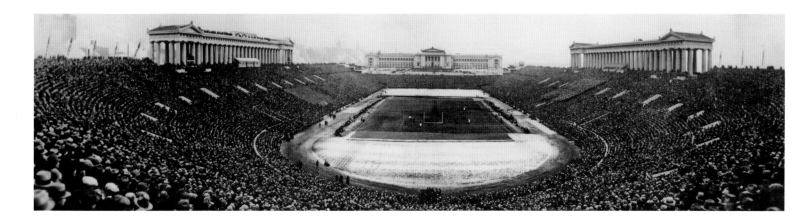

Tilden and Helen Wills), and swimming (Johnny Weissmuller and Gertrude Ederle). At each of the three Olympic summer games held in the 1920s, the United States surpassed by wide margins all other nations in the medal counts. The definitive sports superstar, however, towering over all others, was the New York Yankees' Babe Ruth, whose charismatic personality and status as the best baseball player, on the best team, of the most cherished sport, playing in the nation's media capital and the world's biggest city, remains the most perfect alignment of forces in American athletics.

Being "golden" also meant providing meaningful competition. In football's case, this was accomplished through established regional leagues; the American Football Coaches Association, founded in 1922; and the creation of a referees' association, which provided schools with lists of qualified game officials for hire. The Western Conference (later called the Big Ten), organized in 1895, was soon followed by the Eastern League (precursor to the Ivy League). By 1921, other major groupings were in place, including the Missouri Valley, Southern, Southwest Athletic, Rocky Mountain, and Pacific Coast Intercollegiate Athletic conferences. With jet travel only becoming common for big-time college teams in the 1960s, most squads went by rail or bus; thus, conference membership was based, in part, on ease of travel but also on enrollment size and established or natural rivalries. Not everyone chose to be in, or was welcome to join, a conference. Such was the case with the team that would dominate football throughout the 1920s, running off five undefeated seasons from 1919 to 1930 and parlaying its perfectly timed success in the Golden Age into both a synonym and symbol for the college game.

Notre Dame was an unusual but consistent early football powerhouse, with only two losing seasons from 1889 until 1960. The Fighting Irish hailed from South Bend, Indiana, whose location, for most people at the time, amounted to a classified secret. The Big Ten refused the university membership, and for years the Ivies declined to schedule games, each citing

(Below) "Talking Small," by Joe W. McGurk, ink drawing, ca. 1925. A stylish flapper representing football fandom looks down on an attention-seeking boxer. She tells him, "Your face is familiar, but you'll have to speak louder." Amid cheers from the crowded football stadium, he responds, "Hey, when's dis racket goin' to stop? I can't make me-self hoid." He will get his audience back when football season ends.

(Opposite, bottom) Advertisement for a dual homecoming game, Topeka, Kansas, 1921. Graduates of two established black colleges in northeastern Kansas were invited to a game that promised a parade, student snake dance, band competition, and "Yell Leaders with the Trimmings."

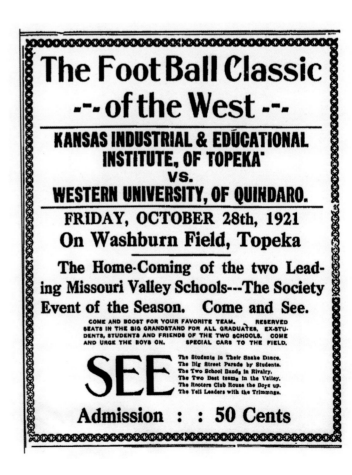

(Left) Clovis High School varsity, Clovis, California, 1922.

(Above) New sweat suits, Lake Forest, Illinois, 1924. Members of the Lake Forest University Red Devils pose in hooded athletic wear with fabric horns over their helmets.

concerns about the school's academic reputation. (Reportedly, All-American halfback George Gipp had not much more than his name on his transcript after two years on the team.) Notre Dame officials suspected that anti-Catholicism was at play, and the team's visits to Nebraska ended after a string of bigoted incidents in Lincoln. As an independent school free of required conference games, Notre Dame drew national recognition as it racked up frequent-railroader miles: Its teams were regularly on the East Coast to play Army or Navy, and the school booked long-running home-and-away series with Georgia Tech in the Deep South and USC in the Far West. Unlike other major teams that sold exclusive radio rights to their games, Notre Dame maintained an open-door policy in the press booth, allowing any and all broadcasters to emit waves of coverage nationwide. What the Irish missed in radio income, it made up for in nationwide name recognition.

Like Carlisle, Army, and Navy, Notre Dame had an inherent constituency. When Princeton deigned to play them in 1923, the Irish crushed the Tigers, 25-2, launching a nationwide following of fans whose loyalty to the school and team was a religious association rather than shared geography. Coach Knute Rockne's publicity-grabbing ploys also added to their renown. When they traveled to Pasadena for the 1925 Rose Bowl, the coach used the trip to charm and chat up the local press at each stop. He feigned concern over his team's chances, declaring that the trip west had made "our men soft, and growing softer every day . . . We will be satisfied to win by a mere score of 3 to 0." (Rockne's supposedly enfeebled men defeated Pop Warner's Stanford crew, 27-10.)

Taking a page from Walter Camp's playbook, Rockne wrote—or lent his name to—football books, newspaper columns, and commentaries, spreading the Rockne gospel. He hosted coaching clinics and sports camps, provided color commentary in early radio broadcasts before it was commonplace, and even escorted a tour group to the 1928 Olympic summer games in Amsterdam. Rockne's astonishing 105-12-5 record and his ever-present, myth-polishing approach ensured that Notre Dame, even in its leanest years and long after his sudden death, still had aura to spare. (In 1990, Notre Dame signed an exclusive and unprecedented television contract with NBC, giving the Irish a nearly constant national presence each autumn that no other team enjoyed.)

Notre Dame's heroics and other must-read sporting events generated demand for greater news coverage. In the 1920s, sports increased to an average of 15 percent of a newspaper's content (a figure that would reach 24 percent in the twenty-first century, when there were far more events to cover), and more reporters were hired

to focus solely on athletic competition. Working with teams' press agents—who traced their professional lineage to nineteenth-century circus hucksters—most reporters highlighted only the positive, in part for continued team access. It was in the interest of both teams and their chroniclers to present sports in a wholesome, almost mythical light, especially after the Black Sox betting scandal in 1919–20, which so tarnished baseball. It all came down to figures: Heroic athletic figures meant higher newspaper circulation figures.

Although not all reporters indulged in the practice, melodramatics characterized Golden Age sportswriting. Grantland Rice, Paul Gallico (who regarded himself as a storyteller), and John Kieran were among those who extended just-the-facts game reportage to attempts at literary prose. Rice was responsible for the best-known sports lead in American journalism, which also serves as an example of the era's purple prose at its most vivid. His account of Notre Dame's 13-7 victory over Army in 1924 opened with a description of the Fighting Irish backfield: "Outlined against a blue-gray October sky the Four Horsemen rode again. In dramatic lore they are known as famine, pestilence, destruction and death. These are only aliases. Their real names are: Stuhldreher, Miller, Crowley and Layden. They formed the crest of the South Bend cyclone before which another fighting Army team was swept over the precipice at the Polo Grounds . . ."

In Rice's telling, the Four Horsemen and the deceptive cyclone that "opened like a zephyr" roamed a landscape ravaged by a halfback-spouting, black-mouthed howitzer, a rim of darkness, hurricane dashes, African buffaloes, and those "who seemed to carry the mixed blood of the tiger and the antelope." Rice did not mention that Death lost a fumble and missed a field goal, or that Famine tossed an interception and blew an extra point attempt. Their overall performance—excellent as it was—and the final score—low as it was—could hardly justify the hyperbole, but hyperbole was the lingua franca of the sports world, expected and understood by everyone. "When a sportswriter stops making heroes out of athletes," said Rice, "it's time to get out of the business."

With the advent of radio, American sports gained a bountiful and soon-to-be omnipresent ally. No other medium manifested itself as so great a departure from what had preceded it or what followed. Since the late nineteenth century, fans had received timely reports on their

favorite teams, if not in the evening edition of a big-city newspaper, then certainly by the next morning. A live radio broadcast, however, was *now*, in the moment. As one heard it, it was happening. Listeners were practically in the stadium itself, though they might be hundreds of miles away. Beginning with NBC in 1926, national programming further bound together the commonalities of American culture, as millions of people, spread over a continent, were exposed to news, trends, music, and personalities at the same time and in the same way. Football's earliest intersectional radio broadcast, carried nationwide in 1922, featured Princeton at Chicago. At the time, only 60,000 American households even owned a radio. Before the game, the city's landmark department store, Marshall Field, announced that "For

(Opposite, top) *Competition*, **by Herblock, October 24, 1930.** Notre Dame's peripatetic schedule gave the team a national following unlike any other.

(Opposite, bottom) Grantland Rice (1880–1954). A widely read and influential sportswriter, Rice also produced sports-related poetry (including "Alumnus Football," which famously concludes that it's "not that you won or lost, but how you played the game"). His column was chatty and well informed, and by the time he died, he had long been regarded as the dean of the nation's sportswriters.

(Above) The Four Horsemen of Notre Dame, 1924. The Irish backfield of Don Miller, Elmer Layden, Jim Crowley, and Harry Stuhldreher in football's most famous photograph, a pioneering example of branding a team and marketing the game.

(Left) Knute Rockne (1888–1931), September 17, 1930. The Notre Dame coach directs practice from his customized perch equipped with a microphone and loudspeaker. This photo was taken at the start of his last season, in which the Irish went undefeated. Rockne's death in a plane crash six months later prompted a national outpouring of grief and greatly damaged the fledgling airline industry.

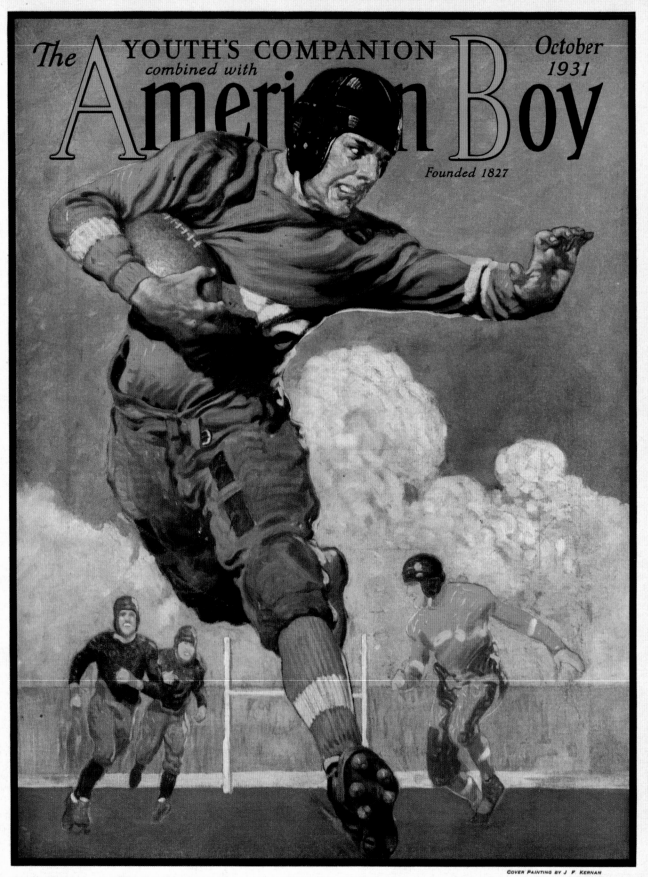

The **A**merican **Boy**

The YOUTH'S COMPANION combined with

October 1931

Founded 1827

COVER PAINTING BY J. P. KERNAN

FOOTBALL :: "GHOSTS OF THE SCARLET FLEET," BY REAR ADMIRAL EVANS :: COWBOYS

PRICE 20 CENTS

$2.00 A YEAR

FOOTBALL IN THE GOLDEN AGE OF ILLUSTRATION

"Can you beat it!" wailed Hicksie. "The backfield combination's gone blooey because Maynard's got the pip and we've got to put a yellow jelly-fish in his place!" —From "Hemmingway Plays the Game," by Brewer Corcoran, *Boys' Life*, October 1922

(Opposite) *American Boy* magazine, October 1931.

(Top left) *Lucky Bag*, U.S. Naval Academy yearbook, 1928.

(Top right) "Her Hero," *Liberty* magazine, November 7, 1925.

(Bottom left) *Associated Sunday Magazines*, November 22, 1914.

(Bottom right) *Modern Priscilla* magazine, by Charles A. MacLellan, November 1925.

(Top left) *Boys' Life* magazine, October 1915.

(Top right) *Home Arts* magazine, by Ralph Pallen Coleman, November 1935.

(Bottom left) "Tackle," by Frederic Stanley, *Saturday Evening Post*, November 13, 1926.

(Bottom right) *Thrilling Love* magazine, December 1933.

(Opposite) *American Boy* magazine, October 1928.

From the late nineteenth century through the 1920s—deemed the Golden Age of Illustration—commercial artists provided a visual record of the historical and fictional times that was unmatched in both quality and popularity. Every fall, readers could expect crisp-hued renderings of football in their magazines and Sunday newspapers as the sport deepened its association with autumn in America. Typical images centered on carefree boys at play and young women alternately pining for and captivating the varsity hero. While football players figured in romance stories for women, all-male casts were the norm in sports fiction for boys. Football tales used game action to enliven moral instruction and themes of personal integrity, discipline, and teamwork. As Bill, Jim, Tom, or Frank (and similarly named examples of vintage American stock) struggled with self-doubt, vanity, peer pressure, or doing the right thing, the skills a fellow acquired playing football usually resolved the troublesome issue.

The October American Boy 1928

Football—Aviation—Detectives—Adventure in the North Country

Price 20 Cents $2.00 a Year

the benefit of customers who have not been able to obtain tickets to the game, we have installed radio outfits on the Fifth Floor of the Store for Men, where returns from the game will be received play by play. You are cordially invited to be present."

Pioneering announcers included the informative Ted Husing, who described the action blow-by-blow, and the popular, emotionally lyrical Graham McNamee, a former singer, who sought to create an atmosphere and evoke imagery rather than focus on specifics or even accuracy. His style is reflected in his initial account of the infamous "Wrong Way Riegels" run at the 1929 Rose Bowl, in which California's Roy Riegels picked up a Georgia Tech fumble, then inadvertently ran 65 yards toward his own end zone before a teammate grabbed him. Here is McNamee's call: "What am I seeing? What's wrong with me? Am I crazy? Am I crazy? Am I crazy?" These early broadcasts lacked commercials, game analysis, interviews, pre- and post-game banter, and, of course, calls from listeners. In some ways, then, early radio should be appreciated for much more than its ability to reach mass audiences.

Graham McNamee (1888–1942), October 1924. McNamee was America's best-known sportscaster in the early days of radio, though he was no sports expert. Radio critic Ben Gross once asked NBC's founding president, Merlin Aylesworth, "What does McNamee actually know about football?" Aylesworth responded, "Damned little, but he certainly puts on a great show."

McNamee recognized the role his profession was having in glorifying and scrutinizing athletes, and he expressed concern about it. "I began to get a new slant on all this after Riegels," he wrote several months after the Rose Bowl. "Newspapers all over the country began to moan about this boy having ruined himself. One would have thought he was plastered with some terrible disgrace . . . I am not trying to smear athletics. I am merely suggesting that both newspapers and radio . . . have in mind a sense of proportion which, while preserving the dramatics, will also put forward real sporting, rather than sensational values." As for the good-natured Riegels, devastated as he was, he got through the spasm of ridicule among sports fans, and neither his coach nor his teammates criticized him. He would later console other players, including a high school student (in 1957) and Minnesota Vikings' Jim Marshall (in 1964) with letters of commiseration after they, too, reeled off long runs in the wrong direction.

Major league baseball was slow to accept radio out of fear that fewer people would attend a game if they could listen to it. Football, with fewer games, was less concerned. In 1925, the Associated Press put annual college football attendance at twelve million spectators; two years later, that estimated audience more than doubled, as football outdrew major and minor league baseball (combined) for the first time. The nature of these figures and the identity of the spectators intrigued Hugh Fullerton, a prominent Chicago sportswriter who broke the Black Sox story. "It is true that the World's Series . . . draws many who otherwise would

prefer football," he wrote in 1926. "It is certain that fully fifty percent of those who attend college football games do so to witness the spectacle rather than the game itself, as well as to enjoy the social appeal. A large percentage of spectators at any great football game go merely to say they saw the game and do not understand the play."

Who were these people? They were honored guests, alumni, faculty, students, and those with ties to the players and coaches; for major games, persons not falling into those categories (i.e., the general public) had great difficulty securing tickets. (Most scalpers acquired their tickets from students who sold their allotment.) "Fewer than four percent of the population of the United States are college bred," Fullerton observed. "Probably not more than 12 percent of the people have close enough college affiliation or sufficient 'pull' to buy a ticket to the big college football games. The idea that 90 percent of the people can be barred from seeing a game as good as football is offensive to many, and perhaps spurs their determination to see one." Radio offered some consolation to the ticketless. The 1928 Rose Bowl between Stanford and Pittsburgh was played before 70,000 spectators, but twenty-five million people—a fifth of the U.S. population—listened in to the NBC broadcast.

Going Pro

I do not like football well enough to play it for nothing.
—Red Grange, on why he left the University of Illinois to play professionally for the Chicago Bears, in 1925

In the waning days of the Wilson administration, mapping the geographic path of American football milestones could be likened to tracing a wide receiver's deep out pass route: The game was first documented in English on scenic, early seventeenth-century Atlantic beachfront; it defined itself and flourished as a college sport on the nineteenth-century Northeastern academy greensward; and, such was the nation's subsequent development that its successful professional origins emerged in a Midwestern car dealership.

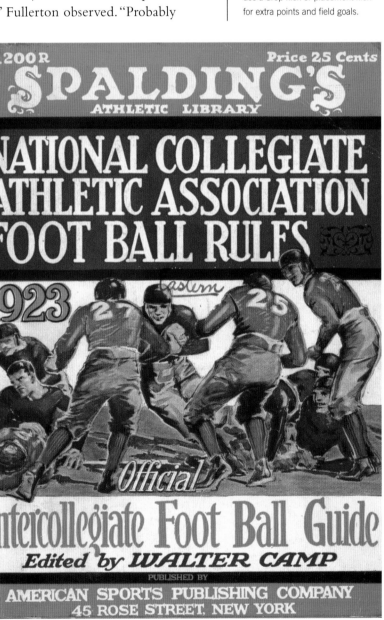

No. 200 R Price 25 Cents

SPALDING'S
ATHLETIC LIBRARY

NATIONAL COLLEGIATE ATHLETIC ASSOCIATION FOOT BALL RULES

1923

Official

Intercollegiate Foot Ball Guide

Edited by WALTER CAMP

PUBLISHED BY
AMERICAN SPORTS PUBLISHING COMPANY
45 ROSE STREET, NEW YORK

Usher Tales

Harry Blackmun, Harvard class of 1929, served for several seasons as a ticket taker and section head usher at Crimson football games. Prohibition was in force, which barred the manufacture and sale of alcohol but not its consumption, and Blackmun had a front-row view of mass intoxication. He did not think much of Princeton's cheers but acknowledged that its students had the best liquor, and he appreciated dealing with a sober student body when West Point visited. A Harvard law school graduate, he was appointed to the U.S. Supreme Court in 1970 and authored the landmark *Roe v. Wade* decision. An excerpt from his college diary describes the drama of usher duty:

October 23, 1926: Had my ushers assigned to me OK and got enough this time. The crowd started coming early. I had Dartmouth cheering section and also their band. The liquor flew muchly, but no trouble came directly because of it. Had only one scrap and that with two fellows who got in some way on one check. The weather was perfect and the stadium packed. And the game, oh, oh, the game. It was absolutely the best football game I have ever seen, bar none, not even the Yale game of last year. Harvard was the decided underdog in the betting, but started off with a bang and kept going . . . Harvard scored first . . . Pandemonium broke forth in the Harvard stands . . . The stadium

CHAPTER 2 · COLLEGIANS AND SPORTSMEN

VARD-DARTMOUTH

JACK CRAWFORD

927 OFFICIAL 25 Cents

was just one continued roar . . . The time was short, only a minute or two . . . A few plays and then something broke, for [Arthur] French was running like the devil. He eluded two Green defensive backs and was over for the final winning touchdown!!!!! Did we holler!!! We marched around the field after the game and threw the hats over the goalposts.

Harry Blackmun's football memorabilia. Tickets, stadium identification, and a game program from the Supreme Court justice's days at Harvard, as well as a ticket to Northwestern vs. Minnesota, when he returned to his home state.

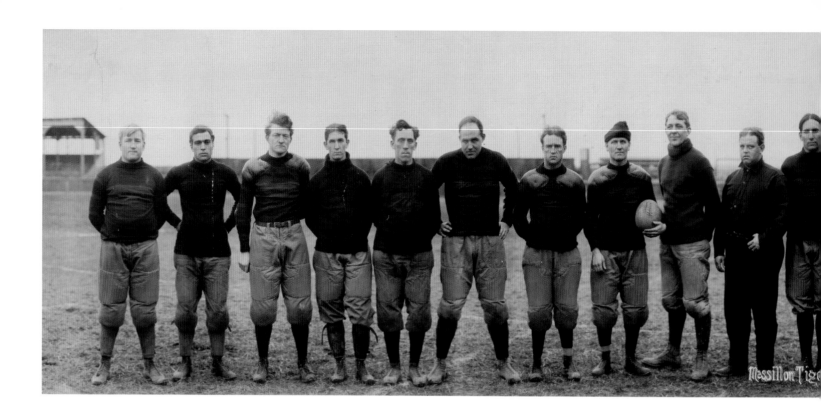

Massillon Tige[r]

The 1905 Massillon Tigers (above) and the 1906 Canton-Massillon game (below), by H. F. Peck. Panoramic photographs were especially popular in the early twentieth century. These gelatin silver prints, measuring less than a foot high and more than three feet wide, document the Ohio League's two most successful teams as they plunged into scandal. At the time, there was considerable suspicion that the game shown here at Massillon was fixed.

Professional football's "Fertile Crescent" and the cradle of the National Football League lie in northeast Ohio, where the Lincoln Highway (now U.S. Route 30) and U.S. 21 (Interstate 77) served as the Tigris and Euphrates, transporting players and fans from field to field. There, at the intersection of the Western Conference and the East Coast college football spheres of influence, was a major center for manufacturing and industry that numerous companies and innovative entrepreneurs called home. Tough workingmen appeared on the gridiron after hours, and businesses—from steel companies to breweries to men's clubs to independent investors—backed local teams. Akron, Canton, Elyria, Massillon, and Youngstown dominated the resulting so-called Ohio League, a loose, statewide association of teams that prospered intermittently in the early twentieth century.

Meanwhile, the earliest-known individual professional players, toiling in western Pennsylvania for "amateur" clubs in the 1890s, found regular work across the border on Ohio League

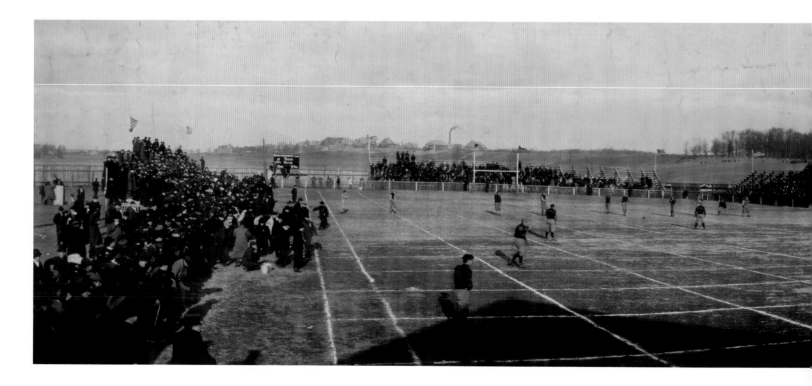

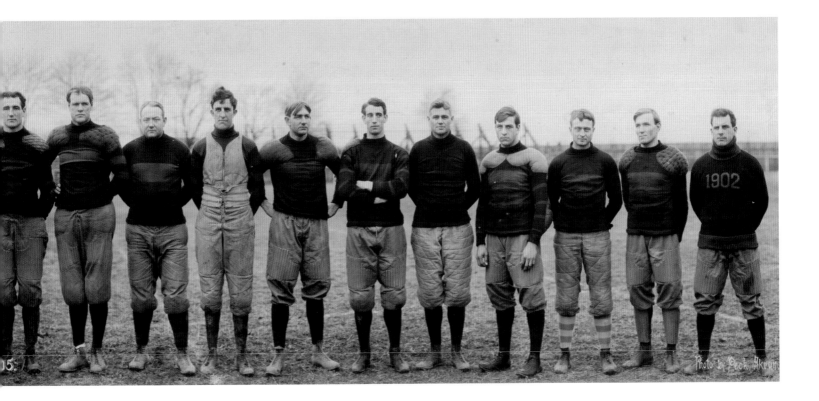

teams. In 1903, the Massillon Tigers hired several Pittsburgh professionals, and, despite the criticism, within a few seasons, players throughout the league were openly paid. Among them were many former Carlisle players, including Jim Thorpe, who brought national attention to pro football when he signed with Canton in 1915. Consequently, Ohio's quality of play surpassed that of other independent pro, semi-pro, and amateur teams around the country. The competition for talent, however, led to higher player fees that modest sponsorships and even more modest gate receipts (ticket prices topped out at fifty cents) could not support. Overpaying stars, it turned out, was not a profitable business model.

Indebtedness was not the only obstacle for Ohio squads. The two leading teams and archrivals, the Massillon Tigers and the Canton Bulldogs, which paid the most and hired the best, often mauled everyone else, resulting in grossly lopsided matches, including one 96-0 debacle. No one wanted to see a game like that, much less pay for it. Accusations that

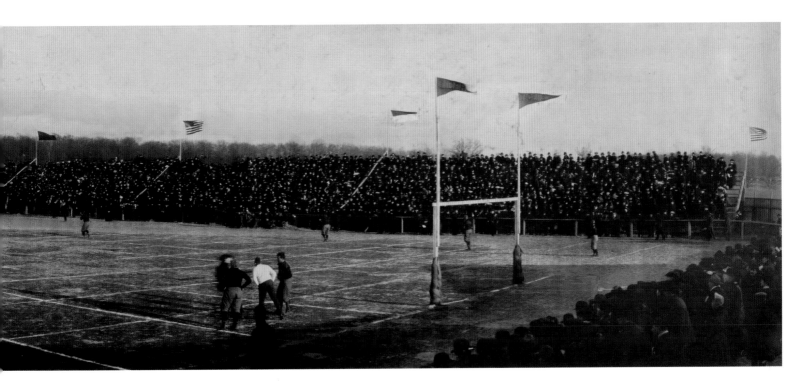

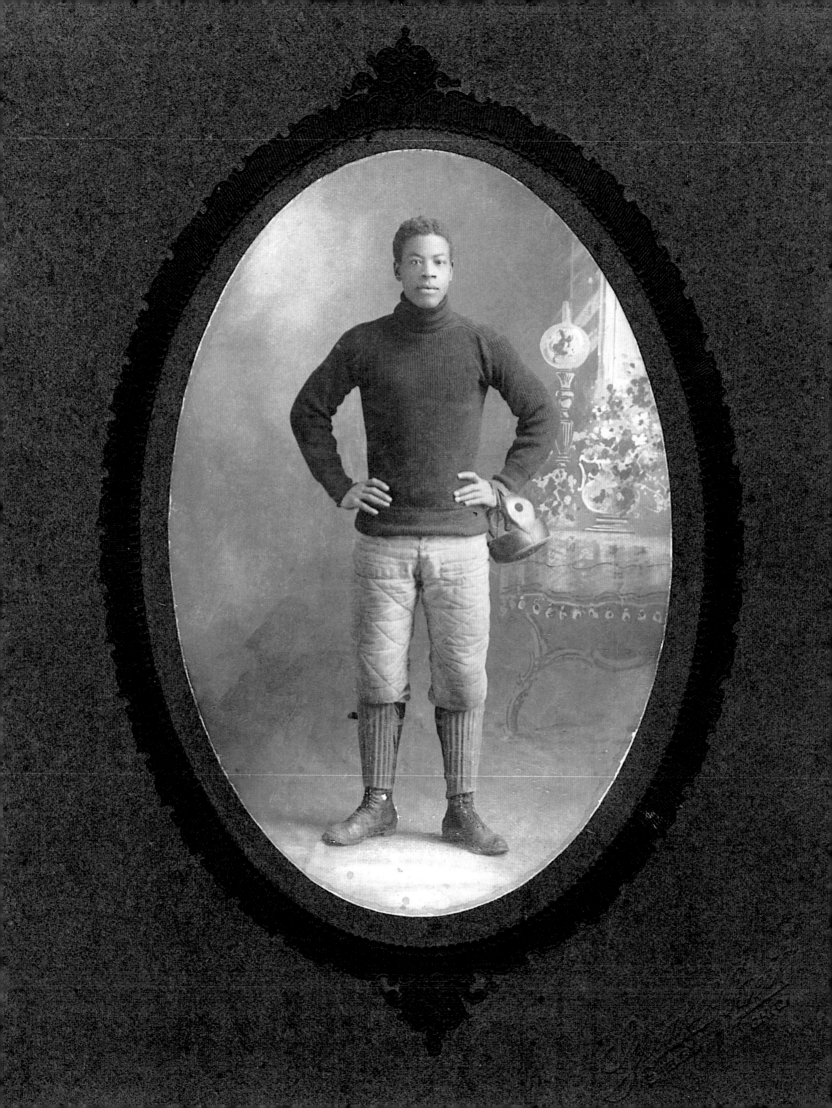

Canton and Massillon fixed games against each other in 1906 also damaged the league. Participating teams varied from year to year, as weaker outfits came and went, but a core level of interest among owners, players, and fans kept the system upright for nearly two decades. Most important, the Ohio League led to what ultimately became the National Football League, and its lessons were not lost when, a couple of generations later, the NFL's new young commissioner, Pete Rozelle, used team parity and profit-sharing to maintain both popularity and solvency in the pro game. Here, planted in the rich soil of pro football's Fertile Crescent, was the root of an NFL philosophy that would make it the most profitable sports league in the world.

By the end of World War I, Ohio League teams had reached a crossroads. There had to be a way to make a national professional league work, just as baseball had done, and a pro game had real potential to succeed: It could attract fans with no collegiate affiliations, and it could offer a higher quality of play showcasing trained players already made famous in college but now coming into their prime physically. With the war over and most servicemen back home, 1920 seemed as good a time as any to develop a feasible association, and the cramped showroom in Ralph Hay's Hupmobile dealership in Canton, while not the most obvious place to organize a professional football league, proved to be a satisfactory one. In August, Hay, owner of the Canton Bulldogs, hosted representatives from the Akron, Cleveland, and Dayton teams to make preliminary plans for a new league. Unlike the Ohio League arrangement, teams agreed not to use active college players or to poach pro players from one another. A month later, amid a cluster of Hupmobiles, a larger group formally established the American Professional Football Association (the name was changed to the National Football League in 1922). Jim Thorpe, the best-known player, was unanimously elected president, and team membership in the league was set at $100. That first season, fourteen teams from Illinois, Indiana, Michigan, New York, and Ohio competed, but few games were actually competitive—most were blowouts.

(Opposite) Charles W. Follis (1879–1910). America's first black professional player, Follis signed with the Shelby Blues of the Ohio League in 1902, starring on the team for four seasons.

(Above) U.S. patent application drawings for football equipment. Hugo Goldsmith's patented football pants (1923) were designed to hold in place his previously invented thigh guards. Henry Ridgeway Hart developed a leather helmet (1924) to protect the top of the head and neck in one continuous form. It also featured small air vents. He received a patent in 1925 for his double-laced football meant to balance the ball in flight and make it easier to grip.

In the early going, the NFL went through numerous rough patches that left abrasions on the collective body. Clubs went in and out of business even as 400,000 spectators turned out for the 1922 season. (Only two franchises, Chicago's Bears and Cardinals, would survive the first dozen years of the league's existence; they would still be playing in the twenty-first century.) Teams scheduled their own games, with some playing three or four times as many contests as others. Champions were determined by vote based on year-end won-loss records and schedule difficulty, leading to a dispute in 1925 between the Chicago Cardinals and the Pottsville Maroons that was initially settled in the Cardinals' favor and officially confirmed thirty-eight years later. The league got a huge publicity boost and a shot of credibility when Illinois superstar Red Grange signed with the Chicago Bears in 1925. In 1926, the NFL boasted twenty-two teams, all based in the Midwest or East Coast, including, peculiarly, the Los Angeles Buccaneers. Led by Cal star Brick Muller, the Bucs featured primarily Californians on the roster and received coverage in the *Los Angeles Times*, but, rather inconveniently, at least from the perspective of West Coast fans, the team played all its home games in Chicago.

Given the precarious finances of the professional game, the NFL attracted team owners who were passionate about the sport and for whom profits were not the main idea but an afterthought. "Oh, it's a great game—this pro football. But it's never been a great money-making game," admitted league president Joseph Carr in 1926. "A lot of us have gone broke . . . Running a football club is the most risky business I know. You stand a chance of injury to your stars and you run the chance of bad weather. Tim Mara went into New York

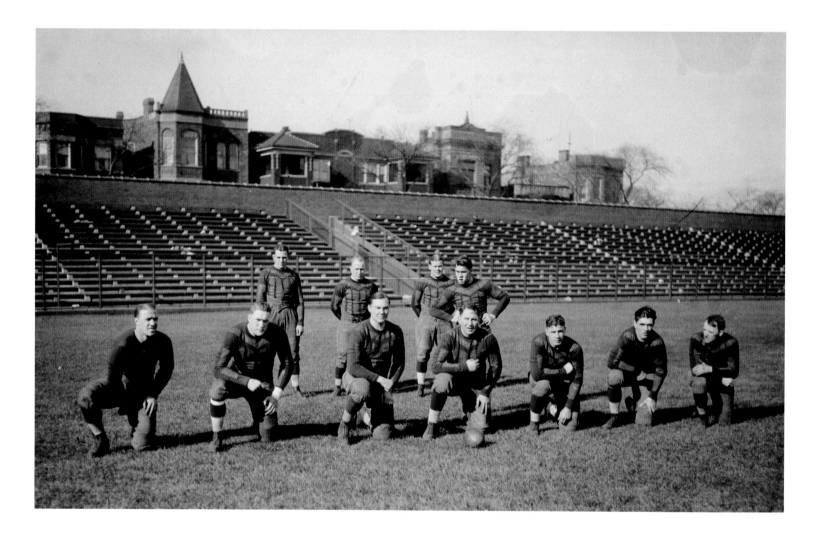

prepared to lose thousands of dollars." Actually, Tim Mara went to New York and lost tens of thousands of dollars after just a few games. "I founded the Giants on brute strength and great ignorance," said Mara, "my players' strengths and my ignorance."

Like many others in the league, Carr was good at juggling. Even as NFL president, he helped found the American Basketball League, and he headed up a minor league baseball team. Illinois grad George Halas, aptly known as "Mr. Everything," also wore many hats, as well as a helmet, since he not only owned the Chicago Bears but was also the coach, PR man, ticket seller, team ankle wrapper, and starting receiver/defensive end. One did not need to own a team to multitask in the NFL's early years, though. Former University of Chicago quarterback Walter Eckersall often worked as a publicity man, sportswriter, and on-field referee for the *same game.*

Despite the NFL's shaky existence, college football viewed the league as a threat. Walter Camp wondered, in 1920, "what this mere infant, professional football, is likely to grow into within another season." He naively hoped that players would not, out of loyalty to their schools, jump to the pro game as long as they remained eligible in college football. But he accurately predicted that "if the public wants professional football, they are pretty likely to get it, no matter what the colleges think or do." What the college establishment did not realize at first, but the NFL grasped, was that the United States was big enough to accommodate both games. It was also big enough to handle thousands of high school teams, and soon enough it would welcome organized children's leagues. The country was well on its way to becoming Football Nation.

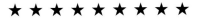

Three men whose views figured so prominently in shaping public opinion during the early days of organized football passed away within a few years of one another: Walter Camp (1925), Charles Eliot (1926), and Caspar Whitney (1929). Camp alone surely would have been dazzled and delighted by the position the game acquired. Eliot had been a sportsman once, but his experience as an educational reformer had utterly soured him on major collegiate athletics. The concerns he expressed from the 1890s on are still valid. Whitney's devotion to the amateur ideal was not well suited for what had been unfolding on college campuses and was impending at the professional level. If pneumonia had not killed him, the release of an in-depth Carnegie Foundation report ten months later might have done so. The study of 130 colleges indicated that more than one hundred of them subsidized athletes. Released shortly before the stock market crashed in October 1929, the much-discussed report was soon overtaken by events that would profoundly affect the country's economic health until the onset of World War II. Collegians and sportsmen, like everyone else, had more urgent matters to attend to as a decade of financial free fall and social turmoil was under way.

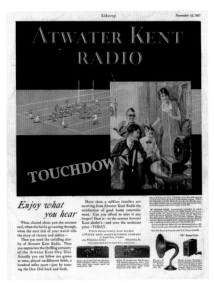

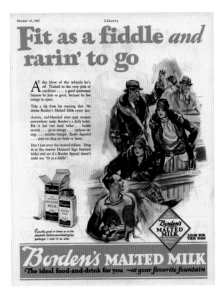

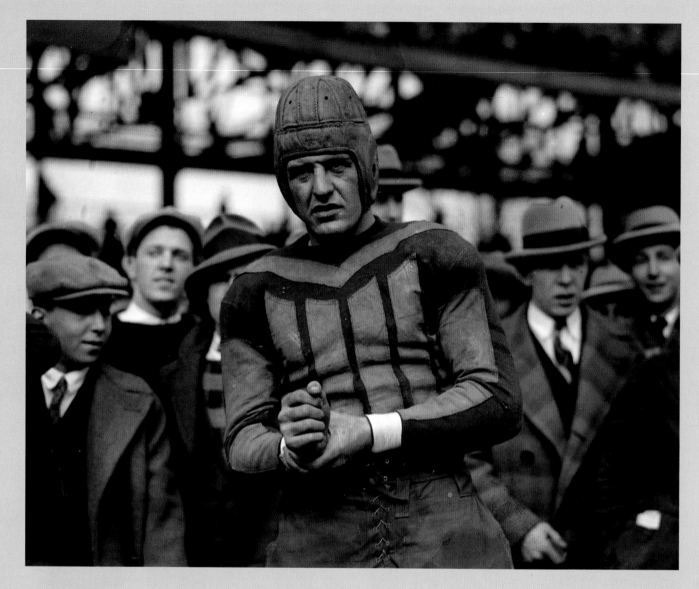

GAME CHANGER: Red Grange (1903–1991)

(Above) Grange at Griffith Stadium, Washington, D.C., December 8, 1925. Grange was run ragged as the Chicago Bears played five games in six days his first year as a pro. After the Washington game, he played in Boston, then aggravated an arm injury in Pittsburgh and sat out the games in Detroit and Chicago.

(Opposite) The University of Illinois retired Grange's famed number 77 jersey after his last college game in 1925.

Football's strategic complexity makes it difficult for the fortunes of an entire team to hinge on the efforts of a single player. However, the success of an entire football league can be attributed to one man, Harold "Red" Grange. The ever-grateful New York Giants owner Tim Mara would never have built his football dynasty were it not for the ice deliveryman from Wheaton, Illinois. And Grange did not even play on his team.

Grange took all of twelve minutes to become a football legend. On October 18, 1924, a Michigan team that had given up only four touchdowns during its twenty-game unbeaten streak rolled into Champaign, Illinois, looking for number twenty-one. They ran into or, rather, were outrun by, number 77. Students of football know the stats: In the first quarter alone, the flame-haired Illinois halfback scored four touchdowns on runs of 95, 67, 56, and 45 yards; he later ran for another score and tossed a touchdown pass as the Illini won, 39–14. While that was his single greatest performance, as a three-time All-American he regularly produced eye-popping numbers that left reporters rummaging through their *Roget's* for words to describe him. Grantland Rice called him a "rubber bounding blasting soul," whatever that was, and Paul Gallico referred to him as a "touchdown factory." Dubbed "the distinguished ice peddler" and "pigskin purveyor," his lasting nickname was "Galloping Ghost" for his quickness and shifty moves. Grange made up for his unimposing size (5'11" tall, 175 pounds)

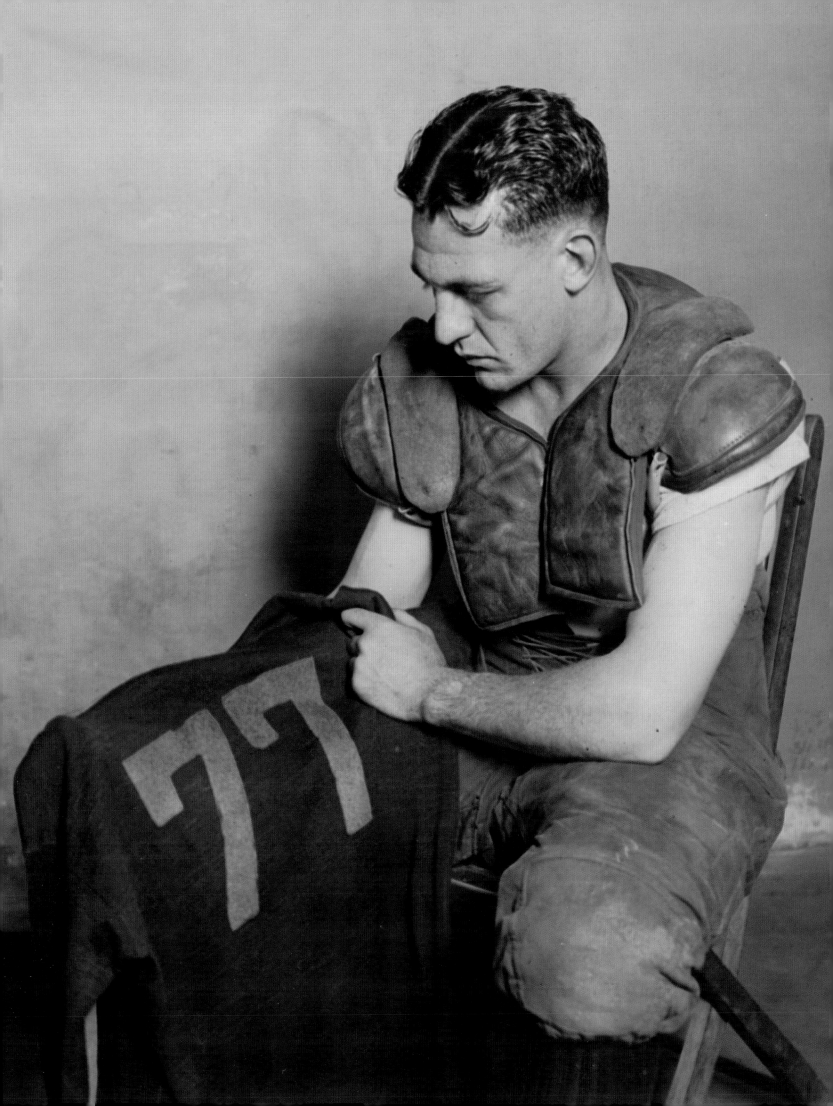

on trailblazing end runs, dispatching would-be tacklers with a straight-arm sculpted from hauling around seventy-five-pound blocks of ice.

Grange's immense talent, however, is not the fundamental reason for his hallowed place in football history, which, because he got there first, no one else can rival.

When Grange played his last college game in November 1925, the pro sport was on thin ice and losing money. Who better, then, than a man of Grange's stature to shore up the league before it melted away entirely? The thing was, few exceptional college players were in the National Football League; professional players were about as respectable as actors in Shakespeare's era and sometimes paid even less. There was a discomfiting sketchiness to the NFL. Grange, however, questioned that. "You coach for money," he told his college coach, Robert Zuppke. "Why isn't it okay for me to play for money?" Zup was not amused.

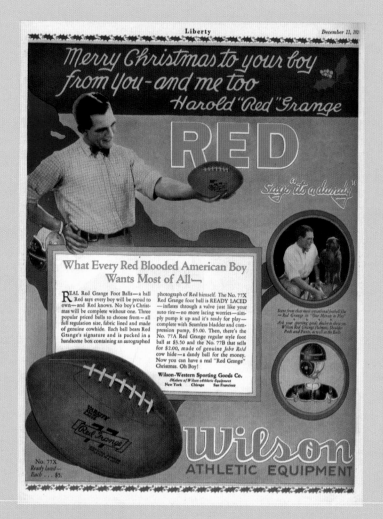

Grange's decision to play in a Chicago Bears game five days after Illinois's season ended was shocking, yet it had exactly the effect the NFL hoped: It prompted a second look at what professional football could be. But the Ghost's decision did not go down well with those closest to him. "My coach, Bob Zuppke, didn't talk to me for four years. My father wasn't happy about it," Grange said later. "All of my friends looked upon me as if I was a traitor or something, as if I had done something terrible."

At the time, good players might make $100 a game; most scraped by on less. His manager-agent, the enterprising but not always law-abiding C. C. Pyle, arranged for himself and Grange to split the gate fifty-fifty with Chicago Bears owner George Halas. It was an astonishing contract, matched only by the audacious and brutal schedule Pyle and Halas organized for the Bears. From late November 1925 to late January 1926, the Bears toured the country, playing nineteen games, and Grange was in all but two. In his first outing, he filled Cubs Park (Wrigley Field), drawing six times the usual gate. When he showed up at the Polo Grounds, so did more than 70,000 spectators, one of whom was Babe Ruth, sitting at midfield. Eying the crush of news

Red Grange football by Wilson, advertisement, 1929. Grange was the first football player to appear on a box of Wheaties cereal, and he regularly endorsed cigarettes (he did not smoke but said that, if he did, Lucky Strike would be his brand), food, drinks, toys, and football equipment.

media that greeted Grange, the Yankee slugger quipped, "I'll have to sue that bum. They're my photographers." Tim Mara probably did not mind that his Giants lost that day. The team, which he had recently purchased for $500 and now wanted to sell, had already put him $45,000 in the hole. In a single afternoon, though, Grange single-handedly filled the stadium and sent Mara home $130,000 richer.

The Bears' blitz and Grange's presence gave professional football a sense of legitimacy among fans, and it demonstrated to potential club owners that, with the right personnel, the NFL could be a profitable venture. Grange's success inspired other college stars to join the NFL, which dramatically improved the quality of professional play. Without Grange pulling in huge crowds everywhere he went, the tottering NFL might have gone the route of every

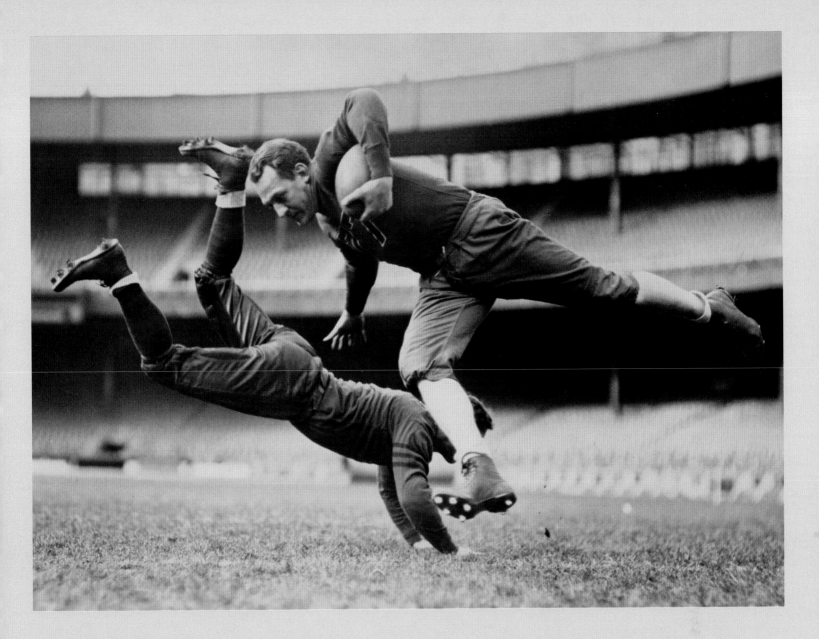

other short-lived pro league that preceded it. Despite injuries that made much of his nine-year professional career painful, Grange carried on, earning a place in both the college and professional football halls of fame. No better authority than George Halas, the last surviving founder of the NFL, put Grange's impact on the league in perspective when he said that "Grange was to us then what television is to the modern era." At the time, he was the best thing the NFL had to sell itself.

Red Grange was football's first national superstar, and the sport was fortunate to have such an esteemed representative. Coming from very modest means, he had paid his own way through college. Everyone agreed that his most pronounced quality was humility ("With the kind of blocking I had, my Aunt Mathilde could have run for a touchdown," he would say). He saw nothing unusual about returning to work the ice truck in the off-season, even as the *New York Times* described him in 1925 as "the most famous, the most talked of and written about, the most photographed and the most picturesque player the game has ever produced." Grange later worked the dinner-lecture circuit, announced football on radio and television, and sold insurance before a long, quiet retirement, only occasionally watching the pro game he did so much to make possible. Into his eighties, he willingly answered the same questions, told the same stories on request, and responded to the fan mail that still arrived on occasion. As he had since high school, the Wheaton ice man always delivered.

Grange, right, practicing moves with Chicago lineman Joe Zeller, 1934. ESPN's Chris Berman described an interview he once had with George Halas: "'Who is the greatest running back you ever saw?' And he said, 'That would be Red Grange.' And I asked him, 'If Grange was playing today, how many yards do you think he'd gain?' And he said, 'About 750, maybe 800 yards.' And I said, 'Well, 800 yards is just okay.' He sat up in his chair and he said, 'Son, you must remember one thing. Red Grange is 75 years old.'"

HALF

At halftime on October 7, 1916, at Grant Field in Atlanta, Georgia Tech led Cumberland, 126-0. However, Tech coach John Heisman urged his team to remain vigilant, because "there's no telling what they have up their sleeves." Georgia Tech hung on to win, 222-0.

Music, Marchers, and Mayhem

The earliest halftime activities in modern organized football consisted of tired players lounging about the field sucking on lemons, a scene that in no way anticipated the day when performers would use the intermission to arrive by parachute and depart by jet pack. Halftime did not get much more entertaining until school bands appeared at games in the late 1880s. These bands, modeled after army units, originally functioned as a part of on-campus student military training. Over time, as coaches used the midgame break to make necessary adjustments and rally the team, the band rallied fellow students and other spectators. Following increased music education in public schools at the turn of the twentieth century, more colleges and high schools sponsored bands that found their biggest crowds at weekly football games.

Historically, the marching machines most closely associated with halftime pageantry reside in the Midwest, and Big Ten bands are usually among the largest, comprising 200 to 350 members each. With their military pedigree, Big Ten precision marching bands initiated sophisticated routines and popularized intricate choreography, leading to full-scale productions with accompanying drill teams, flag twirlers, color guards, decorated conveyances, artillery, card stunts, live animal mascots, and, later, costumed characters that danced, cheered, and attacked other mascots. The University of Illinois's Marching Illini developed what became the traditional halftime show in 1907, and that season Purdue debuted its block "P," the first letter formation. The most famous formation in the country, Ohio State's "script Ohio," was created as a gesture of courtesy for a 1932 game by—of all bands—the University of Michigan, OSU's archrival.

(Previous pages) "Script Ohio" formation at Ohio State, Columbus, by Jay LaPrete, 2010.

(Right) Hamlet High School (North Carolina) players absorb the halftime pep talk, by Douglas Jones, 1952.

(Left) Jackson State University drum line, Jackson, Mississippi, by Charles Smith, 2011.

(Below) Majorette Rita Phillips, 1939.

One knock against the early NFL was that it lacked the exciting, celebratory atmosphere that bands and cheerleaders provided in college football. In 1937, volunteers founded the Washington Redskins' Marching Band, the first in the NFL, followed ten years later by the Baltimore Colts Band. So committed was the Colts band, renamed the Marching Ravens in 1998, that it remained in town and continued to play even when its football teams did not. The Ravens band, the largest in the NFL, has functioned much like a college outfit, performing several halftime shows a year. Other pro teams have experimented with volunteer pep bands and drum lines.

"Scramble" or "scatter" bands emerged at midcentury, as members ran, rather than marched, from one position to the next. This informal and comparatively undisciplined approach translated into more irreverent sensibilities when it came to song selection and formation design. Scrambling became common among the already less elaborate Ivy League bands, and in the 1960s, Columbia led the countercultural beat with its provocative halftime performances, including one on birth control. Rice and Stanford's scramble bands similarly staked out reputations for impertinence. Stanford mocked its precision band rivals by executing such formations as a straight line and a square.

Grambling, Florida A&M, Southern University, and other black college bands introduced a new level of showmanship with high-stepping marches, energetic, instrument-swinging dance routines, and a wider range of musical styles that delved into R & B and hip-hop. These "show style" bands earned such a reputation for their pre-game, halftime, and fifth-quarter performances that it has long been understood at many black schools that fans come for the music and stay for the football. In the early 1990s, Southern Historically Black Colleges and Universities, notably Prairie View A&M, reinvented the drum line as a dazzling unit with its own halftime segment, a subject later celebrated in the hit film *Drumline* (2002).

Beginning in the 1970s, television broadcasts allotted less attention to halftime performances, redirecting valuable airtime to game analysis, score updates from other games, and ever

Purdue Marching Band its big bass drum, by Brent Russell, 2009.
The Boilermakers' "World's Largest Drum" was first wheeled onto the field in 1921.

more commercials. (Whether coincidental or not, the streaking craze also manifested itself at halftime in this era, as naked spectators sprinted across the field, with startled security personnel in pursuit. The practice has never entirely died out.) During the 1980 season, Sears advertised its new Betavision videocassette recorder as an ideal way to watch football at one's own convenience, assuring viewers that the device "has faithfully recorded everything, including the halftime show you may prefer to skip."

Rapid improvement in videotape technology during the 1970s allowed producers to quickly assemble and broadcast highlights packages from games around the country, further eating into the halftime schedule. Eventually, viewers at home saw little or nothing of halftime entertainment, with a few notable exceptions. In the 1980s, the Orange Bowl game earned a reputation for extravagant productions involving large casts, fabricated sets, and pop music—such that the halftime presentation received considerable on-air hype. At the turn of the twenty-first century, an ever-growing number of online halftime videos occupied YouTube and various corners of the Web, a latter-day compensation for the loss of television coverage. Bands incorporated Jumbotron, smartphone, and other technologies into their performances, expanding their repertoires to include themes, memes, and other elements drawn from the Internet age.

The Super Bowl hosts the country's biggest halftime show, and in its first several years, producers relied on college bands and local performers to provide the entertainment.

Gradually, however, the NFL devoted more effort to the festivities. Broadway star Carol Channing and the Southern University band did the honors in 1970, marking the start of Super Bowl halftime salutes and tributes to everything from Mardi Gras, Motown, and the Caribbean to such things as voting, happiness, and "the world of children's dreams." Superstar Michael Jackson turned halftime on its head in 1993. His electrifying appearance and the accompanying worldwide television audience led to a host of top acts clamoring for a Super Bowl gig.

Among those taking the stage before more than a billion viewers were the Rolling Stones, U2, Prince, Madonna, and Jackson's sister, Janet, whose "wardrobe malfunction," as co-star Justin Timberlake termed it, received nearly as much press attention as the 2004 game itself. The most infamous half-second incident in halftime history and charges that the performances were not family friendly prompted a national discussion about television standards, particularly the perceived double standard that allowed greater leniency toward televised violence (including football) than other forms of expression. For many of those recording Super Bowl XXXVIII, that controversial halftime show was clearly one they would not "prefer to skip." Shortly after the game, TiVo, maker of digital recording devices, reported that the "wardrobe malfunction" incident was the most replayed television moment in the company's history.

Two, Four, Six, Eight: Cheers and Chants We Appreciate

Who would ever have guessed that one day cheerleaders would surpass football players in the rate of catastrophic injuries and days spent recovering from physical ailments? Certainly not the guy clad in a white sweater bearing a large block letter on the front, flannel pants, and wielding a megaphone in 1920, nor the girl appareled in an even tighter sweater, a box-pleated skirt, and saddle shoes, waving pom-poms in 1955. Their job, after all, was to lead cheers, not to execute an x-out double full maneuver into the arms of fellow squad members. But since that first "Rah!" was uttered, cheerleading's purpose—to stir up a loud, sustained, upbeat, and supportive atmosphere of unanimity—remains the same. How cheerleading accomplishes that has evolved from combining yells with simple jumps to adding cartwheels, then backflips, human pyramids, and moving on to catapulted bodies and Olympic-caliber aerial stunts.

The first intercollegiate football game, between Princeton and Rutgers in 1869, was accompanied by informal cheers, including one derived from the rocket yell used by artillerymen in New York's 7th Regiment, which passed through Princeton during the Civil War. The students transformed "Siss boom ah!" into "Ray, ray, ray/Tiger, tiger, tiger/Siss, siss, siss/Boom, boom, boom, aaaaaaaah!/Princeton! Princeton! Princeton!" In time, a variation, "Siss boom bah!" found its way into the cheers at other schools.

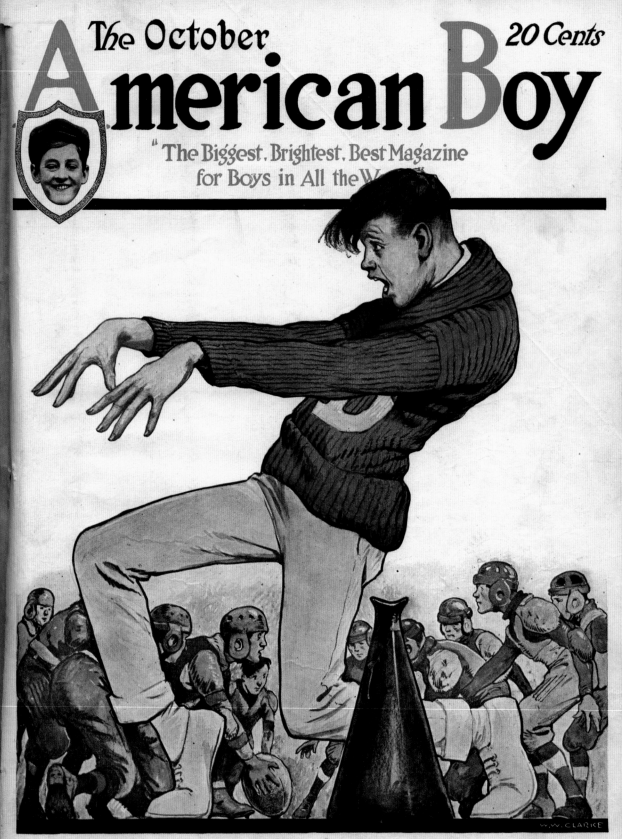

The October **American Boy** 20 Cents

"The Biggest, Brightest, Best Magazine
for Boys in All the World"

W.W. CLARKE

"Offensive Football"—"Defensive Football"
Two Great Articles by Coach Graves
A Hallowe'en Story—A New Barbour Serial

PUBLISHED BY THE SPRAGUE PUBLISHING COMPANY, DETROIT, MICHIGAN

"Rah!" as an abbreviated form of "hurrah!" was in use at Harvard before modern football arrived. The custom at commencement ceremonies was to yell "hurrah!" as well-liked students received their diplomas; those held in lower regard received a mere "rah!" The "Rah, rah, rah!" cheer was well established by 1869, when the British got an earful of it during a Harvard-Oxford crew meet. The Crimson men, on returning stateside, were criticized for their abbreviated cheer and abandoning "Hurrah!" But the shorter term would last in the long term, and by the 1880s, with widespread intercollegiate sports competition under way, other colleges had adopted "Rah, rah, rah!"

Yale's classic long cheer emerged in the early 1880s. Students studying Aristophanes's play *The Frogs* found the amphibian chorus chant "Brek-ek-ek-ex ko-ax, ko-ax" an excellent noisemaker. Kansas was using "Rah, rah, Jayhawk, KU" in 1886 before "Rock chalk" replaced the "rah-rah"s a few years later. At Minnesota, Johnny Campbell, credited as the first official cheerleader in the country, bounded out of the stands during the Northwestern game on November 12, 1898, to rouse the *crowd*, not just the team, with "Rah rah rah! Sku-u-mah, hoo-rah! Hoo-rah! Varsity! Varsity! Minn-e-so-tah!" Notable longstanding cheers and chants of later vintage include Alabama's versatile salutation, "Roll, Tide!"; Arkansas's calling the hogs, "Woo Pig Sooie!"; Florida's Gator Chomp; Florida State's potent Seminole War Chant; LSU's Cajunesque "Geaux Tigers!"; Michigan's "Let's Go Blue!"; "We—Are—Penn—State!" at same; "Gig 'em, Aggies!" at Texas A&M; and "Hook 'em, Horns!" with an accompanying two-fingered hand gesture at Texas.

Like Minnesota's Campbell, early cheerleaders were male, and, if so inclined, they regularly performed their own dance and tumbling moves. Organized cheerleading, performed by one to four men before designated cheering sections in the stadium, became common in the early twentieth century, just as schools were developing fight songs. Minnesota again took the initiative in 1923, when women were first welcomed to the cheerleading squad. Social commentator and newspaper columnist Will Rogers was especially taken by a 1925 Tuskegee-Alabama State Normal matchup he witnessed in Montgomery: "It was by far the most colorful game I ever saw. They have a bunch of cheerleaders down front, and their yells are mostly songs. And you want to see those girls do the Charleston."

World War II brought about the transformation to majority- or all-female squads. The shortage of young men due to military service meant that millions of women were working in traditionally male jobs, and that extended to cheerleading. After the war, women were strongly encouraged to hang up their welding equipment and rivet guns, but they did not abandon the cheerleading industry, which now offered summer camps and school leadership training. In the postwar period, at many colleges and nearly all high schools, all-female teams remained in place. With its tryouts, select small numbers, and campus visibility, cheerleading

(Opposite) *American Boy* magazine, by W. W. Clarke, October 1930.

(Above) Louisiana State cheerleaders, Baton Rouge, AP Photo, 1937. Neither rain nor the University of Texas dampened the spirits of this soggy pep squad, whose Tigers shut out the Longhorns.

(Right) Tennessee cheerleaders rouse the orange-visored Vols during a victory over Mississippi State, by Marvin E. Newman, 1957.

(Below) Lawrence Herkimer, demonstrating the "Herkie" jump. A former SMU cheerleader and founder of the National Cheerleaders Association (1948), Herkimer popularized his signature leap through his summer training camps. He also invented and patented the pom-pom.

(Opposite) The UCLA Marching Band and USC card stunt, *Sports Illustrated*, November 26, 1956. Back when halftime performances were regularly televised, USC students greeted viewers at home.

offered a sense of status among girls that being on the football team gave boys. In a few quarters, though, there was some "push 'em back, push 'em back, waaaayyy back."

"While the girls do wonderfully well at baton twirling, pompon waving and in high-stepping dance numbers, they lack the commanding presence of men when it comes to leading cheers," wrote *Sports Illustrated*'s Martin Kane in 1955. In the 1970s, criticism came from feminists, who argued that cheerleading relegated young women to, quite literally, the sidelines, while the more important action was on the field.

One catalyst for changes in cheerleading occurred in 1978, when CBS first broadcast the national cheerleading championships, drawing more than a third of the entire television audience. Teams had steadily progressed to acrobatics and airborne stunts, making cheerleading itself an interschool competitive activity. By the 1990s, regularly televised championships on ESPN emphasized the rigorous athletic nature of the competition, and more than eighty colleges offered cheerleading scholarships. It was no longer just about attitude but about altitude. As teams developed ever more challenging routines, cheerleading

SPORTS ILLUSTRATED

NOVEMBER 26, 1956

a Time Inc. weekly publication

25 CENTS
$7.50 A YEAR

USC VS. **UCLA** **BEHIND THE SCENES AT TELEVISION'S GAME OF THE WEEK**

became the most physically dangerous activity for high school and college women, but it also attracted more men at the college level. By the turn of the twenty-first century, more than three million Americans were participating in organized cheerleading.

Cheerleading in the professional ranks featured women early on. Promoter C. C. Pyle introduced cheerleaders to the pro game in the one season his American Football League existed. During a 1926 contest between his New York Yankees (starring Red Grange) and the Boston Bulldogs, "two lady cheerleaders, who Mr. Pyle said were society girls . . . flounced along the low wall in front of a certain section of the bleachers," reported the *Washington Post*. When a successful field goal sent the ball into the stands, a spectator attempted to carry it off, leaving the ill-equipped Yankees with only one ball. The police

intervened, the ball was returned, and the fan "was solaced somewhat for his loss when the two lady cheerleaders clapped their hands, jumped in the air, and led the cheering section in a cheer of 'Rah, rah, rah, nice customer.'"

In 1954, the Baltimore Colts became the first NFL team to use cheerleaders, a trend that was slow to develop, but, eventually, most of the league would employ cheering squads as well. Dallas used high school cheerleaders at Cowboy games in the 1960s, but in 1972, general manager Tex Schramm hired dancers for a revolutionary, all-female, twenty-something cheerleading squad. Outfitted in blue and white boots, short vests, and even shorter shorts, the Dallas Cowboy Cheerleaders set the NFL standard, making regular television and promotional appearances and generating a large product line of merchandise. Team manager Suzanne Mitchell explained in 1978 that "Sports has always had a very clean, almost puritanical aspect about it, but by the same token, sex is a very important part of our lives. What we've done is combine the two." Did they ever. And no other NFL cheerleading team has equaled Dallas's success. The *Wall Street Journal* noted that during each game of the 2009 season, NFL cheerleaders "were only on camera for an average of three seconds. 'We make it a point to get Dallas cheerleaders on, but otherwise, it's not really important,' [said] Fred Gaudelli, NBC's *Sunday Night Football* producer. 'If we're doing the Jets, I couldn't care less.'"

Welcome Grads!

OFFICIAL
PROGRAM

PRICE 10c

Saturday,
Nov. 2, 1940
2:00 p. m.

St. Benedict Ravens
vs.
Pittsburg Gorillas

HOMECOMING GAME

Homecoming

Bragging rights have always been a part of football. Since 1910, however, the bragging has even focused on who invented homecoming as Americans have come to know it.

Alumni and former players have returned to campus for football games almost since the sport began. Michigan started hosting games between its varsity and alumni in 1897, but annual, organized homecoming weekends did not come into fashion until the early twentieth century. Although Baylor (1909), Illinois (1910), and Missouri (1911) laid out examples for others to follow, some of the earliest homecomings in the Midwest grew out of autumn harvest festivals that coincided with the football schedule. Baylor faculty initiated homecoming when it invited graduates to return to campus for the usual reasons—to reconnect with the school and renew old friendships—and one unusual reason, to enjoy the experience free of any requests for donations. The Thanksgiving week activities included a parade and a football game with some 5,000 spectators in attendance. Homecoming at Baylor then went on a six-year hiatus.

The first Illinois homecoming featured football as well as a track meet and the now seldom seen pushball. At Missouri, coach and athletic director Chester Brewer launched a major offensive effort when he invited the old grads to "come home" to Columbia for the 1911 contest against archrival Kansas. As a further enticement, the school also held a parade and rally, drawing some 9,000 fans to see the Tigers and Jayhawks battle to a 3-3 tie and establishing a schedule of traditional homecoming events.

(Above) Pittsburg homecoming game program and accompanying Gorillas patch, 1940. The Kansas school is the only one in the nation with a gorilla mascot. The most common team names are the Eagles, Tigers, Bulldogs, and Panthers.

(Right) Baylor homecoming parade, Waco, Texas, 1909.

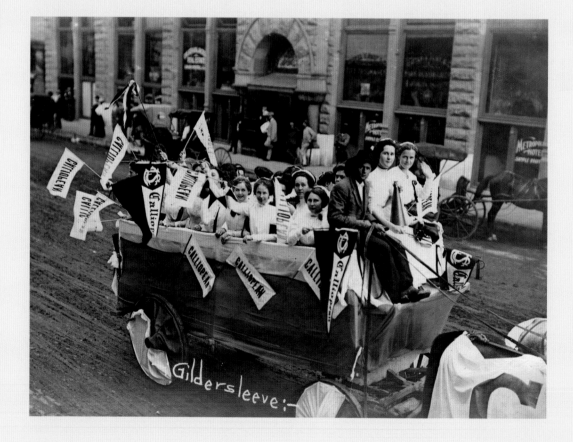

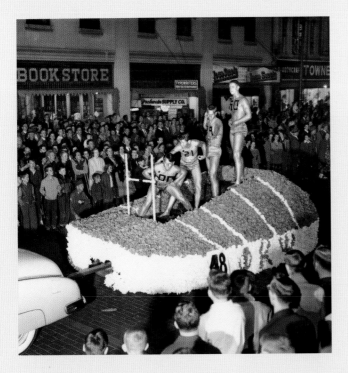

By the 1920s, fall reunion weekends had become common practice, and it was customary to enhance the pageantry of it all by selecting a homecoming queen. Along with queens—and in some places, kings—parades, bonfires, pep rallies, musical performances, and dances, many schools have added student-run charitable events and community service to the homecoming program. Ideally, the host school is savvy enough to schedule a weaker football opponent, and the game remains the central event in homecoming proceedings. This was illustrated in 1987, when Southern Methodist University, then without a football team as part of its punishment for repeatedly violating NCAA rules, turned to its soccer squad for the big game. Only 3,000 people showed up—a huge crowd for college soccer but a mere fraction of the number that appeared at Mustang football games—while the Texas governor, an SMU fan and a homecoming regular, jetted off to New York on business. Apparently, for most people, homecoming without football was simply not worth coming home to attend.

(Top left) The Phi Kappa Psi fraternity gridiron float passes the reviewing stand at the Iowa homecoming parade on Clinton Street, Iowa City, 1950.

(Above) Homecoming king Jerome Kennedy and queen Illuminada Relacion, Wilson High School, Washington, D.C., 1981.

(Left) Pinckney High School homecoming queen and varsity placekicker Brianna Amat, Ann Arbor, Michigan, by Alan Ward, 2011. After being crowned at halftime, Amat kicked a 31-yard field goal to secure a 9-7 victory over Grand Blanc.

Barbecue, Brownies, and Beer: America's Tailgating Heritage

Wherever there has been football, there has been food. Nineteenth-century fans arrived at games by train, streetcar, and horse-drawn buggy laden with picnic baskets. Soon, vendors offered sandwiches, hot dogs, and beverages outside the grandstands, and in the early twentieth century the twenty-five-cent boxed lunch was an easy way to go. Later, stadium concession-stand food, not known for its deliciousness, offered high-priced convenience. In the 1980s, recognized food franchises appeared on some stadium concourses, a practice that continued to grow, but the aroma of barbecue and side dishes piled high suggests that the tastiest edibles are found in the parking lot.

(Above) Bucky Badger, the University of Wisconsin mascot, commiserates with former school cheerleaders after a home loss to Michigan State, by Dave Stluka, October 27, 2012.

(Below) A Ford Country Squire station wagon hosts a tailgate spread at Michigan Stadium, by Arthur Rothstein, 1960.

America's tailgating past includes the pioneers' Conestoga wagons and cattle drivers' chuck wagons. Tailgaters in the modern sense appeared along with the first station wagons in the 1920s. The celebrated art of tailgating at football games, however, did not emerge until after World War II, and popular culture did not take notice of it until the 1950s, when the term also came into regular use. By then, millions of station wagons, with room for essentials and lots of extras, were on the road and the expanding interstate highway system. Turning the car tailgate into a picnic table was an economical way to dine whenever and almost wherever for people on the go. And where they were going, quite frequently, was to the game. Early arrivals,

Tailgating at Texas A&M, College Station, by Frank Bauman, 1955.

staking out prime parking spaces for optimum ingress and egress, found that tailgate dining was an excellent way to kill time before kickoff. Another part of tailgating's early appeal was its emphasis on simple foods prepared beforehand and that required few utensils or supplies. In the 1960s, newspapers and women's magazines regularly ran tailgating recipes and menu ideas featuring easy-to-fix finger food. Tailgating's surge in popularity during that era was even credited with increased game attendance.

In the 1980s, the trend in tailgating fare moved from basic foodstuffs to gourmet offerings, and as station wagons disappeared, pickup trucks, campers, motor homes, and sports utility vehicles took their place between the white lines. An actual tailgate was no longer necessary, as fans gathered around folding tables and under canopies, making a day of it rather than a quick meal. Instead of bringing wholly prepared food, more tailgaters barbecued and cooked on site. They also brought with them rugs, folding chairs, and couches; ice chests, space heaters, and power generators; small and industrial-size grills, and mobile kitchens equipped to survive the apocalypse: overtime and traffic. The early twenty-first century saw a greater emphasis in publications and products specifically designed for and aimed at the tailgating community, such as compact, all-in-one, cooking-storing-serving devices. Competition increased over such matters as decorative displays in team colors and barbecue seasoning supremacy, and each year, connoisseurs rank the best tailgate gatherings nationwide, evaluating atmosphere, access, and aliments.

Tailgaters were quick to respond as more stadiums limited or banned alcohol sales. Time spent waiting for the game encouraged beer consumption, preparation of creative cocktails,

Tailgate Fare

Tailgate fare has always been subject to regional preferences, but some traditional items on the menu appear everywhere, including barbecue, fried chicken, hot dogs, cold cuts, potato and pasta salads, and deviled eggs. Certain signature items, however, are more prevalent in various regions.

Northeast: chowder, lobster salad

South: gumbo, jambalaya, poor boys

Midwest: stew, chili, coleslaw

Northwest: grilled salmon, seafood

West Coast: burritos, sushi

and imbibing spirits not available in the stands. Pre-game meals are often followed by post-game repasts while the parking lot clears—because, except for brownies, there is usually plenty of everything left over. For some, tailgating culture surpasses their interest in the game itself. Those without tickets come to socialize; others prefer to watch the game on the TV they brought along, with instant access to refreshments and sources of warmth. Hard-core tailgaters will tailgate in their own backyards when the team is playing on the road.

Like any other piece of real estate, stadium-tailgating spots are about location, location, location. Committed tailgaters will arrive a couple of days before the game to set up. At the universities of Washington and Tennessee, tailgaters arrive by boat, and at South Carolina some fans purchase their own parking spaces. New stadiums come with designated tailgating areas worked into the master plans, and for those wanting to experience the tailgate scene without the effort, "activity zones" offer tailgate cuisine, games, live music, and ever more entertainment. What began as a picnic on wheels evolved, in many locales, into a highly commercial, multimedia carnival brought to you by corporate sponsors. What has remained, though, at its core, is a bond among those who wear the same colors, amid all the fixin's.

At halftime on November 3, 1956, at Folsom Field in Boulder, Oklahoma was down 19-6 to Colorado. Oklahoma coach Bud Wilkinson told his team, "Gentlemen, there is only one person who believes you are going to win this game. That person is me." The Sooners came back to win, 27-19, and went on to capture the national title following an undefeated season.

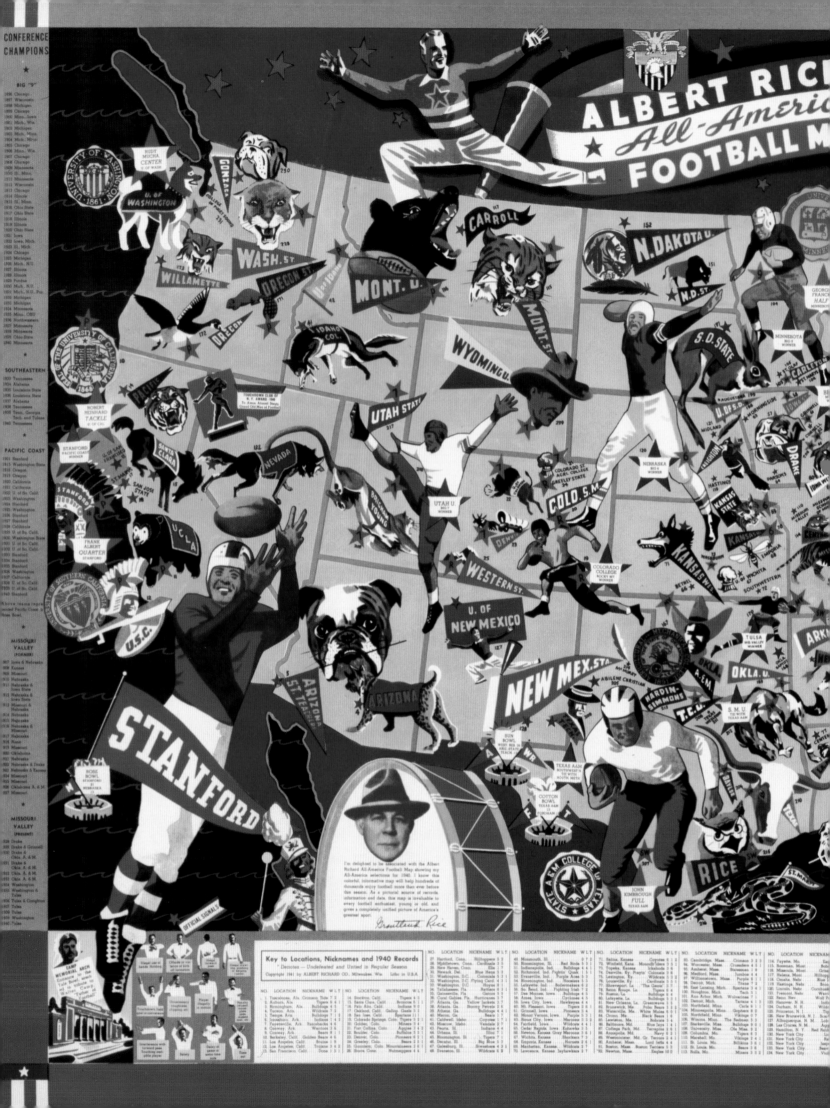

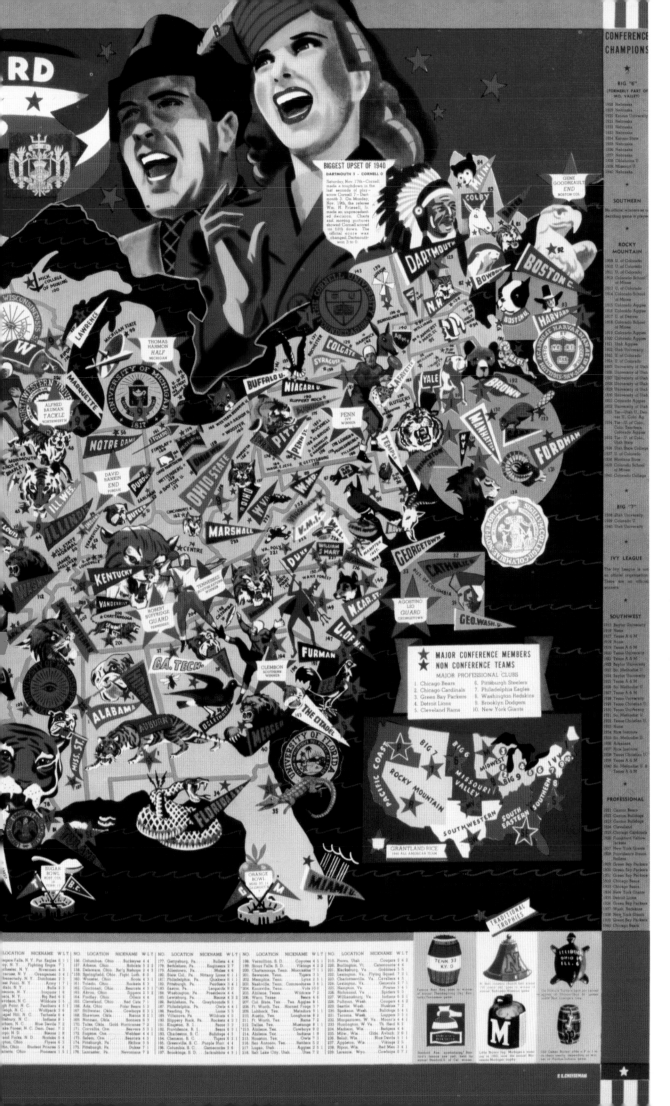

Albert Richard All-America Football Map, by F. E. Cheesman, 1941. Amid the hoopla depicting college football powers and their mascots, a small inset at lower right illustrates the major conferences and lists the NFL's ten clubs. The packed map also includes a message from sportswriter Grantland Rice, a key to referee signals, conference champion listings, 1940 team records, and bowl game results.

If it were about football, I could rally popular sentiment quick enough. —U.S. President Herbert Hoover (1929–33), on public apathy toward a matter of national importance during the Great Depression

The president was not kidding. As a former student manager for the Stanford University football team and U.S. Secretary of Commerce, Hoover understood both gridirons and gross domestic product. And the fact was, the statistics that Michigan, Notre Dame, and Southern Cal generated were far more uplifting than anything supplied by Wall Street or the White House. When the bill for 1920s-style ballyhoo came due, and as the Depression set in, the numbers were staggering. The unemployment rate hit 25 percent in 1933, national income dropped from $88 billion to less than half that, wages fell by 60 percent, and millions of bank accounts representing lifetimes of labor vanished, irrecoverable. The economic free fall resulted in a devastating inventory of foreclosed family farms, shuttered businesses, and collapsed banks. An ill-timed drought over the dust-laden Midwest and the Great Plains, combined with years of poor land management, turned a terrible situation into a desperate one. In the United States, the Depression cast American economic invincibility and unfettered capitalism into doubt, but elsewhere, notably in Germany, Japan, and the Soviet Union, it allowed totalitarian regimes to launch more aggressive efforts in securing their interests.

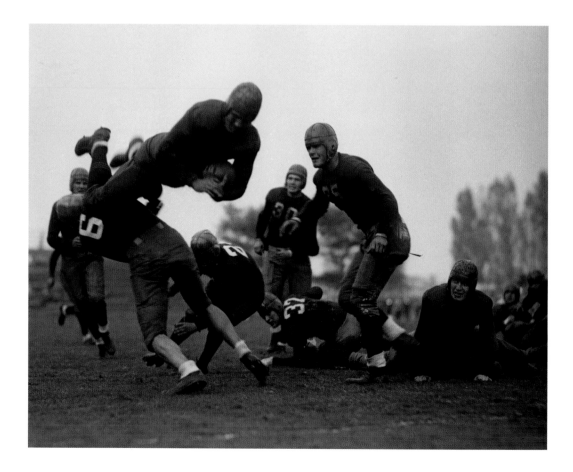

Bronko Nagurski, University of Minnesota, vaults over the Northwestern defense, Evanston, Illinois, 1929. Nagurski starred for the Chicago Bears from 1930–37 after a stellar career at Minnesota. "If I had my choice of one man to play all eleven positions on a team, I'd take Nagurski," said Clarence Spears, his college coach. The hard-charging Nagurski was an ideal pro ball carrier in the 1930s, when NFL teams relied heavily on the run and were stingy with the pass.

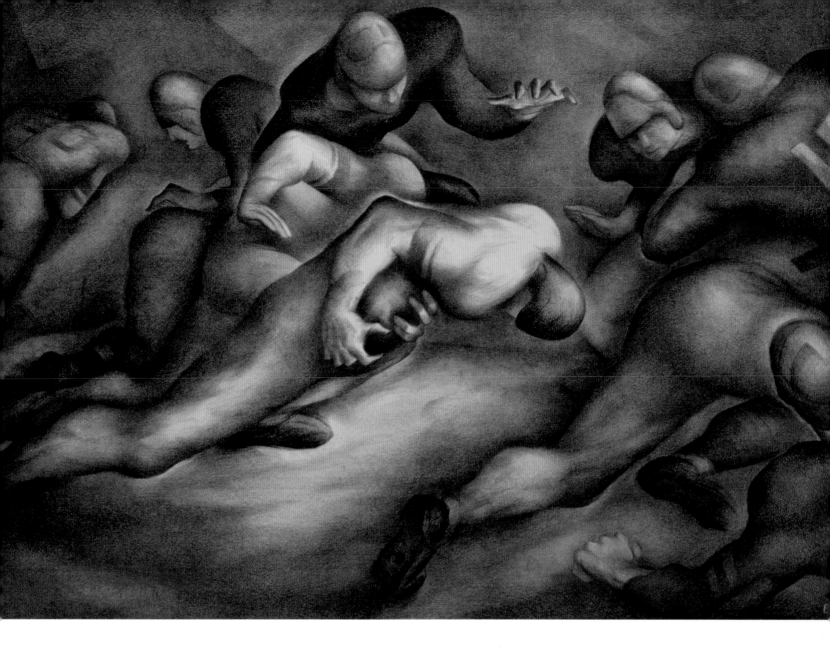

When it became clear that the Depression was no mere short-term setback, football took a hit along with everything else. Overall college game attendance fell 25 percent in 1930–32 compared with the 1928 season. Many players were compelled to give up school and football to find work, and some small colleges could not get enough men into uniform; in some cases, like many high schools, they adopted six- or eight-man teams or dropped the sport entirely. And in an astonishing turn of events, tickets to major Harvard, Princeton, and Yale games were available to the general public. No one could remember the last time that had happened.

Part of the American response to the crisis was seeking solace in its sports teams and occupation in tracking athletic minutiae. "The general practice for the ordinary American these days is to read about 15,000 words of football news on Sunday and another 15,000 on Monday," wrote the *Boston Daily Globe*'s Carlyle Holt in 1931, instantly contributing to the word total himself. "Now just imagine the condition of this country if, instead of reading every scrap of football gossip, each of us read every scrap of the foreign news and political news, and followed the course of economic tendencies with the avidity we devote to football . . . We would be so rottenly prosperous, we could actually go to some of the games we only read about now."

Spinner Play, by Benton Spruance, lithograph, 1934. A leading lithographer from Philadelphia, Spruance was a regular in the stands at Penn games and earned the nickname "the football artist" for his many gridiron images. His heroic, action-oriented style, well suited for the sport, was also emblematic of New Deal era art. As his biographer, Lloyd Abernathy observed, "He found and conveyed the excitement in the physical clash of sinuous bodies and a rhythm in the patterns of play that other artists had not yet discovered."

Meanwhile, major college programs remained fairly hardy, and football enjoyed boom times in the Far West. "The tendency . . . in the Pacific Northwest is to expand rather than curtail. We see a great future in this region," prophesied Earl Campbell, the Washington Huskies' student manager. California, Stanford, and USC reported they would not scale back their programs, and the Rocky Mountain Conference, by scheduling a number of night games, experienced especially strong attendance. All in all, college football withstood the calamity better and rebounded faster than any other sport and most forms of entertainment. "A Depression?" asked a *Chicago Tribune* headline in 1931. "There's No Such to Grid Fans."

Al Capone at the Nebraska-Northwestern game, Evanston, Illinois, October 3, 1931. The nation's most notorious criminal, Chicago gang leader, bootlegger, and sports fan Al Capone (center) looked uneasy pulling for the Wildcats. As word of Capone's presence filtered through the crowd, fans grew hostile, pummeling him with boos. "I'm here to see the game," he insisted. "I'm going to stick it out." He'd had enough by the end of the third quarter, however, and as one news report described his departure, "hardly a person in the stand refrained from the uproar. The Capone party walked hurriedly and apparently somewhat abashedly to the nearest exit." Two weeks after the game, a jury convicted Capone of tax evasion, and the gang boss spent the next eight seasons in prison, including five years at Alcatraz.

From the Dust Bowl to the Sugar Bowl

No depression, even a sturdy one, can stand up against the flying wedge of another football season. And America . . . sits in the stands to prove it. —Lewis Nichols, *New York Times*, November 3, 1935

Football's resilience during the Depression underlined not only the intense, sustained interest of its huge constituency, but also the game and its supporters' ability and ingenuity to adapt as necessary. Colleges slashed ticket prices (premium seats at Southern Cal dropped from $5 to $3.50) and reduced or eliminated lavish training tables, spring practice, travel, and player financial assistance. They also turned to the radio, offering to sell broadcasting rights for their entire seasons, not just major games. The nominal radio revenue did not cover what most teams lost at the gate in the early 1930s, but the increased coverage was an investment in new fans who could afford to attend games once the economy recovered.

Ticket purchases represented only a fraction of fans' expenses on game day. "They buy chrysanthemums, pennants, feathers, and gasoline or railroad tickets, they lunch and they dine on the way, they pay parking fees and bridge and ferry tolls," sportswriter Westbrook Pegler pointed out in 1931, "and, to some extent which science has no way to determine exactly, the girls insist upon and get a gradual but constant supply of replacements in the matter of things that are fit to wear, possibly the most important item of all." The fashion industry saw to it that fans remained stylish, even in dark times. "Two- and three-color costumes appear to be far in the lead," reported a Boston fashion purveyor on spectator wear for the 1935 season. "Bright colors look right—kelly green, sealing wax red, royal blue . . . All in all it's the gayest season we've seen and deserving of three cheers!"

Once fans were in the stadium, athletic directors leveraged the game's reputation as a "spectacle" into an ever-greater extravaganza. Louisiana State closed its 1933 season with an air show over its stadium that included a mock dogfight. Particularly in the Midwest, bands clad in elaborate regalia executed dazzling, kaleidoscopic, Busby Berkeley–style halftime numbers. Card stunts reached new levels of complexity on the West Coast, especially at

Oregon, UCLA, and USC as intricate, animated routines depicted school mascots pouncing on their rivals. Other expressions of escapist exuberance were cause for alarm. The National Football Coaches Association issued a statement in 1937 commenting that "Since the spectator rushed into the Dartmouth line-up against Princeton in 1935, there has been an increasing number of intoxicated spectators trying to rush the field. Strict police supervision is needed until this craze dies down." Then there was the habit of tearing down goalposts after a big win. "No one tears up the bases after a baseball game," wrote the *New York Times'* John Kieran in 1935. "But in the wake of football games there have been riots of great vigor staged around the goal posts, with plentiful blacking of eyes, tearing of clothes . . . the only ultimate relief may lie in closing down the stadia and giving the game back to the Indians."

In addition to the longstanding All-American designations, football found other ways to sustain public interest in individual and team achievement. In 1934, Manhattan's Downtown Athletic Club commissioned a young sculptor, Frank Eliscu, to create a trophy that would be awarded to "the most valuable football player east of the Mississippi." Eliscu's bronze rendering of a stiff-armed ball carrier in stride symbolized the college game's highest honor. The next year, the award was renamed the Heisman Trophy for club director John Heisman, who coached just about everywhere, most famously at Georgia Tech, and players nationwide were eligible recipients. The Associated Press poll, established in 1936, ranked the top college teams based on sportswriters' picks and soon became the nation's leading method for declaring the country's best teams. To produce greater interest in the pro game, NFL teams were organized into eastern and western divisions, and the league inaugurated its playoffs and championship game in 1933, its amateur draft in 1936, and its most-valuable-player award in 1938. The league also began efforts to maintain player and team statistical data, a task no one had really bothered with before 1932.

(Above) *Liberty* magazine, October 14, 1933. The two gentlemen seen here in stylish raccoon coats represent the height of 1920s collegiate fashion.

(Left) Brown students tear down the goalposts following an upset victory over Columbia, New York City, AP Photo, October 23, 1937.

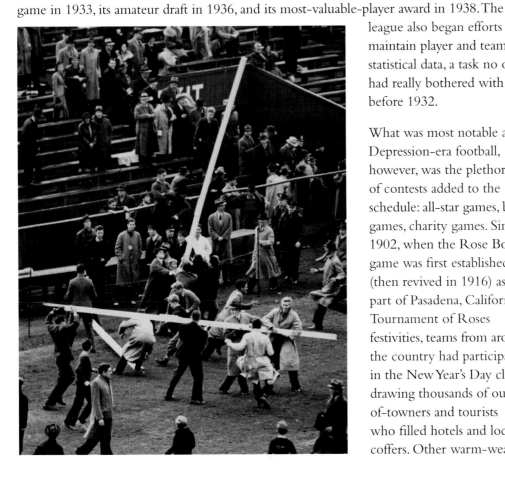

What was most notable about Depression-era football, however, was the plethora of contests added to the schedule: all-star games, bowl games, charity games. Since 1902, when the Rose Bowl game was first established (then revived in 1916) as part of Pasadena, California's, Tournament of Roses festivities, teams from around the country had participated in the New Year's Day classic, drawing thousands of out-of-towners and tourists who filled hotels and local coffers. Other warm-weather

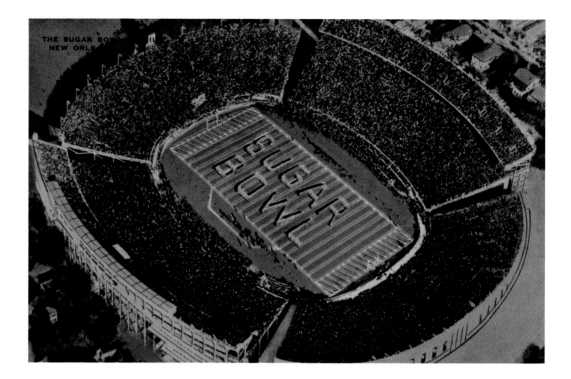

cities realized that they, too, could attract paying customers to their stricken municipalities by hosting interesting football matchups and whatever else the local chamber of commerce could devise to cap off the holidays. Thus, on January 1, 1935, three major games were added to the calendar: the Sugar Bowl in New Orleans, the Orange Bowl in Miami, and the Sun Bowl in El Paso. Two years later, Dallas added the Cotton Bowl, and smaller, short-lived fruit- and commodity-named bowls were also attempted.

Meanwhile, the crushing effects of the Depression presented more urgent requests for additional games, with proceeds to assist the poor and unemployed, and well-intentioned organizers scrambled to produce events. A New York charity game held on a frigid, rainy night in late December 1930 between college all-stars representing the North and the South drew few spectators and lost money, but, as the AP reported, "The failure of the gate receipts also solved the problem of naming the charity for which the match was staged, a question that had not been decided up to game time." Everyone seemed to be in agreement, though, that the marquee game of the year, and one sure to bring in desperately needed funds, would be an Army–Navy contest. Unfortunately, the two service academies were engaged in a bitter feud over player eligibility and had not faced each other since 1927. Chicago offered, or rather pleaded, to host the game at Soldier Field. Army claimed the game would interrupt the cadets' studies. Navy said it would play another team.

It took the machinations of congressmen, the secretaries of the army and navy, and President Hoover to pull it off, but West Point and Annapolis finally agreed to restore their rivalry. Tickets for the contest at Yankee Stadium cost up to $50 each, then the highest printed price ever charged for a football game. The Salvation Army served as the designated charity, and its extremely grateful commander, Evangeline Booth, was more than happy to attend her first football game. Two hundred debutantes were on hand selling programs at $1 apiece, and the coin flipped before kickoff was auctioned off. The navy arranged for the radio broadcast to be heard at its stations worldwide and all its ships at sea. Afterward, officials checked to see if the game came through "clear and speedy." It was *too* clear and speedy, replied one navy operator, as sailors distinctly heard Army's Ray Stecker dash off a 57-yard scoring run for a

(Above) The Sugar Bowl, Tulane Stadium, New Orleans, Louisiana, postcard, ca. 1935.

(Opposite, top) Western State College Powder Bowl, Gunnison, Colorado, AP Photo, October 14, 1939. Team captain Alice Shanks cuts through the line, leading the upperclasswomen to a 13-6 intramural win. (Note that the right defensive tackle, the only woman not wearing sensible shoes, has fallen.) That year, Spalding & Bros., the leading sporting goods company, published *American Football for Women: Official Rules*. At many high schools and colleges, women's "powder-puff" football games are part of homecoming festivities or charitable fund-raisers. The term "powder-puff," in reference to a "softer" version of sports, dates back to the 1920s.

(Opposite, bottom) Boston College players aboard a fire truck parade through Dallas prior to the 1940 Cotton Bowl, AP Photo.

6-0 victory. Navy could take some comfort, however, in knowing that the game produced $607,000 in donated proceeds.

Throughout the 1930s, there were hundreds of benefit games, many played by police and fire departments and powder-puff teams. Several NFL clubs used charity matches against college all-star teams as September warm-ups. In the first game of its kind, the 1938 Chicago Bears cruised past the Negro All Stars, a collegiate team whose roster the black press selected based on reader balloting. The fact that such a game was even played in a racially divided nation was more surprising than the 55-0 score. Occasionally the collegians would pull off an upset, most notably when a national all-star team knocked off the reigning NFL Champion Washington Redskins to open the 1938 season.

W. W. "Pudge" Heffelfinger, former All-American guard at Yale (1888–91), was the main attraction at a charity game in his home state of Minnesota not only because of his fame, but also because he was sixty-five years old and still had a move or two left in him. "I hope I convinced a few of those boys that they can't fool with an old man," Pudge said after his

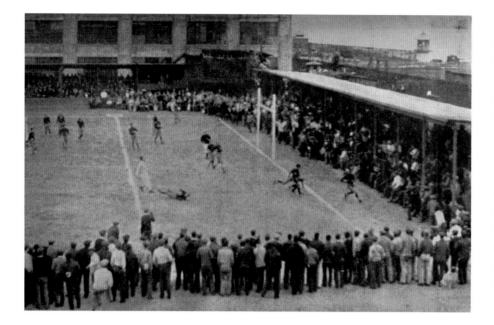

nine minutes on the field. In one of the more unusual charity benefits, the Ossining, New York, naval militia team faced off against the Black Sheep, a team of inmates from the high-security prison at Sing Sing. The prison band performed on the field, and the incarcerated population cheered loudly for "Dear Old Sing Sing." It looked like almost any other small-town contest, except that the 500 spectators from "the outside" were frisked upon entering the grounds and warned to stay away from the home team. Sing Sing won handily, 33–0, but the $250 proceeds went to the militia's unemployment fund.

(Above) Prisoners at play, Sing Sing Prison, New York, ca. 1931.

(Below) *Hold 'Em, Girls! The Intelligent Woman's Guide to Men and Football,* by Judson P. Philips and Robert W. Wood Jr., 1936. In a chapter called "Pre-Game Etiquette," the authors wisely advise, "Do not ask who is 'ahead' at any time. There is a score board somewhere. Locate it and find out for yourself." However, they note, "It is permissible when your escort criticizes a quarterback's strategy to ask him what *he* would have done . . . but you must not be sarcastic about it. He really thinks he knows."

By the mid to late thirties, not only had college teams righted themselves, but the game was flourishing. "Intercollegiate football has booted the Depression clear out of every college box office in the nation in what looms as the game's greatest year since the boom days of 1927–28," enthused the *Los Angeles Times* in 1936. In some places, football was the only game in town. "Football was the lone Atlanta commercial sport to survive on the colored side," wrote Ric Roberts of the *Atlanta Daily World* in 1939. "People would save up four-bits once a week to see Clark or Morehouse or Morris Brown play . . . The football trend in Atlanta has impaired the town for baseball. Atlanta is a 'one-time-a-week' sports town. As I say, football and the Depression have made the town that way."

Although football came through the Depression with its popularity intact, a dismayed Grantland Rice commented that player initiative had all but disappeared, and everything a team did on the field was designed and scripted, instructed and documented. Coaches represented a new generation that had edged away from football's early homestead. "The future of football, at least of immediate football, lies not now in the East," said Lewis Nichols. "Consult your football guide and look down the long columns of the country's coaches. None from Harvard, one from Princeton, and thirty-six from Notre Dame."

A Most Costly Hobby

No owner has made money from pro football but a lot have gone broke thinking they could. —NFL president Joe Carr, 1939

Although college football provided a more entertaining atmosphere, the pro game offered a higher quality of play and was continuing to build on the respectability Red Grange had done so much

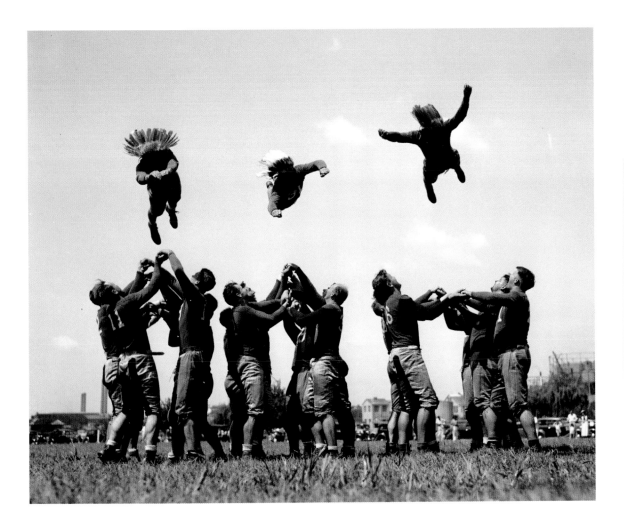

(Left) **The Washington Redskins begin summer training camp, Harris & Ewing, August 28, 1937.** In a publicity shot, the newly relocated team from Boston flings Wayne Millner, Ernest Rentner, and Nelson Peterson, wearing feathered headdresses, high above the practice field.

(Above) *Ken* **magazine, October 1938.** *Ken*, a short-lived men's magazine known for its dramatic covers and aggressive political reporting, ran a regular "Inside Football" photo feature during the season that analyzed college game shots in detail.

to foster. The issue, then, for fans was this: If both college and professional players were compensated for their efforts, why not go see the pros as well as, or instead of, the collegians, who were not as accomplished? On November 15, 1931, the Chicago Bears defeated the Giants in New York City with 30,000 fans in attendance, including Governor Al Smith and Mayor Jimmy Walker, a sure sign that the pro game, no longer a joke, had become, in fact, an accepted sport and a place to be seen. "This year," wrote Westbrook Pegler, "the patrons have seen little spiritual difference between teams which play to support expensive college [programs] and the kind that play to support such as Mr. Mara."

Still, the Depression had wreaked havoc with the more vulnerable NFL franchises, as teams folded or reincarnated themselves in new cities. Of the twelve teams operating in 1929, seven had disbanded or moved within five years. The greater willingness of fans to extend their loyalties from college teams to include the pros affirmed the NFL's decision to forsake its midsize-town franchises and compete directly with other entertainment in major cities. No longer did Newark, Staten Island, Providence (Rhode Island), Franklin (Pennsylvania), Portsmouth, and Dayton (Ohio) have NFL representation; they were replaced by Boston, Cincinnati, Detroit, Philadelphia, Pittsburgh, and St. Louis, where team owners were more confident in their prospects. Only the Green Bay Packers, league champions from 1929 to 1931, remained wedded to their modest-size municipality.

A further move toward stability was the NFL's decision to institute a college player draft. Previously, teams had jostled one another in trying to sign highly sought-after rookies, and Bert Bell, owner of the Philadelphia Eagles, was sick of being outbid by wealthier clubs. Other owners, including the Giants' Tim Mara, who had bested Bell in signing talent, took the long view and agreed to his suggestion for a player draft. The owners realized that to

succeed financially in the long run, their rivals had to succeed as well. "People come to see a competition," said Mara. "We could give them a competition only if the teams had some sort of equality, if the teams went up and down with the fortunes of life." The first draft, held in 1936, listed eighty-one eligible players to choose from, some of whom did not even know they were in the running. Most of the draftees did not sign pro contracts, figuring they could do better for themselves in another line of work, which was saying something during the Depression. One of those saying it was the first ever draft choice—and first Heisman Trophy winner—Chicago's Jay Berwanger. Unhappy with the salary the Eagles and then the Bears offered him, he opted to go into business.

As the NFL struggled through the Depression, scientists and engineers were inadvertently working to save the league. The development of television, well under way, would launch the pro game into the stratosphere of success, though it was years before the technology became common and its magnitude fully comprehended. The Philadelphia Eagles and the Brooklyn Dodgers, playing in pro football's first televised game on October 22, 1939, at Ebbets Field, could hardly imagine the implications this would eventually have, in part because they did not even know they were on TV at the time. Using just two cameras, NBC broadcast the game to a smattering of New York companies and households—a thousand at most—that owned the tiny-screen television sets. One viewer that day, the *New York Times*' Orrin E. Dunlap, expressed a view many fans would come to hold: "So sharp are the pictures and so discerning the telephoto lens as it peers into the line-up that the televiewer sits in his parlor wondering why he should leave the comforts of home to watch a gridiron battle in a sea of mud on a chilly autumnal afternoon."

After two decades, and despite growing interest, the NFL was still a money-losing venture for most team owners—or so they claimed. Yet a tide of opinion was moving toward the conclusion that the NFL might be on the verge of a breakthrough. Even the government noticed. In 1933, President Hoover's research committee on the state of the nation released a

(Above) Luke Johnsos (22) awaits a lobbed pass from Jack Manders for a touchdown, Chicago Bears vs. New York Giants, Gilmore Stadium, Los Angeles, Acme Photo, January 27, 1935. The Bears avenged their upset loss to the Giants in the NFL championship held six weeks earlier by thumping New York 21-0 in an exhibition game. The rematch gave West Coast fans a chance to see the top pros in action and to say farewell to Red Grange, appearing in his last game.

(Opposite) Players resting on the bench, Greensboro, Georgia, by Jack Delano, 1941.

landmark report, *Recent Social Trends in the United States*, which suggested that "public interest may eventually shift from college to professional football because of the superior skill of the latter. If this should happen, college football may follow college baseball and decline as a public spectacle, becoming a game of no more than local interest." Pro football's dominance did, in fact, come to pass, but the college game certainly did not wither away. "Today, they say, football is king again," wrote the *New York Times*' Shepard Stone in 1935. "If you don't believe it, look at this morning's sports section."

Playing for Uncle Sam

I'm not going to sit here snug as a bug, playing football, etc., when others are giving their lives for their country. —Dave Schreiner, University of Wisconsin end, 1942 Big Ten Most Valuable Player, in a letter to his parents

In a scene that vividly remained with longtime *Washington Post* sports editor Shirley Povich for the rest of his life, on a chilly day in the nation's capital, with the Washington Redskins down 7-0 to the visiting Philadelphia Eagles at Griffith Stadium, Associated Press reporter

Pat O'Brien received an unusual telegraph message: "Keep story short. Unimportant." Well, yes, that last part was probably true: It was the last game of the regular NFL season, and neither team was going to the playoffs. Still, O'Brien wondered why his write-up was suddenly of no consequence. A second message, which he shared with Povich and the press box, told him all he needed to know, and in football terminology, no less: "The Japs have kicked off. War now!" It was Sunday afternoon, December 7, 1941.

With Washington playing from behind for much of the game, one spectator at a time left early, but not because they lacked faith in the Redskins' star quarterback, Slingin' Sammy Baugh. First, the public address announcer asked an admiral to please report to his office. Then the commissioner of the Philippines was paged. As their names or occupations were called out over the loudspeakers, assorted army generals, FBI agents, and others returned to their posts and missed Baugh's two fourth-quarter touchdown passes that secured victory and a winning record. Redskins' owner George Preston Marshall, fearing a disruptive mass exodus, told the PA man not to mention that Japan was setting the Pacific on fire.

Meanwhile, nobody watching the division-leading New York Giants fall to the Brooklyn Dodgers at the Polo Grounds realized that anything else might be amiss until the stadium announcer instructed servicemen in the crowd to report for duty. In Chicago, the PA man at

A Thanksgiving Tradition

There was time when football was incidental to Thanksgiving Day; nowadays, Thanksgiving is incidental to football. —*Ladies Home Journal*, November 1895

Thanksgiving is one of the two major holidays that are too sentimental to be delegated to a Monday. That's why we oberve it the fourth Thursday of every November during a beer commercial of the Dallas-Washington football game. —*Erma Bombeck, humorist and syndicated newspaper columnist, 1978*

What is the most "American" holiday? An author and one of the best-known reporters of his generation, Richard Harding Davis passionately wrote in the *New York Herald* in 1894, "We could spare the Fourth of July, we could give up Labor Day gladly, but how can we exist through a long hot summer if it were not that the Thanksgiving Day game comes to us as a reward in the fall!" The holiday had strong religious overtones when Abraham

Lincoln proclaimed a national day of thanksgiving in 1863, during the Civil War. Since the American centennial, however, college football has been played on Thanksgiving Day, a custom that eventually expanded to include everything from NFL contests to neighborhood "Turkey Bowls."

In 1876, the Intercollegiate Football Association hosted a Yale and Princeton matchup on Thanksgiving Day in Hoboken, New Jersey. It marked the first college football game played away from a campus, a precursor to the modern bowl games. The choice of game day proved an instant financial success and brought New York to a standstill where "legitimate gambling on the floor of the Stock Exchange is neglected for the greater interest of betting on the game." In Davis's view, the Thanksgiving Day game was "the greatest sporting event and spectacle that this country has to show."

Not everyone was in favor of pigskin on turkey day. Ministers in New York City churches shortened, postponed, or even canceled religious services "on account of the great football match," prompting Rev. Charles W. Millard to lament in 1892, "As a great home reunion day, delightful and profitable as it was beautiful, it has been wrecked in this city by college football."

By the turn of the twentieth century, an estimated 10,000 games were being played on Thanksgiving by high school, college, and athletic-club teams, many between traditional rivals. In 1926, the Army-Navy game was the dedication game at Soldier Field in Chicago, and a record-breaking crowd of 110,000 attended in the snow. It was the

first sporting event broadcast overseas on radio, and American soldiers abroad tuned in. Domestic fans could listen in while enjoying their Thanksgiving meals, and thousands who couldn't telephoned the *Chicago Tribune* switchboard in record numbers to get the score. The NFL began playing on Thanksgiving in its first season, but since 1934, the day has been most strongly associated with the Detroit Lions. The team's owner began the tradition hoping to carve out a niche in a city whose sports landscape was dominated by baseball's Tigers. The Motor City soon built a holiday trifecta around its famed parade (1924), the Lions game, and dinner. Since 1966, the Dallas Cowboys and their fans have usually celebrated the day on the field as well.

In the 1970s, football expanded its domination of the holiday by scheduling televised games the day after, on Friday afternoon, to hold fans over for the weekend cornucopia of college and NFL offerings. And the words of the *New York Herald* in 1893 are just as true now as they were then: "It is a holiday granted by the State and the nation to see a game of football."

—Jonathan Horowitz

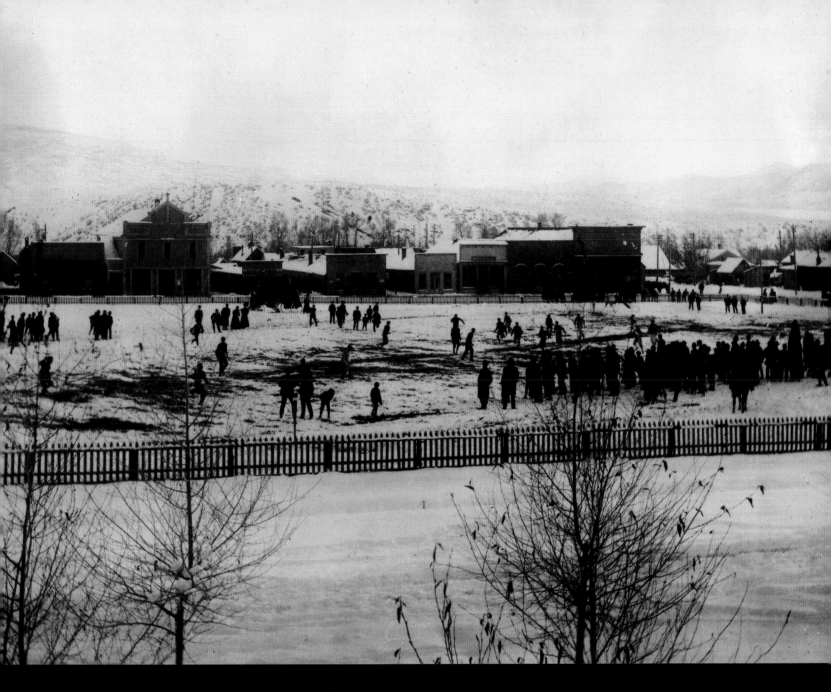

(Opposite, top) *Saturday Evening Post* magazine, November 24, 1928.

(Opposite, bottom) *New Yorker* magazine, November 26, 1949. Fewer than 10 percent of American households had a television set that year, but for those that did, televised football was already on the Thanksgiving Day menu.

(Above) Football game on Thanksgiving Day, Meeker, Colorado, ca. 1910. Spectators watch an offensive charge, at right, during a holiday game on the town's old army garrison parade grounds.

(Right) "Thanksgiving Scene in Ye Old Plymouth Colony," by Samuel D. Ehrhart, *Puck* magazine, November 20, 1912.

the Bears-Cardinals game at Comiskey Park made a similar announcement. Fans hitting the streets then learned that the Imperial Japanese Navy had just attacked the American military base at Pearl Harbor, Hawaii, and other installations, drawing the country into a second world war. Four days later, Germany declared war on the United States, and the need for manpower to wage war across both the Atlantic and the Pacific initiated a tremendous social upheaval affecting every citizen. Eight times as many American servicemen and women took part in this conflict than in World War I, and the home front had an even greater role to play. So did football.

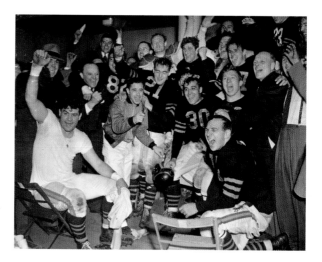

"While we believe professional football has a definite place in the recreational program of a nation at war, nothing connected with it should or will be permitted to hinder the war effort," said NFL commissioner and former Notre Dame horseman Elmer Layden. That spring, one third of all NFL players were wearing different uniforms: those of the armed forces. (More than 600 former and active NFL players would serve in the war; another 600 military veterans would join the NFL after the war.) During the 1942 season, pro teams played charity games for military relief funds, and the NFL participated in war-bond drives that put $4 million into the U.S. Treasury. The league also began playing the national anthem at the start of each game. "It

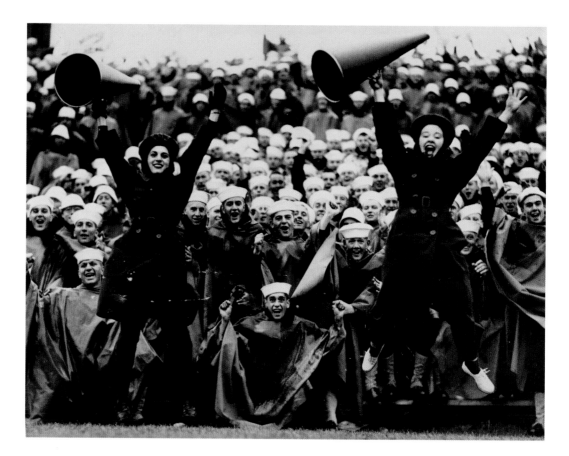

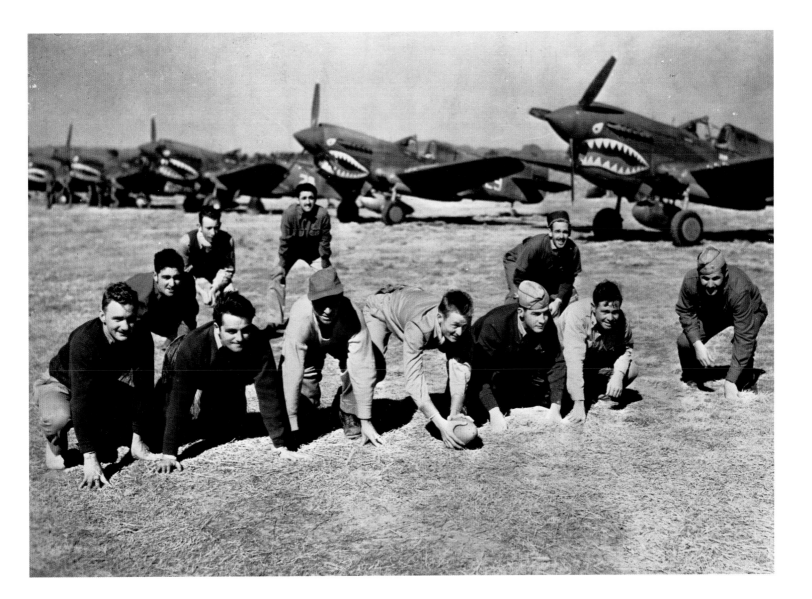

should be as much a part of every game as the kickoff," declared Layden, and the tradition continued after the war.

When the military's increased demand for healthy young men further reduced NFL rosters in 1943, some former players came out of retirement, such as Chicago Bears star Bronko Nagurski. (In the meantime, Bears owner-coach George Halas had departed for the South Pacific, where he spent the war years organizing sporting events for the navy.) The Cleveland Rams sidelined themselves that season, and the shorthanded Pittsburgh Steelers merged operations with the Philadelphia Eagles to field a team known as the Steagles. In 1944, Pittsburgh and the Chicago Cardinals teamed up as Card-Pitt, which almost instantly elided into the Carpets. The nickname was justified, given that every competitor walked all over them in a winless campaign.

In the college game, rosters dwindled, and gasoline rationing contributed to a 25 percent drop in attendance in 1942. As the 1943 season got under way, some 200 colleges did not even field teams, and those that did had to make considerable adjustments. Temporarily revised eligibility rules allowed freshmen to play. Ohio State coach Paul Brown flung open the locker room doors, announcing that "All students will be welcomed by our staff and we will teach them to the best of our ability." Brown's players included those the military had rated as 4-F (physically unfit for service), those waiting to be drafted, and those deferred from service to continue their studies.

Members of the Flying Tigers, a volunteer American fighter squadron based in China, get in a game between attacks on Japanese-held territory, ca. 1942.

Some college football teams benefitted tremendously in the war years if their campus hosted the U.S. Navy's V-12 program, which trained men to become naval and marine corps officers. Those students could continue playing football (unlike those enrolled in army college programs) and were a boon to their teams—until the navy reorganized the V-12 and transferred military students from here to there, angering their coaches. During the 1943 and '44 seasons, "pre-flight" teams, such as Iowa Pre-Flight and the Great Lakes Naval Training Center, were stocked with professional and college players headed to flight school. These teams competed against colleges and were included in the national Associated Press poll rankings. West Point and Annapolis also heavily recruited and signed college stars, to the consternation of their competitors.

The Arab Bowl, Oran, French Algeria, U.S. Signal Corps, January 1, 1944. Fifteen thousand spectators, primarily U.S. supply units and wounded personnel (as well as some Arab chieftains), gathered in San Philipe Stadium to see a football doubleheader among army and navy teams. Army paratroopers landed on the field to initiate the festivities, Red Cross and Women's Army Corps members served as bowl game queens, a group of Texas soldiers was roped into performing lassoing tricks on Arabian horses, and a dozen WACs raced camels and donkeys between games. Other notable contests included the Riviera Bowl in Marseille, the Spaghetti Bowl in Florence, and the Nuremberg Sugar Bowl.

The service academies offered football players an enticing wartime deal: Cadets and midshipmen were exempt from the draft, they received an officer's commission at graduation, and if all went well, the war would end before their football eligibility did. Army was especially dominant during the war years, compiling a 27-0-1 record from 1944–46 under coach Earl Blaik and his Heisman-winning backfield—Doc Blanchard ("Mr. Inside") and Glenn Davis ("Mr. Outside"), nicknamed for their signature running patterns. Rated number one at the end of the 1944 season, Army defeated second-ranked Navy to claim the first of two consecutive undisputed national championships. Thrilled with his alma mater's performance, General Douglas MacArthur, Supreme Allied Commander in the Southwest Pacific, sent Blaik a telegram that read: "The greatest of all Army teams. We have stopped the war to celebrate your magnificent success."

American troops soon poured into Britain in preparation for the Allied invasion of Europe, and in May 1943 the Yanks put on a game, complete with army bands and Red Cross cheerleaders, at the White City stadium in London to benefit the British Red Cross's prisoner-of-war fund. Two-thirds of the 30,000 spectators were Britons who, despite the efforts of American and British sportswriters to explain Yankee-style football in the weeks leading up to the game, were still puzzled by what they saw. One impressed *London Evening News* sportswriter told his readers that "the high-flung passes as men sprint under the ball to take it in their stride must be seen to be believed."

In the Pacific, the 4th and 29th Regiments of the U.S. 6th Marine Division were on the miserably steamy, bug-infested jungle island called Guadalcanal, training for the next island assaults that would bring the Allies closer to Japan. The 29th carved out a playing field on the island's coral surface, and the aptly named Mosquito Bowl kicked off on December 24, 1944. Some 9,000 servicemen saw two teams—packed with college All-Americans and

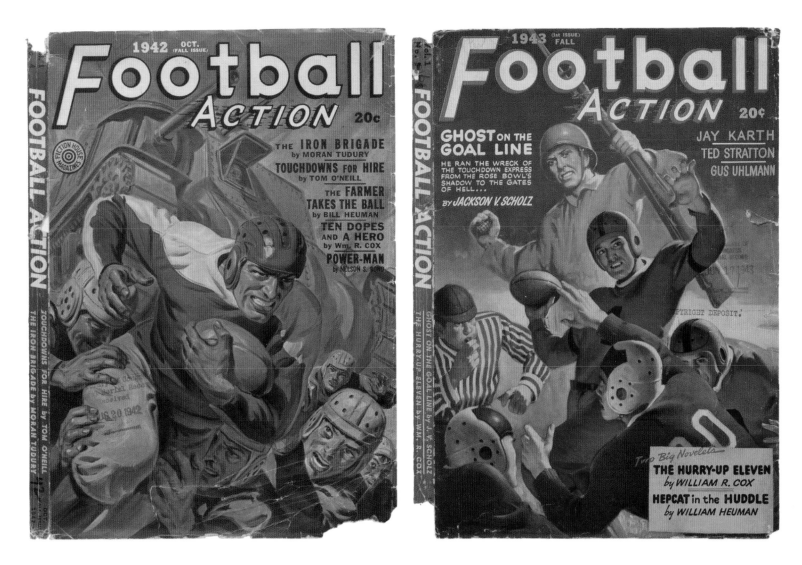

former NFL players—they would have paid good money to see at home, and others in the war zone listened in on the radio. Walter Bergman, platoon leader and halfback for the 29th, had starred at Colorado A&M and was amazed that on "our team alone, we had six college football captains." One of those was George Murphy of Notre Dame. Wisconsin's two-time All-American end, Dave Schreiner, led the 4th Regiment. Years later, participants recalled the scoreless competition as the toughest game they ever took part in. No one wore a helmet or padding, and the raggedy field sliced up knees and elbows.

That spring, Mosquito Bowlers learned where they were headed. On April 1, 1945, 6th Marine Division forces landed on heavily defended Okinawa. The Japanese waged a hellacious, fight-to-the-death defense of what they knew would be the launching pad for attacks on their homeland should the island fall to the Allies. At Sugarloaf Hill, "We lost a lot of men," said Bergman. "One of our platoon leaders was George Murphy . . . He got hit with some mortar fire. And he stood up and emptied his pistol . . . And he never came back." Neither did Schreiner nor ten other Mosquito Bowl players. Of the game's remaining participants, more than half were wounded in combat.

American football also found its way into Axis prison camps. American prisoners of war using hidden, jury-rigged radios occasionally picked up broadcasts of games at home, finding comfort and diversion in the familiar. U.S. Army nurse Lt. Gwendolyn Henshaw, imprisoned in the Japanese-held Philippines, described POW efforts to "organize our lives as if we were free." They played an Army-Navy game on Thanksgiving and held a Rose Bowl contest on New Year's Day. "We even had a bowl of our own called the Talinum Bowl after a spinach-

Football Action and *Thrilling Football*, fiction magazines.
Each autumn during World War II, magazines featuring football-themed short stories and novellas emphasized the game's association with military combat. This sampling of covers illustrates how players were explicitly linked to armor, infantrymen, and airmen.

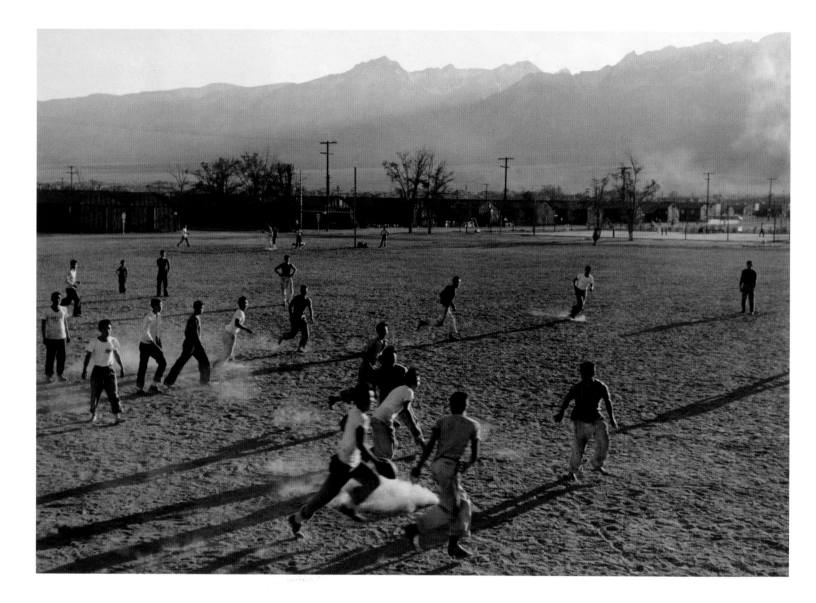

Football at Manzanar Relocation Center, Manzanar, California, by Ansel Adams, 1943. Adams, best known for his epic images of the American West, documented the experience of Japanese Americans interned in desolate camp facilities, where sports were crucial to maintaining morale during the war. In 1944 he published *Born Free and Equal: The Story of Loyal Japanese-Americans*, later donating his original Manzanar negatives to the Library of Congress.

like vegetable that thrived in our Victory gardens." Without the talinum plant, many in the overcrowded prison would not have survived. On the other side of the world, Sgt. Merrill De Vries sent a postcard from Stalag 3B in Prussia to Iowa's athletic department asking for four tickets to the next homecoming game. "Upon my immediate return to the States, I will forward money for these tickets on the west side of the stadium. Good luck to the Hawks in '44." De Vries survived the war and returned to Iowa.

At home, toward the end of the 1944 NFL season, the War Department looked into professional football following complaints that Sammy Baugh—who had done nothing illegal—was commuting from his home in Texas to Washington, D.C., for games. This did not sit well with ordinary citizens coping with wartime rationing restrictions that resulted in aging vehicles with partially filled gas tanks and heavily patched tires. A War Department official admitted, "We got thousands of letters from fathers and mothers of boys in the service asking how Baugh could be permitted to use essential transportation to fly more than halfway across the country for the Redskins' games. They were hard to answer." But football, like baseball, was considered an important asset in maintaining home-front morale, and as such it received privileges not granted to other forms of entertainment, such as horse racing, which James F. Byrnes, director of war mobilization, shut down in December 1944. The Baugh investigation also triggered questions about men rated 4-F playing on professional sports teams, and Byrnes angered NFL and MLB club owners when he ordered the Selective Service to reexamine those cases.

As the war progressed, lists of the dead contained many football names. Ensign Nile Kinnick, Iowa's 1939 Heisman Trophy winner serving aboard the aircraft carrier USS *Lexington*, disappeared beneath the waves after his plane malfunctioned off the Venezuelan coast. Montana State lost fourteen Bobcats from its recent teams. Twenty active and former NFL players also perished, including four who had been playing on that fateful December 7. One of them, Giants end Jack Lummus, was posthumously awarded the Medal of Honor—the nation's highest military award—for his actions at Iwo Jima, when he singlehandedly took out three Japanese strongholds under a barrage of artillery fire before stepping on a land mine. In his final moments, he reportedly had the presence of mind to inform doctors that the Giants were losing a good man.

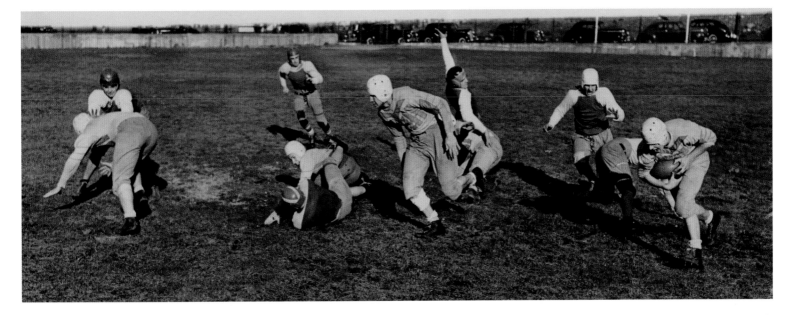

Servicemen returned home to find football a changed game and the country a bustling superpower. More than two million military veterans used the G.I. Bill to attend college, which many of them would not have been able to afford otherwise. In the subsequent campus boom, vets comprised half of all college players in the early postwar years. In 1943, the NFL began requiring players to wear helmets, and resourceful wartime industries dramatically improved sports equipment. Shortly before the 1945 season, manufacturers announced that technology developed for military use and applied to football gear would strengthen uniforms and pads while reducing their weight from eighteen pounds to ten. "Fiber-glass jerseys, nylon pants and foam-rubber pads will make the difference," reported the United Press.

The war also signaled the decline of the sixty-minute man. Until 1941, players usually held both offensive and defensive positions and remained on the field the entire game unless injured. Using players at just one position grew more common during the war, since fewer available men—many of them new to the game—were skilled in more than one role. Michigan coach Fritz Crisler popularized the idea of one position per player during a game against Army in 1945. The scheme so impressed West Point coach Red Blaik that he implemented the system, using the military term "platoon" to refer to his offensive and defensive lineups. The NFL allowed the two-platoon system ("free substitution") in 1950, and the change set in motion the game's growing sophistication and complexity, as players specialized in one position. In addition, better-rested players resulted in higher-quality performances. College and high school officials also preferred the two-platoon format, as it lessened the risk of injury and allowed more students to participate.

(Top) Six-man football, Cleveland High School, New York City, by William C. Greene, 1941.

(Above) Dr. Charles Lombard, director of Aviation Physiology at the University of Southern California, Acme Telephoto, September 13, 1950. A weighted pendulum, swinging at the rate of ten feet per second, pounds the professor's plastic helmet in a test to improve football headgear.

Most colleges that had suspended football during the war were back on the field in 1946, and the college game boasted more teams than ever. At the professional level, significant changes also were under way. The Cleveland Rams, defending NFL champions, bolted to Los Angeles, establishing the league's first genuine presence in California. And despite the NFL's improving but still precarious finances, another professional outfit, the popular but not-so-profitable All-American Football Conference, appeared on the field. Did the country really need two struggling pro leagues? Arch Ward, AAFC founder and *Chicago Tribune* sports editor, sure thought so. The AAFC's existence prodded the NFL to expand its geographic range rather than cede territory to the upstart league, especially out west. During the new league's brief history (1946–49), coach Paul Brown built the Cleveland Browns into a powerful, innovative club with a loyal following, making the team attractive to the NFL. Eventually, three AAFC teams (the Cleveland Browns, Baltimore Colts, and San Francisco 49ers) would join the NFL.

A Sport Divided

Segregation is segregation, but after all, football is football. —A pro-segregationist Georgia state board of regents member, explaining why he voted to allow all-white Georgia Tech to play against an integrated team in the 1956 Sugar Bowl

Like the Fourth of July or December 25, nearly everyone in America knew what would happen on April 15, 1947, although opinion varied as to whether or not it was a celebratory occasion. Ever since Branch Rickey, general manager of baseball's Brooklyn Dodgers, had signed Jackie Robinson—a three-sport star at UCLA and an army veteran—the nation braced itself for the day that a black player would cross the major leagues' unwritten but strictly enforced color line. For nearly seven decades, the national pastime had been rigidly divided between the professional white major leagues and the Negro leagues. So when Robinson, despite death threats, trotted onto Ebbets Field on Opening Day, it was a few short steps to second base for one man, and a collective social leap for 144 million Americans.

Football did not have a Jackie Robinson. There was no defining, momentous occasion emblazoned into the national memory when a black athlete, chosen and groomed for the mission, ran onto the gridiron with the heaviest of expectations weighing on his shoulder pads. Instead, football integrated in a roundabout manner. The gradual willingness of college presidents and state legislatures north of the Mason-Dixon Line to admit black students to white schools lessened opposition to their participation in football. Although few in number, pioneering black players, resilient and determined, won places on college teams as early as the 1880s, generating little fanfare, if any, outside their own communities. Some teams did not even realize until shortly before kickoff that their opponents even had a black player or two. Thus, integration in Northern college football

(Below) *Professor Fodorski*, by Robert Lewis Taylor, Doubleday, 1950. In Taylor's satiric novel, the newly emigrated college professor uses engineering principles to produce a winning football team. Mel Brooks adapted the book for the Broadway musical *All American* (1962), starring Ray Bolger.

(Below, right) Coach Paul Brown at the Cleveland Browns summer training camp, by Jim Hansen, 1955. Serious, meticulous, driven, and decisive, this son of Massillon, Ohio, coached at all levels of the game and developed innovations still in use, including player psychological testing, detailed film study, and use of men dubbed the "taxi squad" for their jobs as cab drivers, which the coach arranged to keep them employed and available to practice against. He did not hesitate to fire players for smoking or drunkenness, and he was instrumental in integrating his Cleveland team in 1946.

progressed as a series of uncoordinated, often unnoticed occurrences in small doses. Several black professionals played in the Ohio League, and thirteen were in the NFL at various times from its inception in 1920 until 1933. When Depression-era financial woes prompted player cuts, blacks were the first let go, lest fans object to the loss of white employment. Among other things, economics and the influence of Washington Redskins owner George Marshall, who marketed his team to the South, conspired to keep blacks out of the league until 1946. Marshall had made his fortune in the laundry business, and it was just as important to him in football to separate whites from other colors.

Although football had no Jackie Robinson, it certainly had Jim Crow—a code, especially fierce in the South, enshrined both in law and in custom, that required blacks to defer to whites and that kept the races apart as much as possible. The legal concept of "separate but equal," which was hardly true in practice, had been in place since the U.S. Supreme Court affirmed it in 1896, in *Plessy v. Ferguson*. A half century later, the country emerged from a world

war in which venomous racial and ethnic ideology accounted for many of the estimated 55 million lives lost worldwide. The war, framed in the West as the struggle of freedom-loving people against tyranny and oppression, raised questions about human and civil rights in a country that had done so much, and at great cost, to destroy evil overseas. Black military men and women had served, in segregated units, yet remained second-class citizens. What would Americans do now about racial inequality in their own homeland? The national slog toward resolution would pass through courtrooms as well as locker rooms.

Historically, black athletes on predominantly white Northern teams were denied access to the dormitories, hotels, and restaurants open to their teammates and were subject to verbal and physical abuse, no matter where their games were played. In Southern and in many Midwestern regions, all-white teams refused to play integrated teams unless the black players were benched. Northern teams were complicit in this "gentlemen's agreement" and willingly sat their black players whether hosting or visiting Southern schools. The Northern press was not oblivious to the agreement, and when New York University agreed to keep its two black players out of a home game against Georgia in 1929, renowned newsman Heywood Broun called NYU coach Chick Meehan a "gutless coach of a gutless university." In 1934, shortly before Michigan played Georgia Tech at home, students in Ann Arbor rallied against their school's decision to appease the visiting team by keeping Willis Ward, the Wolverines' black star end, out of the game. (Future U.S. president Gerald Ford, Ward's roommate on the road, nearly quit the team in protest, but Ward insisted he play.) Responding to the uproar, the

Queen Elizabeth II, front row, center, at the North Carolina-Maryland game, College Park, by Bob Lerner, October 19, 1957. On her first state visit to the United States, marking the 350th anniversary of the English settlement at Jamestown, the queen requested to see an American sport. At the game, her Maryland hosts served hot dogs and tea, and she was so delighted by the halftime card stunts depicting the Union Jack and her insignia that she asked to see it again, commending the student coordinator for his handiwork. After Maryland's 21-7 win, the queen greeted coach Tommy Mont with the words "Splendid! Splendid!" The royal visit obscured other sports news that day, including a landmark innovation in American football, as Fred Bednarski, a Polish immigrant, kicked the first soccer-style field goal in a Texas win over Arkansas.

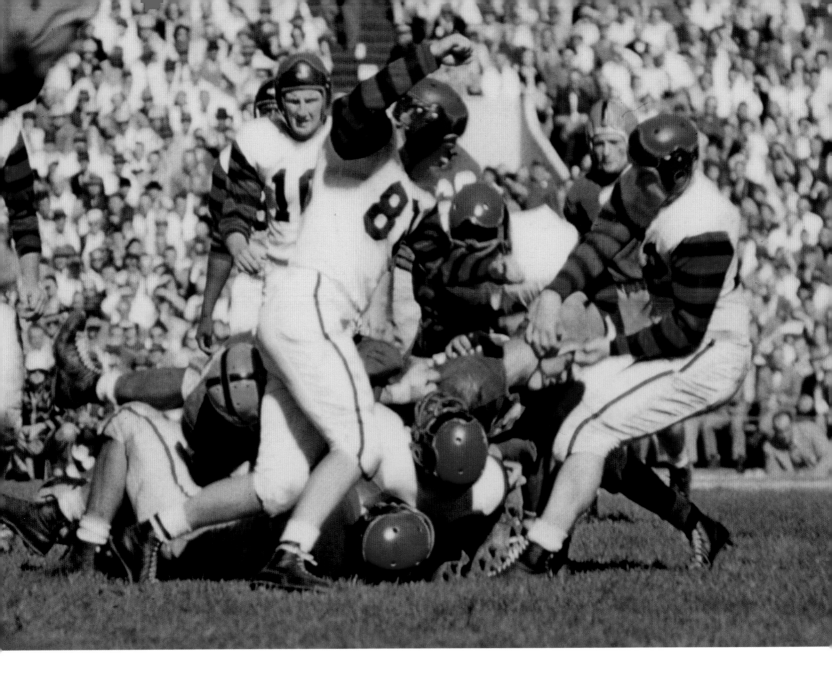

(Top) Helmet removal in progress, Notre Dame and Penn battle to a draw, by Arthur Rothstein, September 27, 1952.

(Above) Bethune-Cookman College huddle, Daytona Beach, Florida, by Gordon Parks, 1943.

coaches agreed that Ward would sit out, but so would Hoot Gibson, the Yellow Jackets' star. This solution nullified the claim that losing Ward to a Southern custom gave Tech an unfair advantage. From the mid-1930s on, Southern schools had to vet their potential competition to avoid messy scenes such as this, especially as opposition to the practice flickered among students and as the National Association for the Advancement of Colored People (NAACP) tackled the issue.

What was occurring in football, of course, was simply an extension of daily American life. Racial segregation was so ingrained that black players went along with it if they wanted to stay on the team. Raymond Kemp, who played for Elmer Layden at Duquesne, coached at Bluefield State College, and was the Pittsburgh Pirates' (Steelers) first black player, in 1933, accepted segregation because of the pressure put on everyone to maintain the status quo. "If a coach of a white team is decent to a colored player, there is nothing else for the colored man to do but step aside when a Southern team refuses to play against him," said Kemp in 1934. "Coaches do not have to use colored men on their teams." He also argued against black players quitting white teams in protest, because "if they keep playing and demonstrating their ability, the prejudice against them will vanish when their presence becomes a common occurrence."

Douglas G. Hertz, owner of the 1941 New York Yankees—no, not *those* Yankees, but the minor league football team—was delighted to share the results of his team's foray into social experimentation. After signing a black player, Hugh Walker, Hertz initially made plans to accommodate him separately, and he worried about the effect Walker's presence might have on his players, especially the Southerners. "I suggested . . . that Walker be given bed and board the first night with the rest of the boys, just to see if and when anything undesirable might occur. I am happy and proud to say that nothing happened," beamed Hertz. "The white boys registered no protest about Walker eating and sleeping among them, and he has lived ever since in our training quarters." By such mundane transactions did progress slink forward.

With insistent encouragement from the local black press, the recently arrived Los Angeles Rams signed UCLA star Kenny Washington in 1946, reintroducing black players to the NFL. (Before the war, pro scouts regarded Washington as perhaps the best player in the nation, but no team signed him.) Once the deal was done, the furor in town wasn't so much that he was *joining* the team, but rather how dare the league or anyone else suggest that this local hero be kept *off* the team. The Rams also signed Woody Strode that season, and the AAFC's Paul Brown hired Marion Motley and Bill Willis for the Cleveland Browns. In 1949, George Taliaferro, star halfback at Indiana, became the first black player drafted by an NFL team, although he chose to sign with the AAFC's Los Angeles Dons. By 1952, nine of the NFL's twelve clubs were integrated, with blacks making up about 12 percent of all players, a figure just slightly higher than the percentage of blacks in the general U.S. population. It was also the only era in NFL history that the league's racial composition closely resembled that of the country as a whole.

Over time, the South's effort to preserve segregation harmed both its relations with Northern teams, which were no longer willing to sit certain players upon request, and its own business interests. In the 1950s, some Southern schools, including two of the most prominent, Georgia and Georgia Tech, took a more pragmatic approach, opting to play integrated teams outside, but not within, the South, a proposition Alabama and Ole Miss

(Above) Levi Jackson, Yale running back, *Our World* magazine, October 1949. As the country approached midcentury, Yale players voted Jackson their first black captain, and Frank S. Jones, a black student from North Carolina, was elected manager of the Harvard football team. On learning he had been unanimously chosen as captain, "I almost fell out of my seat," said Jackson. He went on to a successful career as an executive at Ford Motor Company.

(Left) Uniforms on the line to dry, Columbus, Ohio, by Paul Fusco, 1957.

(Below) Willis Ward and Gerald R. Ford, University of Michigan, 1933.

could not yet even countenance. (Game reports involving integrated rivals that appeared in Southern newspapers excluded mention of a player's race.) Yet white fear that black equality or superiority in sports would undermine the foundation on which much of society was built remained a major obstacle to integration. There was another related factor at play, in which white Southern football victories over Northern teams helped ameliorate a deep resentment held since the Civil War. As historian David G. Sansing noted, "Each time Ole Miss went out to play, it was the charge of the Confederate Gray up Cemetery Ridge all over again."

Early football integration battles in the South centered not on the players but the fans. In 1951, University of North Carolina law student James Walker argued that segregated stadium seating placed black spectators in the least desirable seats, behind the goalposts, and, as a further insult, that he was not allowed to sit with his fellow students. UNC chancellor Robert B. House explained that while black students were permitted equal access to campus educational facilities, the stadium was not included. The student body president and the campus newspaper, the *Tar Heel*, lashed out at the administration; as one editorial elegantly put it, "Our task is not to fight grudgingly the new social situation in which we find ourselves, but to make the transition as gracefully and smoothly as possible." After a week of student resolutions condemning his decision, Chancellor House reluctantly reversed his position.

This was just a warning shot in the battle over civil rights on the Southern gridiron. Various legal decisions, including, most notably, the Supreme Court's *Brown v. the Board of Education* (1954) ruling, which erased on paper the concept of "separate but equal" and prohibited racial segregation in public schools, set in motion a "massive resistance" movement in Southern states against federal authority. Desegregation efforts nationwide challenged the country to reconcile its traditional practices with its long-stated ideals. The process was both hopeful and horrendous.

Late in the day on December 1, 1955, Rosa Parks famously refused to give up her seat to white passengers on a Montgomery, Alabama, bus, an act of defiance that soon focused national attention on the city. Parks's arrest for violating a local segregation ordinance would prove to be a galvanizing moment in the civil rights era. The next day, in Georgia, Governor Marvin Griffin asked the state board of regents to prevent Georgia Tech from

(Above) Kenny Washington, UCLA running back, ca. 1939. Known as the "Dusky Meteor," the highly regarded Bruin was barred from the segregated NFL until 1946, when he signed with the Los Angeles Rams as a twenty-eight-year-old rookie.

(Left) Segregated seating at the Orange Bowl, Miami, Florida, by Phillip A. Harrington, January 1, 1955.

appearing in the upcoming Sugar Bowl, to which the University of Pittsburgh, and its one black player, fullback Bobby Grier, were also invited. Griffin was equally upset that Pittsburgh would not segregate its share of stadium seating, even though that seating was in Louisiana, hundreds of miles outside his own jurisdiction. Within twenty-four hours of the bus and bowl occurrences, two communities, Montgomery's black residents and Georgia Tech's white students, took action. In Montgomery, plans to boycott buses went into effect almost immediately. In Atlanta, Tech students hanged Griffin in effigy on campus, marched on the state capitol, and roared their disapproval outside the governor's mansion. For Rosa Parks, justice trumped social tradition. For Tech students, the Sugar Bowl trumped that tradition, too.

In all of football, the tumultuous civic transformation played out most visibly at New Orleans' Tulane Stadium, home of the Sugar Bowl. As New Year's Day approached, the game served as a representative cauldron of charged public opinion to such a degree that Furman Bisher of the *Atlanta Constitution* referred to it as "the Sociological Bowl." Not only did Governor Griffin want Tech out, but he also proposed statutory segregation at all sporting events (for both teams and spectators) in Georgia, declaring it essential to human existence.

Controversy at the 1956 Sugar Bowl. Teammates of Pittsburgh fullback Bobby Grier, center, express their displeasure with Georgia governor Marvin Griffin, who sought to keep Georgia Tech out of the Sugar Bowl unless all the players were white and the seating was segregated.

"The South stands at Armageddon," he thundered. "The battle is joined. We cannot make the slightest concession to the enemy in this dark and lamentable hour of struggle. There is no more difference in compromising integrity of race on the playing field than in doing so in the classrooms. One break in the dike and the relentless seas will rush in and destroy us." Ironically, Griffin resented federal court rulings affecting Georgia just as much as Tech resented the governor's meddling in its affairs. Indeed, Georgia Tech's president refused to break the Sugar Bowl contract and lose out on a major bowl game appearance.

Georgia's board of regents voted to approve Tech's Sugar Bowl trip but apologized to Governor Griffin and the public for the students' "riotous" behavior. George Harris, Tech's student body president, sent a message to Pitt students, telling the Panthers that "The student body at Georgia Tech sincerely apologizes for the unwarranted action of Georgia's governor. We are looking forward to seeing your entire team and student body at the Sugar Bowl." That same day, Rosa Parks was tried and convicted of violating Montgomery law. It would take another year before the city officially integrated its bus system, but it would take even longer to get the Sugar Bowl on board.

The 1956 game ended in victory for Georgia Tech and hinged on a controversial call in the end zone involving Grier, who turned in the best performance of the game and received hearty cheers. The Northern press and the black press generally interpreted the episode as a sign that white students, universities, and elements of Southern business communities

 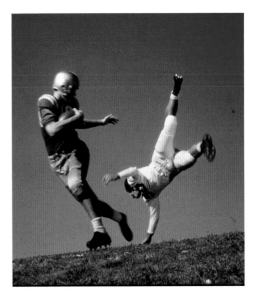

would wave in an era of integration, joining forces with black Americans in calling for good sportsmanship and fairness to all. But those who backed Georgia Tech's participation in the game did not necessarily intend for their willingness to play against mixed teams to be mistaken for support of a fully integrated society. And certainly not all young football-loving Yellow Jackets were prepared to accept that either.

Tulane Stadium and the Sugar Bowl continued to be a source of controversy. In the summer of 1956, Louisiana governor Earl Long signed a sports segregation bill into law, which prohibited integrated sports competition and spectator seating. He had barely put down

(Above) UCLA's Ronnie Knox, left, practicing his moves, Los Angeles, by Maurice Terrell, 1954.

(Below) Football rendering, original black ink artwork, by Jean-Michel Folon, ca. 1960.

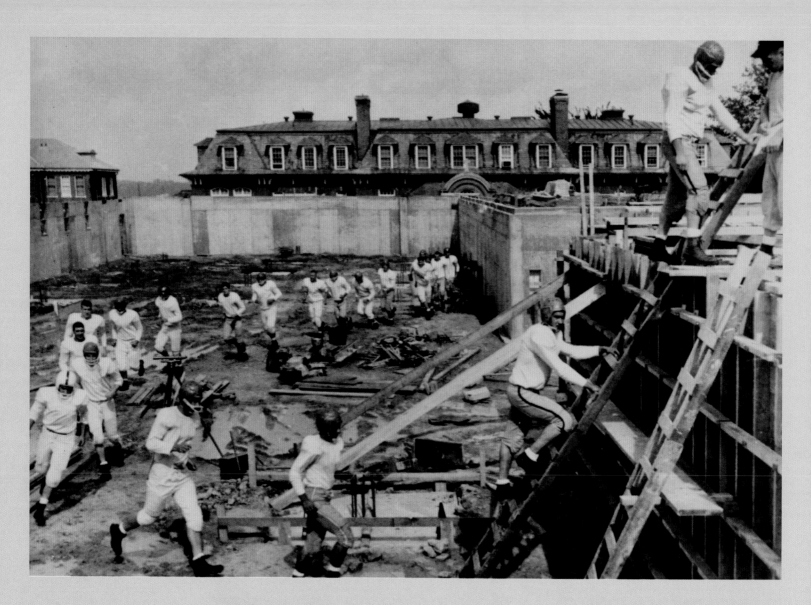

(Above) Construction of a new campus library offers Loras College players a useful obstacle-training course, Dubuque, Iowa, UPI Telephoto, 1959.

(Right) Ohio State coach Woody Hayes celebrates a win with a trip to the showers, by Paul Fusco, 1957.

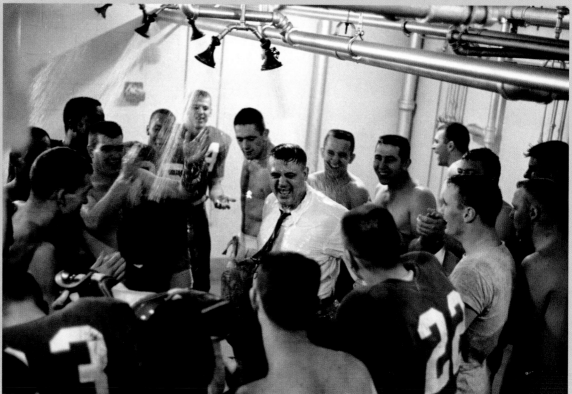

his pen when Wisconsin canceled its games with Louisiana State because the new law would essentially deny the Badgers the right to select the members of its own team. During the 1957 season, the Tulane-Army game was transferred to West Point, since the military academy would not segregate its ticket holders in New Orleans. (Congressman F. Edward Hébert, furious that the game was moved, threatened to stop nominating Louisiana men to West Point.) The *Hartford Courant* editorialized that the South "has been living on the tax money of the North, from states like Connecticut . . . In other words, the South has been integrated back into the Union and has so many ties now that only those who cling to the past can doubt the inevitability of integration . . . The cancellation of the Tulane-Army game is a tiny symptom of the penalties that will surely ensue if the South continues intransigent." The drama was repeated yet again in 1958, as undefeated Air Force canceled its regular season game against Tulane.

The Sugar Bowl averted public relations debacles for the next nine years by inviting only Southern schools. Yet this was exactly what game sponsors did not want—to become a regional game restricted to inviting only the next-door neighbors. The law's effect was especially noticeable in college basketball, as teams from around the country canceled games, declined tournament invitations, and avoided the Pelican State. The U.S. Supreme Court declared the Louisiana sports law unconstitutional in 1959, but the state resisted altering its policies, and it was not until 1965, when Syracuse was invited, that an integrated team returned to the Sugar Bowl.

In the NFL, George Marshall kept his Washington Redskins all-white as long as possible, long after every other team had integrated. When the new Kennedy administration arrived in Washington, D.C., in early 1961, Secretary of the

Interior Stewart Udall was appalled by the team's racial policy. With an assist from Attorney General Robert Kennedy, Udall threatened to bounce Marshall and his "Paleskins," as the secretary referred to them, out of D.C. Stadium, the city's new publicly funded venue, if the team continued its ban on black players. In the Redskins, Udall chose a highly visible discrimination case to pursue. It was *too* high profile to suit other NFL club owners, flush with a new television contract and wary of spoiling the league's rising popularity. They cringed at news images of civil rights activists protesting outside Marshall's home and his supporters brandishing "Keep Redskins White" signs. That summer, the owners dispatched NFL commissioner Pete Rozelle in the name of league unity to deal with Marshall. In December, the Redskins drafted and traded for the team's first black players.

Big-time football's last remaining haven of all-white squads was the college game's Southeastern Conference, home to several historically powerful teams. The Redskins case demonstrated what could be achieved when political will matched the tenor of the law, even as it raised questions about the rights of business owners to hire employees of their own choosing. Udall's case worried the NFL, and ultimately it was the league that forced

Marshall's hand. In the SEC, however, the membership was still united in its support for segregation. The University of Kentucky was the first to test the waters, surveying fellow conference members on their views of integrated athletics. Most did not bother to return their questionnaires. In 1967, defensive end Nat Northington and the Wildcats dove in and unilaterally broke the SEC color line; two years later, in the Deep South, Auburn, Florida, and Mississippi State began signing black recruits.

(Top) Governor Ross Barnett at the Kentucky-Ole Miss game, Jackson, Mississippi, September 29, 1962. The staunchly pro-segregationist governor waves along with Confederate flags amid the furor that James Meredith was about to become the first black student at Ole Miss. At halftime, Barnett introduced the new state song, "Go Mississippi." The *New York Times* reported that the "football team has remained determinedly silent on the Meredith question, which is easy, since it lives in its own dormitory, has its own cafeteria, and practices a good deal of the time."

(Right) Pee Wee leaguers and another young fan, left, watch the high school varsity practice, Plainfield, New Jersey, 1966.

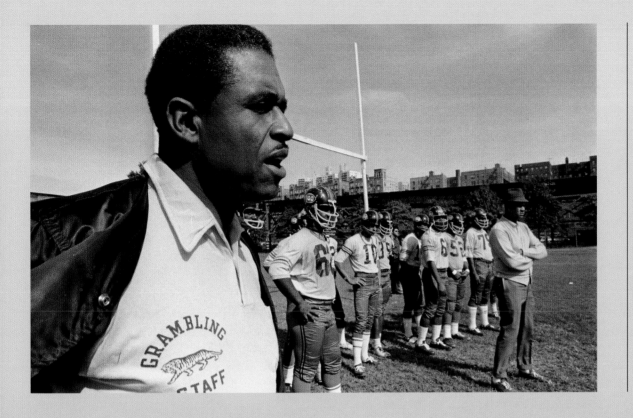

(Left) Grambling State head coach Eddie Robinson on the practice field, Grambling, Louisiana, by Jim Hansen, 1969. Robinson went 408-165-15 in his fifty-seven-year career (1941–1997) as head coach at Grambling, a small historically black college powerhouse. Robinson sent more than 200 players to the pro ranks, and he continued to win even as more top black prospects began signing with major Southern schools.

(Below) Cleveland Browns running back Jim Brown meets the press, by Paul Fusco, 1957. Brown, a star at Syracuse and, as a nine-year member of the Cleveland Browns, one of the greatest NFL players of all time, ran through defenses with ease but ran up against tougher obstacles off the field. When his Orangemen played the 1957 Cotton Bowl, Brown could not stay with his white teammates at their Dallas hotel.

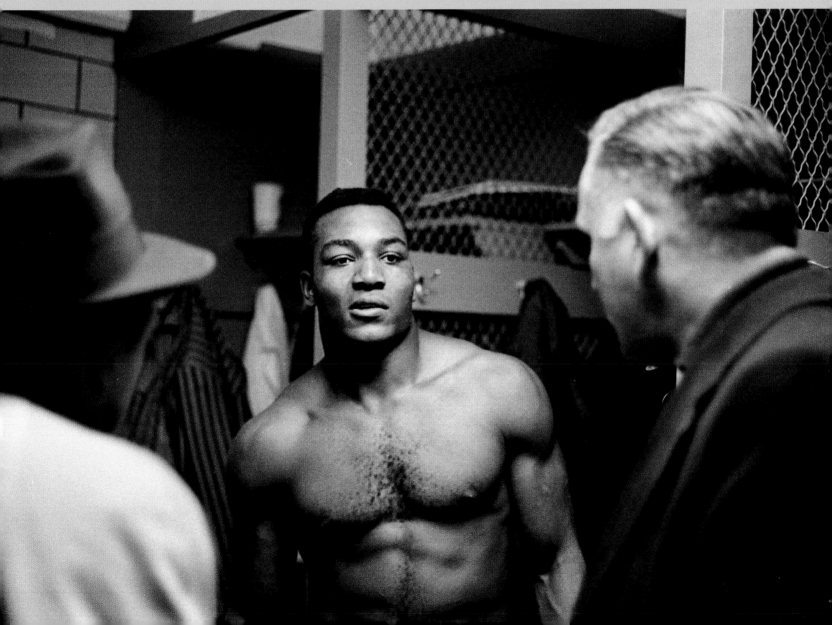

On Further Review: The Johnny Bright Case

"John was ambushed for two reasons: One, he was a hell of a football player. And two, he was black," said Gene Macomber, a teammate of Drake's Johnny Bright, a leading contender for the Heisman Trophy in 1951. What occurred that season in Stillwater, Oklahoma, was emblematic of what other black players had endured, but none so publicly.

The mood in town was not especially welcoming when the undefeated Drake Bulldogs arrived to play 1-3 Oklahoma A&M (as Oklahoma State was then known). Bright, Drake's only black player, was not permitted to stay at the team hotel, instead finding accommodations at the home of a black minister. And the word was that the Aggies would be gunning for Bright. "They told me Johnny wasn't going to finish the game," said Macomber, who had visited a local barbershop that morning. And so it was. Three times in the first quarter, Aggie tackle Wilbanks Smith viciously struck Bright in the face, knocking him out cold. In each instance Bright was hit well after he was out of the play and without the ball. No penalties were called. The dazed Bulldog, his jaw broken, then tossed a 61-yard touchdown pass and left the game, catching sight of a sign in the stands reading "Get the nigger." The Aggies went on to a 27-14 victory.

A&M coach J. B. Whitworth denied that Smith had been instructed to go after Bright (despite A&M student eyewitness admissions to the contrary). After the jawbreaking hits, Smith made a jaw-dropping statement, saying he was sorry if he had "overcharged Johnny." The incident might have ended in a "Drake said, A&M said" stalemate had not the *Des Moines Register* run indisputable proof of the outrage on its front page the next day. Don Ultang and John Robinson's photographs clearly depicted what *Life* magazine would call "the year's most glaring

IOWA FAILS, 21-0;
Bright's Jaw Broken, D
JOHNNY HURT ON FIRST PLAY, THEN

example of dirty football," and the *New York Times* would later name this "one of the ugliest racial incidents in college sports history."

The story drew national attention and widespread criticism of A&M, whose athletic council, even after seeing film footage of the plays, pronounced the hits as merely "illegal blocks" and "just another football incident." Neither the college nor Coach Whitworth disciplined—or even reprimanded—Smith. Infuriated, Drake presented its case, photographs and all, to the Missouri Valley Conference, asking that it take action. Officials declined to do so, prompting Drake to withdraw from the league. In a supportive gesture, Bradley University withdrew as well. The

University of Detroit, scheduled to play A&M next, received "scores of letters" according to its coach, asking that his team avenge Bright.

Johnny Bright played briefly once more that season, finished fifth in the Heisman voting, and accepted an offer to play professionally in Canada, where he enjoyed a Hall of Fame career and later became a school principal. As a result of the Oklahoma A&M game, Drake downgraded its football program, college football helmets were reconfigured to include face bars, and the NCAA made hands-to-the-helmet moves illegal. In the spring of 1952, Ultang and Robinson won a Pulitzer Prize for their series of photographs.

Bright refused to be bitter about what he deemed a life-changing event. "Because one person chose to do wrong, not all of the good derived from sports should be overlooked," he said shortly after the game. "The letters I have received from people all over the country indicate [that] most people are for fair play, regardless of race, creed or color. Among those letters were several . . . from Stillwater."

Front-page coverage of the attack on Johnny Bright, photographs by Don Ultang and John Robinson, October 21, 1951. Newspapers around the country reprinted the award-winning images of the vicious hits on Bright. In 2005, Oklahoma State issued an apology for what had occurred on its field. The next year, Drake named its new gridiron Johnny Bright Field.

IOWA STATE WINS

rake Streak Ends, 27-14

IURLS SCORING PASS (STORY: PAGE 8)

The Pros Have It

The game is professional football, now established as the spectator sport of the '60s . . . No other sport offers so much to so many. —Time magazine, December 21, 1962

Mid-twentieth century America worried about Communism, embraced suburbia, and watched television—sometimes in that order, sometimes not. Increasingly, football occupied TV screens on the weekend, with NBC's college Game of the Week on Saturdays and various NFL games that CBS carried on Sundays. Television, it has often been noted, is what made the NFL the megasport that it is. But football was also, literally and figuratively, a good fit for television. The game's horizontal format was perfectly suited to the TV screen; nearly all the players were visible at the line of scrimmage as several cameras followed the action, neatly panning back and forth. (Baseball's diamond and player position configuration has always made camera angles more problematic on television.) The fact that late-season and playoff games were held in cold to arctic conditions—no team played in a dome then—also made the game more comfortably viewed from the couch or recliner.

There were about six million television sets in the United States in 1950, and televised games resulted in sharp drops in stadium attendance. The NFL responded in 1951 with its blackout policy, in which games that had not sold out a few days before kickoff would not be shown in the home team's city. Some fans maneuvered around this obstacle by driving seventy-five miles

(Above) *1958 Football Handbook and Schedules*, United Press International.

(Middle) NBC's WNBT New York television press crew, 1947. Announcer Jim Stevenson, far right, waits to deliver color commentary as Bob Stanton, seated at the microphone, reviews his crib sheets on the University of Pennsylvania squad, and Bill Garden, foreground, gives instructions to cameramen elsewhere in the stadium.

(Right) Baldwin High School players after a rough first half, Freeport Municipal Stadium, Long Island, New York, by Walter Albertin, 1950.

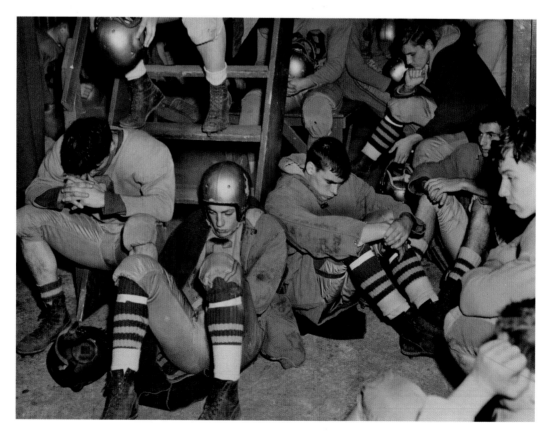

or so outside of town to catch the game in a motel room. (By the 1960s, some motels in the New York area offered season packages for football fans and allowed pre-game tailgating in their parking lots.) Despite financial losses at the gate, television money kept teams afloat, and incessant press coverage kept fans better informed than ever. Then, in a perfect storm of events, television and what came to be known as the "Greatest Game Ever Played" met on the same field.

The Colts-Giants championship game at Yankee Stadium on December 28, 1958, was at first heralded for its thrilling finish. The Colts tied the score on a field goal with seven seconds remaining in the fourth quarter; then Baltimore's Alan Ameche plunged into the end zone for the 23-17 overtime win. But the game's lasting impact, and television's role in it, is the latter-day headline. Several factors contributed to the game's exalted place in football history: It was the first championship game decided by "sudden death" overtime (the first team to score wins); the teams' electromagnetic star power; the consequential legacies of so many participants; and that it was, until that time, the largest spectacle the NFL had ever staged, seen by 45 million people, or about 25 percent of the U.S. population.

NFL commissioner Bert Bell immediately declared it the greatest game he had ever seen, and almost everyone regarded it as an instant classic, although Baltimore's resident perfectionist,

(Above) NFL Commissioner Bert Bell (1895–1959), Acme Telephoto, January 1951. Bell holds his hat as NFL club officials draw numbers from it to determine the order in which teams will draft eligible college players. He brought decisive leadership to the table— actually, to his own dining room table, where he set up a complex grid to figure out each team's yearly schedule, designed to sustain fan interest by keeping weaker teams in the running deep into the season. During his thirteen-year tenure, Bell introduced stronger rules to ward off gambling, implemented the NFL's first television contract, and deployed a TV blackout policy to encourage ticket sales.

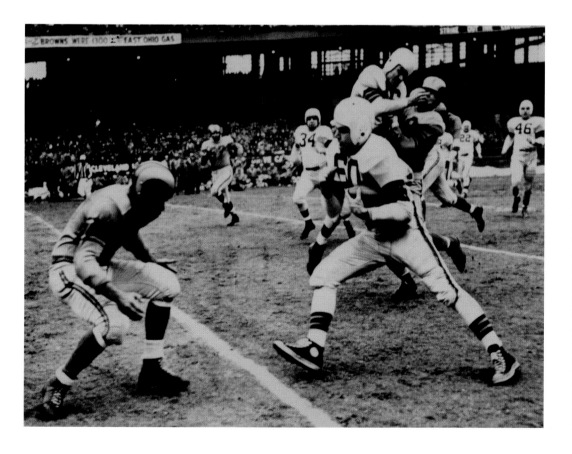

(Left) The Cleveland Browns defeat the Los Angeles Rams, 30-28, in the 1950 NFL championship game, Municipal Stadium, Cleveland, Acme Telephoto, December 24, 1950. Cleveland quarterback Otto Graham, right, sporting high-top tennis shoes on the frozen field, led his club to victory in the first season that three former AAFC teams, including the Browns, played in the NFL. Graham tossed four touchdown passes and ran for 99 yards on twelve carries.

N.Y. GIANTS

Sam Huff
Alex Webster
Tom Landry
Cal Karilivacz
Billy Lott
Don Chandler
Bob
Kyle Rote
Phil King
Jack Kemp
Sta
Jim Patton
Don Maynard
Ed Hughes
Jo
Andy Robustelli
D. Modzelewski
Jim Lee Howell
John
Cliff Livingston
Pat Summerall
Buzz Guy
Charlie Conerly
M.L. Brackett
D

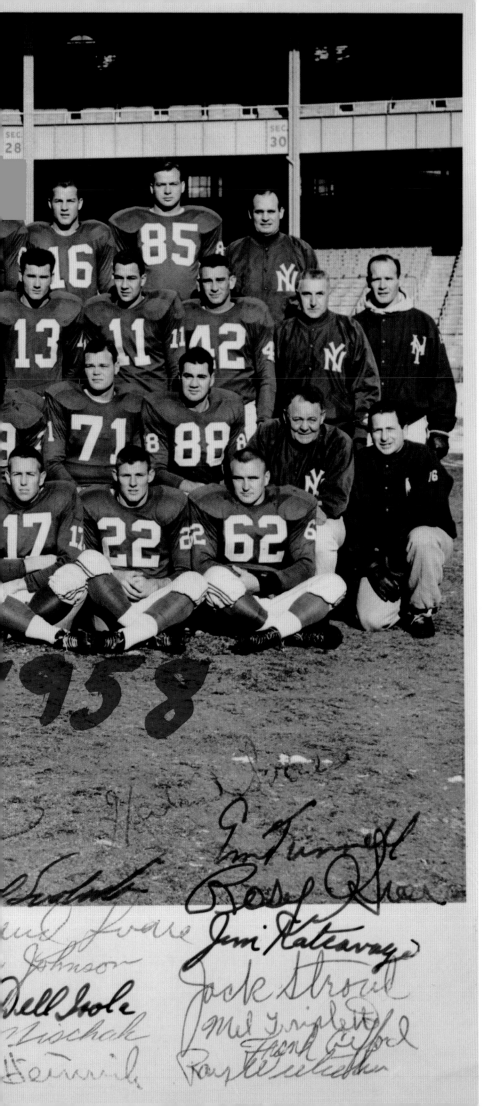

1958 New York Giants, autographed team photograph.
"I just blow up the footballs and keep order," said head coach Jim Lee Howell, third row, far left, who was accompanied by extraordinary talent. His legendary 1958 team included offensive coordinator Vince Lombardi (next to Howell) and defensive coordinator Tom Landry, third row, far right. Among the cast of notables: DE Andy Robustelli (81), LT Rosey Brown (79), K Pat Summerall (88), DT Rosey Grier (76), LB Sam Huff (70), HB Don Maynard (13), QB Charlie Conerly (42), and LH Frank Gifford (16).

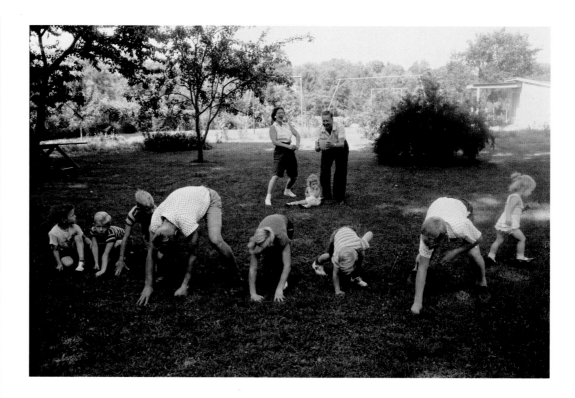

quarterback Johnny Unitas, who directed what is considered the first "two-minute drill" in leading the Colts' comeback, didn't even rank it as their best game of the season. Seventeen men associated with the game as players, coaches, or team officials were eventually inducted into the Hall of Fame. Their collective contributions to the sport were critical to the modern NFL and resonated well into the twenty-first century. Baltimore featured the iconic Unitas, a flat-topped, black-booted master of time management; Raymond Berry, who revolutionized the wide receiver position through monastic film and scouting study; and coach Weeb Ewbank, who would add a win in Super Bowl III to his resume. New York boasted visionary coaching genius in offensive coordinator Vince Lombardi and defensive coordinator Tom Landry, who would each win a pair of Super Bowl titles as head coaches of Green Bay and Dallas, respectively; and two acclaimed play-by-play announcers in halfback Frank Gifford, a steady mainstay on *Monday Night Football*, and placekicker Pat Summerall, a beloved sportscaster for more than fifty years.

Even with the 1958 season closing so spectacularly, Commissioner Bell had no interest in expanding the NFL; rather, he sought to protect and strengthen the league and its twelve teams. The success of '58 and the hermetically sealed NFL owners' fraternity prompted those who had been refused membership to find another way in. When Violet Bidwill Wolfner, the first woman to own an NFL team in her own right, declined to sell her Chicago Cardinals to Lamar Hunt, the young Texas sports promoter did what others before him had resorted to: He and his colleagues established their own professional league. The American Football League, after

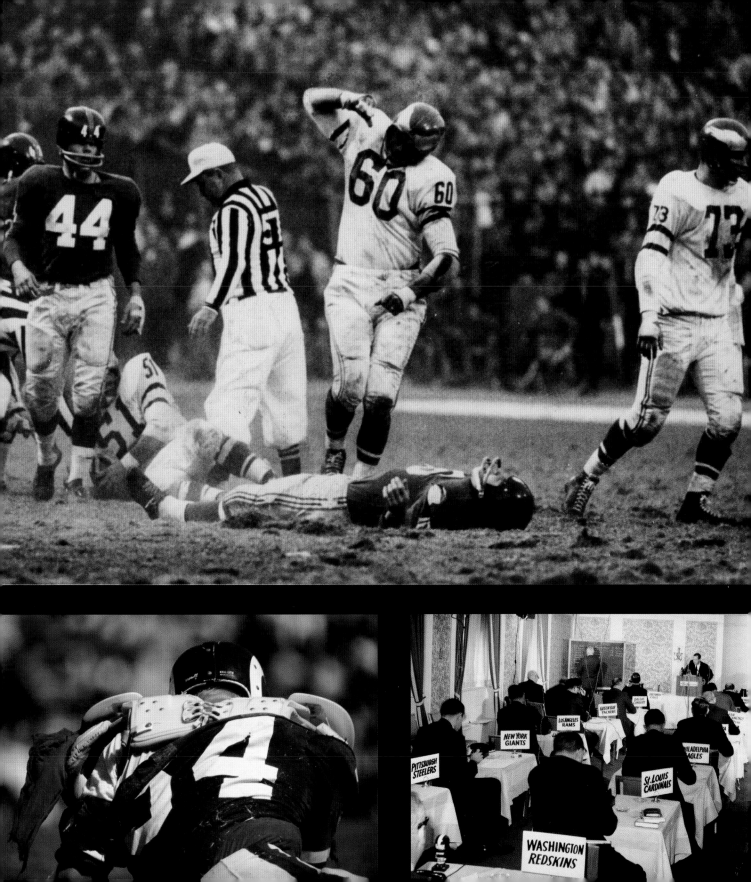

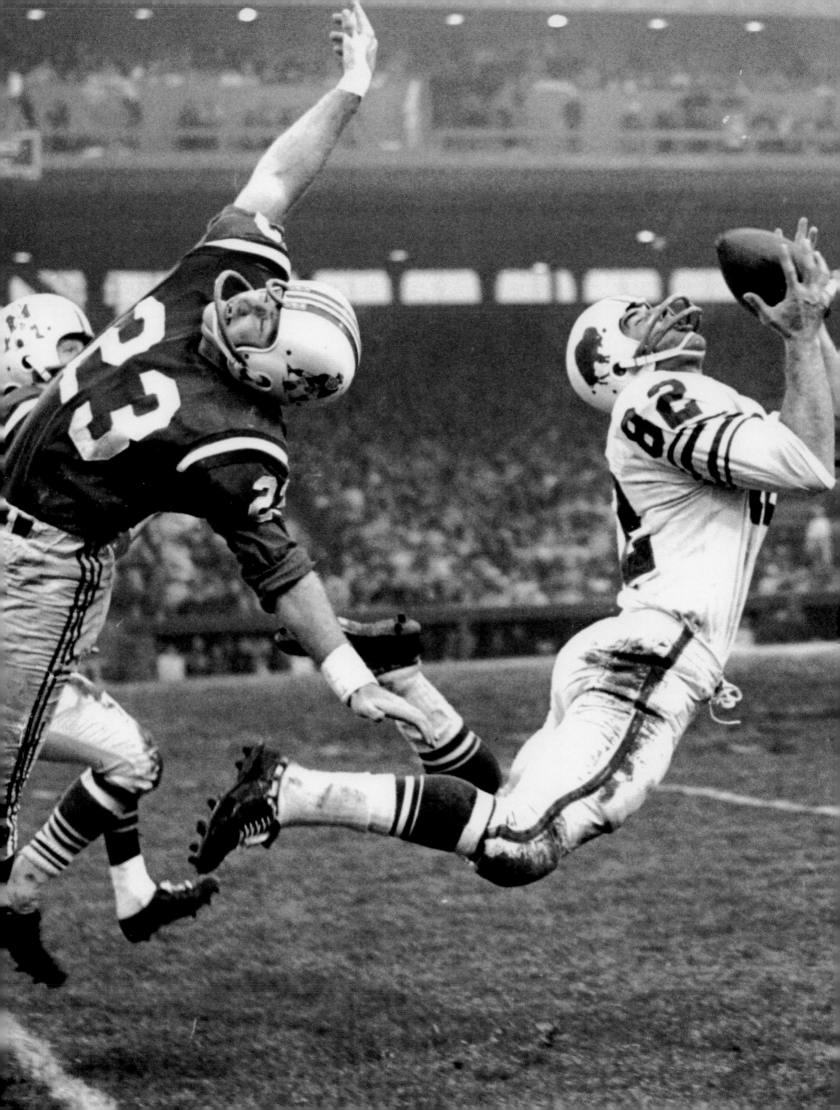

a wobbly start, had its intended effect. In 1966, the competition prompted the NFL to agree to a merger and to a championship between the two (dubbed the Super Bowl, first played in 1967), while improving the quality of both organizations.

The AFL, which existed from 1960 to 1969, brought major professional football to uncharted territory, both in geography and performance. Denver, Kansas City, Miami, and San Diego each received AFL franchises. As a side effect, the NFL welcomed Atlanta and Minnesota to keep them out of the rival league, and the Cardinals found a new home in St. Louis. The AFL further shook up the sport with its flashier, faster style of play. Owners snatched up

(Opposite) The Buffalo Bills defeat the Boston Patriots, Fenway Park, by Robert L. Smith, November 7, 1965. Paul Costa of the Bills hauls in a pass beyond an arching Ron Hall as Buffalo enjoys its AFL championship season.

(Top left) Oakland Raiders–San Diego Chargers AFL game program, by Karl Hubenthal, August 27, 1961. In its second year, the renegade AFL clearly differentiated itself from the more staid NFL, promoting its freewheeling style of play and its teams' brash identities.

(Top right) *What It Was, Was Football!* Andy Griffith monologue, Capitol Records, 1953. In a classic, folksy routine, Griffith describes inadvertently coming upon a football game but not knowing what it is he's seeing. He never uses the word "football," and the influential, best-selling record includes his observation that "I seen five or six convicts a-running up and down, and a-blowin' whistles!"

(Bottom left) NFL Championship Game, Green Bay Packers and New York Giants, Yankee Stadium, New York, by Marvin E. Newman, December 30, 1962. Green Bay won 16-7, but on this play, New York's Bill Winter (31) got the best of the Packers at the feet of Sam Huff (70).

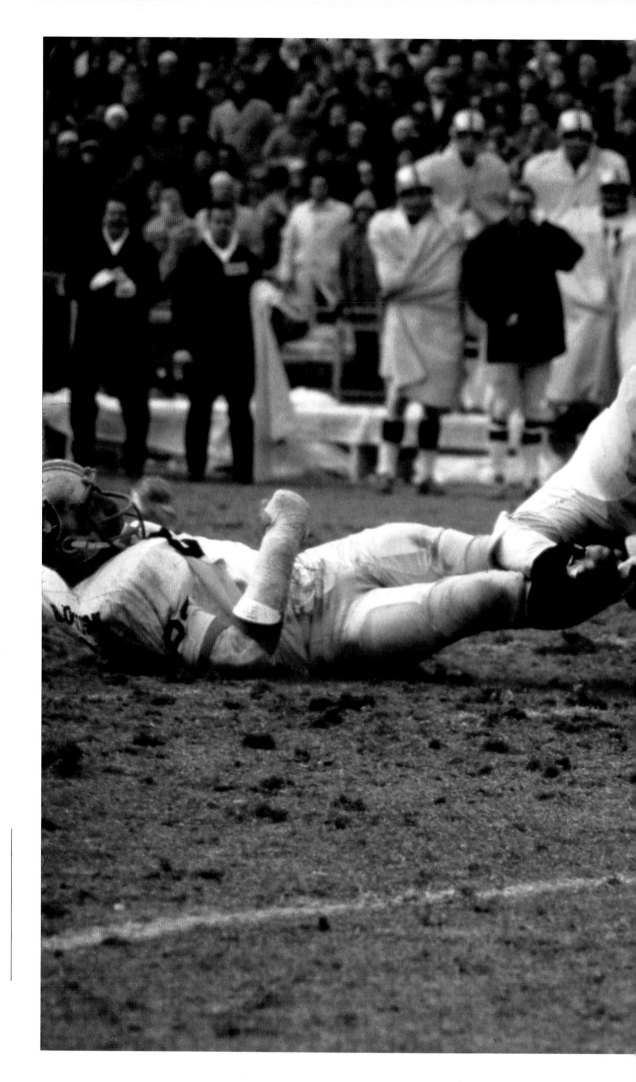

AFL Championship game, Oakland Raiders and New York Jets, Shea Stadium, New York, by Thomas Koeniges, December 29, 1968. The Raiders take Joe Namath to the dirt, but the Jets quarterback launched a fourth-quarter rally to get the win. Eleven days later, he guaranteed a victory in Super Bowl III and delivered.

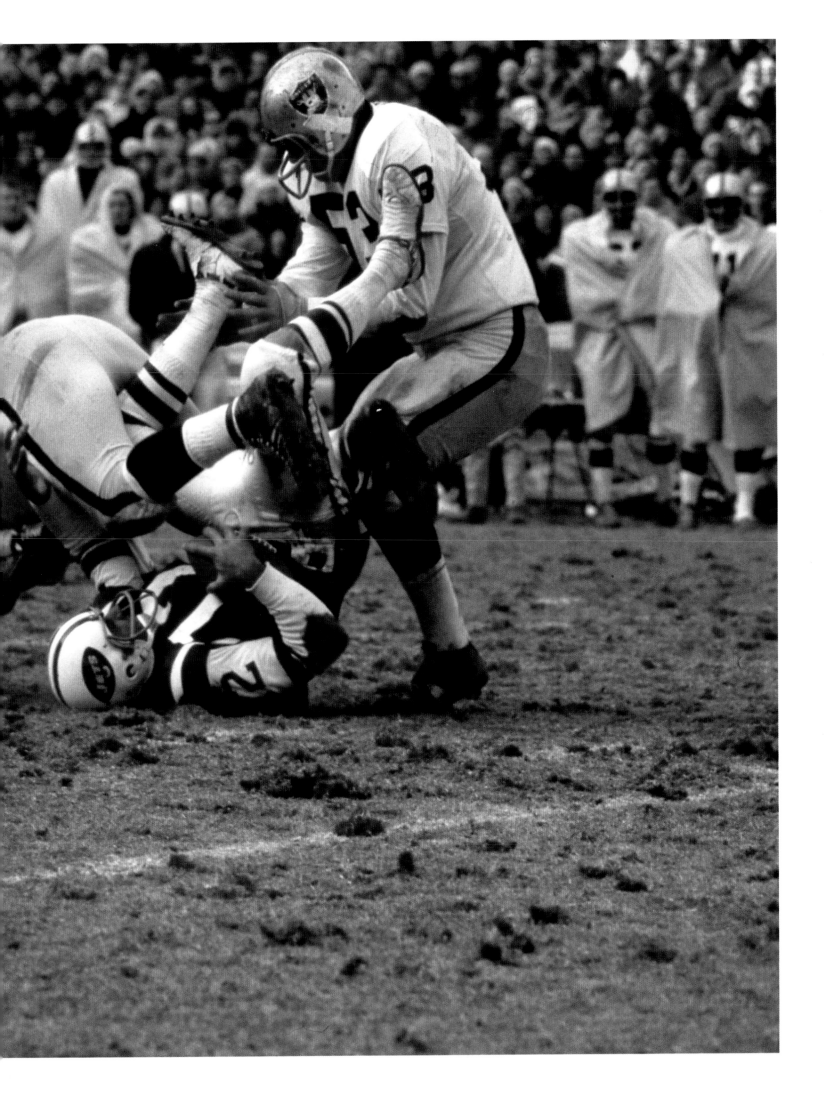

GAME CHANGER: Vince Lombardi (1913–1970)

Photographs (pages 188–90) by Frank Bauman, 1960.

(Above) Lombardi preparing to lead yet another film study session.

(Opposite) A pre-game meal at Sneezer's.

He felt called to be a priest.

To worshipful football fans, he was a god.

And although Vincent Thomas Lombardi had a gift for coaching, he was no deity. For one thing, he never rested on Sunday—at least not during the season.

Years after realizing that his true vocation was to be a coach rather than a cleric, the Brooklyn-born Lombardi wrote the bible on twentieth-century professional football, illuminating the pages with creative blocking schemes and power sweep formations. His pulling guards opened holes in defenses, allowing his ball carriers to "run to daylight" rather than curse the darkness. Beyond the technical innovations, Lombardi preached teamwork, effort, and discipline, and he led by example. He even appeared to perform miracles, turning perennial losing teams into winners immediately after taking the helm, as with the 1959 Green Bay Packers and the 1969 Washington Redskins. An NFL head coach for just ten seasons, Lombardi led the Packers to five NFL championships (including the first two Super Bowls) in seven years. No wonder the man was called St. Vincent, or that fans continue to make pilgrimages to his modest brick house on Sunset Circle in Green Bay, Wisconsin.

Few have had as profound an impact on the ethos of sport as the fiery 5' 8" former lineman, who during the 1930s was one of Fordham University's "Seven Blocks of Granite." The product of a large, extended Italian family, a strict Catholic education, and a five-year stint

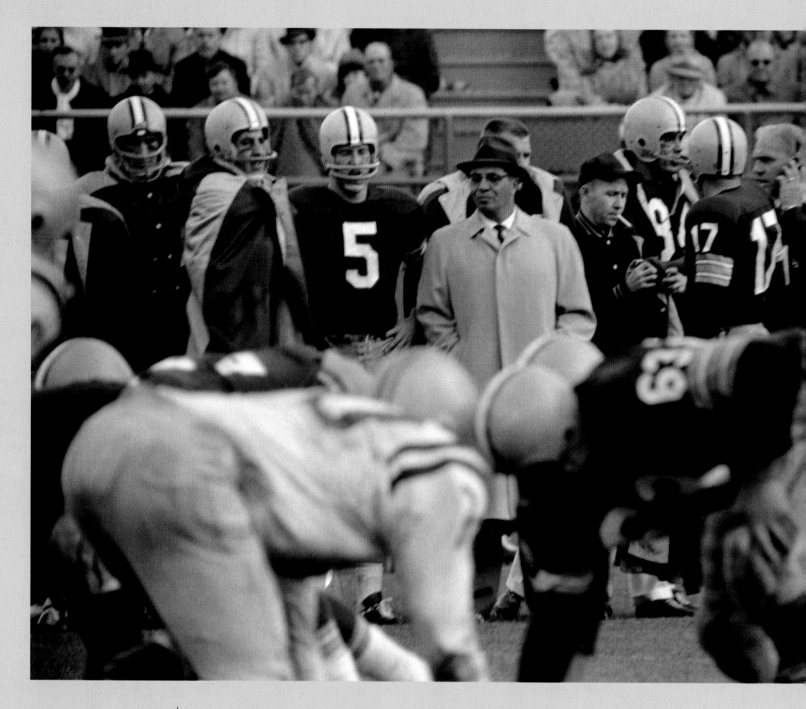

The coach in his usual sideline pose, camel-hair coat, and fedora. Lombardi was impervious to the weather conditions in Green Bay. When a player expressed concern about frostbite during a game with the temperature -14°, the coach responded, "What do you want to talk to a doctor about it for? The weather's beautiful. The sun is shining."

as an assistant coach at Army, Lombardi believed that "Football is a symbol of what's best in American life, a symbol of courage, stamina, coordinated efficiency or teamwork. It's a Spartan game, a game of sacrifice and self-denial, a violent game that demands a discipline seldom found." Ideally, mused Packers linebacker Dave Robinson, "Vince Lombardi should coach every National Football League team one year to show everybody what football is all about."

As head coach, Lombardi typically worked seventy hours a week, and he insisted on punctuality that came to be known as "Lombardi time," fining players who were late to practice or missed curfew. "When he says, 'Sit down,' I don't even bother to look for a chair," admitted defensive tackle Henry Jordan. Yet Lombardi was also a warm and generous father figure to even his biggest stars, including Paul Hornung and Bart Starr. Ultimately, everything revolved around the good of the team and the value of each player's contribution. In Lombardi's locker room, no space was assigned for personal glory.

In expecting the most of his players, he stressed mental preparation as well as physical conditioning, and his grueling summer training camps paid off in winter's playoffs. He demanded something else, too, well before the civil rights era crested: "You can't play for me if you have any kind of prejudice," he told his team in his first year as Green Bay's coach. Nor would he allow the team to patronize segregated hotels and restaurants, and he swatted away NFL commissioner Pete Rozelle's request that he intervene to prevent a black player from marrying his white fiancée, lest the union reflect poorly on professional football. Lombardi's insistence on fairness and respect extended to players who were gay, all the more remarkable given the times and the sport's virile, conservative mien. But then, as Jordan famously pointed out, "He's fair. He treats us all the same—like dogs."

Lombardi's pioneering coaching methods were manifest while he served as offensive coordinator for the New York Giants (1954–58). During games, he had photographs taken of opponents' formations from an upstairs booth. The Polaroid images self-developed in minutes and were then transported down to the sideline on a pulley system using a weighted sock. "That was the beginning of that kind of analysis; now all teams do it, but with computers instead of socks," said former Giants tight end and placekicker Pat Summerall. Lombardi advocated "visual education," and he used early videotape technology to record practice, adding wide-angle projections to the camera to see the entire playing area. He was also behind the concept of rule blocking in the NFL: the idea that each offensive lineman blocked a zone rather than a specific defensive player. This scheme was later adopted throughout the league.

Even those who know little or nothing of Lombardi know the saying he was most associated with: "Winning isn't everything. It's the only thing." The phrase, coined by UCLA football coach Red Sanders, encompassed Lombardi's drive, ambition, and the purpose of his team's tightly controlled training regimen. For a long time Lombardi denied that he ever said it—but he once asked, quite reasonably, "If winning isn't everything, why do they keep score?" In response to criticism that he placed too much emphasis on victory, Lombardi began using phrases such as, "Winning isn't everything, but making the effort to win is," which, though not as catchy, better reflected his actual philosophy. Toward the end of his life, he confessed to journalist Jerry Izenberg, "I wish to hell I'd never said the damned thing . . . I sure as hell didn't mean for people to crush human values and morality."

No other coach is as intrinsically linked to professional football as Lombardi: He and his Packers dominated the game at the same time the NFL came to dominate the American sports psyche. Although his success came at the expense of a tranquil family life, Lombardi's lasting legacy in sports is a devotion to winning through discipline and teamwork that subsequent coaches strove to emulate. A week after Lombardi died, Rozelle christened the Super Bowl trophy the Lombardi Trophy; thus, each year, the championship team—*the winner*—continues to be associated with him. He was inducted into the Pro Football Hall of Fame in 1971. Since 2003, his likeness, rendered in bronze, from his fedora to his signature overcoat, has stood at historic Lambeau Field: the statue of a sport's saint, beside its cathedral.

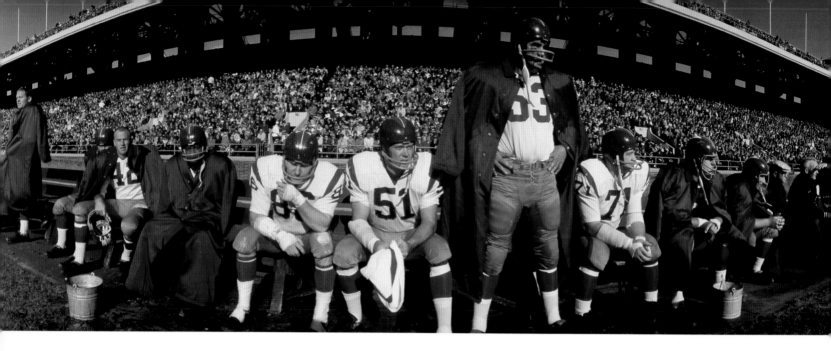

top talent with astonishing salaries (Alabama quarterback Joe Namath signed with the New York Jets for a whopping $427,000) and offered more opportunities for black players. Some suspected NFL clubs had quotas that kept down the number of black players. There were also accusations that teams used a system known as "stacking," in which blacks competed against one another for a few positions rather than against whites, who held a greater variety of positions. Stacking, it was said, permitted many white players "the luxury of mediocrity." AFL teams were more open to signing anyone who could help them win.

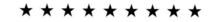

In just two years, from 1959 to 1961, the number of major professional football teams doubled to twenty-four. Meanwhile, the number of television sets had increased tenfold

(Top) Linebacker Rod Breedlove (63), Washington Redskins' sideline, D.C. Stadium, by Neil Leifer, 1967.

(Above) *In* magazine, September 1966. "The magazine that shows you how to be" regarded a stylish football fan as "the girl of today, the woman of tomorrow."

(Right) John and Jeff Engbretson, Forbes Air Force Base, Topeka, Kansas, UPI Photo, 1960.

since 1950, not only because viewers "loved Lucy," the era's seminal sitcom queen, but because watching sportscasts, especially football, had quickly become habitual and, for a large segment of the male population, a centerpiece of the weekend routine. The AFL's television contract offered viewers more to choose from and attracted those who now had a team in their area. A late 1965 Harris Poll confirmed that professional football had supplanted major league baseball (then enduring a decade-long, low-scoring offensive drought) as the country's favorite spectator sport. When the NFL and AFL completed their merger in 1970, it opened the way for fresh rivalries and exciting head-to-head matchups between the old guard and a bunch of loose cannons. A new era was under way in Football Nation.

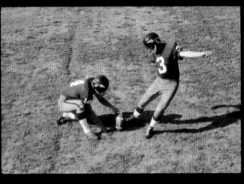

(Above) Charlie Gogolak, Washington Redskins placekicker, by Jim Hansen, 1966. Gogolak and his brother Peter of the New York Giants played soccer growing up in Hungary, but in the United States they popularized soccer-style placekicking. By the early 1980s, straight-on kicking was dying out.

(Left) Buffalo Bills quarterback Jack Kemp signs autographs at training camp, Blasdell, New York, by Ralph E. Hinkson, August 1964.

CARTOONS: FOOTBALL'S DRAW PLAY

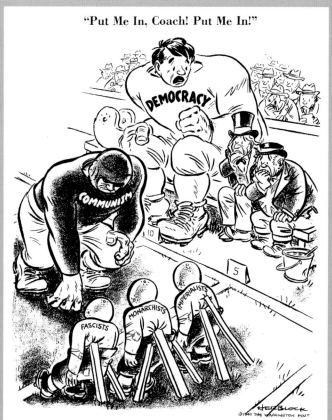

"Put Me In, Coach! Put Me In!"

The artists at *Puck,* the country's first successful illustrated humor magazine, found in late nineteenth-century football myriad opportunities to critique the game itself, lampoon its participants, and comment on its societal effects. Just as significantly, editorial cartoonists saw the sport as the perfect metaphor for the rough-and-tumble nature of politics: It offers an ideal array of imagery with which to convey David-and-Goliath-like scenarios, political gridlock, and warfare using distinct American vocabulary and visual motifs. Cartoonists have examined everything from foreign policy to inflation by dressing the relevant characters and concepts in football uniforms. Thus, it is possible to review a wide swath of American political and social issues simply through football's appearance in cartoons, as this sampling suggests.

(Opposite) **"Present for the Future,"** **original pencil artwork, by Jim Berryman,** **December 31, 1942.** With the United States at war, Father Time has only the upcoming football bowl games with which to welcome Baby New Year 1943.

(Top left) **"The Easy Umpire: He Slugs** **Me Every Chance He Gets, and You Can't** **or Won't See It," by Will Crawford,** *Puck* **magazine, November 10, 1909.** A small battered football player identified as "The Plain People" makes a futile complaint to President Howard Taft that the well-equipped Nelson W. Aldrich is beating him up. Aldrich, a U.S. senator from Rhode Island, had forced numerous changes to a tariff bill that protected American industries but kept consumer costs high. As the cartoon shows, the president had no interest in interfering with Congress.

(Top right) **"Put Me In, Coach! Put Me In!"** **Herblock, March 9, 1947.**

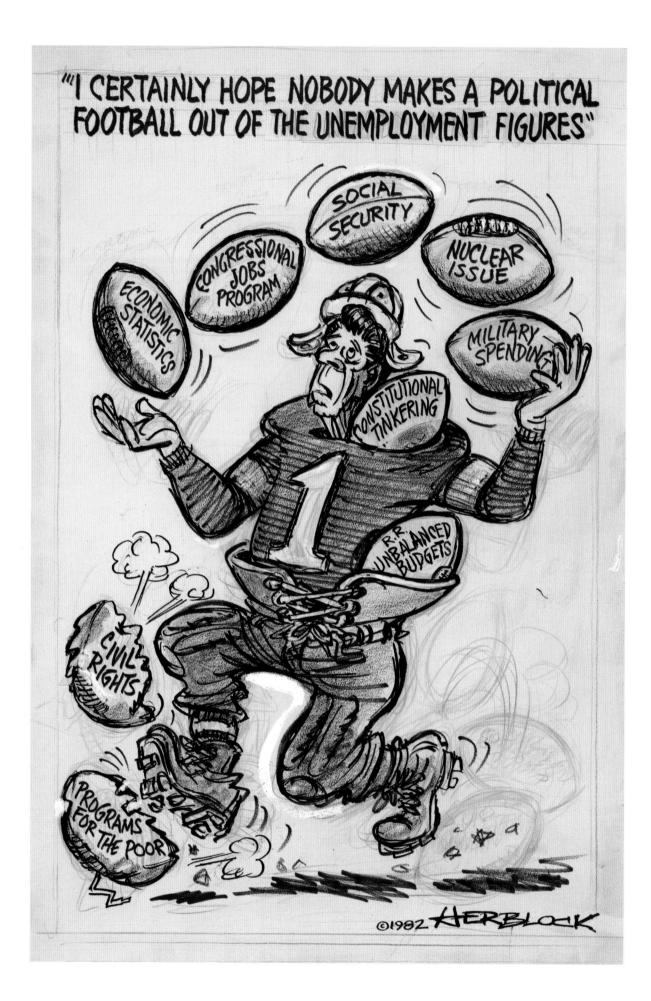

"I can't decide whether to turn pro first or go directly into rehab."

"There are only three signatures on this recall petition. Monday Night Football, therefore, will remain in effect until further notice."

(Opposite) "I Certainly Hope Nobody Makes a Political Football . . . ," pencil and ink, Herblock, October 14, 1982. President Ronald Reagan, depicted in a 1920s-style uniform, juggling 1980s issues.

(Top left) "There They Go, the Four Horsemen—Famine, Pestilence, Death, and Butterfingers," original artwork, by Peter Arno, 1967.

(Top right) "I Can't Decide Whether . . . " by Mort Gerberg, November 22, 1999.

(Left) "There Are Only Three Signatures" by Jack Ziegler, September 9, 2003.

Above) *Peanuts* comic strip, by Charles M. Schulz, September 12, 1976. During *Peanuts'* half-century run, beginning in 1950, an ongoing seasonal gag was Charlie Brown's failure to kick a football held by the unreliable and wholly manipulative Lucy.

Right) "Ha, ha . . . ," by Leonard Dove, November 10, 1928. It has always been the nature of fans to share credit for their team's success.

Opposite) *Doonesbury* comic strip, by Garry Trudeau, September 1, 1974. Trudeau based his quarterback character, B.D., on Yale signal caller Brian Dowling, who played for the Elis from 1966 to 1968.

"Ha, ha, we certainly mopped that lot up, didn't we, eh?"

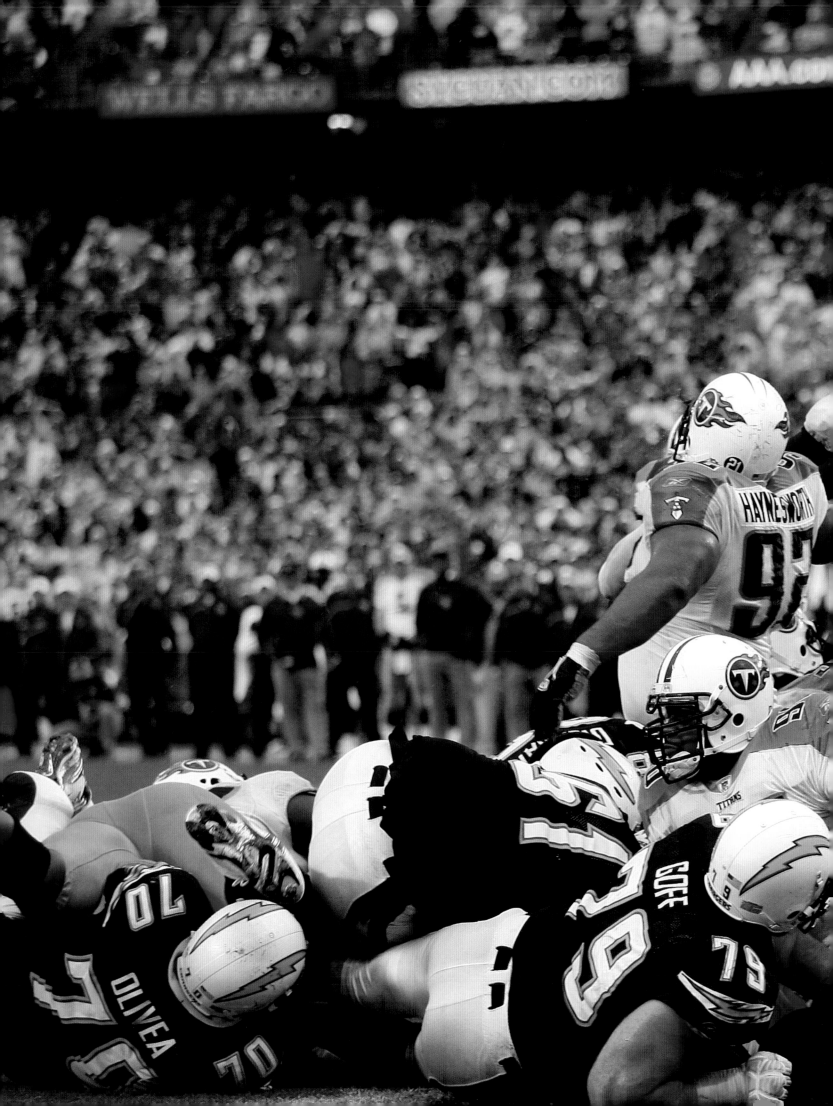

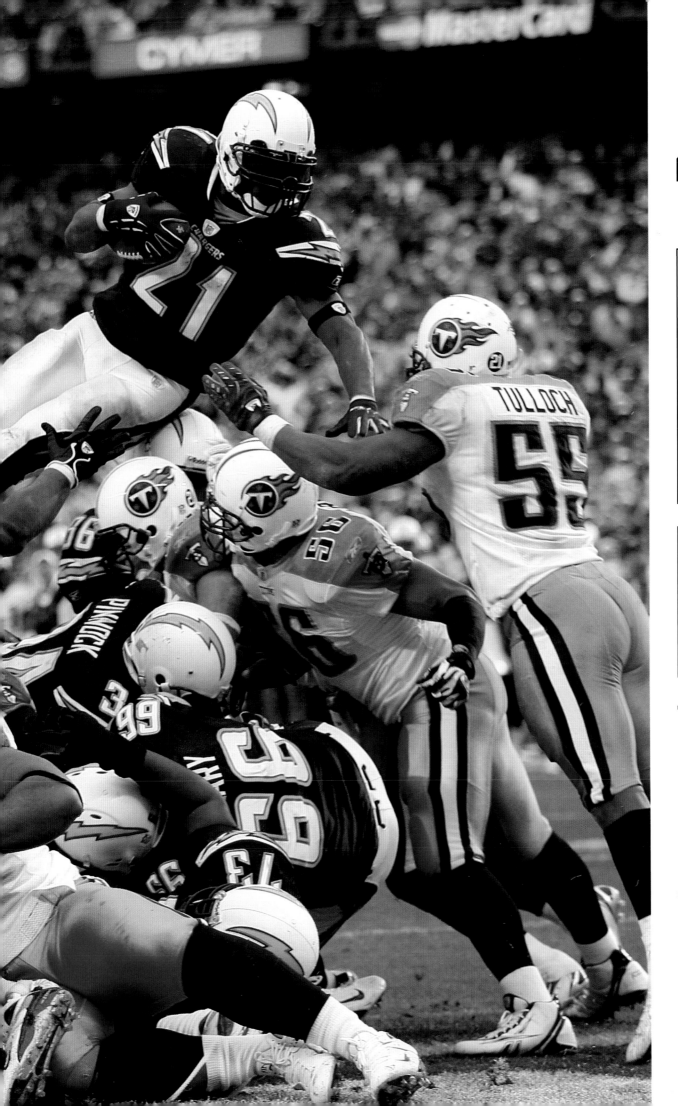

FOOTBALL NATION

1970
–
Going Long

LaDainian Tomlinson
soars over the Tennessee
Titans' defense for a
one-yard touchdown
in a Chargers AFC
wildcard win in San
Diego, by Paul Spinelli,
January 6, 2008.

In twenty-six years in the pros, I haven't noticed many changes. The players are faster, bigger, smarter, and more disloyal to their owners. That's about it. —George Blanda, NFL quarterback and kicker, 1949–75

Football secured its status as Americans' favorite sport in an era of social upheaval that witnessed changes the game's old guard could not have imagined only a few years before: integrated Southern teams, women's professional football, and team owners sharing profits with their rivals. In time, long-haired, tattooed, and bejeweled players expressed their independence in a traditionally conformist institution, and fans incorporated their team loyalty into their everyday lives, ricocheting from support to outrage as events dictated. The sport's unmatched hold on so many Americans has been demonstrated repeatedly: when nearly everything in the country came to a sudden halt at 10:00 AM, Pacific time, October 3, 1995, as more than 150 million people listened to the verdict in the murder trial of football superstar O. J. Simpson; when, in 2001, stadiums nationwide were the setting for large-scale, game day ceremonies honoring the victims of 9/11; when the White House rescheduled a major presidential speech, as it did in 2011, so as not to conflict with the first game of the NFL season; and when it became common practice in Texas not to hold weddings on fall weekends.

How football has maintained its continued presence in American life—and what that means—provides a rich commentary on the national culture.

Fans behind ESPN's *College GameDay* set, Notre Dam vs. Michigan, Ann Arbor, by Michael Young, September 10, 2011.

Capitalist Socialism

Pete Rozelle has made the National Football League the first enterprise in America, in all the world, to have achieved absolute pure socialism. —Ed Garvey, executive director of the NFL Players Association, 1980

It was not the doing of some Soviet-style footballshevik collective, but rather the much-considered agreement among NFL team owners—capitalists, entrepreneurs, moguls, and tycoons—that equal distribution of television revenue would produce both league stability and enormous profit for all. Under Rozelle's guidance, the NFL's business plan worked out far better than any Five-Year Plan. Although the league had long understood that a certain amount of parity among teams was necessary to maintain rivalries, fan interest, and ticket sales, before the young commissioner came along in 1960, each club negotiated its own television contracts. TV revenue exacerbated the disparity between media markets, given that New York City had a population that was 122 times larger than Green Bay's. The Giants could demand a much more lucrative television network contract than the Packers, grow wealthier, afford the best players, and destroy league competition.

Rozelle convinced club owners that an equal share of the television pie would, in fact, make them all more prosperous. He then lobbied Congress, which passed Public Law 87-331 granting the league an antitrust exemption, allowing it to negotiate a single television contract with the TV networks. In 1962, CBS paid the NFL $4.6 million annually for

(Above) U.S. soldiers at Firebase Pace, Vietnam, by Rick Merron, October 25, 1971. Americans practice field goal kicking atop a sandbag bunker shortly before being withdrawn from the base, sixty miles north of Saigon.

(Following page) Houston Astrodome, Houston, Texas, by Jet Lowe, 1965. Regarded as an engineering marvel, the Astrodome, named for the city's major league baseball team, was the first domed venue to accommodate multiple professional-level sports. At the time of construction, it seated 42,000 for baseball and 50,000 for football. Its low-maintenance artificial grass—known as AstroTurf, a green carpet laid over a hard surface—was soon adopted by other sports venues.

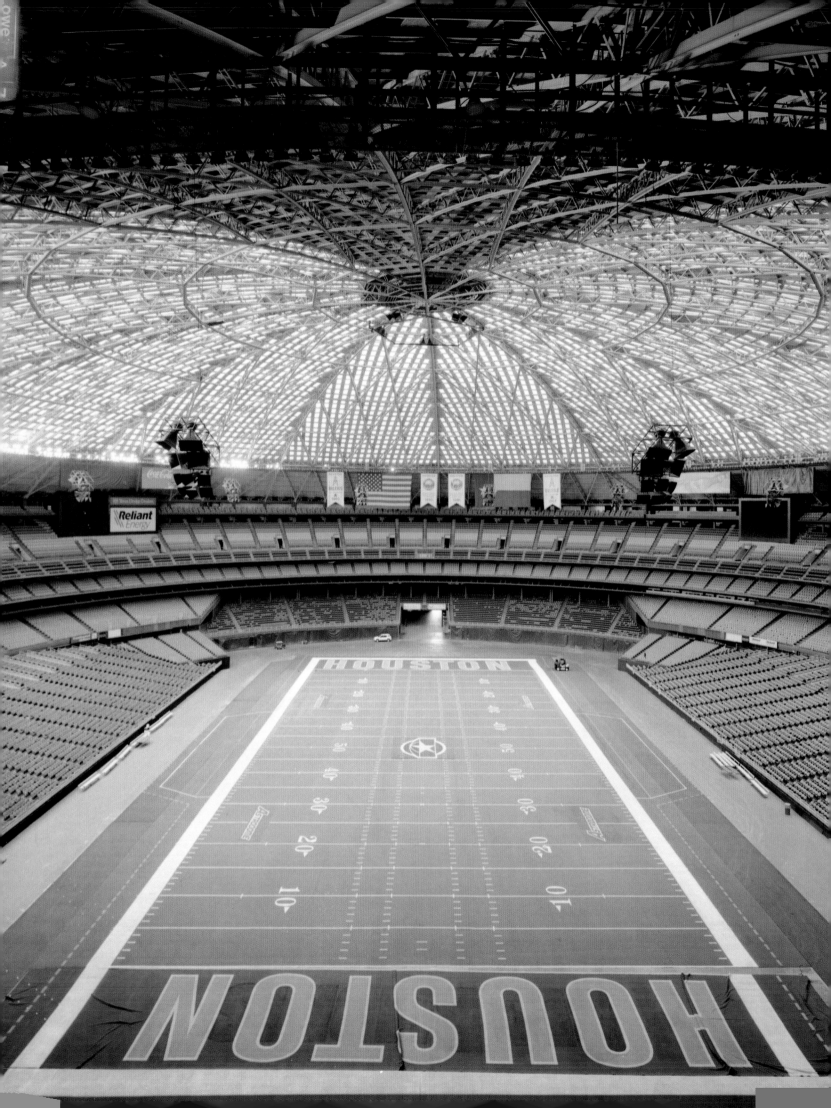

broadcasting rights. Fifty years later, the NFL earned $4 *billion* a year in broadcast television rights fees, which, adjusting for inflation, represented a staggering 11,500 percent increase. The effect of these increasingly valuable deals was to ensure league stability, generate enormous wealth, and, eventually, drive ever upward player salaries. Packers coach Vince Lombardi concluded that "What Rozelle did with television receipts probably saved football in Green Bay."

Television executives were happy to shovel over such large sums because the sport has continued to produce reliably high levels of viewership; at any given minute during the 2011 season, nearly 18 million viewers were tuned in. On Super Bowl Sunday, about a third of the country is watching, and no other regularly televised program comes anywhere near that figure. As a further example of the NFL's dominance—if any were needed—the league brings in nearly as much as professional baseball, basketball, and hockey combined. Television money is only about half the story; billions more come into NFL and club coffers through stadium-naming rights, product licensing, advertising, and ticket sales. When the 2011 season was threatened as NFL club owners and players haggled over a new collective-bargaining agreement, Congress worried about the potential loss of more than $5 billion that fans had poured into local economies the year before. New Orleans, still recovering from the effects of Hurricane Katrina, was especially fearful that eight Sundays without the Saints on the field and fans spending in town would present a major economic setback.

In its first full decade of American sports dominance (1965–75), the NFL did not disappoint. Through the NFL Films production company, Ed and Steve Sabol brilliantly presented players as heroic figures diving in slow motion into end zones or crushing the guy with the ball, accompanied by "the Voice of God" (narrator John Facenda) and musical themes such as

(Above) City Stadium (Lambeau Field), Green Bay, Wisconsin, Lefebvre-Luebke, 1957. The first stadium built specifically for an NFL team, City Stadium was renamed in honor of former Packers coach Curly Lambeau. Its builders bucked the trend of constructing multisport venues that resulted in what critics deemed uncomfortable, unsightly, but fiscally advantageous "concrete donut" style stadiums in the 1960s and 1970s. Numerous expansions at Lambeau have since more than doubled the 32,000-seat capacity seen here.

(Left) Cowboys Stadium (2009), St. Louis Rams and Dallas, Arlington, Texas, by G. Newman Lowrance, October 23, 2011. The $1.1 billion stadium and the home of the Dallas Cowboys advanced notions of what the game-day experience could be. A high-end hybrid of a shopping mall and art gallery, the facility features a 160-foot-long high-definition video screen over the field and a retractable roof.

GAME CHANGERS: Pete Rozelle and Joe Namath

(Above) NFL Commissioner Pete Rozelle and New York Jets quarterback Joe Namath, New York City, by Ron Frehm, July 18, 1969. The two men who most shaped pro football as it rose to dominate American sports meet the press.

(Right) Joe Namath awaiting knee surgery, accompanied by Miss Sunken Gardens, Karol Kelly, AP Photo, 1966.

With Pete Rozelle as the sport's top decision-maker and Joe Namath as its poster child on the field, football became the most popular sport in the United States in the 1960s and the blueprint by which all other professional sports leagues would operate for the rest of the century. With Rozelle's savvy as NFL commissioner and Namath's bravado as celebrity star quarterback of the New York Jets, football was transformed into a business empire, from sporting industry to entertainment industry. Ironically, both men became football's most influential figures during this period of change because of the "non-football" qualities they each infused into the sport.

At thirty-three years old, Rozelle was elected NFL commissioner on January 26, 1960, on the owners' twenty-third ballot after seven days of voting. Rozelle thought his election "was the most ludicrous thing I ever heard of."

"They finally picked Pete as a compromise because both sides [owner factions] thought they could control him," Dallas Cowboys president and general manager Tex Schramm said. "But they were wrong. Pete was a lot stronger than any of them realized."

When Rozelle began his tenure, he inherited a league that was growing but also facing internal threats. Owners operated individualistically, and Rozelle convinced them to work together for the NFL's collective benefit by negotiating a league-wide television deal. He consolidated the league's merchandising, advertising, and media efforts through NFL Properties and NFL Films.

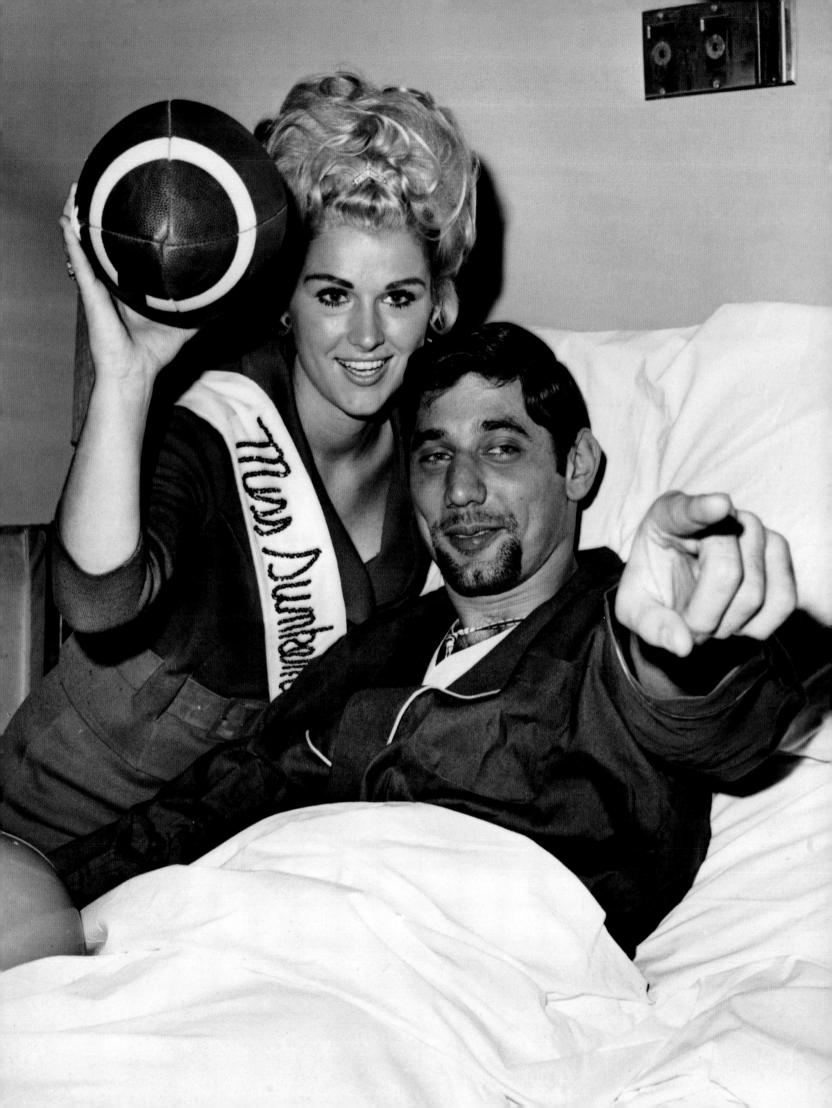

Under Rozelle's strong leadership from 1960 to 1989, average team values increased from $1 million to $100 million, the NFL merged with the AFL, the league expanded from twelve teams to twenty-eight, the Super Bowl grew to be the biggest annual sports spectacle in the world, *Monday Night Football* became the second-longest-running prime-time television show after *60 Minutes*, and increased television ratings demonstrated how the NFL had altered America's viewing habits on Sundays. "Rozelle took us out of our old football phase and made us what we are today, which is big business," said Art Rooney, the owner of the Pittsburgh Steelers from 1933 to 1988.

Five years after Rozelle started convincing owners to change their operational outlook, Joe Namath entered professional football and similarly revolutionized how owners could market the on-field product. The New York Jets did not draft Namath out of Alabama in 1965 just because he was a top quarterback prospect. In fact, the team already held the rights to plainspoken Jerry Rhome, but the Tulsa University QB was "not the guy I need," said Jets owner David "Sonny" Werblin. Werblin had discovered stars such as Liberace and Dean Martin while at the Music Corporation of America talent agency, and while he wanted a good football player, he also craved an entertainer who would shine under New York's brightest lights.

Namath negotiated what was then the richest rookie contract to play in the upstart AFL, and no other football player had ever stepped into the shoes worn by "Broadway Joe" (quite literally, since he was the first to use pearly-white cleats, shunning the standard shoe-polish black). "Mr. Werblin didn't seem like he was a real football person," Namath said. "He believed in a star system. Stars are what brought people in." Namath became a celebrity as much for his lifestyle off the field as for his performance on it. He brashly guaranteed a Jets victory in Super Bowl III despite his team being a seventeen-point underdog, similar to Babe Ruth calling his famous home run shot. As a celebrity, he projected an appealing image as a member of a biker gang in the movie *C.C. and Company* (1970), in memorable commercials for Beautymist pantyhose and Noxzema shaving cream, and in a heroic appearance on television's *The Brady Bunch*. As a contrarian, he was the only athlete on President Richard Nixon's "enemy list." As a ladies' man, he made housewives "nudge their husbands and whisper, 'Introduce me,'" said Werblin's son Tom, who noticed Namath's star power even among his father's many prodigies. As a fur-coat-wearing, headline-grabbing superstar and restaurant owner, Namath blazed a glittery trail for the flamboyant, blinged-out players who would follow.

New York Giants observe a moment of silence, Yankee Stadium, November 24, 1963. After President John F. Kennedy was assassinated two days earlier in Dallas, Commissioner Rozelle ordered NFL games scheduled for Sunday to go ahead as planned. The AFL opted not to play. Rozelle later regretted the decision to play during a period of national mourning, and in 2001, after the terrorist attacks of September 11, the league suspended play the following weekend.

CHAPTER 4 · FOOTBALL NATION

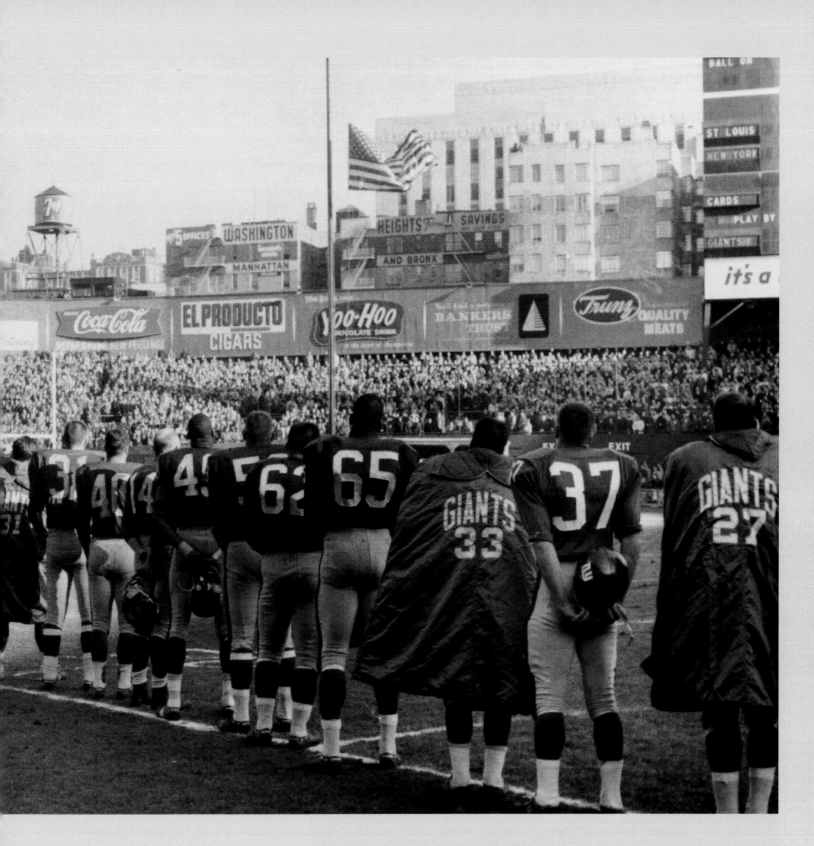

Rozelle and Namath changed football in particular and the American sports scene in general. One built the infrastructure, the other performed on it, and the two were essential in creating what the *New York Times* referred to as "the greatest success story in the modern American entertainment industry."

—Jonathan Horowitz

"The Power and the Glory" and "Magnificent Eleven." *Monday Night Football*, the brainchild of Rozelle and ABC Television's visionary Roone Arledge, president of the network's sports division, debuted in 1970 and immediately became required viewing for many men, especially if one expected to socialize on Tuesday at the office or the plant. It also reorganized weeknight household routines, becoming a cultural touchstone in how Americans invested their time and attention.

Prime-time, nationally broadcast games were critical in developing fan followings well outside a team's region, most notably in the case of the Dallas Cowboys. Led by a widely respected yet humble coach-and-quarterback combination (Tom Landry and Roger Staubach), the club catapulted from its more-than-modest newcomer origins in 1960 to audaciously declaring itself "America's Team" in 1979. Its clean-cut image, intriguing and pioneering use of computer technology, and recent success led to regular appearances on Monday nights that in turn won them fans nationwide. On the other end of the image spectrum, the Oakland Raiders parlayed their renegade, outlaw reputation—an extension of owner Al Davis's persona, represented in the pirate visage on the players' helmets—into a fan base drawn to its nontraditional style. The Pittsburgh Steelers' four Super Bowl wins in the 1970s attracted fans wanting to associate with a winner, as well as those who related to the hard-hatted workingman sensibilities of the team's hometown constituency.

The 1970s has been regarded as a golden age for the NFL as it built on its breakthrough in the 1960s. More extensive television coverage both publicized and took advantage of the colorful personalities breaking loose from the league's traditionally conservative style. The undefeated Miami Dolphins set the bar for perfection in 1972, and Washington was home to the Over-the-Hill Gang, a team of popular, aging veterans. In an age of defense, before rules to protect highly paid, face-of-the-franchise quarterbacks were enacted, the Fearsome Foursome (Los Angeles), the Steel Curtain (Pittsburgh), and the Purple People Eaters (Minnesota) were celebrated. The NFL further ingratiated itself as a charitable, useful community member, and every TV viewer saw players visiting sick children or serving as Big Brothers in hundreds of United Way commercials ("Thanks to you, it works for all of us"). Enough time had also passed for pro football to have a stable of high-profile elder statesmen, who turned up as sportscasters and advertising pitchmen.

The NFL's strength meant it had nothing to fear from the appearance of rival leagues, unlike in the days of the AAFC or even the AFL. In 1974, the prematurely named World Football League formed; after initially signing some big NFL names, it never expanded beyond the United States and collapsed the next season. The better organized and funded United States Football League (1983–85) sought to gain some leverage by starting its season in the spring, dressing its referees in shorts, and signing top college stars, including three Heisman Trophy winners, to unprecedented contracts.

RIMINGTON

Dave Rimington, center, Nebraska.

HOPE

Dave's the strongest man in college
football. He not only bench presses
450 pounds, in the Oklahoma game with
one block he lifted 50 thousand people
to their feet.

FARRELL

Sean Farrell, guard, Penn State.

HOPE

Sean's the greatest insurance a running
back can have. He's not a piece of the
rock.....He's the rock.

McMAHON

Jim McMahon, quarterback, Brigham Young.

HOPE

Jim broke a lot of passing records this
season. His arm is so strong, in one
game he missed the receiver and hit
Voyager Two.

WALKER

Herschel Walker, running back, Georgia.

HOPE

Herschel's back with us again. He's an
electrifying runner. He has more tricky
moves than a belly dancer at an American
Legion Convention.

ALLEN

Marcus Allen, running back, U.S.C.

HOPE

Marcus, this year's sensational Heisman
Trophy winner, led the nation in rushing,
212.9 yards a game...and he's the first
college runner ever to break the two-thousand
yard mark for a season. He ran for 2,342
yards. Fantastic. Marcus is almost
impossible to stop. He carries so many
tacklers along with him he's listed in
the yellow pages under "Public Transportation".

ANDERSON

Gary Anderson, place kicker, University of Syracuse

HOPE

Gary's kicking has done so much for Syracuse,
they want to put his right shoe in the Hall
of Fame. Gary's very flattered....but he
hates to break up the set.

SMITH

Billy Ray Smith, end, Arkansas

HOPE

Nobody ever got to the outside on
Billy Ray. He kept more guys inside
than the sorrority girls.

BYU quarterback Steve Young signed with the Los Angeles Express for a record-breaking $40 million, ten-year deal, while San Francisco's Super Bowl hero, Joe Montana, the highest-paid player in the NFL, was making $6.3 million over six years. Meanwhile, real estate tycoon Donald Trump, owner of the New Jersey Generals, convinced league owners to move the season to the fall and compete directly against the NFL. As with previous leagues, the owners hoped the head-to-head competition might lead to some or all of its teams merging with the NFL. The senior league never took in any USFL teams, but a number of its players went on to major NFL careers. Even in Football Nation, there were limits to how much time and money fans were willing or able to invest in the sport.

The NFL continued to tinker with its game, implementing some of the ideas introduced by its failed rivals, including the two-point conversion, team salary caps, and resolving team challenges to rulings on the field with instant replay. In 2001, the XFL—commonly known as the Xtreme Football League—was another attempt at a spring season pro league that experimented with a different business model. The league was a made-for-television product, owned jointly by NBC (the only major network then without an NFL contract)

Pages from the Bob Hope Joke File, Library of Congress.
The comedian and all-around entertainer (1903–2003) maintained a cataloged and indexed file—more than 85,000 pages—of jokes, including those written for college football All-Americans who appeared on his televised variety show specials. The script pages shown here are from Hope's 1981 Christmas special, which featured appearances by Heisman Trophy winner Marcus Allen (USC) and future winner Herschel Walker (Georgia) as well as Jim McMahon (BYU).

Washington's Robert Griffin III evades the Minnesota Vikings defense, FedEx Field, Washington, D.C., by Cliff Owen, October 14, 2012. The NFL's longstanding charitable activities expanded to include an especially visible endeavor in 2009. The American Cancer Society partnered with the NFL for their "A Crucial Catch" campaign to raise both awareness and funds in the fight against breast cancer. During select October games, players wear pink in support of survivors, and pink-ribbon NFL logos adorn fields and goalposts.

and the World Wrestling Federation. Fewer rules, edgy team names (the Las Vegas Outlaws and the Orlando Rage), in-game interviews, and camera shots looking downfield from behind the quarterback characterized the new venture, as did an unimpressive level of play. Again, the NFL adopted what it liked, such as sideline interviews, but continued to pursue its fun-for-the-whole-family policies rather than publicly court unsavory customers.

For the game in general, corporate cash exercised ever greater influence on teams, players, and fans. In the first Super Bowl (1967), the cost to air a thirty-second commercial was $42,000, but by the 1985 game, that figure had hit $1 million, and updating this particular advertising statistic has since become a staple of Super Bowl news coverage. Following Apple's dystopian-themed ad announcing the Macintosh computer, shown during the 1984 game, rating favorite Super Bowl ads, rather than measuring their actual effect on subsequent sales figures, became a regular postgame activity for viewers and pundits alike. Corporate involvement in football also significantly changed the look and texture of the sport, from low-key visibility in the form of Riddell helmets with their signature "R" logo on the back to designer-brand uniforms, launched by Nike and the Oregon Ducks in 1998. That triggered an expansion of football's basic color spectrum to include metallics, tints, and greater use of black as more teams commissioned uniforms in an eye-blistering array of mix-and-match combinations.

(Above) *Supergirl* comic book, November 1970. Supergirl breaks up a gambling ring that has beaten up Stanhope College's star player, Johnny Dee, and ordered him to throw games. In real life, the NFL used former FBI agents in league cities to monitor associations between players and professional gamblers.

(Right) "The Super Bowl Shuffle," Chicago Bears music record, 1985. The Bears performed a best-selling rap song singing their own praises, which was accompanied by a music video and backed up with a Super Bowl victory in 1986. "We're not doin' this because we're greedy," rapped running back Walter Payton, "the Bears are doin' it to feed the needy." Other participants included defensive end and Super Bowl MVP Richard Dent, speedster Willie Gault, "the punk QB" Jim McMahon, fan favorite William "the Refrigerator" Perry, and Hall of Fame linebacker Mike Singletary. Proceeds from the record went to a Chicago charity.

Companies once content to advertise in the game program later attempted to purchase omnipresence through the naming rights to stadiums, college-bowl games, pre- and post-game shows, and halftime reports. The Fiesta Bowl (established in 1971) was the first to use a corporate sponsor's name when it was the Sunkist Fiesta Bowl (1986). Later called the IBM OS/2 Fiesta Bowl, the game achieved a thematic link between sponsor and region as the Tostitos Fiesta Bowl in 1996. In 2001, after Denver tore down its old Mile High Stadium, which referenced the city's nickname, fans objected to the new stadium's moniker, Invesco Field, named for a financial services firm headquartered in Atlanta. The name was then extended to Invesco Field at Mile High before a new corporate sponsor, Sports

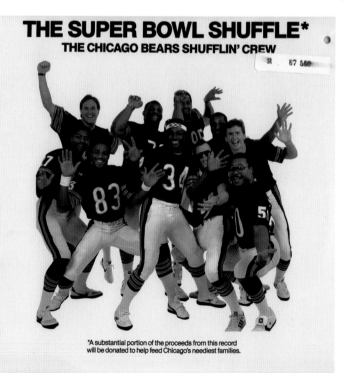

THE SUPER BOWL SHUFFLE*
THE CHICAGO BEARS SHUFFLIN' CREW

*A substantial portion of the proceeds from this record will be donated to help feed Chicago's neediest families.

Arkeith Brown (11) of the Arizona Rattlers intercepts a pass intended for the Philadelphia Soul's Emery Sammons (19) in the 2012 Arena Football League championship game, by Jonathan Bachman, New Orleans. Established in 1987, the league plays on small indoor fields that abut the stands and allow fans to experience the game up close. (Note the tight fit for the orange yardage markers.) Each team has 8 players on the compact field, resulting in a fast-moving, high-scoring game.

Authority, took over in 2011 and changed the name again. Such arrangements have led to the increasing replacement of one American practice, of naming sites and events to reflect local identity, with another American tradition, the corporate tie-in.

Historically, football has been the breadwinner for college and high school athletic departments, and the NFL's booming popularity had a trickle-down effect that reached even the budding stages of game participation. In the 1980s, high schools with prominent teams (notably in Texas) built stadiums to accommodate growing legions of fans. The West Texas oil town of Odessa built a 19,000-seat stadium for its Permian High Panthers, made famous in H. G. Bissinger's 1990 book *Friday Night Lights* and the subsequent film and television series of the same name. In 2012, Allen High School opened its expansive, high-tech, $60 million venue, which, ESPN reported, "the school district decided to build in a down economy, knowing full well it will never recoup the costs" but doing so anyway because the stadium will "serve as a source of pride for years to come."

Like the NFL, college conferences increased their television revenue with each succeeding deal. Teams were so amenable in their pursuit of TV money that Florida State coach Bobby Bowden quipped, "We'll play at 2:00 AM if they wanted us to." In the late twentieth century, conferences seeking increased TV revenue from expansion into larger markets wreaked havoc with traditional competition, as teams joined and departed leagues. School administrators charged with keeping large athletic departments afloat had to consider maintaining conference heritage and age-old rivalries versus accepting membership elsewhere for greater income. Between 1978 and 2012, nineteen members left the Western Athletic Conference in search of better options. The Pac Eight became the Pac Ten and then the Pac 12. The Big Eight turned into the Big 12.

In a huge game of musical chairs in 2005, twenty-three teams changed conferences. The Midwest's Big Ten further twisted the concept of accurate head counts and regional play when traditional powerhouses Penn State (1990) and Nebraska (2011) brought conference

membership to twelve and stretched its range from the East to the Plains. The Big Ten plus two then invited non-football powers Rutgers and Maryland to join, so as to tap into their markets in the New York and Washington, D.C., areas. The Big East planned an even greater geographic contortion in 2011 when it announced that Boise State and San Diego State (football programs only) were joining, thus introducing a new concept: the 6,000-mile round-trip transcontinental league game. Such was the ensuing instability of the Big East that the plan was abandoned, and conference elasticity had at last found a breaking point.

The Fans

My definition of a fan is the kind of guy who will scream at you from the sixtieth row of the bleachers because he thinks you missed a marginal holding call in the center of the interior line, and then after the game won't be able to find his car in the parking lot. —Jim Tunney, the "Dean of NFL Referees," who worked in the league from 1960 to 1991

For so many fans, watching football, often first with Dad, is a bonding experience, a shared activity that can cause a kid growing up in Oregon to root for Philadelphia, the family's long-ago ancestral home. A relative who wandered off to State U may be the only reason some fans need to root for the school; others choose their teams using idiosyncratic criteria: the look of the uniforms, the swagger factor, a particular player. Lynn "Pappy" Waldorf, a longtime college coach, understood that fans could even be those one might least expect. After Oklahoma crushed his Northwestern team in its 1939 season opener, Waldorf received a postcard from a town in Michigan where a convent was located. The card read, in its entirety, "We don't have a team either. Sister Mary."

The tremendous success of *Monday Night Football* and the game's explosive growth attracted foreign figures as well. During a Monday-night game on December 9, 1974, John Lennon told Howard Cosell that "It's an amazing event and sight, it makes rock concerts look like tea

(Above) President Barack Obama demonstrates his Heisman pose in awarding the Commander-in-Chief trophy to the Air Force Academy at the White House, by Charles Dharapak, April 23, 2012.

(Opposite, top) Kansas City Chiefs fans, NFL Pro Bowl, Honolulu, by Paul Spinelli, February 10, 2007.

(Opposite, bottom) A Cowboy fan prepares for Super Bowl V, original artwork, by Bob Taylor, 1971.

parties." (Almost six years to the day later, it was Cosell who first announced to the country during another Monday-night broadcast that the former Beatle had been shot and killed.) Declassified State Department cables show that Japan's Emperor Hirohito was keen to learn more about American football after a visit from President Gerald Ford in 1974. In a series of exchanges between State and the U.S. ambassador to Japan, it is clear that Hirohito was eager to attend an NFL game but that Japanese officials were puzzled by American concern for his safety at fortresslike Shea Stadium in New York. The emperor's staff felt it was worth the risk, and on October 5, 1975, Hirohito watched the Jets defeat the Patriots from behind a bulletproof window.

As fans first introduced to college football in the 1920s and 1930s reached the end of lengthy lives, it became apparent that several consecutive game-attendance streaks had been in the works for decades. "Super Fan" Giles Pellerin, a telephone company executive, began his Southern Cal streak in 1926, attending 797 consecutive home and away games before passing away outside the Coliseum during the 1998 USC–UCLA game at the age of 91. (His brother, Oliver, racked up an impressive 637 consecutive games seen in person.) In 2013, Alabama's top fan, Dick Coffee, an ad man, attended his fiftieth consecutive Crimson Tide bowl game, a minor feat, considering that he had not missed one of the more than 700 regular season games at home or on the road since 1946. As a result, "he has never seen Alabama play on TV," said his son. "Who else in the state of Alabama has never seen Alabama play on TV?"

Other fans express their team loyalty through their everyday wardrobe, home decor, and other logoed merchandise. Caskets in team colors ensure that not even death will separate fans from their teams. A study has shown that college students are more likely to wear school-branded clothing on Monday if their team wins on Saturday. Fans also found new ways to indulge in the sport. Seemingly primitive and simplistic football video games (even to users at the time), introduced in the 1970s and led by Atari, evolved to include greater graphic realism and strategic input from the user. Player-coach-announcer John Madden helped develop Electronic Arts' Madden NFL, first released in 1988. By 2010, more than 85 million copies of the game had been sold.

Fantasy Football leagues, which date back to the early 1960s, began flourishing in the late 1990s, facilitated by rapid growth of the Internet, which made widespread and easy participation possible. In Fantasy Football, participants develop and manage their own teams made up of current NFL players whose actual weekly performances determine the success of the imaginary team. Since fantasy teams comprise players chosen from many different clubs, some fans are torn between rooting for their favorite team or their opponent, if the opponent has a key member on one's fantasy team. The popularity of fantasy leagues led to even greater viewership of televised games, as fans followed more teams to see how their players performed. It also generated a plethora of statistical, number-crunching, and analysis-laden websites for fantasy team owners.

Global obsession with electronic applications manifested itself, for football fans, in apps designed to not only bet on games, a historical pastime, but to gamble on the results of individual plays, rulings challenges, and even the opening coin toss. Hard-core fans signed up to be alerted whenever a scoring play appeared imminent, while stockpiling video clips of their favorite plays and creating their own online libraries and archives. Following a game interactively presented a whole different way of viewing the competition, which, like Fantasy Football, placed emphasis on outcomes that suited the viewer for personal gain over other reasons to watch a game.

(Above, top) Detroit Lions running back Barry Sanders on the cover of the *1998 Fantasy Football Digest*. The explosive growth of fantasy football leagues in the 1990s inspired numerous publications and websites to guide fans in creating their own teams.

(Above, bottom) Goose Girl Fountain (Eleftherios Karkadoulias, 1980), Covington, Kentucky, by Al Behrman, December 2005. Even the heroine of a Grimms' fairy tale is a Cincinnati Bengals fan when clinching a playoff berth is on the line.

(Right) Oregon fans respond to a failed play against California, Autzen Stadium, Eugene, by Tom Hauck, October 6, 2011. Ducks fans usually create the letter *O* for Oregon with their hands at games, but in this instance their O-shaped mouths meant *"OH!"*

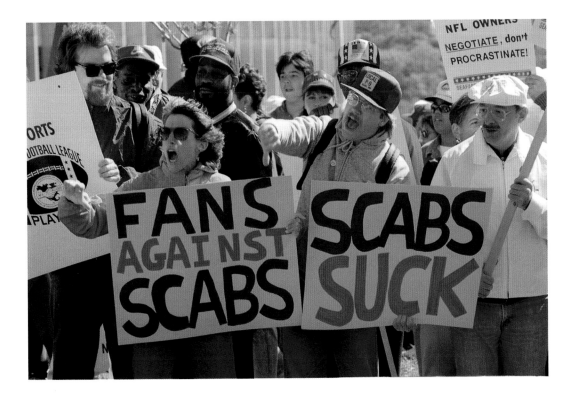

Perhaps the ultimate expression of fan participation is found in Green Bay, Wisconsin, and not simply for the Packers' storied franchise, its history, and the nonchalance with which ticket holders attend games in the worst possible late-winter conditions—*outside*. The Packers are the NFL's only publicly owned, nonprofit team. It has issued stock several times, beginning in 1923, also making it the only team with more than 100,000 owners, who attend shareholder meetings in the stands at Lambeau Field. Thus, the NFL franchise with the smallest metropolitan population, and seemingly ripe for relocation, has never been threatened with a move.

The investment fans make in their teams, even if only from their living room, is rewarded in the pleasure the game itself provides and the camaraderie it can engender. On occasion, though, investments go bad. Throughout the 1980s, fans were put through an emotional wringer as players went on strike in 1982 and 1987 and dissatisfied owners triggered a series of mass team relocations. The 1982 labor strike shortened the sixteen-game schedule to nine. When players struck again five years later, team owners, not wanting to cancel more games, arranged for scab players to step in for three weeks. Average game attendance dropped by more than half, but more often than not, disgusted fans who threatened to quit watching football forever could not help but return to the fold. Since then, it has been difficult for fans to evince much sympathy during ongoing disputes—characterized as "millionaires versus billionaires"—between players and management.

Interrupted seasons were unfortunate enough, but losing one's team to another city was a heartbreaking betrayal. Al Davis led the exodus. Unhappy with the stadium in Oakland, he moved his Raiders to Los Angeles (1982); the Baltimore Colts, displeased with their stadium, settled in greener pastures in Indianapolis, their moving vans sneaking out of the city in the middle of the night (1984); and the St. Louis Cardinals, no longer comfortable in their stadium, departed for Phoenix (1988). Other moves in the 1990s followed (including the Raiders' move *back* to Oakland), as owners sought public financing for new venues equipped with luxury skyboxes and high-tech amenities. Cities that were unwilling

(Left) Demonstrators outside RFK Stadium, Washington, D.C., October 4, 1987. Fans jeer spectators arriving for a game between the Giants and the Redskins that used replacement players during the NFL players strike. Attendance plummeted during the three weeks that scab players competed.

(Above) EA Sports Madden video strategy guide, 2000. After retiring as a football commentator in 2009, John Madden continued to update his bestselling video game by keeping tabs on every NFL team. He told Reuters that at home "I have one big movie theater screen that's 9 feet by 16 feet. Then I have nine 63-inch monitors around it . . . So I get all nine one o'clock games and I can switch them onto the big screen. That's what I do on the Sundays during the season."

or unable to meet these expensive demands lost out to those determined to obtain an NFL franchise. In the case of the Colts, owner Robert Irsay dangled his team in front of Jacksonville, Memphis, and Phoenix, causing Indianapolis, with its freshly built but idle Hoosier Dome, to sweeten its offer with a new practice venue. "To be sure, public subsidies are nothing new when it comes to big league sports facilities," wrote urban affairs and media analyst Howard Kurtz. "What is new is the growing willingness of city officials to prostrate themselves before the demand of sports moguls like Irsay, and the increasing ease with which such owners are playing off one city against another."

Several instances illustrate cases when fan power has prevailed, resulting in immediate, significant change. In 1960, the new AFL franchise in Oakland announced that its team would be called "the Señors." After recovering their senses, the public vociferously objected, a naming contest was held, and the team was henceforth known as the Raiders. Those same Raiders were then involved in the infamous "Heidi Game" that changed procedures for broadcasting live sporting events. On November 17, 1968, with about a minute left to play and the New York Jets leading Oakland 32-29, NBC cut away from the game to air the made-for-TV children's movie *Heidi* promptly at 7:00 PM. "We were screaming, yelling at the TV!" said David Franciosi, then a fourteen-year-old Raiders fan living in Jets territory. "My brother and I watched the movie, thinking they might switch back. They never did. Finally, they showed the score on the screen, and the Raiders won! We couldn't believe it! Then we turned off the movie."

Franciosi and other fans in the eastern U.S. missed seeing Oakland score two touchdowns but got an eyeful of the Swiss countryside as irate viewers overloaded the NBC telephone switchboard demanding that the game come back on. (Jennifer Edwards, the ten-year-old

<div style="float:left;width:22%">

Embarrassed New Orleans Saints fans wearing paper bags to hide their identities, by Bill Feig, 1999, and proud fans basking in an NFC championship victory, by Paul Abell, January 24, 2010. What a difference a decade makes. "The Aints," as disappointed fans referred to their team, went 3-13 in 1999, having endured twenty-four losing seasons since the team formed in 1967. In 2009, the Saints reversed that record, going 13-3 and winning Super Bowl XLIV.

</div>

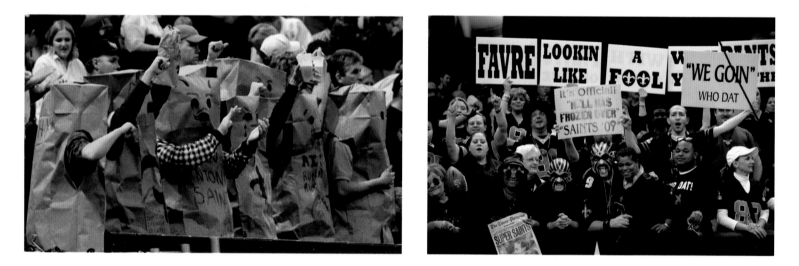

actress who starred as the Alpine lass, even received death threats in the mail.) NBC issued an apology that evening, then changed its policies to accommodate sportscasts that ran long. The other networks did the same. Later in the week, NBC ran a full-page newspaper advertisement quoting television critics praising *Heidi* that included a review from Jets quarterback Joe Namath, who said, "I didn't get to see it, but I hear it was great."

In 2012, fans did not bother picking up the phone to express their fury with the NFL following another come-from-behind victory. In the third week of the season, "replacement refs" who had been brought in to officiate games while the regular officials were locked out

continued to frustrate fans with bad calls and slow decisions. Already in a foul mood, viewers exploded at the conclusion of the September 24 Monday-night game. Seattle was awarded a touchdown on a 24-yard pass play in which the referee ruled that the ball was in the hands of both a Seahawk and a Green Bay Packer as time expired. The call on the disputed play was confirmed after a lengthy instant-replay review, and viewers vented their anger via Twitter, overtaking the social media service. "These games are a joke," tweeted Fox commentator and Hall of Fame quarterback Troy Aikman, in one of the more polite comments. The NFL, which did not appear to be making progress in its negotiations with the officials and insisted that the overmatched replacements were doing just fine, was taken aback by the ridicule unleashed in cyberspace. Within forty-eight hours, the impasse was settled, and although the league claimed that a resolution was already in the works, fans were convinced that it was their online response that forced the NFL to make a deal. In a historic first, fans treated the returning regular referees to standing ovations the following Sunday.

Moving the Chains

He treats us like men. He lets us wear earrings. —University of Houston wide receiver Torrin Polk, referring to his coach, John Jenkins, 1991

The typical football coach would likely have bet a lifetime supply of clipboards and headsets that he would never hear a statement such as that in his life. The typical football coach had been, after all, the very model of a clean-cut, manly American male, and into the 1970s, most had military experience, running their summer training practices like marine corps boot camp. Players were expected to appear in coats and ties in public, clean-shaven, hair above the collar. Coaches preached against the evils of Communism, endorsed the power of prayer, and served as father figures. That strain of coach continues to run through football, but it is no longer the default setting. From the Vietnam War era to the twenty-first century,

football resisted, gradually accepted, and eventually became part of the social change brewing around it.

Changing demographics in the AFL gave black players more leverage to challenge unfair practices than had been possible in the past when teams were all or mostly white. This was especially evident at the 1965 AFL All-Star Game in New Orleans, where players complained they had been turned away from nightclubs and taxi cabs. "People shouted insults, and doors were shut in our faces," said Dick Westmoreland of the San Diego Chargers. Twenty-one black players voted to walk out of the game in protest, prompting AFL commissioner Joe Foss to immediately move the game to Houston the following weekend. New Orleans mayor Victor Schiro criticized Foss for acting "hastily" and argued that "If these men would play football only in cities where everybody loved them, they'd all be out of a job today . . . Almost all of them are educated college men, who must be aware that you cannot change human nature overnight."

The 1969 season marked a turning point for many black athletes, who had, the previous summer, witnessed U.S. Olympians John Carlos and Tommie Smith raise gloved fists at their medal ceremony in Mexico City as a sign of black power. Amid the unraveling of tightly wound cultural values and widespread student unrest, black athletes actively expressed long-held grievances regarding unequal treatment, hostile locker room environments, and programs whose interest in them expired when their playing eligibility ended. Reacting to a heretofore-unknown type of player was a coach for whom the term "old school" was devised and who was flummoxed by the more freewheeling young men (white and black) who graced his roster and irritated his ulcers. The culture clash between that fraternity of coaches and their charges was even greater when it came to racial matters, and it was

why so many players began asking that their teams hire black assistant coaches, who better understood them.

Of the many racial collisions affecting teams nationwide, perhaps the least expected occurred in Laramie, Wyoming, a year after the Cowboys made their first appearance in the Sugar Bowl. Midway through the 1969 season, Wyoming coach Lloyd Eaton, who prohibited his players from taking part in student demonstrations of any kind, summarily dismissed all fourteen black players from the squad for wearing black armbands the day before their game against Brigham Young University. The men were protesting the Mormon Church, which owned and operated BYU, for its policy that excluded black males from the priesthood (a policy that was revoked in 1978). "The demonstrations are not against BYU because it doesn't have any black players—but because it is sponsored by the Mormon Church," said Willie Hysaw, one of the Wyoming Fourteen.

Roosevelt Grier's Needlepoint
Jim Murray on the Los Angeles Rams
Our Air Force by Senator Goldwater Russia: 1974-Style
Booming, Blooming Atlanta Winston Churchill: American Hero
Bowling's Big Spare-Time Strike The Grand Jury and You

Their banishment was the talk of the sparsely populated, nearly all-white state, which had high hopes for a fourth consecutive conference championship and a bowl bid. Most residents backed Coach Eaton. On campus, classmates supported the players; the student senate passed a resolution asking that they be reinstated and that student fees to the athletic department be put on hold. Black students at Colorado State suggested that their school not compete with Wyoming until the players were back on the team. The head of the Western Athletic Conference, Wiles Hallock, described the situation as a "crisis." Eaton thought perhaps his players had been egged on by other black students: "Look, most of these players are only marginal students. They come from split homes and poor families. They are usually C students at best, and we're trying as hard as we can to give them an education through football."

The coach's analysis was actually in sync with arguments sociologist Harry Edwards, author of *The Revolt of the Black Athlete* (1969) and orchestrator of the Olympic protest, was making in his condemnation of standard practices in collegiate athletics. Not only were many of these players brought into completely foreign environments and given little useful guidance, but, wrote Edwards, "lofty academic goals might jeopardize a black athlete's college career and thus wipe out the college's financial investment in him." Scandalous reports in the 1970s, revealing the extent to which so many college

(Left) *Saturday Evening Post* magazine cover, featuring needlepoint by Rosey Grier, November 1974. Grier, a defensive tackle during his career with the Giants and the Rams (1955–66), became America's best-known needlepoint artist, having authored *Rosey Grier's Needlepoint Book for Men* the year before this issue came out.

(Below) Henry Alves, right, runs for daylight in a flag football game, Arlington, Virginia, by Mark D. Alves, 2012. During the 2011 season, there were 3.5 million children competing in youth football leagues nationwide.

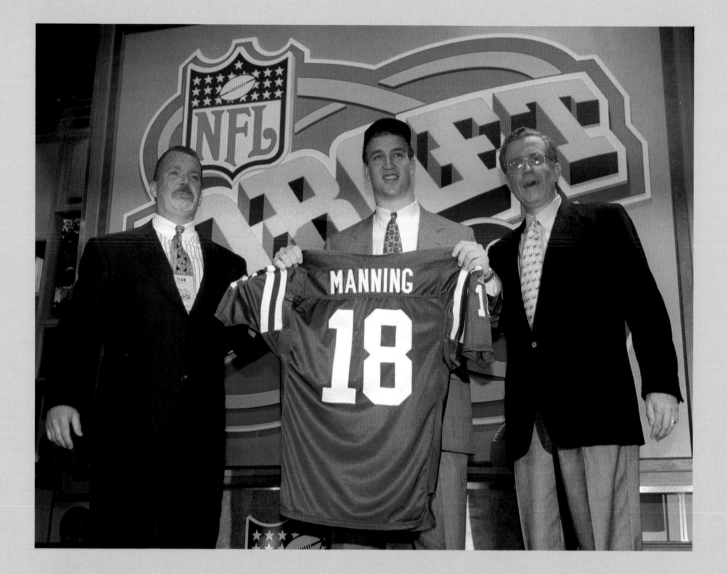

GAME CHANGER: Agent X

I really believe that the NFL would fall apart without me. That may sound cocky, that may sound arrogant, but I am telling you the truth. —Drew Rosenhaus, on *60 Minutes*, 2011

So who is this man who claimed to be the glue that held the NFL together?

Meet Agent X. In a multibillion-dollar industry, the NFL agent whose name is unknown to most fans wields tremendous power and has altered the way professional and college football operate. Agent X generally works behind the scenes, negotiating players' increasingly lucrative contracts, training and shopping players to different teams, arranging endorsements, and even advising clients when not to play and "hold out" for more money. When players have problems, whether disagreements with team management or altercations with the law, the agent is first on call to assist the player or even to post bail. For these services, NFL agents receive a maximum 3 percent commission.

Charles C. "Cash and Carry" Pyle is credited as being the first sports agent. In 1925, when the typical NFL salary was less than $100 per game, Pyle negotiated a $100,000 deal for halfback Red Grange of the Chicago Bears. "Where the average fellow would ask for $5,000, Charley would ask for $25,000," Grange said. Until the 1970s, management generally had

the upper hand over agents. Legend has it that Vince Lombardi would trade players who came into his office with an agent to negotiate a contract. In 1969, Houston Oilers general manager Don Klosterman told *Time* magazine, "We spend $200,000 a year in evaluating talents, and some uninformed agent is going to tell us what a player's worth? They're just parasites, in it for a fast buck." Most players then did not have agents and simply signed a "Standard Player Contract."

The elimination of reserve clauses (which bound players to their teams, even when their contracts expired) and the introduction of free agency gave players more mobility to negotiate with different teams. Competition for the best talent from newly formed leagues like the AFL drove up salaries and gave players more leverage in contract negotiations. Player unions gradually wielded more power. The potential for higher salaries influenced players to seek out agents for their financial advice and negotiating skills.

These factors paved the way for a group of ambitious young lawyers who fostered close relationships with players—the initial client often being signed serendipitously—to become the first modern mega-agents who built and maintained a stable of star players. The 1977 collective-bargaining agreement between the NFL and its players association guaranteed players the right to be represented by an agent. Hiring an agent has gone from rare to ubiquitous, especially following a huge influx of television money beginning in the early 1980s. By 2011, less than a month after a new collective-bargaining agreement was signed, agents collectively negotiated more than $1.75 billion in free-agent contracts.

Agents have also had a major impact on the college game. Despite prohibition of agent-player contact before players are eligible for the NFL draft, some provide their future clients with money and gifts. One such effect has been to rewrite the record book. When the NCAA determined that former USC running back Reggie Bush had received extensive agent largesse, thus rendering him ineligible to play, the school was stripped of fourteen victories, and its 2004 Bowl Championship Series national title was vacated. Six years later, Bush agreed to return his 2005 Heisman Trophy. When three of the top Southeastern Conference teams were being investigated for player-agent impropriety in 2010, Alabama coach Nick Saban lashed out, "The agents that do this—and I hate to say this, but how are they any better than a pimp?" In *The Dotted Line*, a 2011 ESPN documentary, leading football agent Leigh Steinberg acknowledged, "It's almost understandable that athletes would take money when they're sitting on a college campus not able to work. And if they're from any kind of disadvantaged background, small sums of money seem huge to them. The athletes don't view that as a moral issue."

As enterprising agents have shown, it's possible to control the most powerful and popular sport in the United States without playing, coaching, owning, or operating a team.

—Jonathan Horowitz

(Opposite) Peyton Manning, University of Tennessee, with Indianapolis Colts owner Jim Irsay and NFL Commissioner Paul Tagliabue, NFL Draft, New York City, by Adam Nadel, April 18, 1998. Agent Tom Condon got Manning a record rookie contract when the quarterback signed with Indianapolis for $48 million over six years. The investment paid off: Manning was a four-time league MVP and the face of the franchise, leading the Colts to two Super Bowl appearances, including victory in 2007.

(Below) Jerome McDougle takes the call on NFL Draft Day, by David Adame, April 26, 2003. Sports agent Drew Rosenhaus celebrates with his client and the player's mother, Linda McDougle, after the Philadelphia Eagles selected the University of Miami defensive end in the first round. He signed for $9.4 million over six years but played in only thirty-seven games during an injury-plagued career (2003–2008) that included an abdominal gunshot wound as a robbery victim.

athletes—especially blacks, but whites as well—were shepherded through meaningless coursework illustrated the devastating effects of what had once been jokes about jock classes and low expectations. Athletes were completing four years of player eligibility with little progress toward a degree and, in deeply embarrassing cases to both athletes and schools, with the same level of illiteracy they had the day they arrived.

Meanwhile, throughout the 1960s, desegregation lurched along in public schools throughout the country. It reached the farthest recesses of the Deep South in the early 1970s. At the University of Alabama, which had black students but no varsity gridders, Southern football's Lost Cause succumbed to the times and to the USC Trojans. Much has been made of the role Trojan tailback Sam "Bam" Cunningham had on Alabama's decision to recruit black players, after he ran roughshod over the Tide in front of their fans, leading USC to a decisive victory in the first game of the 1970 season. (Said Virginia Tech coach Jerry Claiborne: "Sam Cunningham did more for integration in sixty minutes than Martin Luther King did in twenty years.") Yet Alabama coach Paul "Bear" Bryant, who bristled at the notion that he was responsible for his team's monochrome appearance, had a black freshman in the pipeline and had, he said, invested "$100,000 . . . recruiting Negro players all over the country." Considering local history, it was clear why blacks were not swarming to join the program.

Although the revered coach was frequently mentioned as a gubernatorial candidate, not even the influential Bryant could sway the state's powers-that-be to sign black players until the need arose and legal recourse ceased. "You must remember, these were dangerous times, fearful times," Frank A. Rose, the university president, told Howell Raines, an Alabama

(Right) Head coach Tony Dungy, Indianapolis Colts, during Super Bowl XLI, Miami, by Mark Humphrey, February 4, 2007. Dungy played defensive back on the 1978 Super Bowl–winning Pittsburgh Steelers team, returning to the title game almost thirty years later as the first black head coach to win a Super Bowl championship.

(Opposite, bottom) *Sports Superstars* **comic book featuring Deion Sanders, April 1993.** Sanders, a Hall of Fame cornerback and return man known as "Prime Time," was a dominant personality throughout the 1990s, accumulating record stats, extensive endorsement deals, and cumbersome bling. Between 1989 and 2005 he played for five NFL teams and four MLB clubs. "I'm married to football," he explained. "Baseball is my girlfriend."

CHAPTER 4 · FOOTBALL NATION

native then reporting for the *New York Times*, shortly after Bryant died in 1983. Even before the USC game, Rose and Bryant preferred to quietly urge alumni and business groups to accept integration rather than publicly call for it. Within fifteen years of the Bear's death, the significance of integration's effect on football was most evident, and the majority of Southeastern Conference players were black.

In professional football, several black quarterbacks (Vince Evans, Joe Gilliam, and James Harris) broke through as starters in the 1970s, an especially noteworthy development, since that position, more than any other, was held out as the thinking man's role and the purview of white athletes. Blacks had been blocked from other significant roles in the NFL for so long that much discussion on racial issues ensued when former Raider and Hall of Famer Gene Upshaw became executive director of the NFL Players Association in 1983 and Art Shell signed on as head coach of the Raiders in 1989. The following year, the state of Arizona instigated controversy when residents voted against observing Martin Luther King Jr.'s birthday as a holiday. In response, the NFL, feeling pressure from the NFLPA and civil rights groups, agreed to move Super Bowl XXVII, scheduled for Phoenix in 1993, to the Rose Bowl in Pasadena. Arizona lost an estimated $150 million in visitor spending during Super Bowl week that year, but after the state approved a King holiday in 1992, Phoenix was selected to host Super Bowl XXX.

At the suggestion of Pittsburgh Steelers owner Dan Rooney, the "Rooney Rule" went into effect in 2003. The rule called for minorities to be included in interviews for senior positions. Although somewhat controversial, the rule addressed two significant issues: the benefits white coaches derived in landing job offers due to their connections in a coaching network historically closed to others, and that more than two thirds of NFL players were black but that those percentages were not reflected in upstairs positions. Tony Dungy, the first black head coach of a Super Bowl winner (the 2006 Indianapolis Colts) and one of professional football's most respected figures, explained why seeing those like himself in the upper echelon of the game was so important for the public and the sport: "Watching all those [Super Bowls] when I was a young person, you dream about playing—'Maybe I can be in the game'—but you never seemed to dream about being the coach. It never seemed possible. And now, some young people will be able to dream down the road, 'I might be able to coach that team one day. I might coach in the Super Bowl.' And I think that is really progress."

Football's supremacy among American sports made it a useful barometer for gauging social change in other areas as well. In 1973 an eight-club professional women's tackle football league formed with teams from New York to California. Players, who in their day jobs were "secretaries, computer operators,

(Above) Mean Joe Greene Coca-Cola commercial, 1979. The injured Pittsburgh defensive tackle and mainstay of the "Steel Curtain" defense turns out to be a softie in accepting a bottle of Coke from a young fan (Tommy Okon), who receives the player's jersey in return. The popular commercial, part of the "Have a Coke and a Smile" campaign, won the advertising industry's Clio for Ad of the Year.

students, lab technicians, librarians, and probation officers," were paid $25 per game. Other leagues came and went; six were established between 2000 and 2010, including the Women's Professional Football Association, which expanded to three dozen teams. Thousands of women who had always wanted to play "real" football—rather than flag or touch—found opportunities in cities all over the country. Such leagues, however, won little attention beyond that of the players, their friends, and families, but the fact that they existed at all was the key point.

The most visible changes for women in football, however, were not on field but in the bylines or in front of a news camera. The precedent had long been set. On her way to becoming one of the country's top political correspondents for the Associated Press, journalist Lorena Hickok regularly covered the University of Minnesota football team in the 1920s for the *Minneapolis Tribune*. Elinor Kaine, a member of the Professional Football Writers Association, was the first woman to regularly cover the NFL. When denied press credentials for the Giants-Jets exhibition game at the Yale Bowl in 1969—on the grounds that the only restroom in the press box was for men—she sued, explaining, "I didn't ask to go to the john. I just want to sit in the press box." Her book *Pro Football Broadside*, published that year, detailed the "swingers, softies, and the sadists" in the game and offered a well-reviewed new take on the sport. In the 1990s, media entrepreneur Ann Kirschner founded NFL.com, a pioneering sports website, and oversaw the NFL Sunday Ticket television package.

As more women covered men's teams (in 1976 Lesley Visser of the *Boston Globe* was the first to become an NFL beat writer), post-game locker room access became an issue: Male

reporters hurried in to get player interviews and meet their deadlines, while female reporters were kept waiting outside as players dressed. A 1978 federal court ruling granting equal access to locker rooms for all credentialed news media was slowly implemented among some teams, and in 1985, NFL commissioner Pete Rozelle made equal access official league policy.

While most players and reporters of either sex do not care much for locker room interviews—the already cramped space is usually too crowded—the transition to equal access went rather smoothly. Then came the 1990 season. Three naked New England players, led by tight end Zeke Mowatt, were fined for sexually harassing the *Boston Herald*'s Lisa Olson during a post-game interview, and the team later settled a lawsuit with the reporter. A week after the ugly episode in Boston, Bengals coach Sam Wyche stopped *USA Today* reporter Denise Tom from entering his locker room following a Cincinnati loss in Seattle, insisting that "I will not allow a woman to walk into a room of fifty naked men." ("This is not about women in the locker room," wrote *Washington Post* sports columnist Tony Kornheiser. "That issue can be settled in three words: Wear a towel.") NFL commissioner Paul Tagliabue fined Wyche $28,000, then the largest fine against a coach and more than twice as much as that levied against the Patriots players. Female editors and sportswriters expressed dismay that equal access was still a matter of contention, and that the league apparently regarded Wyche's defiance of management worthy of greater punishment than sexual harassment. Atlanta coach Jerry Glanville weighed in on the side of equality by arguing that "The people who say, 'Well, I wouldn't want my daughter in [the locker room],' well, your daughter's probably not covering sports. This is 1990. Let's not back up."

(Above) Cheryl Luther of the Atlanta Xplosion breaks through the Jacksonville Dixie Blues line, Atlanta, Georgia, by John Bazemore, 2005.

(Bottom left) Reporters swarm around New England quarterback Tom Brady in the Patriots locker room, by Stephan Savoia, 2009. Once a scene of controversy for female reporters, the NFL locker room became an equal opportunity media crush for player access.

(Below) Mary Hutter, left, and her daughter Rashida Jackson, New Orleans Voodoo Dolls, Women's American Football League, Metairie, Louisiana, by Bill Haber, 2002.

(Right) Head coach Natalie Randolph receives a Gatorade victory shower from her Coolidge High School varsity boys team, Washington, D.C., 2010.

(Below) Line judge Sarah Thomas, the first woman to officiate at a bowl game, working the Little Caesars Pizza Bowl, Marshall vs. Ohio, Detroit, by Duane Burleson, December 26, 2009.

(Opposite, top) Colgate fans at the Cornell game, Ithaca, New York, by Larry Fried, 1957. Colgate's teams were once known as the Red Raiders, prompting fans to don Indian-style buckskins and headdresses at games. The university's Indian mascot was later dropped, and in 2001 the "Red" was discarded. Since then, Colgate teams are known simply as the Raiders.

(Opposite, bottom) Kansas City Chiefs game program, August 1963. In a reference to Kansas City's opponent, the Buffalo Bills, an American Indian figure is shown ready to dine on "historic meat," the destruction of which signaled the end of traditional life for Plains Indians.

Once the rediscovery of the towel and shower curtain was achieved, backed by official NFL mandates that players behave professionally in dealing with reporters, and media policies requiring that their employees do the same, the public uproar died down. More women continued to work their way into ever more visible roles as on-camera college and NFL game reporters and TV news sports anchors. Both television executives and NFL officials sought to increase already high levels of viewership among men by appealing to women as well. NFL coaches established clinics to teach women the game—once the purview of the head coach's wife—and simulated training camps that drew thousands each year. In 2007, the Baltimore Ravens established Purple, the first NFL team fan club for women, offering a mix of football and philanthropic activities, and other teams soon started their own female-friendly clubs. In 2012, the NFL announced that women comprised 45 percent of its fan base.

In the social turmoil of the late 1960s and early 1970s, and as a component of the 1980s culture wars that affected roles for women and blacks in football,

Indian activists urged club owners and college presidents to change team nicknames they deemed offensive. Football, more than any other sport, has long been associated with the issue of caricaturing American Indian identity, as students dressed in an approximation of Indian war paint and clothing, rode horses across the field and danced as mascots. Teams with Indian names maintain that such usage has always had an honorable and respectful purpose, representing a link to local history and expressing positive traits, such as strength and bravery, associated with the American Indian. Those opposed to the practice consider such names and associated mascots as crass, demeaning stereotypes and a misuse of appropriated Indian culture. "No wonder people are confused about who Indians really are," wrote Rita Pyrillis, a

member of the Cheyenne River Sioux tribe, in 2004. "When we're not hawking sticks of butter, or beer or chewing tobacco, we're scalping settlers . . . we're leaping through the air at football games, represented by a white man in red face. One era's minstrel show is another's halftime entertainment."

Beginning in 1970, a surge of schools, including Dartmouth, Massachusetts, and Stanford, dropped the nickname "Indian" or related terms. At Oklahoma, "Little Red," who fired up the crowd dressed in a war bonnet, was officially banned. The popular dancing character had debuted in 1953, just as the Sooners began their forty-seven-game winning streak in a decade of dominance, and those who portrayed him included young men of Indian descent. The NCAA also strongly encouraged schools to abandon Indian-related names, and by the turn of the twenty-first century, more than 600 school and minor league teams had done so. In 2005, it announced that colleges with "abusive Indian nicknames" would no longer be permitted to host post-season events. After the NCAA ruling, the University of Illinois's board of trustees retired Chief Illiniwek, the school's symbol since 1926 and one of the country's best-known mascots.

A *Sports Illustrated* survey in 2002 found that while Indian activists were strongly opposed to Indian-themed mascots and nicknames, the general Indian population, by large margins, was not. Academics questioned the validity of the poll that found that 83 percent of American Indians did not believe that teams should give up calling themselves the Chiefs, Braves, or even Redskins. At Florida State, where fans perform a tomahawk chop to the school's "war chant," the university received permission from a local tribe to continue calling themselves the Seminoles and using Chief Osceola as its symbol.

The subject remains a hot-button topic not only because there is no consensus on the matter, but also because sports teams mean so much to Americans. It has been especially prickly in the nation's capital, home of the Washington Redskins. At the National Museum of the American Indian on the national mall, contractors and vendors working on site are told not to wear sports paraphernalia with Indian names or mascots. In a 2006 law review article titled "Hail to the Potomac Drainage Basin Indigenous Persons: Has Political Correctness Gone Too Far?" attorney Marvin L. Longabaugh addressed legal issues surrounding the team name and the federal government's

obligations to Indians based on long-standing treaties. The irony in his conclusion suggests the power of Football Nation. "A significant obstacle remains in the Native American pursuit of eradication of the 'Redskin' name," he wrote. "A substantial number of elected and appointed federal officials live in or near Washington, D.C., and support the Redskins."

A more diverse American population wary of insulting Indians or other ethnic groups also turned its attention to the use of the Confederate flag among Southern sports fans. As early as the 1940s, fans of Southern schools waved Confederate flags when playing Ivy League teams at home. Its use dramatically increased in the 1950s and 1960s as part of an organic reaction to federal court orders to end segregation. White Southerners have long claimed the flag to be a symbol of their heritage, while opponents regard it as an emblem of hate and racist oppression. Black students who had fought for the right to attend state schools viewed its presence as an attempt at intimidation, part of a campaign to drive them out. The University of Mississippi's "Colonel Reb," the most controversial Confederate-related school symbol, originated during the Great Depression about the same time that "the Rebels" became the nickname for Ole Miss sports teams. Colonel Reb, first portrayed in costumed mascot form in 1979, was retired from on-field game appearances in 2003, and in 2010, Ole Miss students chose a new mascot, the Rebel Black Bear.

The Dark Side

They'll fire you for losing before they fire you for cheating. —Darryl Rogers, Michigan State coach, 1976–79

Pro football had never taken a hit quite like the one it received from a journeyman linebacker in 1970. Dave Meggyesy, who spent seven years with the St. Louis Cardinals, described college and pro football as a brutal, "dehumanizing" experience in his book *Out of Their League*. Some players and many fans were surprised by his description of a racist, unethical culture in which team doctors would rather shoot up and suit up players than get them healed. The NFL's response: "We have no interest whatsoever in promoting the sale of Meggyesy's book." Commissioner Rozelle would say nothing about it publicly. Some players, notably Oakland's placekicking quarterback, George Blanda, argued that Meggyesy's claims had no merit. But the door to the locker room had been cracked open and an element of football culture exposed.

The seamy side of football, as recounted by Meggyesy, was nothing new, nor was its dark side peculiar to the sport. By the 1980s, however, steroid and performance-enhancing drug use from the pros even down to high school players had become public knowledge, and there was a growing body of literature describing the devastating effects of long-term use. The NFL instituted a strict and evolving policy in 1987 that included frequent testing to combat the scourge of steroids, which players used to build body mass and recover more quickly from injuries. That players were willing to risk their health and shorten their life spans in what is usually a short career (the NFL average is only three and a half years) speaks to the game's allure and the intense pressure to perform. In 1991, Lyle Alzado, former Raiders defensive end, estimated that about 90 percent of the athletes he knew were users like himself.

Concern about injuries, especially brain injuries and concussions, eventually came full circle. Calls to ban football in the late nineteenth and early twentieth century faded, and the pursuit of better equipment and improved rules continued, but a century later, the future of football was again being debated as further research into head injuries and the hardship stories of retired players were publicized. Football's tradition of playing hurt lent itself to drug use and unethical medical practices among team doctors, but at the root of life-altering injuries was the very nature of the game and how it is played. As Michigan State coach Duffy Daugherty once put it, "Football isn't a contact sport, it's a collision sport. Dancing is a contact sport." The cumulative effects of collisions over time appeared to cause greater damage than the fewer but more obvious head-banging incidents. As a result, former players who were never sacked or slammed going over the middle but simply blocked their way through a career exhibited alarming signs of brain damage and related ailments that other men their age did not. In 2012, more than 2,000 former NFL players filed suit against the league, arguing that it had withheld information on the long-term effects of head injuries and that it had "exacerbated the health risk by promoting the game's violence" as an attraction.

The public began paying more attention as a string of former players, including Super Bowl-winning quarterbacks, spoke out about the issue. "We knew there was going to be a chance for injury," said Jim McMahon (Chicago Bears). "We didn't know about the head trauma, and they did." For Kurt Warner (St. Louis Rams), "It's going to take a whole culture change from top to bottom to say our number one priority is the player . . . It's a hard balance, because of the product, and the players, and the money, and the winning and how that dictates so much of our business." Speaking of his sons, he acknowledged that "They both have the dream, like dad, to play in the NFL. That's their goal. And when you hear things like the bounties, when you know certain things having played the game, and then obviously when you understand the size, the speed, the violence of the game . . . It scares me as a dad."

One of the most intriguing aspects of football culture is that so many former players, knowing how much they would be hurting in retirement, would choose the same profession again. Said Terry Bradshaw, who parlayed his Hall of Fame career with Pittsburgh into decades of work as an on-air game analyst and television host, "Football is an awesome sport, but it's also a violent sport, and that's why all of us love it. We know what we checked in for . . . and I didn't care that I got hurt. And then the question, 'Would you do it again?' Absolutely." Earl Campbell earned his reputation as one of the game's most punishing running backs (he once knocked the contact lenses out of a defender at the goal line),

(Left) *Out of Their League* by Dave Meggyesy, 1970. Meggyesy's bestselling account of his life in football, which described corruption, drug use (including steroids), and racism throughout the game, later became a standard text in college courses on sports and society. At Syracuse, "I accumulated a broken wrist, separations of both shoulders, an ankle that was torn up so badly it broke the arch of my foot, three major brain concussions, and an arm that almost had to be amputated because of improper treatment," he wrote. "And I was one of the lucky ones." He was also one of the few players on his team to graduate. Meggyesy's anti-war activities and growing disillusionment prompted him to leave the NFL at 29, yet he remained close to the game, working for the NFL Players Association from 1979 to 2007.

(Below) Green Lantern comic book, "Fourth Down and Hell to Go," March 1993. Super heroes attend a championship game, where the excitement of a thrilling finish gives the imprisoned demon Sapolu the opportunity to break free. John Madden served as the inspiration for the story's game announcer, right down to his catchphrase, *"Boom!"*

Do you remember those boyhood days when going to college was greater than going to Congress and you'd rather be right tackle than President? —Opening title card from *The Freshman* (1925)

The day they cut the football budget in this state, well, now, that will be the end of Western Civilization as we know it. —Mr. Glenn Holland (Richard Dreyfuss), high school orchestra conductor, in *Mr. Holland's Opus* (1995)

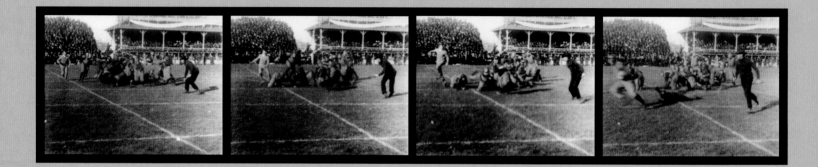

FOOTBALL ON FILM

Seventy years passed between the movies quoted above, but they suggest the same sentiment. Football matters. It matters to some people who might otherwise be national leaders or in a position to fund budget-stricken arts programs. And since the emergence of both the motion picture industry and organized football in the late nineteenth century, filmmakers have regularly turned their lenses on the gridiron. Their early films—silent recordings of scenes at college games lasting only a few minutes—came with self-explanatory titles such as *Yale Football Team at Practice* (1896), *A Football Tackle* (1899), and *Football Game: West Point vs. Annapolis* (1902). Football fans and curious viewers in major cities could watch these snippets of action at their local nickelodeon.

Ultimately, cinema and football—each a multibillion-dollar industry—became cornerstones of the same enormous entity that is the American entertainment business. Their collaboration has richly chronicled football's presence in American life through slapstick and drama, documenting changing attitudes toward the meaning and value of the game and how it rates against other priorities.

He won't let me have a gun, and he'll only play touch football with me, never tackle. —Six-year-old Scout Finch, discussing her father, in *To Kill a Mockingbird* (1962)

In early twentieth-century film features, American audiences welcomed the notion that heroics on the gridiron translated into similar acts off the field. In *The College Widow* (1915), the coach rescues the school president's daughter from a burning building when he and his players burst in using the Flying Wedge formation. *Live Wires* (1921) concludes in spectacular fashion, as the hero races to the stadium by train, then, climbing aboard the roof, is retrieved by an airplane that delivers him to the game in time to ensure his team's victory.

The dapper collegian, the BMOC (big man on campus), was a national phenomenon in the early twentieth century, and, on film, a fellow in a letterman's sweater or clutching a football was shorthand exposition for the all-American male. Hollywood films reflected the

HAROLD LLOYD

"The FRESHMAN"

Is'nt it wonderful to be in love?

A Pathé Picture

Produced by HAROLD LLOYD CORPORATION

national interest in trendsetting collegiate life, including what had become a social mainstay of the college experience: the classic football weekend. From the 1910s through the 1930s, hundreds of movies were set on college campuses, where so much seemed to depend on the fortunes of the football team.

Curiously, after World War II, when college enrollment skyrocketed in an age of postwar stability and the G.I. Bill, the flow of football films ebbed. By the mid 1950s, as movie theaters competed with television sets, Hollywood focused on the spear-and-sandal, cast-of-thousands epic for its cinematic heroics. Football still occasionally appeared on screen, but it enjoyed a resurgence in the 1970s with the demise of the film industry's self-enforced policy that restricted what could be said, addressed, or shown on screen. This made it possible to illustrate the more realistic—and unseemly—aspects of football and its players, as with *Number One* (1969), *Semi Tough* (1977), and *North Dallas Forty* (1979). The fairly steady flow of football films continued unabated well into the twenty-first century.

No matter the era, many of the issues that film presents have remained constant, and more than a century of football movies demonstrates the prevalence of certain themes. Among them:

(Opposite) Film footage from the Michigan-Chicago game, Thomas A. Edison, Inc., Chicago, 1903.

(Above) Lobby card, reissue, for *The Freshman* (1925).

We all know most marriages depend on a firm grasp of football trivia.

—Modell, in *Diner* (1982)

In football, brawny men are not exactly brainy men. The dumb-jock stock character—especially one who plays football—has long been a go-to man for Hollywood. As early as the 1920s, the movies were poking fun at the prominent place that football held—and continues to hold—in higher education. In *The Freshman,* when Harold Lloyd's character, the thin, bespectacled Harold Lamb (who is truly led to the slaughter, as the football team's live tackling dummy) arrives for his first semester at college, an inter-title appears on screen to set the scene. It reads: "The opening of the Fall term at Tate University—a large football stadium with a college attached." In *Horse Feathers* (1932), a Marx Brothers comedy, Groucho plays Professor Wagstaff, the president of Huxley College. "And I say to you gentlemen that this college is a failure," he announces. "The trouble is, we're neglecting football for education."

Walt Disney presents Son of FLUBBER STARRING FRED MACMURRAY · NANCY OLSON · KEENAN WYNN

Underdog success is another staple in the Hollywood playbook. *The Freshman* certainly did not have the last word on underdogs, a beloved American breed. In 1993, that *Rudy* kid triumphed briefly at Notre Dame and a bit longer at the box office. In *Paper Lion* (1968), based on journalist George Plimpton's book chronicling his true-life experience trying out for the 1963 Detroit Lions, the author (Alan Alda), a scrawny, thirty-six-year-old Harvard grad, is in over his awkwardly helmeted head throughout training camp. Lions staff and players, including coach Joe Schmidt and Pro Bowl defensive tackle Alex Karras, who would go on to a successful acting career, appear in the film as themselves, lending a note of authenticity. In a cringe-inducing scene during a pre-season game, Plimpton, as quarterback, lines up behind the right guard on his first play from scrimmage. Viewers came away with a better understanding of, and perhaps a newfound respect for, the rigors and demands of the game in the pro ranks.

A predictably large number of football films rely on predictably dramatic, last-minute, game-winning plays. Even without such life-altering plays, football, Hollywood suggests, offers **a shot at glory and a path to a better life**. In *The Replacements* (2000), quarterback Shane Falco (Keanu Reeves) attempts to rally his fellow scabs who sign with the NFL during a player strike: "I wish I could say something classy and inspirational, but that just wouldn't be our style . . . Pain heals. Chicks dig scars. Glory—lasts forever." Tom Cruise exemplified this idea not once but twice. In *All the Right Moves* (1983), his high school defensive back tries to win a college scholarship and escape a Pennsylvania steel town. In *Jerry Maguire* (1996), Cruise is a sports agent who discovers the meaning of

COLONEL BLAKE: Football game?

GENERAL HAMMOND: Yeah, yeah, we put up a few bets, five thousand maybe, and have a little fun. Special services in Tokyo says it's one of the best gimmicks we've got to keep the American way of life going here in Asia.

BLAKE: Betting?

HAMMOND: No, football.

—*M*A*S*H* (1970)

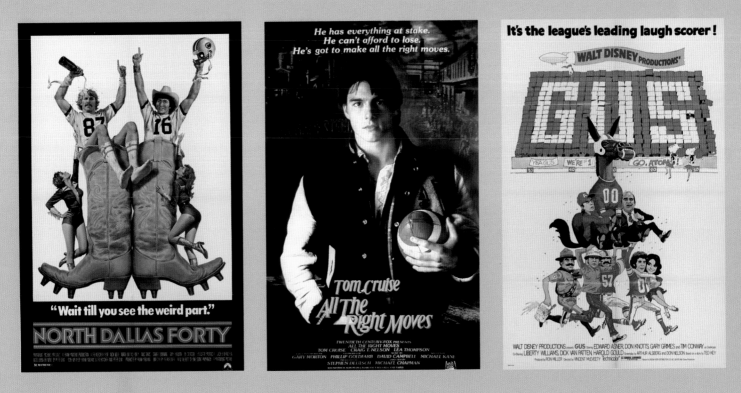

"Wait till you see the weird part."
NORTH DALLAS FORTY

He has everything at stake.
He can't afford to lose.
He's got to make all the right moves.

TOM CRUISE
All The
Right Moves

It's the league's leading laugh scorer!
WALT DISNEY PRODUCTIONS'
GUS

loyalty after his only client, an NFL wide receiver (Cuba Gooding Jr.), loudly asks him to "Show me the money!"

Glorious or not, **the game is violent and takes a physical toll**. *The Longest Yard* (1974) finds prison inmates squaring off against the guards. The NFL declined to cooperate with the productions of *North Dallas Forty* (1979) and *Any Given Sunday* (1999) because of their raw depictions of the pro game. *North Dallas Forty* opens on a hungover note as a veteran wide receiver (Nick Nolte) struggles to get out of bed in the morning. *Any Given Sunday* did not flinch in depicting literally eye-popping hard hits, the drive to play injured, and the dilemma aging players face in deciding when to stop.

As nearly anyone even remotely connected to the game knows, **football is a sport of unrelenting pressure**. In *Friday Night Lights* (2004), high school players are burdened with providing self-esteem and a sense of worth to the West Texas oil town of Odessa. As the coach (Billy Bob Thornton) informs his team, "Gentlemen, the hopes and dreams of an entire town are riding on your shoulders. You may never matter again in your life as much as you do right now." In *The Program* (1993), a college coach (James Caan) must also deal with his players' off-field issues, from alcoholism to cheating, injuries, and steroid use as alumni demand Eastern State become a winner.

Although the film canon regularly illustrates **the effect women have on players,** three films from 1949 alone are Hollywood's irrefutable proof that their impact should not be underestimated. *Father Was a Fullback* features a state university coach (Fred MacMurray) exhausted by his other job, raising two daughters. *Easy Living* centers on a veteran quarterback (Victor Mature) whose wife's ambition threatens both his health and his future in the game. And in one of the more curious offerings of the year, football received the full Technicolor treatment in the musical *Yes Sir, That's My Baby*, in which military veterans on the college G.I. Bill try to balance football and fatherhood.

When the TV movie *Brian's Song* aired in 1971, 20 million American households tuned in, including the one in the Nixon White House. *Brian's Song* is the true story of two Chicago Bears teammates: Hall of Fame running back Gale Sayers (Billy Dee Williams), a black man, and Brian Piccolo (James Caan), his white teammate felled by cancer. Their

(Opposite, top) *Son of Flubber*, lobby card, 1963.

(Opposite, bottom) Alan Alda as a Detroit Lions rookie quarterback, in *Paper Lion* (1968).

(Above, left) *North Dallas Forty*, movie poster, 1979.

(Above, middle) *All the Right Moves*, movie poster, reissue, 1983.

(Above, right) *Gus* movie poster, 1976.

All I'm saying is that you could have robbed banks, sold dope or stole your grandmother's pension checks and none of us would have minded. But shaving points off of a football game— man, that's un-American. —Inmate to a fellow prisoner and former pro player, in *The Longest Yard* (1974)

(Above) *Yes Sir, That's My Baby*, lobby card, 1949.

(Right) *The Blind Side*, movie poster, 2009.

unprecedented pairing as the NFL's first interracial roommates and, later, their close friendship, intrigued the media. *Brian's Song* was the forerunner of other films in arguing that **football can bridge America's racial divide**. Successors include *Remember the Titans* (2000), which chronicles the 1971 season at a newly integrated high school in Alexandria, Virginia, and the challenges facing its black coach; *The Express* (2008), a biopic of Syracuse running back and Heisman Trophy winner Ernie Davis; and *The Blind Side* (2009), about a white family that adopts a neglected black teenager who becomes a highly recruited offensive lineman.

Finally, several films examine **the agony of no longer playing football**. *Heaven Can Wait* (1978) and *The Best of Times* (1986) ask the question: What if you could go back and play again? A short career in football is all most players ever get. *Everybody's All-American* (1988) traces the disappointing post-football existence of a former star at Louisiana State. A *Washington Post* critic described his second life thusly: "Back home in Louisiana, reduced to selling artificial turf and telling old war stories, the golden boy turns into a bloated good ol' boy."

But I will not wear that gaudy orange. I will not. It is not in my color wheel, and I'm not gonna wear it. —Leigh Anne Touhy, encouraging her adopted son to accept a scholarship from Tennessee, in *The Blind Side* (2009)

The cinematic consensus has been that life after football is a letdown, and success *in* other fields will never be as exciting as success *on* the field. This sentiment, true or not of all sports, seems universal, but Hollywood has held it out as a particular American truth. Athletic prowess coincides with youth, leaving former players with decades to contemplate what was and what might have been, giving screenwriters a bevy of psychological and dramatic source material to sift through. Consider Uncle Rico, the middle-aged has-been in *Napoleon Dynamite* (2004), who spends afternoons reliving his high school heroics and videotaping himself throwing passes. He spoke for plenty of others when he told a kid who had never seen him play: "Coach woulda put me in fourth quarter, we would've been state champions. No doubt. No doubt in my mind."

SANDRA BULLOCK
THE BLIND SIDE
BASED ON AN EXTRAORDINARY TRUE STORY

Knute Rockne—
All-American
(1940)

Perhaps no other actor has converted such a small role into a lifelong alter-persona as Ronald Reagan did with George Gipp, an All-American for the Fighting Irish in 1920. Reagan, whose repeated suggestions to do a movie about Notre Dame's Coach Rockne had seemingly been ignored, was shocked to read in *Variety* that Warner Bros. was actually producing such a film. Desperate to play Gipp, the twenty-nine-year-old sportscaster-turned-actor finally won the role after showing a skeptical producer photographs of himself in his Eureka College football uniform. "I've always suspected that there might have been many actors in Hollywood who could have played the part better," he admitted, "but no one could have wanted to play it more than I did."

In less than ten minutes of screen time, Reagan's Gipp races 80 yards for a touchdown, becomes a national hero, and delivers his classic deathbed speech, gamely telling Coach Rockne that, "Someday when things are tough, maybe you can ask the boys to go in there and win just one for the Gipper." An old-time sportswriter who had covered Gipp hailed the accuracy of Reagan's breezy, winning performance, right down to the player's limp. "Actually, I wasn't trying to limp," Reagan later recalled. "I just wasn't used to my new football shoes, and my feet hurt."

Gipp was a career-making part for Reagan, and not just as an actor. So closely was he identified with the character that he carried the nickname Gipper throughout his political life. As president of the United States (1981–89), Reagan used his most famous movie line to great theatrical effect, whether campaigning,

encouraging U.S. Olympians, or urging Congress to pass legislation "for the Gipper."

Pat O'Brien as the coach and Ronald Reagan as "the Gipper" in *Knute Rockne— All American* (1940).

primarily with the Houston Oilers, during an eight-year career that ended in 1985. "I played the way I wanted to play and ran the way I wanted to run. When you want to be the best at something, nobody is going to tell you how to do it. When it was third-and-four, I didn't just want five yards. I wanted seven." The game took such a toll that Campbell was using a wheelchair and a walker in his forties.

Concern about player injuries made allegations of "bounties" among defensive players all the more alarming when NFL commissioner Roger Goodell suspended New Orleans Saints coach Sean Payton for the 2012 season and indefinitely suspended defensive coordinator Gregg Williams. The league charged that players maintained a slush fund to reward those who knocked opponents out of games. According to players league-wide, bonuses for good hits were not unusual in the NFL, but deliberately attempting to injure opponents was considered dirty play. As Dick Butkus, Hall of Fame linebacker with Chicago (1965–73), once said, "I wouldn't ever set out to hurt anyone deliberately unless it was, you know, important—like a league game or something." Fans did not turn away from the game, maintaining their pact with the sport, but in light of further medical research, many reconsidered at what age to let their own children play.

Meanwhile, other types of scandals, centered in college football, have always forced a national discussion on the particular topic at hand, though that has not always resulted in reaching permanent solutions. The cheating scandal involving engineering exams at Army in 1951 raised questions about the pressure on players in academically challenging environments, and most commentators had sympathy for the expelled students. The player payment scandal five years later involving five of the ten Pacific Coast Intercollegiate Conference schools destroyed the league. In 1987, Southern Methodist received the "death penalty"—the NCAA shut down its football program for a season—when it was learned that, over a ten-year period, players were paid in a scheme that ended the career of Texas governor Bill Clements. The desire to win, from keeping good athletes academically eligible to paying for talent, proved to be a root cause of so many "mistakes in judgment" cases—but not the only one.

By the 1980s, bad publicity for college football stemmed from another cause: an increase in player run-ins with the law. The Miami Hurricanes won three national titles in the eighties and were the era's Most Wanted poster boys, exhibiting a fascination with gang culture and weaponry that contributed to extracurricular violence. "Miami may be the only

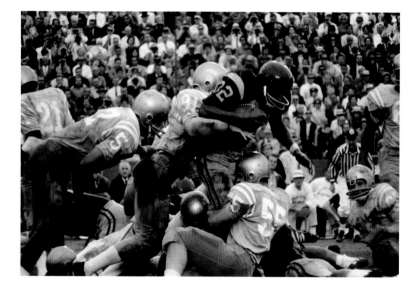

Penn State fans mourn coach Joe Paterno, Happy Valley, Pennsylvania, by Gene Puskar, January 22, 2012. The evening Paterno died, two months after he was fired following revelations in the Jerry Sandusky child abuse scandal, a memorial materialized at the foot of his statue outside Beaver Stadium. Six months later, the university removed the statue. Among other sanctions, the NCAA fined the school $60 million and vacated 111 of Paterno's wins.

squad in America that has its team picture taken from the front and from the side," wrote *Sports Illustrated*'s Rick Reilly in 1986. Miami's difficulties coincided with a sharp increase in NFL player salaries and commentary about players' off-field behavior, particularly those who had achieved celebrity status. The Simpson trial in 1995 drew greater attention to what connection, if any, existed between football players and off-field violence. In 2000, the rising number of incidents prompted the *San Diego Union Tribune* to develop an NFL player arrest database; the most common serious charges included assault, battery, hit and run, and drunk driving. By 2007, though, the media and the public appeared to regard such cases as unsurprising and tiresome, reserving instead particular enmity for Atlanta Falcons quarterback Michael Vick, who pleaded guilty to running a dog-fighting operation. In the meantime, many players still accepted the traditional notions of athletes as role models and heroes to youngsters, and large salaries allowed more pro players to fund charitable foundations and to participate in off-season community service projects.

What's been called the worst scandal in American college sports, however, did not even involve football players but was instead attributed—to a degree hotly debated—to the "culture" that existed at a premier program and its devotion to the game. In a fast-moving scandal amid insatiable press coverage, Joe Paterno, then in his forty-sixth season as Penn State head coach, was fired in November 2011 "for a failure of leadership" following allegations that his former defensive coordinator, Jerry Sandusky, had molested numerous boys on campus and on team road trips. Sandusky was convicted of forty-five counts of child sexual abuse in June 2012 and given a minimum thirty-year prison sentence. Penn State officials, including Paterno, had known of complaints against Sandusky for years but had not gone to the police. At the university's request, Louis Freeh, former director of the FBI, investigated the case and reviewed school policies. Freeh issued a report citing "a culture of reverence for the football program that is ingrained at all levels of the campus community" and that subsequently clouded people's judgment. Some employees feared for their jobs if they reported illegal or unethical activities that might jeopardize the team, even in cases involving children's safety.

The urge to protect its football program was no different at Penn State than at many other schools. What *was* different, and what made the scandal all the more shocking, was both

the heinousness of the crimes and that Penn State enjoyed an unmatched reputation for integrity in big-time college football. To the public, Paterno's program was ideal: It produced competitive teams with high graduation rates, and its famously plain blue and white uniforms, absent player names, suggested solid competence and the importance of teamwork over the flashy posturing so prevalent elsewhere. Recruiters proudly told prospects that the Nittany Lions had the only major program free of NCAA violations. If campus culture could be so corrupt there, went one line of thinking, imagine what it was like at other football powerhouses.

The days of the coach who stays for decades as Paterno did appeared to be on the wane in the early twenty-first century. The demands of the job take a tremendous toll. ("I don't take vacations. I don't get sick. I don't observe major holidays. I'm a jackhammer," said coach Jim Harbaugh, who moved from the pressures of college ball at Stanford to the rigors of the San Francisco 49ers in 2011.) Major college coaches, the most visible figures on campus and charged with filling stadiums and donor coffers, earn considerably more than the school president, and at public schools they are typically the highest-paid state employees. Ohio State president Gordon Gee underscored the exalted status of the football coach more than he may have wished in 2012 when he stood by the embattled Jim Tressel, who was shortly to resign when it was learned he knew his players were selling team memorabilia. "Let me be very clear," said Gee, "I'm just hoping the coach doesn't dismiss *me*."

All Football All the Time

I will not rest until I have you holding a Coke, wearing your own shoe, playing a SEGA game—featuring you—while singing your own song in a new commercial—starring you—broadcast during the Super Bowl—in a game that you are winning—and I will not sleep until that happens. —Player agent Jerry Maguire (Tom Cruise) attempting to land a client, in *Jerry Maguire* (1996)

Philadelphia Eagles coach Dick Vermeil, regarded as an extreme workaholic even by other workaholic coaches, was so engrossed in preparing for the 1981 season that he never even saw the blitz coming—the global media blitz surrounding the impending nuptials of Prince Charles and Lady Diana Spencer on July 29. Asked if he planned to watch the royal wedding, Vermeil responded, "The what?"

The time teams put into training for, competing in, and recovering from the season is no longer seasonal but year-round. In 1961, the NFL adopted a standard fourteen-game schedule that increased to sixteen games in 1978; the season expanded in 1990 with the

inclusion of rotating "bye weeks," allowing for additional television coverage without changing the number of games played. The pre-season exhibition games doubled to four.

For dedicated fans, following football means following summer training camp, pre-season practice games, the regular season, the month of NFL playoffs, and college bowl games, spring practice, predictions for the college draft followed by post-draft analysis, then back to training camp. NFL championships in the early 1960s were played in late December; the first Super Bowl, in 1967, was held in mid-January; and the championship game has since been pushed into February to accommodate extra playoff rounds and a built-in "hype week" for media coverage. The game has so swamped the calendar that off-season football news often receives more play than baseball and basketball when those sports are in season.

A once-orderly weekly schedule of high school football on Friday night, college games on Saturday, and Sunday devoted to the NFL lasted until 1970. The introduction of *Monday Night Football* was later followed by sporadic Thursday-night games that eventually became a regular part of the season. Unpopular with teams because of the quick recovery and prep time demanded, the addition of Thursday games means fans only have to get through Tuesday and Wednesday without live football. Even the announcement of the upcoming season schedule is an event; when the NFL released its 2012 season schedule in April, ESPN ran a three-hour show *about the schedule* and what to look for in games that would not be played for another six months.

In 1908, Josiah Morse of the *New York Tribune* speculated on what Americans in the future would think of their ancestors' football obsession. "The future chronicler—say two thousand years hence—who will turn the leaves of our newspapers to get a sort of living-picture view of our times and see how we lived and what we did, what our interests were, etc., will very likely come to the conclusion that for several months in the year, from October to December, we didn't seem to care for anything much but football. 'Great Heavens!' we can hear him exclaim, 'our forebears in the twentieth century must have been football mad.'"

When that same chronicler comes upon the pages—printed and digitized—of the twenty-first century, he will very likely come to the conclusion that there was not a single day of the year when nothing was happening in Football Nation.

(Above) Christmas Day football game at Bora Jengi checkpoint, Zabul province, Afghanistan, by Sgt. Ian Schell, 2010. U.S. soldiers with the Security Forces Advisory Team, 3rd Afghan Border Police, take on the Seabees of the 26th Naval Mobile Construction Battalion near the Pakistan border. During the wars in Iraq and Afghanistan, the U.S. Air Force drew inspiration from NFL digital archival technology (which quickly locates tagged video clips from old games) to better catalog its own surveillance footage collected by drones. In an unusual twist, technology developed to enhance televised sports coverage had important military applications as well.

In the group picture
of our 1892 football
squad, whiskers and
moustaches grew
almost as lushly as
did goldenrod on the
Chicago prairie.

—A. A. Stagg, University of
Chicago coach, 1892–1932.

THE TEAM PHOTO

The team photo has evolved from the studio
portrait to the stadium shot, and as rosters grew
in size, the casual—even languid—poses and
expressions of individuality gave way to an orderly
yet highly regimented presentation. Early on,
showing off equipment (first the ball, then rubber
nose guards, then helmets) was typical, and once
teams acquired managers, coaches, and a coterie of
assistants, they, too, found their way into the ever-
burgeoning team picture. For successful teams,
the formality of the pre-season official photo
contrasts vividly with the season-ending, on-field
celebratory group shot. And in some cases, fans
have even managed to make an appearance in the
team photo.

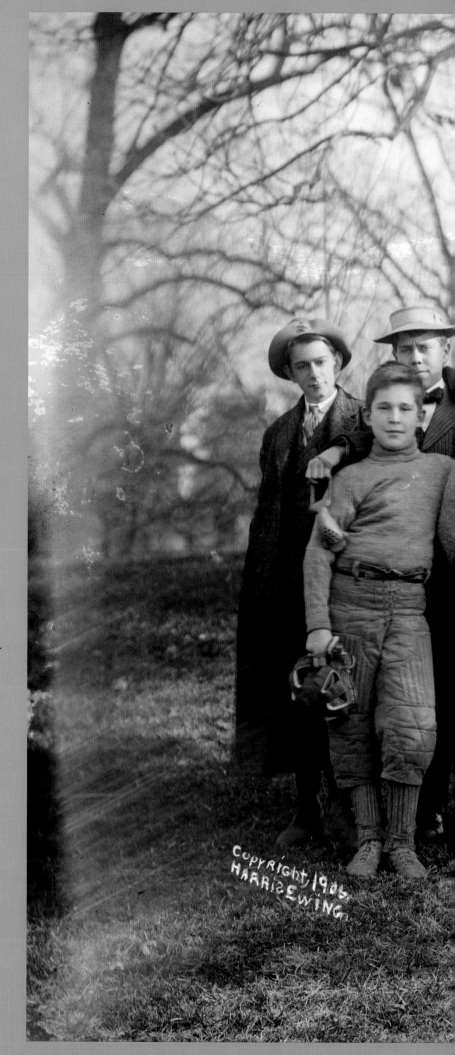

Friends School team, Washington,
D.C., 1906.

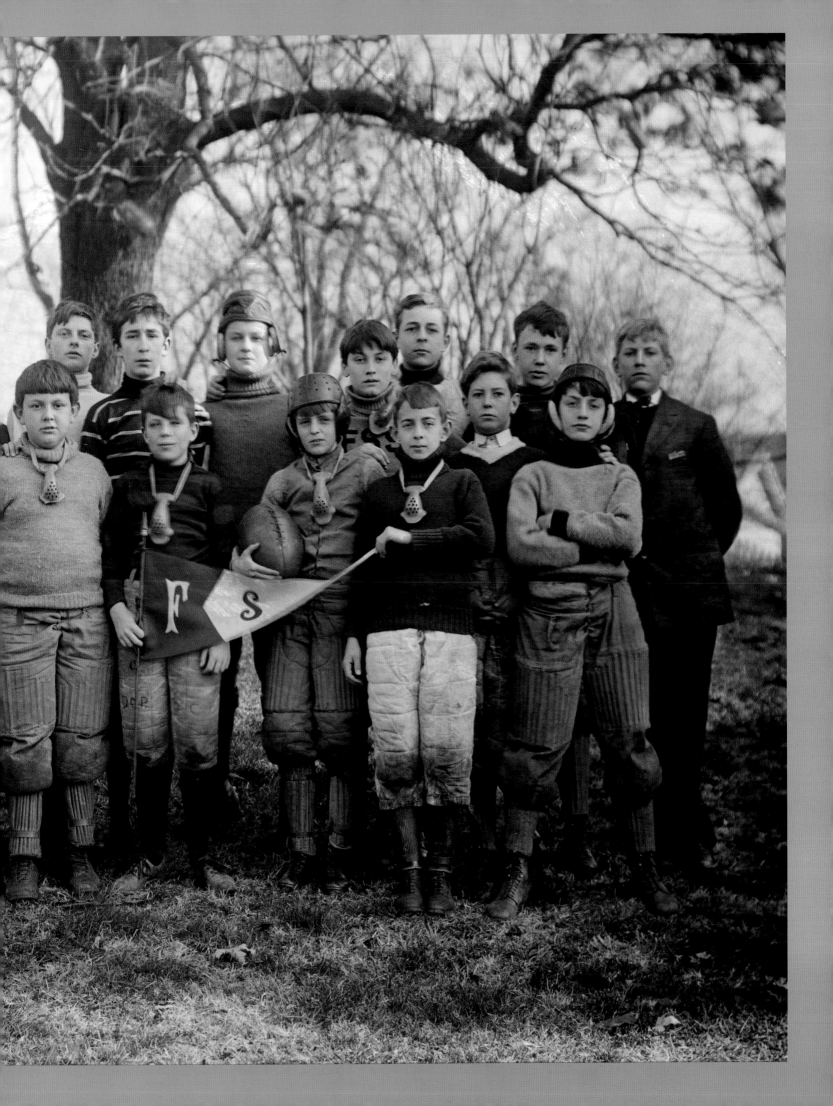

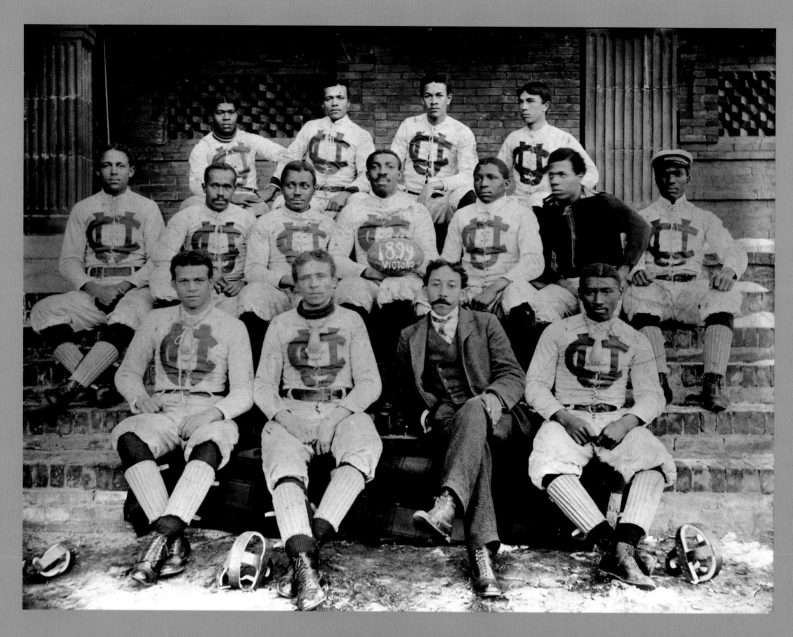

(Above) Claflin College varsity, Orangeburg, South Carolina, 1899.

(Right) Rutgers varsity, New Brunswick, New Jersey, 1891.

(Opposite, top left) U.S. Marine Corps team, 1923.

(Opposite, top right) Drake University team at the White House, 1924.

(Opposite, bottom) Fifth Air Force team, Nagoya, Japan, 1947.

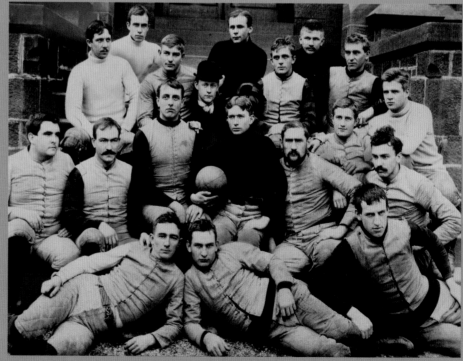

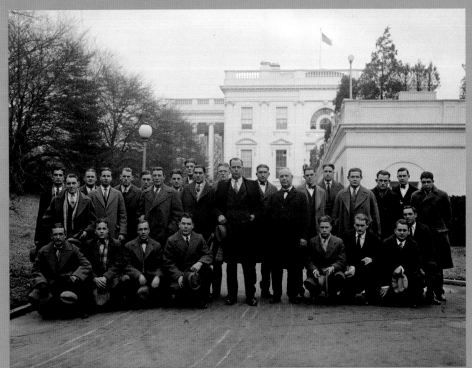

5th AIR FORCE FOOTBALL TEAM
NAGOYA, JAPAN
1947

SEASON'S	RECORD				
11th AIR BORNE	36	0	8th. ARMY	19	0
1st CAVALRY	20	6	G.H.Q.	6	0
NAVY	8	6	25th DIVISION	6	8
24th DIVISION	6	6	KOBE BASE	0	25

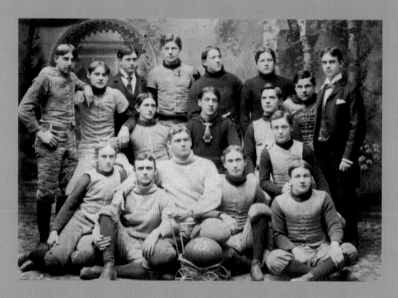

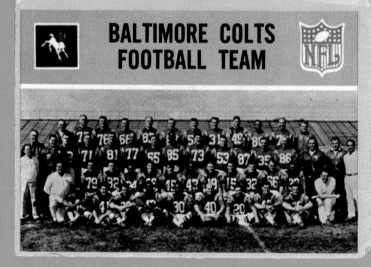

(Above) University of Maine, 1932.

(Middle left) Terre Haute High School team portrait, Terre Haute, Indiana, 1895. Note the doll carriage holding the ball.

(Middle right) The Baltimore Colts, 1966.

(Bottom) Fans pose with the Arizona Cardinals team photo display, Phoenix, 2008.

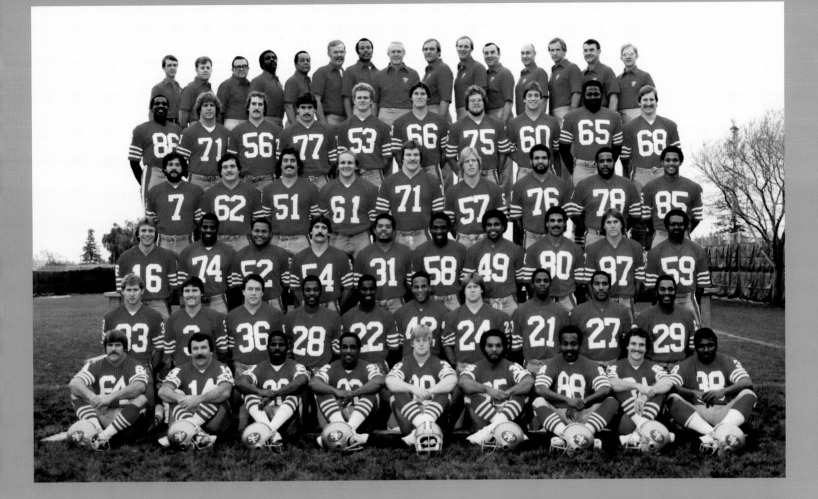

(Top) The San Francisco 49ers, 1982.

(Above) East Bay High School girls flag football team, Gibsonton, Florida, by Robert Angelini, 2012.

(Left) The Las Vegas Showgirlz, 2007.

Not everybody can be first team, but you can always put the team first. —Lou Holtz, whose coaching career included stints at Arkansas (1977–83), Notre Dame (1986–96) and South Carolina (1999–2004).

ACKNOWLEDGMENTS

Of all sports, football most demands teamwork, in every second of play. —George Halas (1895–1983), Chicago Bears player, coach, and owner

Books demand teamwork on every page, and a project of this size and scope required the expertise, talent, and skill of many people. I am especially thankful to image researcher/editor Athena Angelos for her sharp eye, invaluable suggestions, and quick wit, as well as for her willingness to tackle four centuries' worth of visual material. Jonathan Horowitz, who contributed several pieces to the text and combed both the vast archives of the Library of Congress and the outer edges of the Web, is a gifted, indispensible researcher and an always convivial presence. It was my very good fortune to work closely with both of them.

I am very grateful to the staff at Abrams Books, especially Laura Dozier, an excellent editor in every way; associate publisher Deb Aaronson, who is such a pleasure to work with; and John Gall and Danielle Young, who produced such a smart, thoughtful design. In the Library of Congress Publishing Office, thanks goes to W. Ralph Eubanks, director, and Margaret Wagner, Peter Devereaux, Aimee Hess Nash, Linda Osborne, Christel Schmidt, and Myint M. San for serving as readers and cheerleaders. I am particularly obliged to senior editor Tom Wiener, sports conversationalist extraordinaire. Hicks Wogan offered valuable insight on football films, and I appreciate the contributions made by researchers Heather Noel, Stacia Odenwald, Julie Thompson, Cypress Walker, Luke Wilson, Gabrielle Winick, and Jessica Wolpert.

In digging through the amazing collections at the library, my colleagues and I benefitted greatly from the helpfulness of curators, subject specialists, and reference librarians, starting with Dave Kelly, former sports reference specialist. We also drew on the knowledge and good graces of Judith Gray, American Folklife Center; Glen Krankowski and Domenico Sergi, Information Technology Service; Ed Redmond, Geography and Map Division; Connie Cartledge, Jeff Flannery, Joe Jackson, Patrick Kerwin, Bruce Kirby, Michelle Krowl, and Julie Miller, Manuscript Division; Bryan Cornell and Zoran Sinobad, Motion Picture, Broadcasting and Recorded Sound Division; Pat Baughman and Denise Gallo, Music Division; Georgia Higley and Megan Halsband, Serial and Government Publications Division; Clark Evans and Eric Frazier, Rare Book and Special Collections Division; and Rachel Mears and Alexa Potter of the Veterans History Project. The Prints and Photographs Division is an unrivaled treasure trove, and Jeff Bridgers, Sara Duke, Jon Eaker, Jan Greci, Phil Michel, Barbara Natanson, and Helena Zinkham facilitated our searches and led us to many exciting finds.

Thanks also go to those outside the library for their expertise, including Eugene Connolly, professor of sports history, Edinburgh University; Darius Coombs, associate director of Plimoth Plantation, Massachusetts; and Kent Stephens, curator and historian, College Football Hall of Fame. Paolo Battaglia, Bruce Bober, Kathleen Daly Higgs, David Horowitz, Sharon Hannon, Harry Katz, Amy Pastan, and Paul J. Stouffer contributed artifacts and tips or served as much-appreciated sounding boards.

Finally, I'm grateful to my family for their interest in these multiyear projects. And to Ken Reyburn, with whom watching the Los Angeles Rams and thousands of hours of football was a favorite pastime—thanks Dad!

Susan Reyburn

READ MORE ABOUT IT

Do you know who the best history tutor on campus was? I was.
Damn right. —Woody Hayes (1913–1987), Ohio State head coach 1951–78

Selected Sources and Suggestions for Further Reading

Bissinger, H. G. *Friday Night Lights: A Town, a Team, and a Dream*, Addison-Wesley Publishing, Reading, Massachusetts, 1990.

Fleder, Rob (ed). *The Football Book*, Sports Illustrated, New York, 2005.

Gems, Gerald R. *For Pride, Profit, and Patriarchy: Football and the Incorporation of American Cultural Values*, Scarecrow Press, Inc., Lanham, Maryland, 2000.

Lewis, Michael. *The Blind Side: Evolution of the Game*, W.W. Norton, New York, 2006.

MacCambridge, Michael. *America's Game: The Epic Story of How Pro Football Captured a Nation,* Random House, New York, 2004.

Maraniss, David. *When Pride Still Mattered: A Life of Vince Lombardi*, Simon and Schuster, New York, 1999.

Martin, Charles. *Benching Jim Crow: The Rise and Fall of the Color Line in Southern College Sports, 1890–1980*, University of Illinois Press, Urbana, 2010.

Nelson, David M. *The Anatomy of a Game: Football, the Rules, and the Men Who Made the Game*, University of Delaware Press, Newark, 1994.

Oriard, Michael. *Brand NFL: Making and Selling America's Favorite Sport*, University of North Carolina Press, Chapel Hill, 2007.

Peterson, Robert W. *Pigskin: The Early Years of Pro Football*, Oxford University Press, New York, 1997.

Watterson, John Sayles. *College Football: History, Spectacle, Controversy*, Johns Hopkins Press, Baltimore, 2000.

Whittingham, Richard. *Rites of Autumn: The Story of College Football*, The Free Press, New York, 2001.

College Football Reference at http://cfreference.net

Pro Football Reference at http://www.pro-football-reference.com

IMAGE CREDITS

Information About Images
Many images in this book are from the Library's Prints & Photographs Division and can be viewed or downloaded at http://www.loc.gov/pictures by using the negative or digital ID numbers listed below. Items from other divisions or The Associated Press are noted using the abbreviations that follow. Contact the appropriate custodial division or Duplication Services of the Library of Congress at http://www.loc.gov/duplicationservices or (202) 707-5640 to order reproductions. Restrictions on images may apply.

Library of Congress Divisions
GC General Collections
G & M Geography & Maps Division
LCPO Library of Congress Publishing Office
MBRS Motion Picture, Broadcasting & Recorded Sound Division
MSS Manuscript Division
MUS Music Division
RBSC Rare Book & Special Collections
SER Serial & Government Publications Division

AP www.apimages.com

Chapter One: Early Days & Ivy
1: SER. 2–3: LC-USZ62-123517. 4: LC-USW3-016745-D. 5: LC-DIG-ds-03642. 6–7: HABS CAL,19-PASA,14—69. 8–9: AP. 10–11: LC-DIG-ggbain-16520. 11: photographed by Carol Highsmith. 13: LC-DIG-ds-03632. 14–15: LC-DIG-ds-03672. 16: G&M. 17: LC-USZ62-37992. 18: (top) RBSC, (left) LC-USZC4-4603, (right) GC. 19: GC. 20: (left) LC-DIG-ppmsca-19172. (right) LC-USZ62-48590. 21: RBSC. 22: (left) RBSC. 22–23: charts by Jonathan Horowitz. 23: (top) GC. 24: LC-USZ62-107750. 25: Manuscripts & Archives, Yale University Library. 26: MSS, Marion S. Carson Papers. 27: Beinecke Rare Book & Manuscript Library, Yale University. 28: LC-DIG-ppmsca-22441. 29: (top left) LC-USZ61-1125, (top right) LC-DIG-03754, (bottom left) Courtesy of the Massachusetts Historical Society. 30: (top) LC-USZ62-76266, (left) RBSC, (right) GC. 31: M&A, Yale University Library. 33: GC. 34: M&A, Yale University Library. 35–36: GC. 37: (top) LC-USZ62-45835, (bottom) M&A, Yale University Library. 38: GC. 39: LC-DIG-ds-03674 & 03675. 40: LC-DIG-ds-03793. 41: GC. 42: (top left & right) GC, (bottom left) Bentley Historical Library, University of Michigan, bl# 001008, (bottom right) LC-USZC4-3092. 44: (top) Courtesy of the Franklin

(Pages 248–249) Virginia Tech fans do the wave at Lane Stadium, Blacksburg, Virginia, by Ryan Arnaudin.

(Opposite) Sampling of Los Angeles Rams trading cards. With their horned helmets, introduced in 1948, the L.A. Rams were the first NFL team to sport a design on their headgear, and they continued to set the standard for sharp looking uniforms. After nine seasons in blue and white, they returned to their tri-colored wear in 1973, when they claimed the first of seven straight NFC West division titles.

(Above) Topps trading cards for (top) Jim Plunkett, 1972, and (bottom) Bob Lilly, 1971.

D. Roosevelt Presidential Library and Museum, Hyde Park, New York, (bottom) Archives & Special Collections, University of Nebraska-Lincoln Libraries, RG 39-05-01. 45: GC. 46: (left) Manuscripts & Archives, Yale University Library. 46–47: GC. 48: (top) Moorland-Spingarn Research Center, Howard University Archives, 48: (bottom) SER. 49: (top) GC, (bottom) LC-DIG-ds-03677 (detail). 50: GC. 51: RBSC. 52: MSS, Gifford Pinchot Papers. 53: (top) LC-USZC2-1032, (bottom) Chronicling America. 54: (left) LC-DIG-ppmsca-28567, (right) LC-USZC4-13260. 55: (left) LC-DIG-ds-03729, (right) LC-DIG-ds-03676 (detail). 56: (top) LC-USZ61-566, (center left) GC, (center right) Browne Popular Culture Library, Bowling Green State University, Bowling Green, Ohio, (bottom) SER. 57: (top) LC-USZ62-35921, (center) LC-DIG-ds-03752, (bottom) LC-DIG-ds-03753. 58: (top) RBSC, (bottom) LC-DIG-ppmsca-28649. 59: (top) LC-DIG-ppmsca-28649, (bottom) GC. 60–61: GC. 62: (top) Denver Public Library, Western History Collection # X-22073, (bottom) GC. 63: (top) LC-DIG-ds-03673 (detail), (bottom) GC.

Chapter Two: Collegians & Sportsmen

64–65: LC-DIG-hec-13257. 66: LC-USZ62-35725. 67: LC-DIG-ppmsca-25994. 68: (top) GC. 68–69: LC-USZ62-125359. 69: (top) LC-DIG-ds-03786, (bottom) GC. 70: MSS, Theodore Roosevelt Papers. 71: LC-DIG-ppmsca-24400 (Vol.2, #72). 72: SER. 73: (top) LC-USZC4-3088, (bottom) LC-DIG-ds-03791. 75: Chronicling America. 76: (top) Chronicling America, (bottom) LC-DIG-ds-03795. 77: LC-DIG-ppmsca-26022. 78–79: USC Sports Information Department. 80: GC. 81: LC-DIG-ppmsca-26112. 82: (top) LC-DIG-hec-01594, (bottom) GC. 83: LC-USZC2-1040. 84: LC-USZC2-1041. 85: (top left) LC-DIG-ppmsca-27892, (top right, bottom) GC. 86–90: MUS. 91: LC-DIG-ggbain-10956. 92: (top) GC, (bottom) LC-DIG-ggbain-14737. 93: (left) Chronicling America, (right) GC. 94: (left) Chicago History Museum #SDN-0045279, (right) Chronicling America. 95: GC. 96: LC-DIG-hec-09224. 97: Chronicling America. 98–99: LC-DIG-ppmsca-19488. 100: (top) NARA 111 SC 157232, (bottom) GC. 101: SER. 102: LC-DIG-ds-03800. 103: (left) author's collection, (right) Chicago History

Museum # SDN-065090, (bottom) Chronicling America. 104: (top) © The Herblock Foundation, (bottom) LC-DIG-ds-03718. 105: (top) LC-USZ62-26735, (bottom) LC-DIG-ds-03687. 106–8: GC. 108: (bottom right) LC-DIG-ppmsca-02922, (bottom left) © 1926 SEPS: Licensed by Curtis Publishing, Indianapolis, IN. All Rights Reserved. www.curtispublishing.com. 109: GC. 110: LC-USZ62-136119. 111: (top) MSS Gifford Pinchot Papers, (bottom) GC. 112–13: MSS Harry Blackmun Papers. 114–15: (top) LC-DIG-ds-03950, (bottom) LC-DIG-ds-03952. 116: Courtesy of the Shelby Museum of History, Shelby, Ohio. 117: U.S. Trademark & Patent Office. 118: Chicago History Museum #SDN-065678. 119: GC. 120: LC-DIG-npcc-15254. 121: LC-DIG-ds-03712. 122: GC. 123: LC-DIG-ds-03728.

Halftime

124–25: Ohio State Athletics. 126: LC-DIG-ds-03762. 127: (left) AP, (right) LC-DIG-ds-03738. 128: Purdue University Band. 129: (top) LC-DIG-ds-03773, (bottom) AP. 130: GC. 131: LC-DIG-ds-03717. 132: (top) LC-DIG-ds-03627, (bottom) National Cheerleaders Association. 133: Sports Illustrated Classic/ Getty Images. 134: (top) LC-DIG-highsm-06907, (bottom) LC-DIG-ds-03694. 135: AP. 136: (top, center) LCPO, (bottom) The Texas Collection, Baylor University. 137: (top) F.W. Kent Collection/ University of Iowa Archives/ The University of Iowa Libraries, (bottom left) AP, (bottom right) Courtesy of Athena Angelos. 138: (top) AP, (bottom) LC-DIG-ds-03644. 139: LC-DIG-ds-03764. 140: (top) LC-DIG-highsm-13089, (bottom) AP. 141: Courtesy of Kenneth Bailey.

Chapter Three: Fumbles & Recoveries

142–43: G&M. 144: Chicago History Museum # SDN-069573. 145: LC-USZC4-10212. 146: LC-DIG-ds-03695. 147: (top) GC, (bottom) LC-DIG-ds-03691. 148: LC-DIG-ds-03744. 149: (top) LC-DIG-ds-03696, (bottom) LC-DIG-ds-03698. 150: GC. 151: (left) LC-DIG-hec-23282, (right) GC. 152: LC-DIG-ds-03711. 153: LC-USF33-021246-M5. 154: (top) © 1949 SEPS: Licensed by Curtis Publishing, Indianapolis, IN. All Rights Reserved. www.curtispublishing. com, (bottom) Constantin Alajalov/ The New Yorker; © Conde Nast. 155: (top) Denver Public Library, Western

History Collection # X-12377, (bottom): LC-DIG-ds-03749. 156: (top left) LC-USW3-009922-E, (top right) LC-DIG-ds-03761, (bottom right) LC-DIG-ds-03727. 157: LC-USE6-D-009431. 158: National Archives 111-SC-187001 & 111-SC-332713. 159: SER. 160: LC-DIG-ppprs-00424. 161: (top) LC-DIG-ds-03697, (bottom): LC-DIG-ds-03716. 162: (left) Courtesy of Jonathan Horowitz, (right) LC-DIG-ds-03763. 163: LC-DIG-ds-03766. 164: (top) LC-DIG-ds-03780, (bottom) LC-USW3-014871-C. 165: (top) GC, (bottom left) LC-DIG-ds-03768, (bottom right) Courtesy of Gerald R. Ford Library. 166: LC-DIG-ds-03725. 167 (top) LC-USZ62-62332, (bottom) LC-DIG-ds-03643. 168: SER. 169: (left) LC-DIG-ds-03639, (center) LC-DIG-ds-03636, (right) LC-DIG-ds-03638, (bottom) LC-DIG-ds-03785. 170: (top) LC-DIG-ds-03715, (bottom) LC-DIG-ds-03769. 171: (top) LC-DIG-ds-03631, (bottom) LC-DIG-ds-03770. 172: (top) LC-USZ62-111240, (bottom) LC-DIG-ds-03731. 173: (top) LC-DIG-ds-03778, (bottom) LC-DIG-ds-03770. 174–75: Courtesy of the Des Moines Register. 176: (top) Courtesy of David Horowitz, (center) LC-DIG-ds-03714, (bottom) LC-DIG-ds-03722. 177: (top) LC-DIG-ds-03726, (bottom) LC-DIG-ds-03760. 178–79: MSS Jack Kemp Papers. 180: (top) LC-DIG-ds-03765, (bottom) LC-DIG-ds-03799. 181: (top) LC-DIG-ds-03730, (bottom left) LC-DIG-ds-03633, (bottom right) LC-DIG-ds-03693. 182: LC-DIG-ds-03746 © Robert L. Smith. 183: (left) MSS Jack Kemp Papers, (right) MUS, (bottom) LC-DIG-ds-03630. 184–85: LC-DIG-ds-03634. 186: LC-DIG-ppmscd-01345. 187: LC-DIG-ds-03772. 188–89: LC-DIG-ppmscd-01296. 190: (top) LC-DIG-ds-03645, (center) GC, (bottom) LC-DIG-ds-03721. 191: (top) LC-DIG-ds-03751 (detail), (bottom) LC-DIG-ds-03747. 192: LC-DIG-ds-03798. 193: (left) LC-DIG-ppmsca-27578, (right) © The Herblock Foundation. 194: LC-DIG-ppmsca-11998, © The Herblock Foundation. 195: all, The New Yorker Collection/ www.cartoonbank.com, (top left) LC-DIG-ds-03787 © Peter Arno, (top right) © Mort Gerberg, (bottom) © Jack Ziegler. 196: (top) PEANUTS ©1976 Peanuts Worldwide LLC. Dist. By UNIVERSAL UCLICK. Reprinted with permission. All rights reserved. 196: (bottom)

© Leonard Dove/ The New Yorker Collection/ www.cartoonbank.com. 197: DOONESBURY ©1974 G. B. Trudeau. Reprinted with permission of UNIVERSAL UCLICK. All rights reserved.

Chapter Four: Football Nation

198–201: AP. 202: (LC) HAER TX-108-11. 203: (top) LC-DIG-ds-03759, (bottom) AP. 204: AP. 205: LC-DIG-ds-03692. 206-207: LC-DIG-ds-03723★. 208: (top) AP, (bottom) © American Broadcasting Companies, Inc. 209: MBRS, The Bob Hope Collection, © Bob Hope Enterprises. 210–11: AP. 212: (top) SER © 1970 DC Comics, All rights reserved. Used with permission. (Bottom) MUS. 213–15: (top) AP, (bottom) LC-DIG-ds-03797. 216: (top) GC, (center, bottom) AP. 217: (left) AP, (right) GC. 218: (left, right) AP. 219: (left) AP, (right) Courtesy of David Franciosi. 220: AP. 221: (left) © 1974 SEPS: Licensed by Curtis Publishing, Indianapolis, IN. All Rights Reserved. www.curtispublishing. com, (right) Courtesy of Mark & Elizabeth Alves. 222–24: AP. 225: (top) MBRS, The Coca-Cola Company. Used with permission. (Bottom) SER. 226–27: AP. 228: (top) Jonathan Newton/ Washington Post/ Getty Images, (bottom) AP. 229: (top) LC-DIG-ds-03629, (bottom) MSS Jack Kemp Papers. 230: AP. 231: (top) author's collection, (bottom) SER © 1993 DC Comics, All rights reserved. Used with permission. 232: MBRS. 233, 234: (top) author's collection. 234: (bottom) MBRS. 235: (left) LC-DIG-ds-03788, (center) LCPO, (right) LC-DIG-ds-03789. 236: (top) author's collection, (bottom) LCPO. 237: LCPO. 238: (left) LC-DIG-ds-03776, (right) AP. 239: AP. 240: ESPN Images. 241 (top) AP, (bottom) DefenseImagery.mil. 242–43: LC-DIG-hec-15088. 244 (top) LC-USZ62-35749, (bottom) LC-DIG-ds-03688. 245: (left) LC-DIG-npcc-09274, (right) LC-USZ62-14446, (bottom) Veteran's History Project, Kenneth L. Hoeck (AFC/2001/001/26648). 246: (top) Courtesy of Evelyn Romansky, (center left) GC, (center right) author's collection, (bottom) AP. 247: (top) AP, (left) Courtesy of Dion A. Lee, (right) Courtesy of EBHSGFF. 248–49: Ryan Arnaudin, Shutterstock.com. 250, 256: author's collection.

Front Endpapers: LC-DIG-ds-03743
Back Endpapers: LC-DIG-ds-03742

INDEX

Page numbers in *italics* refer to images.

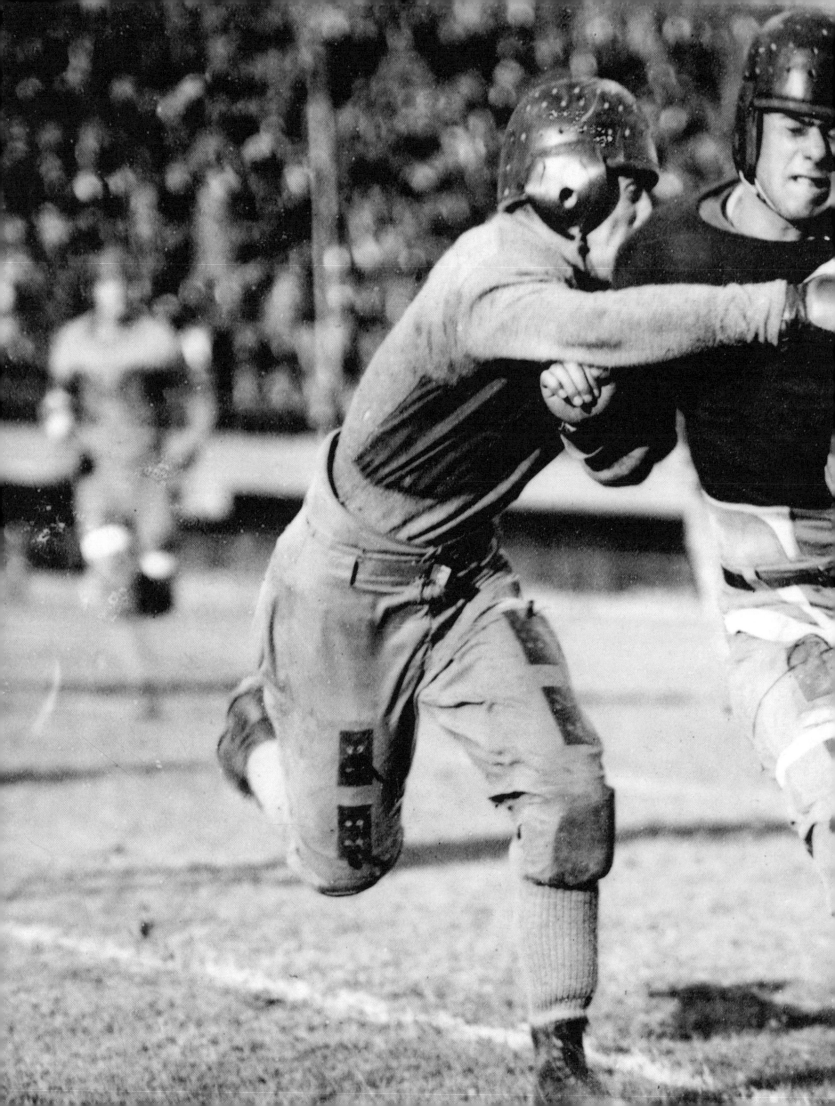